A PLACE TO BELIEVE IN

THE PENNSYLVANIA STATE UNIVERSITY PRESS
UNIVERSITY PARK, PENNSYLVANIA

A PLACE TO BELIEVE IN

LOCATING MEDIEVAL LANDSCAPES

edited by Clare A. Lees & Gillian R. Overing

LIBRARY OF CONGRESS CATALOGING-IN-PUBLICATION DATA

A place to believe in : locating medieval landscapes /
edited by Clare A. Lees, Gillian R. Overing.
 p. cm.
Includes index.
ISBN 0-271-02859-9 (cloth : alk. paper)
ISBN 0-271-02860-2 (pbk. : alk. paper)
1. Civilization, Medieval.
2. Landscape—England—History—To 1500.
3. Sacred space—England—History—To 1500.
4. Landscape in literature.
5. English literature—Middle English, 1100–1500—
 History and criticism.
6. English literature—Old English, ca. 450–1100—
 History and criticism.
I. Lees, Clare A.
II. Overing, Gillian R., 1952-

CB353.P58 2006
304.2'3094209021—dc22
2005030178

The Pennsylvania State University Press is a member of
the Association of American University Presses.

It is the policy of The Pennsylvania State University Press
to use acid-free paper. This book is printed on Natures
Natural, containing 50% post-consumer waste, and meets
the minimum requirements of American National Stan-
dard for Information Sciences—Permanence of Paper for
Printed Library Materials, ANSI Z39.48–1992.

TO *Julian and Steve*

CONTENTS

ACKNOWLEDGMENTS

Many people and places have made this book possible, as we outline in our opening chapter. But we wish to emphasize the importance of one memorable conversation with Sisters Catherine and Hilary in the Sneaton Castle Centre, owned by the Convent of the Order of the Holy Paraclete (Church of England). This Order is the modern manifestation of the Anglo-Saxon convent first founded by Abbess Hild in the seventh century. The sisters' veneration of and connection to Hild, her mission, and her place in the landscape that is both early medieval and modern Whitby is profound, and it inspired us to begin this book. We thank the Offices of the Dean and the Provost and the Graduate School of Arts and Sciences Research and Publication Fund of Wake Forest University, and the Humanities Research Centres of King's College London, for their generous support of the various stages of this book and for their co-sponsorship of "A Place to Believe in: Medieval Monasticism in the Landscape," the conference that brought our contributors together in Whitby in the summer of 2003. We also thank Emily Brewer, our graduate assistant, for her invaluable help in coordinating the conference, and Rosalin Barker (Hon. Fellow, University of Hull, Institute of Learning, and Hon. Secretary, Friends of Whitby Abbey) for her opening remarks. Finally, we wish to record our gratitude to our contributors, some of whom traveled considerable distances to Whitby and all of whom have enriched our understanding of place, medieval and modern.

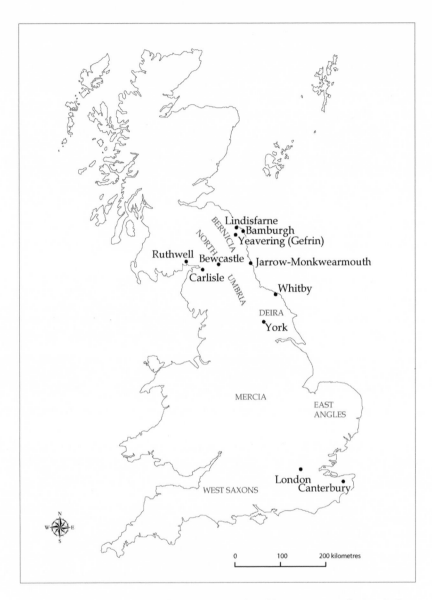

FIG. I Early Anglo-Saxon England. Map reproduced by permission of Sylvie Dubuc, Department of Geography, King's College London.

ANGLO-SAXON HORIZONS:
PLACES OF THE MIND IN THE NORTHUMBRIAN LANDSCAPE

Clare A. Lees and Gillian R. Overing

In an essay first published in 1977, Yi-Fu Tuan, the cultural geographer, offers a rich meditation on human cognition and the meaning of landscape. If we train our eye, he argues—if we look ever more closely—a landscape can reveal its singular ordering of reality, and we see "how various and complex are the ways of human living."[1] For Tuan, the reading of a landscape is always a dialogue between physical environment and human perception. A sense of place is thus construed as dynamic, lived experience—or, put another way, as a window onto human activity. Others have since translated the creative premises of cultural geography into a dizzying array of registers and disciplines, from the now-familiar Foucauldian analyses of spatial power relations, to the work of Michel de Certeau and Pierre Bourdieu, to the "new geography" that is increasingly incorporated into sociohistorical and literary work in many fields of scholarship.[2] But Tuan's evocation of being there—of

1. Yi-Fu Tuan, "Thought and Landscape," in *The Interpretation of Ordinary Landscapes,* ed. D. W. Meinig (Oxford: Oxford University Press, 1977), 89–101, at 101.
2. For an overview, see the critical introduction to *Senses of Place,* ed. Steven Feld and Keith H. Basso (Santa Fe, N.M.: School of American Research Press, 1996), 3–11. See also James Duncan and David Ley's introduction to *Place/Culture/Representation,* ed. Duncan and Ley (London: Routledge, 1993), 1–19, for an overview and critique of scholarship in the fields of cultural and humanist geography. Medievalists have already begun to incorporate spatial and new geographic perspectives into their

what it might mean to be "in place"—and his insistence on kinetic connection remain particularly compelling.

We share places with the past, and medievalists, perhaps especially, have much to gain from a thoroughgoing contemplation of place, an ever more layered and complex understanding of landscapes in and through time. From the disciplinary perspectives of, for example, art history or landscape and settlement studies, the notion of "landscape" is post-medieval, but that of *locus* or place is thoroughly medieval—a familiar element of monastic habits of thought and knowledge.[3] Concepts of landscape and of *locus* converge in the ways in which both can open the mind to considerations of place, time, and memory.[4] These considerations are explored by a number of contributors to this book and in a variety of contexts, such as Goscelin's Life of Edith, as Stephanie Hollis argues in "Strategies of Emplacement and Displacement," or the later thirteenth-century writings of Gertrud of Helfta examined by Ulrike Wiethaus in "Spatial Metaphors, Textual Production, and Spirituality in the Works of Gertrud of Helfta (1256–1301/2)." Ideas of place, whether those of the past or of the present, offer new imaginaries, new possibilities for connection, invention, or consolation (and perhaps all three operate in Goscelin's desire to link people and place in his Life of Edith). Such imaginaries offer, in turn, the lure of storytelling, of continuing the story of the past into the present, which has attracted all the contributors to this volume. Sarah Beckwith's "Preserving, Conserving, Deserving the Past," which takes as its beginning the significance of the ruined Abbey of St. Mary for the staging of the York mystery plays in 1951, provides just one instance of the relation between medieval and modern that is central to *A Place to Believe In*.

If, as Tuan argues, landscapes are windows onto human activity, they are places where we in the present might be connected, unsentimentally, with

scholarship; see, for example, Rita Copeland's introduction to *New Medieval Literatures,* vol. 2, ed. Rita Copeland, David Lawton, and Wendy Scase (Oxford: Clarendon Press, 1998), entitled "Gender, Space, Reading Histories"; Sylvia Tomasch and Sealy Gilles, eds., *Text and Territory: Geographical Imagination in the European Middle Ages* (Philadelphia: University of Pennsylvania Press, 1998); Gillian R. Overing and Marijane Osborn, *Landscape of Desire: Partial Stories of the Medieval Scandinavian World* (Minneapolis: University of Minnesota Press, 1994); D. Fairchild Ruggles, *Gardens, Landscape, and Vision in the Palaces of Islamic Spain* (University Park: The Pennsylvania State University Press, 2000); and John Howe and Michael Wolfe, eds., *Inventing Medieval Landscapes: Senses of Place in Western Europe* (Gainesville: University Press of Florida, 2002).

3. Anglo-Saxon England is a prime area for investigating issues of settlement and its relation to landscape. See, for example, Della Hooke, *The Landscape of Anglo-Saxon England* (Leicester: University of Leicester Press, 1998). For the cognitive aspects of place and *locus,* see Mary Carruthers, *The Book of Memory* (Cambridge: Cambridge University Press, 1990) and *The Craft of Thought* (Cambridge: Cambridge University Press, 1998).

4. Carruthers elegantly demonstrates this point in *The Craft of Thought.*

those in the past. In this book we ask questions about medieval notions of space and place, certainly, but we also consider how medieval concepts and practices might challenge modern assumptions, and we even glimpse moments of continuity between the medieval and the modern. Even as Beckwith uses medieval concepts of relic to underline modern meanings of ruin as transformation and possibility, Ann Marie Rasmussen's "Visible and Invisible Landscapes" demonstrates how the medieval period (however misconstrued) illuminates contemporary understandings of environmental theory and practice in the Pacific Northwest. In a similar vein, Kenneth Addison sets out a methodology that combines contemporary environmental studies with detailed assessments of medieval practices for sustaining and renewing the land in his "Changing Places." The "heritage" industry, Beckwith, Rasmussen, and Addison agree, does not represent the only way to think about the ruins of the past. Indeed, this book argues that medieval and modern viewpoints can be negotiated through and in an experience of place. These negotiations frame a newly created space where the literary, the historical, and the cultural are in an ongoing conversation with the geographic, the personal, and the material. Concepts of place, the essays in this book indicate, offer shared forms of meaning.

It is worth pausing here to consider how the chapters of *A Place to Believe In* relate to each other. This book explores concepts of place in and through time using the discourses of a number of disciplines—preeminently literary studies, history, art history, and religious studies. It conceives of its project by respecting these different discourses but also drawing on interdisciplinary perspectives and a trans-temporal framework. Our project, then, is a shared one, but as editors, we did not strive for uniformity for the sake of mere cohesion; rather, we aimed to study place from a number of different perspectives. Some points of connection and contact across the essays are highlighted in this Introduction, but we have also divided the essays into groups entitled "Place Matters," "Textual Locations," and "Landscapes in Time."

Later in this Introduction, we will contribute to these ongoing conversations about the meaning of place, taking Anglo-Saxon Northumbria as our example. We examine the possibility of locating this particular place from a number of perspectives, two of which are worth mentioning here: a perspective *on* Northumbria in the Anglo-Saxon period and a perspective *from* Northumbria, both then and now. Our Northumbrian journeys unfold in place, in time, and on paper in a manner reminiscent of Margery Kempe's pilgrimages, as Diane Watt reminds us in "Faith in the Landscape." Cognitive, temporal, and spatial perspectives (in place/in time, on paper, in Northumbria/on Nor-

thumbria) combine to produce a relational space wherein we may begin to view medieval writing in the landscape. In *The Book of Margery Kempe,* Watt points out, place is both origin and goal (as it is for Goscelin in his *Liber confortatorius,* Hollis notes). Kempe's foreign pilgrimages chart spiritual and natural ("real") places that enable us to read in the landscape a journey of the mind and soul. These are places to believe in. The Anglo-Saxon poets famously took the metaphysics of travel very seriously, combining the literal voyage with its spiritual resonances, as Stacy S. Klein demonstrates in "Gender and the Nature of Exile in Old English Elegies." Concepts of exile are ways of asking what it means to be *in* as well as *out* of place; these are limit zones, or, to use Kelley M. Wickham-Crowley's phrase, "mutable boundaries" as well as modes of cognition. In her essay for this volume, "Living on the *Ecg,*" Wickham-Crowley tackles the interdependence of land and sea to offer insight into Anglo-Saxon perceptions of place and identity, which are poised between a firm apprehension of the stubborn materiality of place and an equally firm grasp of its metaphorical, spiritual, and poetic reflexes. What it means to be *in* place adds another dimension to the perspectives *on* and *from* place. In positing a Northumbrian horizon or a sense of Northumbria as a region, we, like others in this volume, ask questions about place and time, about places in time.

A sense of the north of England and more particularly of early Anglo-Saxon Northumbria is central to two other essays in this collection: Fred Orton's "At the Bewcastle Monument, in Place" and Ian Wood's "Bede's Jarrow." Both deal with aspects of this northern culture familiar to many. The Bewcastle monument is one of the best-known examples of pre–Viking Ages stone sculpture in Anglo-Saxon England, while Bede and his monastery of Jarrow (or Monkwearmouth-Jarrow) offer us a monk and monastery virtually iconic for the early medieval period. We explore other icons of Northumbria (Lindisfarne, Yeavering, Bamburgh) below, but Orton and Wood bring new and rich perspectives to our sense of this region and its perhaps too-familiar spaces. In the region of the lower Tyne, close to Jarrow, Wood proposes a new "heartland" for the Northumbrian kingdom (one "overlooked" by Bede) and thus redraws the complex and ever-shifting map of peoples and places crucial for our knowledge of both Bede and his world. Orton, in place at Bewcastle—now a place without a name, at least according to the Ordnance Survey map—reconstructs the history of this place quite literally from the ground up and, in so doing, restores to the Bewcastle monument its place. Re-placing the monument in the site of one of the largest Roman forts on Hadrian's Wall reminds us how often places are forgotten

and lost in our memories of the medieval world. Orton asks the question of how places are made—a question that reverberates throughout the essays in this collection.

"PLACES GATHER"

How are places made? "Places gather," writes Edward Casey in his exploration of how we move from the concept of "empty" space to one of filled and particular place.[5] From Casey's adept distillation of a variety of phenomenological arguments emerges the viewpoint that place is always "full," both fully constituted by and constitutive of individual perception: "we are not only *in* places but *of* them."[6] But the "gathering" that constitutes place in this view also engages spatial and temporal dimensions, and clears, in one sense, a continuous space where we can think within and across centuries via the concept of place. Taking up the "heretical—and quite ancient—thought that place, far from being something simply singular, is something general, perhaps even universal," Casey considers the "'eventmental' character of places, and their capacity for co-locating space and time" as a "final form of gathering." He suggests that place itself can be posited as the site that occasions space and time, as these "two dimensions remain, first and last, dimensions of place, and they are experienced and expressed *in place by the event of place*."[7] Casey's argument here runs counter to some forms of Western modernity, in which the absolutes of time and space are construed as prior to place, but this view neither supports the reification or transcendence of place nor attempts a simple reversal of priorities (i.e., place for time and space). Rather, Casey calls for a resituating of binaries in contemplating the particular potency of place, an acknowledgement of "its status as genuinely general—that is, pervasive in its very particularity."[8]

The phrase "pervasive in its very particularity" is worth considering further. The essays by Wiethaus and Hollis demonstrate that those sacred places

5. Edward S. Casey, "How to Get from Space to Place in a Fairly Short Stretch of Time: Phenomenological Prolegomena," in *Senses of Place,* ed. Feld and Basso, 13–52, at 24. Casey's discussion of "gathering" follows aspects of Heidegger's discussion of the "end" of philosophy and the attendant possibility of the "free open . . . within which alone pure space and ecstatic time and everything present and absent in them have the place which gathers and protects everything." See Heidegger, "The End of Philosophy and the Task of Thinking," in *Martin Heidegger: Basic Writings,* ed. David Farrell Krell (New York: Harper and Row, 1968), 374–92, quotation at 385.
6. Casey, "How to Get from Space to Place," 19.
7. Ibid., 38; emphasis added.
8. Ibid., 32.

explored by medieval religious men and women are never located only in one temporal or spatial dimension; they offer instead multiple sites of and for divine transfiguration. The convent, whether as an ideal remembered by Goscelin or as materialized at Wilton or Helfta, offers monastic confinement as a site, paradoxically, for the expansion of the soul. Wickham-Crowley makes a similar case for the power of the dwellings of the reclusive Anglo-Saxon saints Cuthbert and Guthlac. Bearing layers of meaning, exemplary in their very particularity, sustaining the body and soul while occasioning struggle, isolated and yet connected: such sacred places, whether convents, barrows, or islands, are places to believe in. They are also places where belief is sustained, supported, and renewed in very material ways, as Addison's essay on the Cistercians demonstrates. Even Klein's counterargument, which sees in the female-voiced Old English elegies a critique of (if not also poetic revenge for) confinement and enclosure, acknowledges the power and particularity of place and its capacity to generate belief and conviction. This capacity is addressed throughout this collection—but with particular force, perhaps, in Beckwith's essay. The ruin, another place of paradox in its making and unmaking, is, Beckwith argues, not merely an integral component of modern reception of medieval drama in the second half of the twentieth century; it also occasions in that place the making of powerful new meanings for both past and present.

For all that places are, to use Beckwith's phrase, "landscapes of memory," which simultaneously mark loss and the possibility of reconstitution, they are also undeniable. They carry their own consistency. They are the means by which the general becomes local, by which we comprehend a sense of region, as we explore in the case of Northumbria (and as Orton, Wood, and Rasmussen argue). As we have already suggested, the constitution of place can be examined from a number of perspectives or locations, including our own and that of the place itself. We enter into places armed with our cultural memories; we read the landscape, we inhabit it, we shape it, and we remember it. Such remembering is a profoundly interactive process of mind with place. All of the contributors to this collection trace this process in various ways, although Rasmussen's account of how the "visible" landscape has to be invested with "invisible" meanings so that it may be preserved and renewed reveals what is at stake most bluntly. As Simon Schama reminds us, "landscape is a work of the mind. Its scenery is built up as much from strata of memory as from layers of rock."[9]

9. Simon Schama, *Landscape and Memory* (New York: Knopf, 1995), 7.

But even as we gather in all that we might from places, they gather us. To return to Casey: "This form is not the gathering-out of particular persons and things in a configured space of region, or the in-gathering effected by the body as a crux of nature and culture, but a still more pervasive gathering-with that occurs by the very power of emplacement to bring space and time together in the event."[10] Our experience of place will not collapse time or elide history, but it may "gather" us with both, and emplace us, align us with those voices and bodies emplaced by—and in—the past. Gender, of course, makes a difference to our sense of place and bodies, Klein reminds us. And "strategies of emplacement," to use Hollis's phrase, may well be techniques finely honed by the kinds of medieval Christian spiritual exercises explored by Wiethaus in the case of Gertrud of Helfta, but they are by no means to be found only in past worlds, as Rasmussen's exploration of ecological practices in Oregon underscores. Indeed—to stay with Gertrud of Helfta for a moment—Gertrud's own mystical experiences, which reconfigured so profoundly the "ordinary" space of the convent, are offered as guides to and for the future.

"YOU CAN'T MISS IT": NORTHUMBRIAN HORIZONS

Any place is a coming-together of phenomena, perceptions, histories, and lives, which is to say that we are located in various places even as those places locate us. This book brings together scholars of medieval literature, archaeology, history, religion, art history, and environmental studies in order to contemplate the idea of place. The idea of place is firmly grounded in the medieval period but it also takes on, inevitably, a modern view. The idea for *A Place to Believe In* unfolded in a series of places. It is informed and shaped by those places and our experiences—both collective and individual—of them. In this introduction, therefore, we remember these landscapes as an exploration of the idea, and power, of place for us as Anglo-Saxonists. The question of who *we* are, as the editors of this volume, is crucial to our argument: "we" are two women revisiting our memories of our various trips to Northumbria, and "we" are also two Anglo-Saxonists assessing our scholarly understanding of Northumbria through texts and on paper. We do not intend this introduction to be a full analysis of the idea of Northumbria and its horizons, whether historical, cultural, or geographic. We offer instead a meditation on and exploration of that idea.

10. Casey, "How to Get from Space to Place," 38.

And so we begin with a journey to Northumberland, although *which* journey is arguable. We have taken several journeys together and separately that are relevant to this project of understanding and locating place. It turns out that the ambiguity and selectivity of our memories are important dimensions of our thinking. Northumberland, on the northeast coast of England, is the approximate region of the kingdom of Northumbria in early Anglo-Saxon England, a highly influential—and movable—territory. During the seventh and eighth centuries, Northumbrian jurisdiction at times extended further north into Scotland and southwest into Mercia (or parts of modern Yorkshire), according to shifting patterns of alliances within the two at times distinct kingdoms of Deira and Bernicia in the region. These terms of region, area, territory, and kingdom (and even, as we have argued elsewhere, empire) allow us to fudge quite deliberately a central problem not just of definition but of conceptualization of this place that was Northumbria.[11] Where, when, and what, then, was Northumbria as an historical entity? And how was this place thought of in relation to others, such as "early Anglo-Saxon England"—itself at best a useful scholarly fiction when applied to the seventh and eighth centuries?

But to come back to our modern journeys to and in Northumberland, we remember another place and beginning for this book. In a pub in Leeds (or was it York?) four (or was it five?) years ago, Fred Orton ruminated with us on the question of what it meant to be a Northumbrian. Orton's reflections took him in the direction of specifying that place that is Bewcastle, but the question stayed with us as well, as did our conflicting memories about where and when we talked to Fred, and both question and memory translated easily (though exponentially) into terms of place. Indeed, our modern confusion about location—our confusion of place with its memory—is a fruitful point of entry into thinking about medieval writing and Anglo-Saxon places. After all, the best-known Anglo-Saxon poem, *Beowulf,* can be read as a meditation on place, its fictions, and its memories. In a similar way, the recovery of Northumbrian notions of place from the perspective of Anglo-Saxon England turns out to be an exercise that demands both history and imagination. Casey's question of "just when does a horizon happen" is helpful to our efforts in locating Northumbria, because it incorporates both synchronic and diachronic viewpoints. Horizons, argues Casey, "form the perceptual basis of boundaries [that] are themselves spatiotemporal in status. To be in a percep-

11. See Clare A. Lees and Gillian R. Overing, "Signifying Gender and Empire," *Journal of Medieval and Early Modern Studies* 34, no. 1 (2004): 1–16.

tual field is to be encompassed by edges that are neither strictly spatial—we cannot map a horizon (even if we can draw it)—nor strictly temporal."[12] Where, then, in place and time, should we place the Northumbrian horizon? What constitutes regional affinity for the Northumbrian? How and where does a Northumbrian align him- or herself with the landscape? How does place intersect with individual and regional identity? These questions, which we consider further below, find no simple answers.[13] And we haven't yet broached the question of *which* Northumbrian—literate, lay, clerical, secular, male, female, of high status or low.

Anglo-Saxonists are perhaps more accustomed to think of Northumbrian identity in cultural and artistic terms than in terms of landscape: all those splendid artifacts, those glories of a Golden Age for early Anglo-Saxon England as well as for Anglo-Saxonists. A quick examination of any manuscript page from the Lindisfarne Gospels and a contemplation of what the production of art at this level involves offers, rightly, an easy way to refute assumptions about the so-called Dark Ages in this period, assumptions of surprising longevity that Anglo-Saxonists often encounter from students (and the occasional colleague).[14] More to the point, identity has sometimes been thought through in terms of place. Rosemary Cramp, for example, traces Northumbrianness in terms of "the distinctive articulation of word and image which emerged from the Northumbrian artistic crucible,"[15] but she also sees it as a cultural entity "shaped by its geography—its highlands which allowed refuge in times of stress, and its seaboards, in particular the open way to the British West and to Ireland—but also by Roman territorial development and the early takeover by unruly native tribes who called themselves the Men of the North."[16] The histories of the Angles, the British, the Picts, and the Irish intersect with the peoples and geographies of the region of Northumbria, even as these histories intersect with a past that was Roman (at least in part) and a future that will be English. So many stories in this landscape.

Notwithstanding these complexities of definition (both past and present) of our destination, we go there. Or rather, we target modern icons of North-

12. Casey, "How to Get from Space to Place," 43.

13. A good measure of the complexities and intransigence of the evidence that would answer these questions may be found in David Rollason's *Northumbria, 500–1100* (Cambridge: Cambridge University Press, 2003).

14. See Michelle P. Brown, *The Lindisfarne Gospels: Society, Spirituality and the Scribe* (London: British Library, 2003) for a recent overview.

15. Rosemary Cramp, "The Northumbrian Identity," in *Northumbria's Golden Age,* ed. Jane Hawkes and Susan Mills (London: Sutton Publishing, 1999), 1–11, at 11.

16. Ibid., 10.

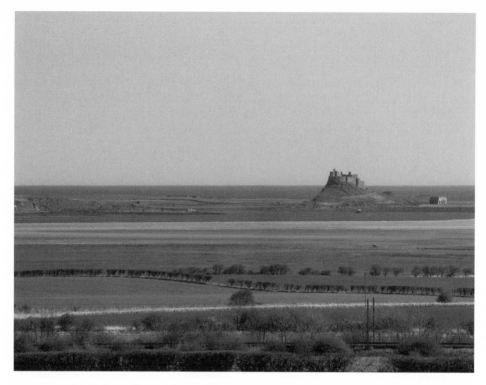

FIG. 2 Lindisfarne. Photo: George Skipper.

umbrianness: Lindisfarne, Yeavering, Bamburgh (see fig. 1). Lindisfarne, or
Holy Island—the site of the monastery of St. Cuthbert, Northumbria's best-
known saint—retains its stunningly distinct geographic identity as a tidal is-
land, and it sits ready to conjure for any visitor, medievalist or otherwise,
powerful evocations of solitude, interiority, and community (fig. 2). Yeaver-
ing, a high-status settlement long associated with the Northumbrian royal
house, is a less-visited site where there is nothing, really, left to "see" (see
fig. 4). And at Bamburgh, an important early fortification, there is almost too
much to "see," as the existing castle is now a gathering of buildings dating
from the later medieval period on through to the nineteenth century (fig. 3).
(Bamburgh served as the temporary resting place of the arms [literally] of the
saintly Northumbrian King Oswald; his head resided at Lindisfarne.) These
sites assumed prominence at differing times in the era of the kingdom of
Northumbria. To visit them now is to encounter these differently layered
pasts with a sense of their simultaneity in the modern landscape of Nor-
thumberland. These are monuments that mark the complexities of chrono-
logy, events, and memories.

There are several ways to get to Bamburgh and its castle from the A1

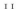

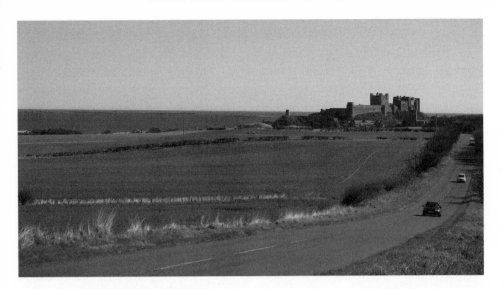

FIG. 3 Bamburgh. Photo: George Skipper.

motorway (the major north-south axis for the east of England); none is direct. The way is signposted, but at several junctures that way is open to interpretation. Stopping to ask for directions—itself a matter of debate—elicits an enthusiastic waving of hands toward the coast together with a cheerful insistence that, whichever fork in the road you choose, "you can't miss it." Our local guide was right. Bamburgh castle will come inevitably into view: its massive promontory assures this inevitability. Of course you can't miss it. Like many royal and military fortifications, medieval or otherwise, this castle was built with a view toward maximum defensibility and visibility. These perspectives of visibility and defense render the castle at Bamburgh (reconstructed in the early twentieth century) a "public statement" in the landscape. We shall return to this idea, but here let us simply register in our story of "getting there" the beginning of the idea of inescapable presence—a stable *locus*—in our experience of the Northumbrian landscape. You can't miss it. This presence has pervaded and shaped our sense of "being there." A second and related point also emerges from our story so far, and that is the way in which direction shapes our understanding and indeed naming of this place: north and south, with the cultural weight and freight these terms carry in the British Isles; Northumbria and south of the Humber, to recall King Alfred's famous phrase in his Preface (or Letter) to Gregory's *Pastoral Care;* up (the Old English term *uplendisc* springs to mind, with its connotations of the rural and perhaps the northern) and down; here (*her*) or there (*þær*).[17]

17. A convenient edition of Alfred's Preface (or Letter) to his translation of Gregory's *Cura Pastoralis* can be found in Bruce Mitchell and Fred C. Robinson, *A Guide to Old English,* 6th ed. (Oxford:

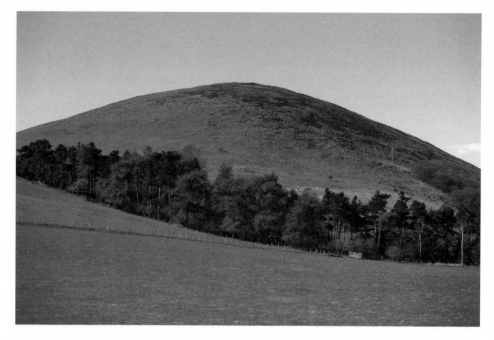

FIG. 4 Yeavering. Photo: George Skipper.

Bamburgh Castle is a dozen or so miles down the coast from Lindisfarne, and both are a few miles further than that from Yeavering, which is inland. The three sites form a kind of isosceles triangle with Yeavering at the head. While distances as the crow flies are entirely negotiable in the Northumberland climate with its coastal fogs, these sites remain potentially and often actually visible one from the other. As we moved within this landscape, by car or on foot, a process of orientation set in, whereby our sense of where we were was often found or defined in relation to these sites—whether or not they were visible. What we actually saw, in fact, was decidedly un–Anglo-Saxon, in that the original structures on the sites of Lindisfarne and Bamburgh are long gone and replaced or built over by later ones. Yeavering now looks like a large, somewhat hilly pasture just below Yeavering Bell. We soon developed a pervasive awareness of the presence of these places, however, one invested not only with our prior understanding (as scholars of their iconic histories) but also with an awareness conditioned by proximity and

Blackwell, 2001), 204–5, at 205. The term "Northumbria" seems to be relatively recent in Bede's time; see Rollason, *Northumbria*, 106–7. Sealy Gilles explores the voyages of Ohthere and Wulfstan (familiar places to look for Anglo-Saxon notions of location and direction) in "Territorial Interpolations in the Old English Orosius" in *Text and Territory*, ed. Tomasch and Gilles, 79–96.

ordained by contour and mass. What might the nature of this power and presence be for the seventh- or eighth-century Northumbrian living in the visual orbit of these places or in the sphere of their various influences? What might these places *mean* to a Northumbrian? Such a question is soon complicated by another: What might the inevitable interconnection of these places mean when this is played out and experienced via the drama of landscape?

The particular dynamic of the triangle of Lindisfarne, Bamburgh, and Yeavering intertwines histories that are both secular and religious—the power of belief and the power to structure belief—in which are embedded Roman, Romano-British, and Irish (or Celtic, as it is sometimes known) forms of Christianity. The very terms of these various identities indicate the complex histories of peoples and allegiances in this place, as Bede is well aware in his *Historia Ecclesiastica.* The iconic place that is Northumbria has its iconic historian in Bede, of course, and for this reason narratives of place and self are not simply intertwined in Northumbria; they are, in a sense, interleaved. Our knowledge is as much dictated by the textual record as the material one. This point can be exemplified by looking at Yeavering in place and in text.

Yeavering is one of two excavated high-status sites that attest to the rise of an elite early in the Anglo-Saxon period. Its impressively large timbered halls, successively built in the early and mid-seventh century, "are the largest domestic structures uncovered so far on any early Saxon site." There is also a temple building, which later became a church. The extent of Yeavering's housing and varied enclosures indicates that it functioned as an administrative center, a "township," as well.[18] The site is connected with a Romano-British past; according to Cramp, its unusual "amphitheatre, together with the great scale of the fortified enclosure, set that site apart even today; so this region may indeed have possessed its own Roman-derived traditions."[19] The place where there is now nothing left to see must have had a public presence and visible authority. Whose?

Yeavering is closely associated with Edwin, the first Northumbrian king to convert to Christianity. It is to Bede we must turn for an account of Edwin's carefully considered adoption of this new religion.[20] Indeed, it is not

18. Heinrich Härke, "Early Anglo-Saxon Social Structure," in *The Anglo-Saxons from the Migration Period to the Eighth Century: An Ethnographic Perspective,* ed. John Hines (Woodbridge: The Boydell Press, 1997), 125–70, at 148. The second site is Cowdery's Down in Hampshire.

19. Rosemary Cramp, "The Making of Oswald's Northumbria," in *Oswald: Northumbrian King to European Saint,* ed. Clare Stancliffe and Eric Cambridge (Stamford: Paul Watkins, 1995), 17–32, at 29.

20. Bede focuses at unusual length on the details of Edwin's reign and conversion. See *Bede's Ecclesiastical History of the English People,* ed. and trans. Bertram Colgrave and R. A. B. Mynors (Oxford: Clarendon Press, 1969), book II, chaps. 9–17. Hereafter cited as *HE.*

too much of a stretch of the imagination to think that one of the Yeavering halls might be *the* place that occasioned the famous story of the sparrow, whose brief flight in and out of the hall suggested to Edwin's counselors—if not immediately to the king himself—that Christianity might hold more permanent promise than existing beliefs.[21] The path of the sparrow's flight in one door and out the other fits all the descriptions of such halls that have been excavated at Yeavering (though this is not to say much, given the fairly stable structure of Anglo-Saxon halls generally). If Bede's story of the sparrow has been read as virtually archetypal in its allusive references to older "pagan" beliefs by many scholars, then Bishop Paulinus's thirty-six-day marathon of preaching from morning until night and baptizing countless souls "from every village and district" in the nearby river Glen would lay a serious counterclaim to the spirit of this particular place (*HE* II.14). And yet birds and bishops, not to mention pagans, are all forgotten, even by Bede. Bede briefly recounts that "this palace was left deserted in the time of the kings who followed Edwin" (*HE* II.14), and he later "forgets" the church that Edwin built there.[22]

The question of whose presence is felt at Yeavering—pagan kings or evangelical bishops—leads us to consider how place and landscape participate in the idea of conversion and in the process of change at religious, social, or agricultural levels. Peter J. Fowler argues that "in no farming sense were the Anglo-Saxons pioneers," pointing out that the shapes and contours of the land, its field and farming structures, were relatively unchanged from Roman Britain through to the middle Anglo-Saxon period.[23] Changes in sacred topography, on the other hand, could be profound, leading to a "wholesale reinterpretation of geography" in which religion has the power to "mediate perceptions of the numinous in the landscape."[24] Such powers of mediation

21. And here we do mean imagine: Bede's account of the conversion of Edwin is itself a conflation of stories and of places that stretches perhaps from Yeavering (where Paulinus preaches and baptizes) to near York, where Coifi destroys the old shrine. For discussion, see *HE* 180 n. 1.

22. See *HE* III.2, where Bede extols the church built in honor of St. Oswald at Hexham as the first to be erected in Bernicia, and see also Colgrave and Mynors's comment in the note to 217. The dry-stone and timber structures at Yeavering had probably vanished by Bede's time; see Cramp, "The Making of Oswald's Northumbria," 31.

23. Peter J. Fowler, "Farming in Early Medieval England: Some Fields for Thought," in *The Anglo-Saxons from the Migration Period to the Eighth Century,* ed. Hines, 245–68, at 251.

24. Alexander Pluskowski and Phillipa Patrick, "'How Do You Pray to God?' Fragmentation and Variety in Early Medieval Christianity," in *The Cross Goes North,* ed. Martin Carver (York: York Medieval Press, 2003), 29–57, at 49. John M. Howe also argues that conversion presages a "reinterpretation of geography itself" in "The Conversion of the Physical World: The Creation of Christian Landscape," in *Varieties of Religious Conversion in the Middle Ages,* ed. James Muldoon (Gainesville: University Press of Florida, 1997), 63–78, at 63.

afforded by the sacred seem palpable when we consider relics and their ability to create a sense of place. Relics and their stories are the means by which patterns of locale and local identity can be detected, patterns that map what we envision as a sacred jurisdiction of place. The power of the relic and its emplacement to create a place for and of belief (a point we return to later in this essay) is also a means of defining the purview and horizon of believers. But in a broader sense, sacral landscape takes many centuries to "convert." This certainly is the implication of Wickham-Crowley's reading of at least one of St. Guthlac's spiritual encounters. According to Schama, some landscapes—especially northern Germanic ones—always retain a complex residual stratification of cultural meaning.[25]

At issue, then, in the interplay between place and conversion is not simply an exchange of one set of symbols for another. Nor is it a reinvestment of existing sacred places with new significance, despite Gregory's injunctions to do just this in the conversion of the Anglo-Saxons.[26] Instead, we might consider sacred space as a place of and for cultural memory, a place where strata of meanings have been gathered and deposited. Some of these meanings may lie dormant for a while, but they are nevertheless ready, *there,* to be reactivated by new stories, new histories.

In Bede's account of Augustine's mission to convert the kingdom of Kent in the sixth century, for example, we are told that King Æthelberht instructs the missionaries to remain on the island of Thanet (where they first landed) until he has decided how to proceed. In this telling move, the king fulfills the royal mandate of hospitality to newcomers and at the same time keeps these new men at bay. When king and missionaries do meet on Thanet, Æthelberht is careful not to enter any building, suspicious of traditions of "magic art" that the newcomers might have. The king will preside over the meeting on the island sitting in the open air. If this is a sign of the king's jurisdiction, he appears to wait for Augustine to arrive with his own symbols. And so Augustine carries the Christian silver cross and painted standard, with images of Christ, and chants litanies (*HE* I.25). Bede's description of this place and meeting is rich in symbols: royal and ecclesiastical, Christian, secular, and pagan. Æthelberht and Augustine are both represented as recognizing the power invested in place, its "already plenary presence permeated with culturally constituted institutions and practices."[27] But whose place is this? Does it belong to Æthelberht, who marks this meeting spatially with the

25. Schama, *Landscape and Memory,* especially the section in chap. 2, "The Hunt for Germania."
26. See *HE* I.30.
27. Casey, "How to Get from Space to Place," 46.

rituals of his secular power—sitting down, outdoors? Or Augustine, who responds to these royal protocols with his own Christian mappings? Furthermore, Thanet's power as a sacred and royal place persists well after Bede. This island, yet another of those islands so important to the history of the Christian mission in England, would later become a monastic home for a remarkable dynasty of Anglo-Saxon royal female saints.[28]

When Æthelberht gives Augustine's mission a home in Canterbury, Bede describes this place in ways reminiscent of an Anglo-Saxon hall (one at Yeavering, perhaps) as well as a monastery. Augustine's dwelling, as Bede calls it, is a place apart, a place of authority, hierarchy, and masculinity—a *locus,* in short, for a particular kind of community. Did Æthelberht give the new religious men a home intended to recall secular power (*HE* I.25–26)? Instrumental in first keeping Augustine on Thanet and then giving him a place in Canterbury, Æthelberht achieves a delineation, a bounding, indeed a jurisdiction of place that can be read as royal, secular, and Kentish from his perspective, but Christian, Roman, and other from Augustine's. After Augustine has "moved in," he soon "moves on" . . . to churches. He moves into the church of St. Martin, built in Roman times, but itself far from vacant. This is not one of those deserted British holy places enumerated by Bishop Wilfrid, all of which he planned to bring under the jurisdiction of his new seat at Ripon.[29] The church of St. Martin is the place of worship for the already Christian queen Bertha (wife of Æthelberht), whom Augustine in effect replaces. The fact that it was a royal Christian woman from Gaul who afforded Augustine an entrée into Kent in the first place and then occasions this remapping of gender and place is one further indication of the complexity of meaning with which sacred spaces are invested.

These church spaces/holy places, vacant or not, are far from empty when Augustine's mission begins, and if the "conversion" of places is always ongoing, so too is that of Bede's English people, who regularly backslide not only throughout the *Historia* but on through the Anglo-Saxon period overall. Places, like their inhabitants, are redolent with contradiction and with the multivalence of the past. To an early-seventh-century Northumbrian living in the time of Edwin, Yeavering might hold the memory and presence of a warrior hall culture as well as that of the drama of conversion—for drama it

28. See David Rollason, *The Mildrith Legend* (Leicester: Leicester University Press, 1982), and Stephanie Hollis, "The Minster-in-Thanet Foundation Story," *Anglo-Saxon England* 27 (1998): 41–64. The island is, of course, central to Wickham-Crowley's essay in this collection.

29. Stephen of Ripon, *The Life of Bishop Wilfrid by Eddius Stephanus,* ed. and trans. Bertram Colgrave (1927; rpt., Cambridge: Cambridge University Press, 1985), cap. 17.

must have been, given the unusual amphitheatre or "grandstand" excavated at the site.[30] But it must also have held the memory of the public presence of royal authority, an authority as much aligned with Romano-British roots as with Roman Christianity.[31]

That same Northumbrian, looking out to sea toward Lindisfarne, might have had no less complex an understanding of the tangle of political and religious claims to precedence, no less complex a perception of the power of place. The early history of Holy Island is closely connected to that of the Bernician royal house and to the career of the saintly King Oswald, Edwin's eventual successor, who is in turn associated with the temporary ascendance of Irish forms of Christianity and its patterns of authority. Established in the Irish tradition from Iona (another island, this time in the west) as both monastery and bishopric, Lindisfarne flourishes as a result of charismatic religious leadership, not to mention sizable donations of land from Oswald's successors.[32] It can be seen as a "possession of the Bernician royal family," suggests Michelle Brown: a prize "bestowed upon its chosen vehicle for spiritual validation and support in establishing a stable society, the Irish-oriented 'Celtic' church."[33] Add to this its "national" and continental reputation as an artistic and educational center—as well as a center for healing, both medical and spiritual—later in the seventh century.[34] And cap these, or perhaps encapsulate them, with its uncanny, awesome visual presence.

Lindisfarne presents, to this day, a visual paradox. It remains both center and margin. (As is, in another sense, Lindisfarne's best-known artistic monument, the Gospels, now at home in the capital, London, and thus distant from its earlier medieval homes in the north.) The island is regularly packed with tourists; the flow of visitors recalls, though does not resemble, the earlier regular passage of royal and clerical guests.[35] Many of these modern visitors

30. B. Hope-Taylor, *Yeavering: An Anglo-British Centre of Early Northumbria,* Department of the Environment Archaeological Reports, no. 7 (London: HMSO, 1977).

31. See N. J. Higham, *An English Empire* (Manchester: Manchester University Press, 1995), for a discussion of Edwin's rise to power.

32. The history of Lindisfarne and its foundation is far more detailed and complex than we present here. See Brown, *The Lindisfarne Gospels,* chap. 1, for a more thorough account.

33. Ibid., 19.

34. Bede refers to Lindisfarne's housing "very skilled physicians," a first recourse for the abbot of another local monastery who tries to cure a paralyzed youth; the second and more successful option is contact with shoes worn by the dead Cuthbert. See Bede's prose *Life of Cuthbert* in *Two Lives of St. Cuthbert,* ed. Bertram Colgrave (Westport, Conn.: Greenwood Press, 1969), cap. 45.

35. Both Bede and the anonymous monk of Lindisfarne who wrote an earlier *Life* of St. Cuthbert refer to the "guesthouse" and to the casual presence of visitors, such as Clement, bishop of the Frisians, who comes over from the continent to visit for a few days. See Bede's *Life of Cuthbert,* cap. 44, and the anonymous *Life,* IV.16.

make the journey to Lindisfarne, as we did, in order to understand its isola-
tion, to experience what it feels like to *be* there. Once on the island, we
remain aware that we can leave, but there is a time limit that the tides will
dictate and a slight pressure of discomfort in that we might get "cut off" if
we don't watch out. Others want to get cut off. They wait for the tourist
buses to leave, for solitude and isolation and what quiet they bring—for a
short and predictable space of time. It is as though we are measuring, calculat-
ing, the idea of solitude as it comes and goes with the tides, conducting a
private negotiation with the onset of the mainland world.

The island's best-known saint and bishop, Cuthbert, remains famous for
his populist pastoral mission and uncompromising eremitic ambitions. In-
deed, he exemplified an important characteristic of Irish monasticism: its
"outreach to the world through preaching and mission."[36] Cuthbert's di-
lemma—torn between his pastoral mission and his longing for a solitary life—
makes sense in place and makes sense of place, of Lindisfarne and of yet
another island retreat, Inner Farne. Bede's prose *Life of Cuthbert,* for example,
charts a deeply divided course, where the demands of Cuthbert's followers,
both monastic and lay, are frequently at odds with Cuthbert's own desire to
exist in complete isolation in order to sharpen his spiritual struggle. Cuthbert
changes places several times, moving physically further away from Lindis-
farne. He finally arrives on a "real" island, carefully described by Bede:

> Now indeed at the first beginning of his solitary life, he retired to a
> certain place in the outer precincts of the monastery which seemed
> to be more secluded. But when he had fought there in solitude for
> some time with the invisible enemy, by prayer and fasting, he sought
> a place of combat farther and more remote from mankind, aiming at
> greater things. There is an island called Farne in the middle of the
> sea which is not like the Lindisfarne region—for that owing to the
> flow of the ocean tide, called in Greek "rheuma," twice a day be-
> comes an island and twice a day, when the tide ebbs from the uncov-
> ered shores, becomes again contiguous to the land; but it is some
> miles away to the south-east of this half-island, and is shut in on the
> landward side by very deep water and on the seaward side by the
> boundless ocean.[37]

Bede's detailed descriptions of Lindisfarne and Farne, also observed by Wick-
ham-Crowley, are worth noting here, both for their display of learning and

36. Brown, *The Lindisfarne Gospels,* 22.
37. Bede's *Life of Cuthbert,* cap. 17. Subsequent references will appear in the text.

for the clarity with which their location and importance are expressed. (Elsewhere, Bede places Lindisfarne within a mental landscape of ecclesiastical episcopal hierarchy.)[38] Cuthbert's location on Farne and his physical distance from the "half-island" that is Lindisfarne does not stop the world coming to him, however. People flock to see him "not only from the neighbourhood of Lindisfarne but also from the remoter parts of Britain" (*Life of Cuthbert*, cap. 22). When he is periodically persuaded out of isolation to resume his pastoral round, Cuthbert engages at the highest level with the intricacies of Northumbrian dynastic politics. He is invited by the influential abbess Ælfflæd, sister of King Ecgfrith and Hild's successor at Whitby (another place and beginning for our Northumbrian journey and this book, as we discuss below), to "visit and talk over matters of importance" such as the Northumbrian succession, and coincidentally, the fate of the powerful and controversial Roman-affiliated Bishop Wilfrid (cap. 24).

Physical distance cannot sever Cuthbert's ties to the "real" world of Northumbria. Even in Carlisle, away from his real and half-islands, Cuthbert has a vision of Ecgfrith's death (cap. 27). And even as he constructs for himself a small enclosure on Farne, made of turf and stone, where he could see nothing but sky, "thus restraining both the lust of the eyes and of the thoughts and lifting the whole bent of his mind to higher things," he is always placed within the spectacular purview of Bamburgh (cap. 17). Ironically, the remote island of Farne provides no wilderness (that British analogy for a desert retreat), no escape from the social landscape. Though farther out to sea, it is closer to the royal fortress—a mere two miles away. It is so close that Cuthbert's predecessor, Aidan, who had retired to the island hoping to pray in secrecy and solitude, cannot avoid the sight of the citadel burning. (He saves the castle from the heathen Penda's ravages by a few well-chosen words).[39] The saintly bishops of Lindisfarne, Brown reminds us, "conduct their feats of spiritual and physical endurance on behalf of humankind within direct view of the royal citadel."[40] Indeed, you can't miss it.

Being "in place" at Lindisfarne does not resolve its paradox, but it does gather perspectives. Cuthbert's view inward—and upward—exists along with the view outward to the local, the Northumbrian village, and to the wider Roman continental and Irish worlds. The monastic gaze, the view *from* place, is reflected, perhaps refracted, by the view *of* place as well as informed

38. Ibid., cap. 16. See also the related discussion of this passage in Wickham-Crowley's essay below.

39. Aidan will later die outside the church at Bamburgh (*HE* III.17).

40. Brown, *The Lindisfarne Gospels*, 22.

by it. The islands of Lindisfarne and Farne, often in full view of one another, weather permitting, are informed by the memory of other islands—Iona most obviously, but also Thanet, for example. Monastery, eremitic retreat, and fortress are in view of one another, a physical, geographic analogue for their interconnecting spheres of influence and their inevitable convergence. But these relationships between places suggest other triangles as well. When we think of Iona, Thanet, and Lindisfarne, or of Farne, Lindisfarne, and Bamburgh, or of Jarrow, the *portus Ecgfridi,* and Donemutha (to mention but three places brought back into view by Ian Wood), we are exploring the relationship of place with desire, whether that desire is secular, spiritual, political, or indeed all three.[41]

Lindisfarne and Bamburgh have long histories—possibly prehistories—but it is only now that the full extent of Bamburgh's rich history is coming to light in the new excavations at this site. These excavations suggest continuous habitation from the pre-Roman Iron Age to the present day, while evidence for the sixth to eighth centuries offers the possibility of a great hall constructed on the scale of those at Yeavering, together with temple and church sites. There may also be evidence for a seventh-century stone church and crypt found beneath a twelfth-century foundation.[42] When we visited the dig currently in progress, researchers were daily unearthing material indicating a high-status settlement, their findings offering material parallels to written accounts of the fortress's particular rise to prominence as a center of Northumbrian power.[43] Along with household items, glass beads, and hair ornaments, however—and fully as important—was the search for relics. With the discovery of a crypt came the exciting possibility, in terms of attracting research funding and visitors, of discovering the silver reliquary reputed to house St. Oswald's incorrupt right hand (*HE* III.6). Even today, such relics sustain their ability to create, enhance, and define the power of place.

A relic's ability to command a jurisdiction of place is particularly apparent in early medieval Northumbria, where episcopal centers like Lindisfarne and major royal monasteries such as Whitby spearheaded the transition from Roman ideals and definitions of sanctity and burial to more local practices—

41. For the relationship between desire and place, see Overing and Osborn, *Landscape of Desire.*

42. Building on the unpublished work of the late Brian Hope-Taylor, archaeologists at Bamburgh have published some preliminary findings in Graeme Young and Paul Gething, *The Archaeology of the Fortress at Bamburgh,* AD 500 to AD 1500 (Bamburgh: Bamburgh Research Project, 2003); for reference to the seventh-century church, see 11–16.

43. See *HE* III.6, 12, 16; *The Anglo-Saxon Chronicle,* ed. and trans. Michael Swanton (New York: Routledge, 1998), especially entries for 547 and passim. See also Symeon of Durham, *Historia Dunelmensis,* ed. T. Arnold, in *Symeonis monachi opera omnia,* 2 vols., Rolls Series 75 (London, 1882–85).

the elevation of local saints and the adoption of the distinctly non-Roman practice of the translation and division of a saint's body.[44] Also at stake in this transition, Alan Thacker argues, are some fundamental shifts in Christian attitudes toward and conceptions of place and the development of a "new personalized sacred topography."[45] As orientation toward Rome and Roman saints shifts to the local, identity is redrawn in terms of place and belief. Getting one's own saint—and thereby becoming a focus and *locus* for holy relics—not only puts a community on the map but also *creates* that map. Local saints designate the coordinates of place and region in geographic, political, and spiritual terms. Indeed, the saint, the relic, and/or the shrine carry the power to particularize place, to make a geographic and spiritual purview; these are particularly profound examples of the sacred jurisdiction of place. The dead body and its lived *habitus* combine to present a compelling instance of that "pervasive gathering-with" that Casey sees as essential to the idea of place. Here we have a means, a place, to speak of a stable *locus* for belief and its dynamic capacity to connect and to organize. If, as we have argued, places carry their own consistency and are the means by which the local becomes general and by which we can comprehend regionality, the emplaced relic will tell us much about the identity and *locus* of Northumbria and about literal as well as sacred topography.

We might, for example, imagine the history of Oswald's bones in terms of Northumbrian power and its emplacement. A year after King Oswald's death in 643, the story goes, his brother Oswiu dug up his head and arms, buried where he fell in battle. He gave the arms to the Bamburgh community and founded a church to house the relics, and he then gave the head to the monks at Lindisfarne. If the timing of this story holds up, Thacker argues, it provides a remarkable affirmation of Northumbrian hegemony and independence, in that the division of the corpse counters at an early stage ingrained Roman custom.[46] The treatment of the relics emplaced in these two regional bastions of Bamburgh and Lindisfarne, moreover, tells another, more complicated story of the delicate balance of episcopal and royal power within the

44. For an overview of developments and changes in processes of sanctification, see Alan Thacker and Richard Sharpe, eds., *Local Saints and Local Churches in the Early Medieval West* (Oxford: Oxford University Press, 2002); for reference to early Anglo-Saxon England and Northumbria in particular, see Alan Thacker, "The Making of a Local Saint," 45–72, and Catherine Cubitt, "Universal and Local Saints in Anglo-Saxon England," 423–53, in *Local Saints and Local Churches.*

45. Alan Thacker, "*Loca Sanctorum:* The Significance of Place in the Study of the Saints," in *Local Saints and Local Churches,* ed. Thacker and Sharpe, 1–43, at 2.

46. Alan Thacker, "*Membra Disjecta:* The Division of the Body and the Diffusion of the Cult," in *Oswald,* ed. Stancliffe and Cambridge, 97–127, at 101.

region. The ornate silver reliquary housing Oswald's reportedly incorrupt arm, with its reputed miracle-working properties (the same excitedly pursued by the current group of archaeologists at Bamburgh), contrasts with the discreet burial—tantamount to hiding—of the head at Lindisfarne, a contrast that has much to do with the tangle of dynastic and episcopal ascendancy that marks Northumbrian politics.[47]

The relics of the saintly Oswald mark the landscape in various ways, evoking community and defining the extent of regional influence and Northumbrian identity. But the intersection of place and belief is also an individual *locus*. It begs the questions, once more, of *which* Northumbrian we are evoking and of how the experience of place might be mediated by myriad social, religious, and gender differences. To return briefly to the other essays in this book, we see that Wood argues that Bede's reticence about his perhaps central place in Northumbria may derive from what might be termed a "desert" *mentalité*. Goscelin's construction of Wilton, Hollis contends, clearly involves his loss of place and community. Wiethaus demonstrates that gender is manifestly a factor in the mystical experience of place, and Klein notes that it distinctively shapes the meaning of place in Anglo-Saxon elegies. So how, then, might regional identity be understood? Here we can only pose that question in the broadest terms—and only in terms of the cultural cognitive difference to which our limited sources allow us most access. That is, we must trace the shaded differentiation between lay and literate *mentalités*.[48] Brian Stock asks that we pay more literal attention to our modern metaphorical understanding of how we experience place and "read" a landscape.[49] But what does this mean if you do not "read" in any textual sense, and what other forms of cognitive perceptual "reading" can be proposed? Stock suggests that oral tradition, with its nonlinear forms of collation and expression, may provide access to a different mode of reading and seeing. The oral and the literate, he writes, are "two pathways to modern literate institutions," and they are "also expressed in different attitudes towards the visual elements in landscape."[50] This would seem to imply, for example, that a highly literate man of the church such as Bede, resourced by the mental landscapes of ecclesiastical

47. See ibid., esp. 97–104, for a detailed analysis of the relics and the translation of the remainder of Oswald's body.

48. It might also be productive to consider the specific relation of high-status women to the concept of jurisdiction of place. Their active role in late seventh- and early eighth-century Northumbria in translating relics defined and created such jurisdiction.

49. Brian Stock, "Reading, Community, and a Sense of Place," in *Place/Culture/Representation,* ed. Duncan and Ley, 314–34, at 315.

50. Ibid., 320.

learning and episcopal hierarchy as well as by his observation of the tides, "sees" Lindisfarne differently. Wiethaus also details how strategies for developing literacy are imbricated in a mystical sense of place in Gertrud of Helfta's writings. How, then, is the power of place experienced by the unlettered observer? And what can we make of our present perceptions as Anglo-Saxonists, literate now but according to different modes?

The dichotomy of orality and literacy—if indeed it is a dichotomy in the Anglo-Saxon period—is mediated, or rather re-placed, by the idea and presence of place as well as time.[51] While Stock finds that the only valid analogy for "reading" a landscape is that of nonlinear oral process, some of this cognitive process, which he prefers to call "visual ritual," involves what is "pre-read": "Indeed, before the text is read visually in the monument, it is known by oral means to everyone."[52] Similarly, the dichotomy of public and private is mediated by place, for although a landscape may be "read" privately in whatever mode, "it none the less remains a public statement," one embedded with varying and competing texts, visual and textual, oral and literate, secular and religious.[53] And indeed the concept of visual literacy, as developed by Lesley Webster for Anglo-Saxon art, would provide support for ways of seeing and reading place.[54] Webster's notion of the continuing visual grammar of artifacts together with Stock's sense of seeing/reading place resonates with Rasmussen's essay in this collection, which posits visible and invisible landscapes—the one informing the other, and both deepening communal as well as individual memory.

The great hall at Yeavering may be seen or read as a memorial to pre-Christian warrior culture—in this case a memory of a memory—or as a monument to Edwin's gala baptismal marathon or to his visible regional lordship. Lindisfarne is at once profoundly connected and disconnected to this world and the next. The fortress at Bamburgh defends the secular realm while housing the bones of the local king-become-saint. And each of these places is invested with further significance because of its complex relation to the others. In this sense, Bamburgh, Lindisfarne, and Yeavering create a Northumbrian horizon, one that is effective and operative beyond the geographic

51. For a related discussion of orality, literacy, and gender, see Clare Lees and Gillian Overing, *Double Agents: Women and Clerical Culture in Anglo-Saxon England* (Philadelphia: University of Pennsylvania Press, 2002).

52. Stock, "Reading, Community, and a Sense of Place," 320.

53. Ibid.

54. Lesley Webster, "Encrypted Visions: Style and Sense in the Anglo-Saxon Minor Arts, AD 400–900," in *Anglo-Saxon Styles,* ed. Catherine E. Karkov and George Hardin Brown (Albany: State University of New York Press, 2003), 11–30.

inevitability of presence and proximity, but that is realized and made possible by the experience of place. When does a Northumbrian horizon happen? When we ask this question, we—like those in the past—continue to see the "end" through the lens of "place," terms that Heidegger correlates in that "'from one end to the other' means from one place to the other."[55] For Casey, the horizon correlates space and time: "A given horizon is at once spatial and temporal, and it belongs to a field that is the perceptual scene of the place whose horizon it is. Once again, but now coming in from the margins, we discover that place includes space and time as part of its own generative power. Rather than being the minion of an absolute space and time, place is the master of their shared matrix."[56] The horizon is porous, its boundaries shifting, available to us across the span of centuries, and open to perception while in place. A compelling argument—though we did not need one—for "being there."

GATHERING IN WHITBY

There is one final genesis for *A Place to Believe In,* and that is the conference "A Place to Believe in: Medieval Monasticism in the Landscape," which was cosponsored by Wake Forest University and King's College London. This conference brought our contributors together in Whitby (now North Riding, modern Yorkshire) in the summer of 2003 in order to think about place while *in* place. And the genesis for that conference, and subsequently this book, was a conversation in this place that remains a vibrant memorial to Northumbrian culture and that offers us a present perspective on the lived experience of the landscape. For here we experienced place by our contact with those who lived in it, the sisters who occupy the Sneaton Castle Centre, owned by the Convent of the Order of the Holy Paraclete (Church of England). This Order is the modern manifestation of the Anglo-Saxon convent first founded by Hild in the seventh century. We had gone to Whitby with a distinct sense of pilgrimage—our research previously having focused on Hild and her key role in Northumbrian religious and political culture—and we found first her successors who, like Cuthbert in Lindisfarne, made sense of the place and made a sense of place. The sisters' veneration of and connection to Hild, her mission, and her place in the landscape that is both early medie-

55. Heidegger, "The End of Philosophy and the Task of Thinking," 375.
56. Casey, "How to Get from Space to Place," 43.

val and modern Whitby are profound. Following our meeting with the sisters, it was a short imaginative step (though a somewhat longer organizational one) to planning our return in the form of a conference. Our gathering was a true convergence: we gathered "in place" to begin this series of meditations, and we were gathered with and by place.

Early medieval Whitby was famous not merely for Hild—one of the earliest royal women to lead a double monastery—but also for its close relationship to Rome. (The earliest Life of Gregory the Great, who prompted the conversion of the Anglo-Saxons to Christianity, was written at Whitby.) The original monastery perches high on a promontory, overlooking the harbor and the modern town. The dramatic landscape provides a particularly compelling place in which to assess the convergence of past and present. For here in Whitby, this place of belief, we find not merely memory and nostalgia, narrative and desire (all of which help map the relationship between past and present), but also gender, faith, learning, the local (northern, Northumbrian, English), and the metropolitan (Roman, Latin).

Not all of our contributors have taken medieval religious life as central to their thinking about place, but whether as concept, ideal, physical place, or lived daily reality, that life opens an important window onto the lived experience of many kinds of medieval people and invites us to contemplate the practices of faith and the functions of belief in conjunction with physical space. The modern convent at Whitby thus provided a starting point for the range of questions raised by these essays, whether they focus on material structures (monuments, convents, monasteries, ruins, harbors), on the relation of bodies to those structures and their place in sea- and landscape, or on the ideological purview and residue of material forms. As they explore places, these essays define place as well, in ways both material and conceptual. They draw maps of place, power, and belief; of stones; of bodies; of journeys both imagined and real; of memory; and of generation. Wood explores the intersections of the royal and the ecclesiastical in the early Anglo-Saxon period, while Orton traces the roots of the remarkably sophisticated stone sculpture that is the Bewcastle monument. Wiethaus and Hollis chart geographies of desire and devotion in communities of nuns. Klein describes the place of sexuality in Anglo-Saxon England, and Wickham-Crowley offers an analysis of the liminality of people and places. Watt revisits the real journeys of Margery Kempe and her imaginings of them. Beckwith scrutinizes the powerful association between monasticism and ruins—and Rasmussen finds a modern re-creation of the medieval in the sacred landscape of the Pacific Northwest. Finally, Addison illuminates the Cistercians' lived experience of monastic set-

tlement. These authors' ideas of place are situated at crossroads: at the intersection of land and sea, or of space and belief; at the coming together of physical spaces and the bodies that inhabit and co-create them; and last but by no means least, at the juncture of past and present.

PART I ❧ PLACE MATTERS

The following three essays by Fred Orton, Ian Wood, and Kelley Wickham-Crowley work together in one major sense because of the affinities of their respective disciplines of art history, history, and archaeology. They deal with aspects of Anglo-Saxon culture that are familiar to many later medievalists as well—with monuments, monasteries and saints—but are equally concerned with the physical geography of place, with valleys, harbors, seas, and shores. Each essay is profoundly interested in the "matter" of place, how it is "made" on physical and literal levels, and how it then matters—how it becomes culturally construed and recorded via the lens of these different disciplines.

1

AT THE BEWCASTLE MONUMENT, IN PLACE

Fred Orton

> Place is the first of all beings, since everything that exists
> is in a place and cannot exist without a place.
>
> —ARCHYTAS, AS CITED BY SIMPLICIUS,
> *COMMENTARY ON ARISTOTLE'S CATEGORIES*

What do people make of places? What gives them their identity and mean-ing? When we focus on the Bewcastle monument (see figs. 5–8)—arguably our premier survival of pre-Viking Anglo-Saxon stone sculpture—with the intention of interpreting and explaining it, how can we hang onto the idea of "place" and our sense of "place" in relation to it?[1] The Bewcastle monu-ment has probably stood where it is since it was produced and first used, probably in the first half of the eighth century. A sandstone mass of stubborn resistance. A stone in the memory. A fragment of history. With only a few

For their help and advice, thanks are due to Paul S. Austen; Paul Bidwell; Stephen Eisenman and Mary Weismantel; Alex Hannay; Martin Henig; Mike Jackson; Jo McIntosh; TimeScape Research Surveys (Allan Biggins and David Taylor); Geoff Woodward; and Brian Young.

The epigraph to this chapter is taken from Keith H. Basso's *Wisdom Sits in Places: Landscape and Language Among the Western Apache* (Albuquerque: University of New Mexico Press, 1996), 3, which directed me to Martin Heidegger's "Building Dwelling Thinking" and gave me my first sentence, as well as more besides.

1. For those unfamiliar with it, a useful introduction to the Bewcastle monument is provided by the description and discussion in Richard N. Bailey and Rosemary Cramp, *The British Academy Corpus of Anglo-Saxon Stone Sculpture, Volume 2: Cumberland, Westmorland, and Lancashire North-of-the-Sands* (Oxford: Oxford University Press, 1988), 61–72, and illus. 90–116. For a somewhat different way of seeing and understanding it, see Fred Orton, "Northumbrian Identity in the Eighth Century: The Ruthwell and Bewcastle Monuments; Style, Classification, Class, and the Form of Ideology," *Journal of Medieval and Early Modern Studies* 34, no. 1 (Winter 2004): 95–145.

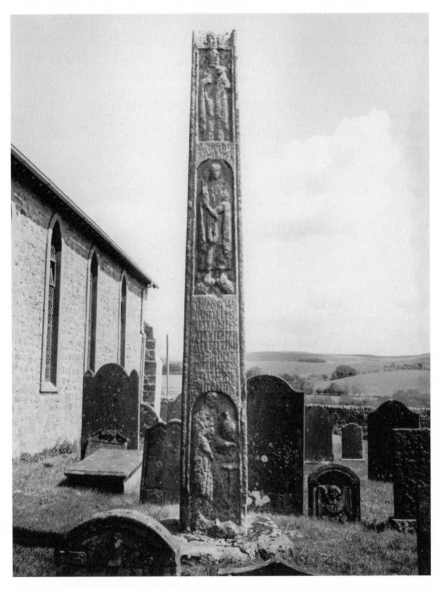

FIG. 5 The Bewcastle monument, west side. © Department of Archaeology, University of Durham. Photo: T. Middlemass.

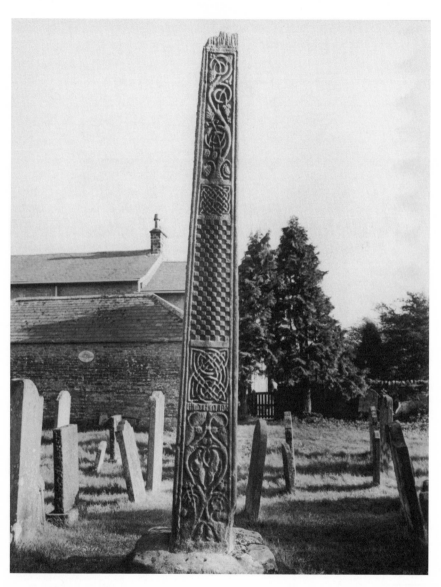

FIG. 6 The Bewcastle monument, north side. © Department of Archaeology, University of Durham. Photo: T. Middlemass.

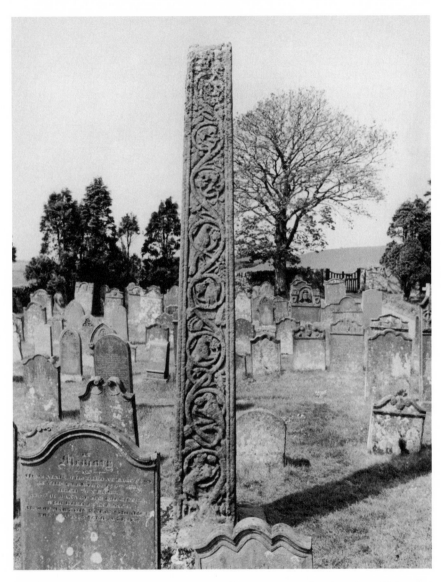

FIG. 7 The Bewcastle monument, east side. © Department of Archaeology, University of Durham. Photo: T. Middlemass.

FIG. 8 The Bewcastle monument, south side. © Department of Archaeology, University of Durham. Photo: T. Middlemass.

exceptions, everyone who has attended to it has concentrated on its material form and ideological content. Indeed, until recently, most attention was paid to the latter, to the meaning of its elaborate carved decoration: John the Baptist with the Agnus Dei, Christ on the Beasts, a long runic inscription, and a representation of a secular aristocrat on its west face; an inhabited plant scroll on its east face; plant scrolls and interlace patterns on its north face; plant scrolls, interlace patterns, and a sundial on its south face. If the place of this or, indeed, of any particular survival of Anglo-Saxon stone sculpture was considered at all, it was by way of geology and topography and sometimes by way of thinking about its circumstances of production. Each volume of the *Corpus of Anglo-Saxon Stone Sculpture,* for example, includes a useful discussion of geology and topography, which *must* figure in any consideration of place. But that discussion is there primarily to help identify, in precise or general terms, the stone type of each individual survival. To some extent, geology and topography determine place, but they are not themselves place—not quite. We might want to move closer to understanding the monument by answering questions such as: For whom was it made? To do what kind of job? How was it made? What was the degree of possession or separation of those that made it and used it from ownership of the means of making it? How was it understood by those who made it and those who used it? Such questions address the monument's circumstances of production. Nevertheless, though circumstances of production determine place, they, too, do not quite constitute it.

What follows begins with as close a description as space permits of the nitty-gritty of a region. The scope of this essay is extensive: it moves through geological time to the early medieval period. But its focus is narrow. It concentrates on one feature in a region and on what came into being there. What begins in materialism ends in a metaphorics associated with a kind of metaphysics. I realize that some readers might find this unfamiliar and uncomfortable matter. It's there for what it's worth—and the maps will help.

"Place" is the area of one's being-in-the-world: of being-alongside things; of being-with others and being-one's-self; of feeling and understanding one's relations with other things and other individuals. It's a part of a region brought close to one's being-in-the-world. A "region" is a large area of land, a more or less defined extent of the Earth's surface, especially as distinguished by climate, natural features, fauna and flora, by things that are within the world but not necessarily as the effects of human intervention. It's a free expanse. It's the general whereabouts of something. A human individual arrives in a region and gets to know the natural things or mere things there,

the earth, rocks and soils, springs, rivers and lakes, plants, trees, and animals that are present-to-hand there, and that individual opposes himself or herself to them. He or she recognizes these mere things for what they are and realizes that equipment or ready-to-hand things—a hammer or an axe or a plough, for example—can be assigned use there, so that the mere things can be appropriated in forms adapted to the individual's own wants. By becoming involved in a region in this way, by intervening in the present-to-hand and modifying it with the ready-to-hand, the human individual recognizes what is given in the region, brings it close-to-hand, and uses it; comes to a general sense of things as a whole there; becomes changed by them and changes them; builds there and dwells there, cultivates crops and rears animals, puts up habitable and non-habitable structures; comes to understand what is there, to represent it in language and, every day, to be engaged in it; makes a place there. So, unlike a region, a place isn't something a human being just comes across. Human beings make a place by their activity, by their being-in-the-world.[2]

> Thus the first fact to be established is the physical organisation of these individuals and their consequent relation to the rest of nature. . . . the natural conditions in which man finds himself—geological, orohydrographical, climatic and so on. The writing of history must always set out from these natural bases and their modification in the course of history through the action of men.

—KARL MARX AND FREDERICK ENGELS, *THE GERMAN IDEOLOGY*

By way of delimiting it, we can take our region to be the "district" described by the Geological Survey of Great Britain in the *Geology of the Country Around*

2. My use of the terms "place" and "region" derives mainly from Martin Heidegger, *Being and Time* (1927), trans. John Macquarrie and Edward Robinson (Oxford: Basil Blackwell, 1967). "Space," which holds within its meaning—almost undecidably—both time or duration and area or extension, does not concern me in this essay. The vocabulary of "being"—"being-in-the-world," "being-alongside," "being-with," and so on—and "present-to-hand," "ready-to-hand," and "close-to-hand" also derive, in the first instance, from *Being and Time*. "Mere things" and "equipment" are there in *Being and Time*, but I had most in mind the way in which Heidegger uses them in "The Origin of the Work of Art" (1935–36), in *Martin Heidegger: Basic Writings*, rev. and exp., ed. David Farrell Krell (London: Routledge, 1993), 143–203. "Building," "dwelling," and "thinking," of course, come mainly from "Building Dwelling Thinking," and I shall have more to say about these later. Though I have found Heidegger's words and meanings useful, I haven't resisted the temptation to tinker with them or with the structures of interpretation and explanation they enable. Sometimes I provide a brief definition of a term when I first use it; on other occasions, I assume that its context makes its meaning clear. Some readers will, inevitably, find the definitions obscure or, in context, disputable. A convenient guide to Heidegger's language, his use of new words, and his revival of old words is provided by Michael Inwood, *A Heidegger Dictionary* (Oxford: Blackwell Publishers, 1999). It was always ready-to-hand during the preparation of this essay, as was Richard Poult's commentary on *Being and Time* and Heidegger's later philosophy, *Heidegger: An Introduction* (London: University College London Press, 1999).

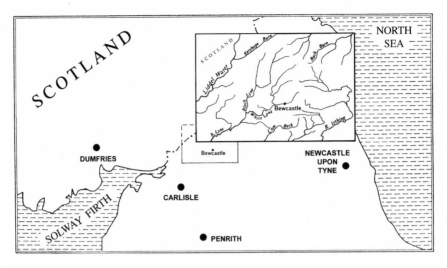

FIG. 9 The Bewcastle district, the north of England, and Scotland. Map by Fred Orton, after Geological Survey of Great Britain.

Bewcastle (see fig. 9).[3] This district includes the northern tip of the county of Cumberland, a few miles west of where it meets Northumberland. The Scottish border crosses it about seven miles northwest of Bewcastle. Within it, the ground rises from below 200 feet on the low-lying Carlisle Plain in the southwest to over 1,700 feet in the north and northeast. In the north, the high ground coincides with the Cumberland-Northumberland border and locally forms the primary watershed between the river North Tyne, which flows eastwards to the North Sea, and the Cumbrian and Scottish border rivers that discharge southwestward into the Solway Firth—principally Liddel Water and the rivers Lyne and Irthing (Day, *Geology*, 1–2).

That maps the terrain for what follows. But how far must one go back to find its beginning? The Geological Survey records that nothing is known of the area's pre-Carboniferous history:

> The lowest [or oldest] rocks exposed belong to the Border Group and consist of marine limestones, shales and sandstones. These rocks were deposited rhythmically in the Northumbrian Trough—a flat-bottomed shallow tranquil sea bordered by the land masses of the Southern Uplands to the north and by the Cumbrian and Alston

3. J. B. W. Day, with contributions by D. H. Land, R. H. Price, D. A. C. Mills, and others, *Geology of the Country Around Bewcastle*, Institute of Geological Sciences, Memoirs of the Geological Survey of Great Britain (London: HMSO, 1970).

Blocks to the south. The trough was connected to a shelf-neritic sea to the south-west and was fed mainly by sediments brought in [by rivers flowing into it] from the north-east. During Middle Border Group times arenaceous sediments invaded the north-eastern part of the region and occasionally extended into the southern and western parts, where they became interdigitated with finer marine muds. This sandy influx decreased in Upper Border Group times and coal-forming vegetation became periodically established in swamp environments. There followed a reversion to marine sedimentation represented by the Liddesdale Group and the Millstone Grit Series. During this time the sea extended southwards across the Alston Block and also breached the Southern Uplands Massif to the north. This marine phase, like that of the Lower Border Group times, ended with an influx of sand from the north-east as represented by the thick sandstones at the top of the Millstone Grit and base of the Coal Measures. Similarly this sandstone phase was followed by a swamp sedimentation that gave rise to the Coal Measures.

Throughout the Carboniferous, cyclic sedimentation seems to have continued without break . . .

Lower Carboniferous times were marked by considerable volcanic activity in Scotland, but in the Bewcastle district such activity is represented by a single basalt lava and by a few thin bands of tuff.

Towards the close of Carboniferous times the district was affected by earth movements, which resulted in widespread folding, faulting and upliftThere followed a lengthy period of subaerial denudation, which ended with the northward encroachment of the sea during the late Permian. . . .

At some time subsequent to the Triassic period further uplift occurred and faults which affect the Triassic sediments are usually ascribed to widespread Tertiary earth-movements. It is probable, too, that the present drainage system was initiated as a result of Tertiary uplift.

Glacial deposits occur throughout the district; they consist of thick Boulder Clay overlain by heterogeneous sands and gravels, the products respectively of a main glaciation and subsequent retreat. After the close of the glacial period, most of the larger rivers resumed their pre-glacial courses, successive erosional stages being marked by flanking terraces and, most recently, by alluvial flood plains.

The post-glacial climate favoured the growth of peat, not only on

the high upland moors of the primary watershed but also in ill-drained hollows on the lower-lying drift-covered plateaux of the Spadeadam area, where depths of peat exceeding 40 ft have been recorded. (Day, *Geology*, 5–6)

The orohydrography, geology, and topography of the region have ensured a predominantly agricultural subsistence. Arable land is present on the lower ground bordering the Carlisle Plain, but most of the ground between the plain and the high fells (and the high fells themselves) forms rough pasture, much of it poorly drained. Some thin coals were once mined in the region (Day, *Geology*, 2). Limestone has been quarried there since the region was occupied by the Romans, but its moment of intensive industrial development, like that of coal mining, is long gone, and only a few commercial quarries are still working.

Bewcastle, the place that removes the distance between the region and us, that draws and guides us into it, is in the river White Lyne catchment—the surface area from which rainfall flows into the White Lyne either directly or indirectly by way of Bothrigg Burn, Ellery Sike, and Kirk Beck. Bewcastle sits on the north bank of Kirk Beck between Bride's Gill on its east and Hall Sike on its west. Much of the area around it, up to 800 feet or so, is covered with a grey or chocolate brown till or boulder clay (Day, *Geology*, 255). In the northeast and east, sandstone outcrops form prominent crags, such as the Long Bar and Christianbury Crags (93–94, 123–24). In some places in the valleys, the rivers have formed gravel beds and terraces, primarily composed of stone washed out of the clay and from outcrops revealed in their courses.[4] Peat covers much of the high ground, particularly in the east and southeast above High Grains and on Spadeadam Waste, with thinner covers in the west on the Bailey and Arthurseat.[5] The lower beds of peat contain many old birch and pine stumps, evidence that the region once enjoyed a dryer, warmer climate than it does now.[6] Below these superficial deposits is the deep (and not so deep) geology of a giant dome or anticline, the Bewcastle Anticline, which resulted from several deformational episodes of folding, uplift, and faulting that occurred during post-Carboniferous and Tertiary times.[7] The center of this dome forms the lower ground of the White Lyne, flowing

4. Ibid., 261–62. See also Iver Grey, "The Landscape of Bewcastle and Its Rocky Foundations," in *A Bewcastle Miscellany* (Carlisle: The Bewcastle Heritage Society, 2000), 9.

5. Day, *Geology*, 6, plate XV, 262–63.

6. Ibid., 262; Grey, "The Landscape of Bewcastle," 9.

7. Day, *Geology*, 232, 262; Grey, "The Landscape of Bewcastle," 10.

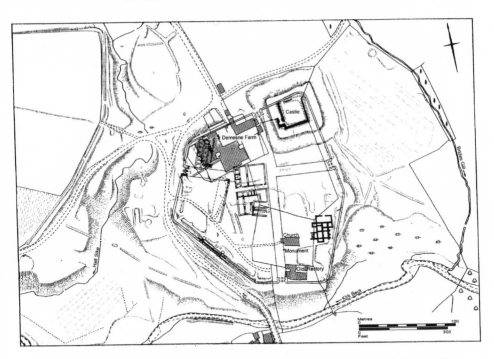

FIG. 10 Bewcastle Roman fort, earthworks and environs. Diagram by Fred Orton, after Paul Austen, J. P. Gillam, I. A. Richmond, TimeScape Research Surveys, and the RCHM England.

through Nixontown to the northwest of Bewcastle; one finds the oldest rocks here. The youngest rocks lie under and to the east of Bewcastle: the sandstones, shales, and limestones of the Bewcastle Beds. Further east and southeast, these rocks and later limestone groups rise and then dip or slope over the Bewcastle Fells into the Irthing Valley and on toward Hadrian's Wall, where they become the crags and wild country of Northumberland.[8]

Last in this incomplete description of the area's geology are the sands and gravels widely distributed throughout most of the southern half of the region, excepting the Spadeadam area (Day, *Geology*, 252, 255–56, plate xv). We should note here a few small mounds or low hills of sand, or sand and gravel, associated with drainage channels in the upper White Lyne valley. The hamlet of Shopford is flanked to the north by two such hills. The eastern hill, a flat-topped low hill of sand, is of particular interest because it provided the site for the monument, a Roman fort, a church, a castle, and various other buildings. Though the castle—Beuth's Castle or Bew Castle—gives its name

8. Grey, "The Landscape of Bewcastle," 10.

to a parish, to the monument, and to several nearby geological and topo-
graphical features such as the Bewcastle Anticline, the Bewcastle Beds, and
the Bewcastle Fells, our place has never been named by the Ordnance Sur-
vey. That is to say, inasmuch as Bewcastle is a place, it occupies the flat-
topped low hill of sand just across Kirk Beck from Shopford (fig. 10).

The sandstones and limestones of the White Lyne catchment support a
light, impoverished soil, producing grassland of indifferent quality. Though
attempts were made to develop it under the various Acts of Enclosure in the
nineteenth century, Bewcastle has never been turned over to arable agricul-
ture. Sheep and some cattle could be raised there, of course. And surely there
must have been game to be had: in the late nineteenth century, an elk's horn
was taken out of a bog on the high ground in the northeast of the region
(Day, *Geology*, 262). In prehistoric times, up to the arrival of the Romans,
the area seems to have been heavily forested.[9] As we've seen, birch and pine
once grew here, but evidence has also been found for hazel, willow, and
some oak.[10] So far, there has been no evidence for alder—now the area's
predominant tree. Alder can thrive in marshy conditions up to 1,500 feet.
We do not know when it arrived and established itself, but that moment
probably coincided with (or accompanied) the climate change to wetter and
colder conditions in the Bronze Age.

The present-to-hand of the region has never offered much that was useful
for being-in-the-world. Nevertheless, from prehistoric to present times, the
area around Bewcastle seems to have attracted human beings who have built
and dwelled there and realized some surplus from it.

A scattering of prehistoric sites has been identified. Some have been exca-
vated, properly or improperly. I count sixteen sites in the parish of Bewcastle

9. Guy de la Bédoyère, *Hadrian's Wall: History and Guide* (Stroud: Tempus Publishing, 1998), 101,
notes that the pollen evidence that came to light in the Birdoswald excavations suggests that when the
wall builders arrived, they found dense woodland with a peat bog in the middle. See also Paul Bidwell,
ed., *Hadrian's Wall, 1989–1999: A Summary of Recent Excavations and Research Prepared for the Twelfth
Pilgrimage of Hadrian's Wall, 14–21 August 1999* (Carlisle and Newcastle upon Tyne: Cumberland and
Westmorland Antiquarian and Archaeological Society and the Society of Antiquaries of Newcastle
upon Tyne, 1999), 145, which notes that excavation of the earliest feature at Birdoswald, the Turf Wall,
found undisturbed pollen showing that the site was under 95 percent tree cover before the wall was
built. The same forest conditions probably pertained around Bewcastle as well.

10. On the pollen evidence for hazel, willow, and oak around Bewcastle, see A. Raistrick, "Report
upon Earth-Samples from Bewcastle," in I. A. Richmond, K. S. Hodgson, and K. St. Joseph, "The
Roman Fort at Bewcastle," *Transactions of the Cumberland and Westmorland Antiquarian and Archaeological
Society* [hereafter *TCWAAS*] 38 (1938): 235–36, and A. Raistrick, "Report upon Earth-Samples from
Shield Knowe," in K. S. Hodgson, "Some Excavations in the Bewcastle District: I. A Bronze Age
Tumulus on the Shield Knowe," *TCWAAS* 40 (1940): 160–61.

where the remains of buildings have been identified or tools and utensils found, all of them on the rising ground to the northwest, north, northeast, east, and southeast—traces of the likely first persons to have moved into and across the region and made places around the flat-topped low hill of sand on the north side of the beck, if not on it.[11] All the sites date from that moment of transition from late Neolithic times to the Bronze Age, when the two modes of production would have become thoroughly blurred.

Little remains of "the Currick" near Skelton Pike, once a great stone cairn that is the only characteristic Neolithic building found in the area.[12] The Currick seems to have been an outlier (one of three in Cumberland and Westmorland) of a group of long cairns related to those found in Galloway and Dumfriesshire.[13] We should, perhaps, situate it in some relation of association with "Stiddrig," an unchambered, trapezoidal long cairn five miles southwest of Moffat, toward the head of Annandale, and "Windy Edge," a chambered long cairn less than ten miles to the northwest of Bewcastle, 1,000 feet up on Bruntshiel Hill just above Liddel Water.[14] Windy Edge, the larger of the two at about 140 feet long and 33 feet wide, can itself be regarded as an outlier of a group of long cairns sixty miles to the west at Cairnholy, above the eastern shore of Wigtown Bay, Kirkcudbrightshire.[15] From what remained of the Currick in the nineteenth century, John Maughan, antiquarian and rector of Bewcastle from 1836 to 1873, could describe it as having been "rectangular, about 45 yards long, 20 broad, and about 10 feet high."[16]

11. For a useful survey of sites, see M. Jackson, "Earliest Bewcastle," in *A Bewcastle Miscellany*, 15–16, with location map. For the most complete survey, see the Cumbria Sites and Monuments Record, County Offices, Kendal. Like Jackson's, my discussion of sites, except for the reference to the hut circles at Woodhead, stays within the boundary of the parish of Bewcastle. Several important Bronze Age sites, such as those around Woodhead, are located a short distance from Bewcastle in the parish of Askerton. Another site worth mentioning here, also in Askerton, is the hut circle at High Grains near Watch Cragg. As yet nothing prehistoric has turned up on the hill, but see Cumbria SMR no. 19213. In 1986, a partly polished axe of "dark green volcanic tuff" was found in a sike near Whitebeck, close to Shopford.

12. K. S. Hodgson, "Some Notes on the Prehistoric Remains of the Border District," *TCWAAS* 43 (1943): 168–70; R. G. Collingwood, "An Introduction to the Pre-History of Cumberland, Westmorland, and Lancashire North-of-the-Sands," *TCWAAS* 37 (1937): 168, 172.

13. A. S. Henshall, *The Chambered Tombs of Scotland* (Edinburgh: Edinburgh University Press, 1972), 2:160 and note 3. The others are Samson's Bratful at Ennerdale, South Cumberland, and Cow Green at Crosby Ravensnorth, Westmorland.

14. On Stiddrig and Windy Edge, see ibid., 2:419–20 and 2:420–22, respectively; see also the entries in Royal Commission on the Ancient and Historical Monuments of Scotland, *Eastern Dumfriesshire: An Archaeological Landscape* (Edinburgh: The Stationery Office, 1997), no. 432, pp. 19, 59, 102, 294, and no. 433, pp. 100, 102–4, 294, respectively.

15. Henshall, *The Chambered Tombs of Scotland*, 2:30.

16. John Maughan, "The Maiden Way, Section III—Survey of the Maiden Way through the Parish of Bewcastle," *Archaeological Journal* (London) 11 (1854): 233. Maughan refers to it by its local

So it was a big structure, close in size (and perhaps plan) to Windy Edge. At the moment it was built and first used, it must have been a very impressive sight. It surely remained so until most of it was carted away to build dry-stone walls around 1813, during the enclosures. It was computed to contain 10,000 cartloads of stones.[17] Two indentations in what remains of it, one in each of its long sides, are probably the absent presences of two megalithic chambers whose stones have been removed.[18]

The other prehistoric sites are characteristically Bronze Age. Whoever the Bronze Age people were around Bewcastle, they lived in circular huts— single huts or sometimes in settlements of two or three—and they buried their dead in round barrows or cairns along with some of the utensils that have come to be regarded as the material signature or characteristic artifact assemblage associated with the "Beaker phenomenon."[19] A hut circle found and excavated in the 1930s about a half-mile east of Woodhead, for example, held a perforated jet button and perforated jet ring of "well-known Bronze Age types."[20] When "Shield Knowe"—a large tumulus on the edge of Black Lyne Common, high in the valley of the White Lyne not far from its source in Christianbury Crags—was partially excavated in 1939, it was found to hold two burial cists and a cremation hollow.[21] The "well and elaborately

name, the "Curragh," presumably because those who lived around it thought of it as having the shape of an upturned boat.

17. Ibid., 233.

18. Hodgson, "Some Notes on the Prehistoric Remains," 168–70.

19. Collingwood, "Pre-History of Cumberland, Westmorland, and Lancashire North-of-the-Sands," 169. Here I follow Colin Burgess and Stephen Shennan, "The Beaker Phenomenon: Some Suggestions," in Colin Burgess and Roger Miket, *Settlement and Economy in the Third Millennia* B.C.: Papers Delivered at a Conference Organised by the Department of Adult Education, University of Newcastle-upon-Tyne, January 1976, British Archaeological Reports 33 (Oxford: BAR, 1976). See especially Burgess, "Part I: General Comments on the British Evidence," who proposes that the term "Beaker" should signify not so much a "culture" or "folk"—for there are no signs of a common social or economic system, settlement types, ritual monuments, or burial traditions—as an assemblage of artifacts, albeit perhaps cult artifacts (309–23).

20. K. S. Hodgson, "Some Excavations in the Bewcastle District: II. A Hut-Circle Near Wood-head," *TCWAAS* 40 (1940): 162–66. Jackson, "Earliest Bewcastle," 15, has it that in the late nineteenth century, a hammerhead, several perforated stones, two adzes, and an axe were found between Wood-head and Mount Hulie on the Askerton side of Kirk Beck. Unfortunately, this find could not be confirmed by the Cumbria SMR.

21. Hodgson, "Bronze Age Tumulus on the Shield Knowe," 154–60. See also Maughan, "The Maiden Way, Section III," which refers to it as "Shiel Knowe" and describes it as appearing to have been "a very extensive cairn, rising to a considerable height in the centre, and having three ridges or barrows running from it at smaller elevations, and diverging toward different points. The centre cairn is 22 yards on the slope of the north-west side, and the ridges or barrows about one-half of that length. The ridge or barrow running to the south-west is about 100 yards long; the ridge to the south-east is about 140 yards long; and the ridge to the north about 380 yards long. They are now covered with green turf and heather, but stones show themselves in abundance" (225).

constructed" central cist contained a pair of nearly perfect food vessels and evidence of both inhumation and cremation. The secondary cist, smaller and less elaborately constructed, about five feet away from the central cist, contained another food vessel.[22] Bone from the cremation hollow indicated that two corpses had been burned there.[23] To the northwest of Shield Knowe, between it and the Currick, the "Camp Graves" ("a circular cairn or heap of stones piled up without observing any regular order, about 12 yards in diameter and about six feet high") was "opened" in the 1790s. This cairn was found to have two chambers, each of which contained bones and an urn holding black ashes. About thirty Roman coins, a sharp-pointed two-edged iron sword 30 inches long, and a bronze "pint jug" were also found.[24] This seems to have been a Bronze Age burial that was reused during the Roman occupation of the district. Some three miles to the west, a "similar cairn, but rather larger," was opened about 1814. It contained two "similar" graves: each held one urn as well as a quantity of bones and pieces of human skulls, but no coins.[25] This place was ploughed over, and attempts to locate it have proved unsuccessful.

Around 1907, a large, much-repaired bronze cauldron of the second century, or probably earlier, was found during peat cutting on Black Moss. The repairs, nineteen bronze patches both inside and outside the cauldron, suggest that it was long cared for and highly valued. Though it is in certain respects different, it is taken to be "similar in style" to a cauldron found at Stanton Darnham, Suffolk, in 1897.[26] Other "similar" cauldrons, also much repaired, include one found in Carlingwark Loch, Dumfriesshire, and two found in Ireland. The Bewcastle Cauldron, as it is known, seems to be a stray that came into the district by trade or was left behind by someone passing through; it's one of those finds of tools or utensils that turn up but seem not to relate to the existence of any local society corresponding to it.

Of the Iron Age there are no traces, no remainders. If there was an Iron Age culture in the region, it left the area around Bewcastle unaffected.[27]

22. Hodgson, "Bronze Age Tumulus on the Shield Knowe," 156, 158–59.

23. Ibid. See Alex Low, "Report on the Bones from the Shield Knowe Tumulus," *TCWAAS* 40 (1940): 161.

24. Maughan, "The Maiden Way, Section III," 230; Maughan also records that in the late 1840s or early 1850s, a bronze spearhead was found in the peat near Camp Graves (230–31).

25. Ibid.

26. J. Davenport, "The Bewcastle Cauldron," *TCWAAS* 96 (1996): 228–30.

27. Collingwood, "Pre-History of Cumberland, Westmorland, and Lancashire North-of-the-Sands," points out that "the fortified hill-top towns of the Early Iron Age, that are so common in southern England . . . are in general less common in the north, and in our district they are absent, unless the fort on Carrock Fell, be an example" (188). The stone-walled hill fort at Carby Hill on Liddel Water, some eight miles away to the northeast and about a half-mile from the northern boundary

Though the late Neolithic–cum–Bronze Age character of the area likely remained undisturbed until the coming of the Romans,[28] it is difficult to imagine what kind of character that presence around Bewcastle might have had. So much has been literally carted off. Just the same, the clusters of hut circles and the cairns, including the Currick and Shield Knowe, are particularly representative of their period and suggest that the area was important in prehistoric times as a place of habitation, funerary activity, religion, ritual, prestige, and cult.

We do not know why or whence the first inhabitants of the area around Bewcastle came. It seems to have been a "back of beyond" into which people drifted or wandered, some from Dumfriesshire in the west and probably more from the Eden Valley in the south, and some perhaps, via that route, from Yorkshire.[29] Peoples who came from outside the region, orienting themselves toward and within the given present-to-hand. But we do know whence the people who marked the region most indelibly came—and why. The Romans came from the frontier zone along the line of Hadrian's Wall, sometime between ca. AD 122 and AD 139–42, to build a fort. This fort would be one of three outpost forts north of the Wall's western section; the others would be erected at Netherby/[Axeldunum?] Castra Exploratum and Birrens/Blatobulgium (see fig. 11).[30]

Hadrian's Wall was built to establish the material and ideological boundary dividing the inhabitants of the Roman Empire from the barbarians, the people of Britain from the peoples of the borders—the Scottish Lowlands and beyond.[31] It ran some 76 Roman miles (about 70 statute miles) along the

of the parish of Bewcastle, in Roxburghshire, Scotland, was probably built a hundred years or so after the Roman occupation of the region began. See the Royal Commission on the Ancient Monuments of Scotland, *Roxburghshire* (Edinburgh: HMSO, 1956), 1:32, 90.

28. Collingwood, "Pre-History of Cumberland, Westmorland, and Lancashire North-of-the-Sands," 192.

29. The three food vessels that came to light when Shield Knowe was excavated are all "Yorkshire Vases" of the "Abercromby type." In 1939 these were "the first specimens of this type to be found in Cumberland," according to Hodgson, "Bronze Age Tumulus on the Shield Knowe," 159. For more Abercromby-type Yorkshire Vases, see Clare I. Fell, "Two Enlarged Food-Vessels from How Hill, Thursby, and Notes on the Distribution of Food Vessels in Cumberland, Westmorland, and Lancashire North of the Sands," *TCWAAS* 67 (1967): 17–24.

30. I generally follow Austen's explanation of the fort's history, which revises that put forward by Richmond. See Paul S. Austen, *Bewcastle and Old Penrith: A Roman Outpost Fort and a Frontier Vicus*, Cumberland and Westmorland Antiquarian and Archaeological Society Research Series, no. 6 (Kendal: Cumberland and Westmorland Antiquarian and Archaeological Society, 1991), 41–50.

31. I've taken David J. Breeze and Brian Dobson, *Hadrian's Wall*, 4th ed. (London: Penguin Books, 2000), as my guide to the general history of the Wall, occasionally supplemented by Bidwell, ed., *Hadrian's Wall*, and de la Bédoyère, *Hadrian's Wall: History and Guide*.

FIG. 11 Hadrian's Wall. Map by Fred Orton, after Guy de la Bédoyère, G. D. B. Jones, and D. J. Wooliscroft. From east to west: SS South Shields, W Wallsend, Nw Newcastle, Bw Benwell, Rd Rudchester, HC Halton Chesters, Corbridge, C Chesters, Cw Carraw-burgh, H Housesteads, V Vindolanda, Cv Carvorun, GC Great Chesters, B Birdoswald, Bewcastle, Cs Castlesteads, Sx Stanwix, Carlisle, BgS Burgh by Sands, D Drumburgh, Bs Bowness-on-Solway, N Netherby, Br Birrens.

topographical northern edge of the natural gap formed by the valleys of the rivers Tyne and Irthing; it connected what is now Newcastle-upon-Tyne/ *Pons Aelius* in the east with Bowness/*Maia* on the Solway Firth in the west. It was conceived and initially constructed as a stone wall 10 Roman feet wide (about 9.84 feet wide) that ran for 45 Roman miles (41 statute miles) from Newcastle to the Irthing at Willowford and, thereafter, for the remaining 31 Roman miles (28 statute miles), as a wall made of laid turves. It thus com-prised the "Broad Wall" and the "Turf Wall." Work on the Wall began in the early AD 120s after Hadrian's visit to Britain. It was probably completed by ca. AD 138. Sometime toward the end of the AD 130s, even before the Broad Wall was completed, workers began to rebuild the Turf Wall in stone.

As well as being a powerful sign of Rome's presence and power, Hadrian's Wall would have hindered large-scale direct attacks on Britain and prevented petty raiding. It also allowed the army to supervise and control the small-scale movement of people across and along the frontier, and it encouraged the peaceful development of economic and social relations up to and beyond it. Moreover, it could protect, if necessary, the vital east-west line of commu-nication that preexisted it, the road that connected Corbridge/*Coria* and Car-lisle/*Luguvalium*—the Stanegate. Hadrian's Wall marked and controlled a more or less open frontier. As for the outpost forts like Bewcastle, it seems that their primary purpose was not to give advance warning of any impend-ing attack on the Wall—that could have been given by scouts—but, more likely, to keep secure a part of Britain that had become isolated from the

province by the Wall.[32] Of course, in protecting Britain North-of-the-Wall, the outpost forts would also have protected the Wall itself.

Between the late AD 130s or early AD 140s and the late AD 150s or early AD 160s, Hadrian's Wall was partially abandoned while the Romans tried to establish a new frontier about 100 miles north by building a turf wall, the Antonine Wall, across the Forth-Clyde isthmus. Netherby and Birrens were probably built at this time as hinterland forts on the western trunk road north through Annandale, Nidderdale, and Clydesdale to the new frontier.[33] When the Romans gave up the Antonine Wall in the late AD 150s or early AD 160s and recommissioned Hadrian's Wall as the frontier, the hinterland forts of Netherby and Birrens were reused and rebuilt to function as outpost forts. Bewcastle, then, was the only outpost fort in the frontier zone north of the western section of the Wall—and probably the only one of all the forts that might be regarded as outpost forts—that was purpose-built from scratch.[34] Indeed, it seems to have been an integral part of the original plan for the Wall.[35] I'll develop this point in a moment, but here I need only mention that at Milecastle 50 on the Turf Wall, between the "primary" forts Birdoswald/*Banna* and Castlesteads/*Camboglanna,* a special road was provided through the Wall that seems to have been set on a line over Gillalees Beacon toward Bewcastle.[36] Once Birdoswald, the primary fort closest to Milecastle 50, came in place on the stone wall that replaced the Turf Wall, the decision was made that the road to Bewcastle should start from there, and it was relocated.[37]

The fort at Bewcastle, which encompasses an area of about six acres, covers the whole of the low hill's flat top.[38] (See fig. 10.) It seems always to have

32. Breeze and Dobson, *Hadrian's Wall*, 26, 33, 46.

33. This in answer to the questions posed by table 2 in Bidwell, ed., *Hadrian's Wall*, 15.

34. The first-century fort at High Rochester/*Bremenium*, close to the line of Dere Street—the eastern trunk road north and the principal invasion route into Scotland—was abandoned until the building of the Antonine Wall. After the Antonine Wall was abandoned, it became an outpost fort for Hadrian's Wall. See de la Bédoyère, *Hadrian's Wall: History and Guide,* 121, and Bidwell, ed., *Hadrian's Wall,* 181. Little is known of the fort at Risingham/*Habitancum;* it may have come into being in the first century. If so, like High Rochester, it was probably rebuilt in the AD 140s as an outpost fort for the wall (de la Bédoyère, *Hadrian's Wall: History and Guide,* 121).

35. Breeze and Dobson, *Hadrian's Wall*, 46.

36. Ibid., 40, 46, 58; see also F. G. Simpson, I. A. Richmond, and K. St. Joseph, "The Turf-Wall Milecastle at High House," *TCWAAS* 35 (1935): 220–32, and A. M. Whitworth, "The Cutting of the Turf Wall at Appletree," *TCWAAS* 85 (1985): 71–76.

37. Breeze and Dobson, *Hadrian's Wall*, 46.

38. For excavation reports or fieldwork, see R. G. Collingwood, "The Roman Fort at Bewcastle," *TCWAAS* 22 (1922): 169–85; Richmond, Hodgson, and St. Joseph, "The Roman Fort at Bewcastle," 195–237; J. P. Gillam, "Recent Excavations at Bewcastle," *TCWAAS* 50 (1950): 63–69; J. P. Gillam,

had the shape of an irregular hexagon,[39] a unique shape for a Roman fort that is generally explained by the need to maximize the hill's natural defensive position. My not necessarily incompatible explanation is that the fort was built to accommodate a *cohors milliaria peditata,* a cohort of some eight hundred infantry, or a *cohors milliaria equitata,* a mixed unit of infantry and cavalry with more than a thousand troops as well as horses.[40] This would have required using the maximum area made available by the plateau and thus breaking with a fort's usual four-sided, playing-card shape. Nevertheless, a certain measure of standardization in some of the Wall forts has been discerned, and Bewcastle may conform to that standard despite its atypical shape. Several forts, for example, no matter what their area, have 580 feet as the length of either the main or minor axis. At Chesters/*Cilurnum,* Birdoswald, Burgh-by-Sands/*Aballava,* and Bowness, the main axis is 580 feet. So is the minor axis at Stanwix/*Petriana.*[41] It is probably no coincidence that this is the approximate measure of the fort at Bewcastle, curtain wall to curtain wall, east to west and north-south across lines projected from those bits of the *via decumana* (the street leading from the rear of the headquarters building to the rear gate) and the *via praetoria* (the street leading from the headquarters building to the front gate), and across the *via principalis* (the main street across the fort), that have been found by archaeology and geophysical survey.[42] With its internal area of about six acres, Bewcastle is a very large fort, close in acreage to Chesters (5.75 acres) and Bowness (5.88 acres). Of the forts on or connected with the

"The Roman Bath-house at Bewcastle," *TCWAAS* 54 (1954): 265–67; I. Sainsbury and H. Welfare, "The Roman Fort at Bewcastle: An Analytical Field Survey," *TCWAAS* 90 (1990): 139–46; J. P. Gillam, I. M. Jobey, D. A. Welsby, et al., *The Roman Bath-house at Bewcastle, Cumbria,* Cumberland and Westmorland Antiquarian and Archaeological Society Research Series, no. 7 (Kendal: Cumberland and Westmorland Antiquarian and Archaeological Society, 1993); and Austen, *Bewcastle and Old Penrith.*

39. See Sainsbury and Welfare, "The Roman Fort at Bewcastle," 140, fig. 1; Austen, *Bewcastle and Old Penrith,* 43.

40. On the organization of the Roman army, see Breeze and Dobson, *Hadrian's Wall,* 159–62; on these kinds of units being stationed at Bewcastle, see the discussion below.

41. See Breeze and Dobson, *Hadrian's Wall,* 70, regarding Chesters, Birdoswald, and Stanwix, but note also David J. A. Taylor, *The Forts on Hadrian's Wall: A Comparative Analysis of the Form and Construction of Some Buildings,* British Archaeological Reports 305 (Oxford: Archaeopress, 2000), 123, which measures Stanwix ca. 609 ft. x 700 ft. based on the excavations of 1984. On Burgh-by-Sands, see Taylor, *The Forts on Hadrian's Wall,* 124; on Bowness-on-Solway, see Paul S. Austen, "How Big Was the Second Largest Fort on Hadrian's Wall at Bowness-on-Solway?" in *Roman Frontier Studies 1989: Proceedings of the* xvth International Congress of Roman Frontier Studies, Exeter, 1989, ed. V. A. Maxfield and M. J. Dobson (Exeter: Exeter University Press, 1991), 7.

42. Austen, *Bewcastle and Old Penrith,* 5, fig. 2; D. J. A. Taylor and J. A. Biggins, "Interim Statement of a Geophysical Survey of the Roman Fort and Vicus at Bewcastle, Cumbria, September 2002" (unpublished report, TimeScape Research Surveys, 2003).

Wall, only Stanwix (9.32 acres), which was the military center of the whole frontier and garrison to the largest cavalry unit (or *ala milliaria*) stationed in Britain, is bigger.[43] The *cohors I Dacorum,* which may well have been the first unit stationed at Bewcastle, was one of only two *cohors milliaria peditata* stationed in Britain and had the fort as its primary garrison.[44] The *cohors I Nervana Germanorum milliaria equitata,* which may well have been stationed at the fort in the third century, was one of only five such units stationed in Britain. Several of these were, at one time or another, stationed in the outpost forts at either end of the Wall.[45] Insofar as a fort's size, or the likely units that were stationed in it, might be taken as an indication of its strategic importance in the planned military order of things, the fort at Bewcastle must have been a highly significant fort from the first. Given that it was an integral part of the plan for the Wall from the beginning, and bearing in mind the size and strength of its garrison, we might be wrong to regard it as "secondary" to the primary forts built on the line of the Wall. We might more correctly think of it as a primary fort *on* the Wall.

The fort seems to have gone through four periods of structural change.[46] In the first period, the moment of its Hadrianic foundation between AD 122 and AD 139–42, its defenses consisted of a ditch and turf-revetted rampart, possibly with stone gateways (without guard chambers); perhaps a stone headquarters building/*principia;* and certainly a stone bathhouse within the walls. The other buildings would have been in timber. In the second period, about AD 163 to AD 180–207, a stone wall replaced the primary turf revetment and the rampart's tail was cut away to make room for a new intervallum road. The south portal of the northwest gate/*porta decumana* was blocked and perhaps converted into a guardhouse. The commander's house/*praetorium* was rebuilt in stone, and stone buildings replaced some of the original timber

43. For the sizes of the forts on the Wall, see Breeze and Dobson, *Hadrian's Wall,* 54, table 3, and Taylor, *The Forts on Hadrian's Wall,* appendix, 140, table 1. Note, however, that Bowness's size, once estimated as covering 7 acres, has now been established as 5.88 acres; see Austen, "How Big Was the Second Largest Fort on Hadrian's Wall. . . ?"

Note also that though Breeze and Dobson measure Maryport as 5.8 acres and Ian Caruana measures "the visible fort" as 6.5 acres (in *Hadrian's Wall,* ed. Bidwell, 186), Taylor, *The Forts on Hadrian's Wall,* gives its area as about 1.96 hectares or 4.84 acres, an area obtained by geophysical survey (128). G. B. D. Jones and D. J. Wooliscroft, *Hadrian's Wall from the Air* (Stroud: Tempus Publishing, 2001), 132, measure the almost square site as 6.5 acres.

44. On the *cohors milliaria peditata,* see Breeze and Dobson, *Hadrian's Wall,* 159–62; on the *cohors I Dacorum* being stationed at Bewcastle, see Austen, *Bewcastle and Old Penrith,* 44, 50.

45. On the *cohors milliaria equitata,* see Breeze and Dobson, *Hadrian's Wall,* 159–62; on the *cohors I Nervana Germanorum milliaria equitata* being stationed at Bewcastle, see Austen, *Bewcastle and Old Penrith,* 46–47, 50.

46. Following Austen, *Bewcastle and Old Penrith,* 41–50.

buildings. In the third period, about AD 180–207 to AD 273, the rampart was removed to increase the area of the fort, some leveling of the site was undertaken, some buildings were rebuilt, and some new buildings were added to the *praetorium*. In the fourth period, about AD 273 to AD 310–12, when the garrison was perhaps reduced, the fort's defenses were altered. The *porta decumana* was demolished, and a new fort wall was built on top of the old southwest wall. It's possible that the north wall was also demolished at this time and brought forward and realigned, thus putting the demolished *porta decumana* and the northwest barrack blocks/*centuriae* outside the fort. The interior seems to have been comprehensively replanned, with some of the stone buildings being remodeled and perhaps given different functions. The fort was probably garrisoned until about AD 312 and possibly until about AD 370.[47] (The topography restricts the possible location of any township/*vicus* to the narrow area of land on the west between the fort, the descent to Hall Sike and Kirk Beck, and to the northern approaches where the ground is relatively level.)[48]

In the nineteenth century, fragments of two altars were found to the southwest of the fort in Kirk Beck, about 50 yards upstream from the site of Byer Cottage. Another altar was found on the Roman road about three quarters of a mile away from the fort to the west of Oakstock. A cemetery and temples in this area—on well-drained land to the east and in sight of the fort, where the road crossed the beck and then proceeded to the main gate/*porta praetoria*—would conform to the usual pattern.[49]

So much for the fort. If we take a closer look at its situation, we can see that the low hill on which it is built projects into the little valley of Kirk Beck. It is sited in the middle of a natural basin whose north, east, and south sides make a "wide amphitheatre of bleak and lofty hills"[50] that affords only restricted views with distances of just over a mile to the north and south and two miles to the east. The outlook is open only to the west, where the view extends some three miles to the rise at Roadhead. The fort's position is commanding, but in a topographical cul-de-sac. Tactically, the low hill is

47. See ibid., 42; numismatic evidence suggests that the fort was abandoned ca. AD 312. But note ibid., 32, on the Cambreck parchment ware and Huntcliff type of cooking pot found at Bewcastle that may indicate that it was occupied as late as ca. AD 370; see also Gillam, Jobey, Welsby, et al., *The Roman Bath-house at Bewcastle*, 23.

48. Sainsbury and Welfare, "The Roman Fort at Bewcastle," 143.

49. Ibid., referencing J. Hodgson, *History of Northumberland,* part 2, vol. 3, *Newcastle-upon-Tyne,* 296, and John Maughan, *A Memoir of the Roman Station and Runic Cross at Bewcastle and the Runic Inscription in Carlisle Cathedral* (London: Groombridge and Sons, 1857), 4, 7.

50. J. C. Bruce, *The Roman Wall: A Historical, Topographical, and Descriptive Account of the Barrier of the Lower Isthmus, Extending from the Tyne to the Solway* (London: John Russell Smith, 1851), 344.

strong, protected by a fall of up to 40 feet on the east, west, and south sides, by the loop of the beck at the south, and by a bog or "a sort of quicksand" at the southwest.[51] But strategically it commands nothing more than the basin. There's now a route across from Bewcastle to Kershopefoot, in Liddesdale, and from there into the Southern Uplands of Scotland. This route may have pre-dated the fort; it may instead have arrived when cross-border commerce in livestock began to establish its drove roads in the fourteenth century. From Kershopefoot there were few points at which a border crossing could not be made. In the seventeenth century, the route from Kershopefoot through the parish of Bewcastle would have been a good one for any drover wanting to get around the toll of 8d a head that was levied at Carlisle.[52]

Though many Roman forts were built on low ground, often with limited outlooks, the choice of Bewcastle as the site of an important outpost fort is puzzling at first. It's on road to nowhere, "hidden away" in the bottom of a natural basin, and out of direct visual communication with the primary fort on the Wall to which it was connected. It may be that the site was a British fort reoccupied by the Romans. But even if we discount this idea, we need not discount the possibility that the Romans occupied a British "place," a low hill of sand with hazel and willow growing on it, and perhaps a little oak, near a bog, in the bend of a river. It might have been a natural feature with which the indigenous people of the region had already established a lived relation; invested with shared bodies of local knowledge and endowed with special significance; thought sentient; made numinous[53]—as a cult site, for example, that the Romans considered best occupied or otherwise appropriated. Devoted to Cocidius, perhaps.

Any place can be the site of gods who are fled, gods present still, and gods arriving. Indeed, one would expect it to be so. Cocidius was a Celtic deity

51. Maughan, *A Memoir of the Roman Station*, 4. If, in the nineteenth century, it could be accurately described as "a sort of quicksand," it's a lot less lively today.

52. A. R. B. Haldane, *The Drove Roads of Scotland* (London: Thomas Nelson and Sons, 1952), esp. chap. 1, "The Early Drovers," 6–19. The drove roads seem not to have passed through Bewcastle itself; see William Hutchinson, *The History of the County of Cumberland,* vol. 1 (Carlisle: F. Jollie, 1794), 96, who records that "there are two great drove roads through the parish, one from Scotland to the southern parts of England, the other from the western parts of Scotland to the eastern parts of England, by which many thousands of cattle and sheep pass yearly: and yet it has to be said that there are no statute fairs in Bewcastle, for either the sale of cattle, or hiring of servants."

53. I'm aware, of course, that bogs were the depositories of votive offerings from the Bronze Age through Romano-British times into the medieval period. Perhaps the bog at Bewcastle hasn't received the attention from historians and archaeologists that it deserves. Of course, we don't need archaeology to establish the mystery and magic of bogs. They intrigue.

that was appropriated by the Romans and honored on a large scale along Hadrian's Wall between Housesteads/*Vercovicium* and Stanwix.[54] At the last count, twenty-five dedications to him are known, six or possibly seven coming from Bewcastle, including those on two silver plaques that were found in the fort's strongroom/*sacellum*.[55] Cocidius was identified with Mars at Bewcastle and with Silvanus at Housesteads.[56] So he seems to have had at least two sides to his character: he was a deity with warrior characteristics, and he was also a deity of woodlands and hunting. It has been suggested that "Cocidius" means "The Red One," which either by warfare or the chase or both, for they are related activities, would permit connotations of bloodedness.[57] It may well be that the fort at Bewcastle—where among the dedicants we find unit commanders[58]—is *Fanum Cocidii*, the shrine or temple of Cocidius that was listed in the Ravenna Cosmography along with the names of most of the primary forts at the western end of the Wall.[59] If the low hill above the beck and the area around it were not a cult site—devoted to Cocidius, perhaps—before the Romans arrived and recognized it as something close-to-hand that could be used, it became one when they arrived and built their fort there.

Be that as it may, although property relations and ideology are important, we should stay a while with those "first premises" of orohydrography, geology, and topography.

I mentioned a moment ago that Bewcastle/*Fanum Cocidii* seems to have been an integral part of the original plan for Hadrian's Wall. (See fig. 11.) It would seem that the original plan for the Wall was that it should have twelve

54. Breeze and Dobson, *Hadrian's Wall,* 282. On Cocidius, see Kenneth J. Fairless, "Three Religious Cults from the Northern Frontier Region," in *Between and Beyond the Walls: Essays on the Prehistory and History of North Britain in Honour of George Jobey,* ed. Roger Miket and Colin Burgess (Edinburgh: John Donald Publishers, 1984), 228–35.

55. Fairless, "Three Religious Cults," 228. R. G. Collingwood and R. P. Wright, *The Roman Inscriptions of Britain,* vol. 1 (Oxford: Clarendon Press, 1965), provides a catalogue of the known inscriptions on the surviving or lost inscribed stones and plaques attributable to or found at Bewcastle. See entries 966 (there is no record of the discovery of this altar, which was recorded in 1772 at Netherby but is now thought to have come from Bewcastle), 986–97.

56. Fairless, "Three Religious Cults," 229.

57. Ibid., 234, citing I. A. Richmond and O. G. S. Crawford, "The British Section of the Ravenna Cosmography," *Archaeologia* 93 (1949): 34, while acknowledging the philological difficulties involved in translation and interpretation and pointing to the need for caution.

58. See Collingwood and Wright, *The Roman Inscriptions of Britain,* entries 966, 988–89.

59. Fairless, "Three Religious Cults," 229. I. A. Richmond and O. G. S. Crawford, "The British Section of the Ravenna Cosmography," suggested that the shrine of Cocidius was situated somewhere in the area between Stanwix, Netherby, and Bewcastle. E. Birley, *Research on Hadrian's Wall* (Kendal: Wilson and Son, 1961), 231, 233, suggested that Bewcastle was the site of the shrine, and in 1978 the fourth edition of the Ordnance Survey Map of Roman Britain tentatively accepted it as *Fanum Cocidii*.

primary forts spaced, with no special regard for whether they would be at strong or weak points, at intervals of 7 1/3 Roman miles (6.8 statute miles).[60] Surely it is no coincidence that Bewcastle is about 7 1/3 Roman miles from both Milecastle 50 on the Turf Wall and Birdoswald. Let's follow the route taken by the road that was built to connect Birdoswald to the fort.[61] After leaving Birdoswald, the road immediately crosses the boggy ground of Midgeholme Moss and then, rising slightly, crosses more bog on Whitehead Common before climbing to the plateau of Spadeadam Waste—and yet more boggy ground—until it arrives at the rim of the "amphitheatre." From the rim, looking at the land extending around them and down in the basin, it is clear why the Roman surveyors built their fort where they did. About 6 1/2 boggy Roman miles from Birdoswald, the two glacially deposited hills of sand on the north side of the beck (the only sand hills of any size in the area), especially the flat-topped low hill to the east just over a mile away, offered a prime site. While more or less everything around the hill couldn't be excavated to any depth, ditches could be dug in it, and turf ramparts could be raised on it; timber suitable for construction work must have been readily available there. It was well drained, and a good water supply was close by. And the surveyors would have known that, if and when they were needed, sandstone, limestone, and other stone suitable for building work were available a short distance away.[62] But it would also have been clear to them that, were they to continue their road on its line to the hill, they would have to

60. Breeze and Dobson explain why and how the original plan was varied; see *Hadrian's Wall*, 51. Table 2, p. 50, gives the actual distances between the forts.

61. The road is marked on the most recent Ordnance Survey map to within half a mile of High House, 2 1/2 miles south-southeast of the fort. Today, it is difficult to discern and, because of the terrain and restrictions, practically impossible to walk. Maughan surveyed it in March 1854. See John Maughan, "The Maiden Way: Survey of the Maiden Way from Birdoswald, the Station of Amboglanna, on the Roman Wall, Northward into Scotland; with a Short Description of Some Remarkable Objects in the District. Section I—Survey of the Maiden Way through the Parish of Lanercost," *Archaeological Journal* 9 (1854): 1–22. R. G. Collingwood surveyed it in September 1921. See also Collingwood, "The Roman Fort at Bewcastle," 178–82.

62. See Day et al., *Geology of the Country Around Bewcastle,* 266–67, which is of the opinion that the fort was built with stone that "probably came from ancient quarries in the Earthwork and Parkhead sandstones near Grossgreens. Some larger blocks may possibly have been brought from the great crags of the Long Bar on Whitelyne Common." The crags of the Long Bar are said to have provided the stone for the Bewcastle monument also. See the "Rough-out of cross-shaft(?)" on Long Bar that the *Corpus of Anglo-Saxon Stone Sculpture,* 162 and illus. 621, describes as "a tapering rectangle of stone cut out of the outcrop on three sides but still attached at the base." We should note, however, the discussion about this "tapering rectangle of stone" in *Geology of the Country Around Bewcastle:* "At outcrop this sandstone has a system of rectangular joints so that on weathering it tends to break into roughly rectangular blocks, some of which are pockmarked in a fashion resembling artificial working by chisels. It thus seems unlikely that a similarly pockmarked rectangular block, locally reputed to be the 'brother' of the stone which now forms the monument, was in reality quarried" (94).

cross the beck at the point where the terrain was at its most ravine-like and then run into more boggy ground on its north bank. I suppose that's why they redirected it to the east, over more favorable terrain, to cross the beck at a point clear of the bog and thence up the hill to the fort.[63] Down in the basin, the low hill wouldn't be in visual contact with Birdoswald but, mathematically and topographically, it was where the surveyors wanted it to be, and visual communication could be achieved between it and Birdoswald by building two observation or relay posts: one on the ridge to the north-northeast at Barron's Pike; the other back along the road, on the south side of Gillalees Beacon on Spadeadam Waste at the Butt.[64] Given the topography, geology, and orohydrography of the region, the flat-topped low hill above the beck presented the surveyors with an almost ideal site, straight out of the manual. They built on it and, if it was not one already, it became a place.

63. Sometime between spring 1852 and early 1854, John Maughan traced the road to its river crossing at a ruin called the "Dollerline," about 700 yards east of the fort: see "The Maiden Way, Section I," 19, fig. 3, and 22. The Dollerline is the earthworks and buried remains of a medieval dispersed settlement, including a house platform with a small appendage on the east side; see Cumbria SMR no. 68. Maughan mentions and measures this platform (see "The Maiden Way, Section I," 22). Three years later he refers to it again and records that across from it, on the north side of the beck, there "is a small embankment or raised road leading to the eastern gate of the Station." See Maughan, *A Memoir on the Roman Station,* 4.

Collingwood, "The Roman Fort at Bewcastle," 178–82, was able to follow the road from Birdoswald to just beyond Spadeadam, then could not find it until about half a mile from Bewcastle, where he thought it was "represented by the straight length of the modern road for about 700 yards S. of Shopford." He reckoned that it "forded Kirk Beck where the modern bridge stands, and approached the fort as it does now." In June 1923, Collingwood's son W. G. Collingwood, along with a "digging party" of three companions, tried to find the line from High House to the fort; see W. G. Collingwood, "The End of the Maiden Way," *TCWAAS* 24 (1924): 110–16. He tracked the road cutting northwest from "about 500 yards S.S.E. of High House" to Kirk Beck, 50 yards east of Byer Cottage. (Richmond, Hodgson, and St. Joseph, "The Roman Fort at Bewcastle," 196, fig. 1, and 199, fig. 3, favored a point closer to Byer Cottage.)

The end of the road was most recently surveyed by Taylor and Biggins in June 2000 and September 2002. See the "Interim Statement of a Geophysical Survey," 2. Biggins and Taylor identified the line of the road from the *porta praetoria* to the point where it crossed Kirk Beck: "The road was seen as a well-defined agger close to the river and as an anomaly on the magnetometry image. Its line differs from that put forward by Collingwood (1924, pp. 115–16) and Richmond (1958 [sic], 119 [sic]). The proposed route enters the fort at a slight angle to the *via praetoria* and not at the acute angle put forward by Collingwood and Richmond." This is not quite correct. Collingwood did not project the line of the road from its river crossing to the *porta praetoria;* see Collingwood, "The End of the Maiden Way," 116, where the road seemed "to be traceable at first," then could not be found, and thereafter "would need a considerable excavation to decide." It seems to me that the results of Biggins and Taylor's survey situate the road's river crossing more or less where Collingwood found it, 50 yards east of Byer Cottage.

64. On Gillalees Beacon, which was first identified by Maughan, "The Maiden Way, Section I," 9, fig. 2, and 10, see also I. A. Richmond, "The Tower at Gillalees Beacon, called Robin Hood's Butt," *TCWAAS* 33 (1933): 241–45. On Barron's Pike, see F. Topping, "A 'New' Signal Station in Cumbria," *Britannia* 17 (1987): 298–300; see also Jones and Wooliscroft, *Hadrian's Wall from the Air,* 135 and 141 fig. 89.

The Romans came, and the Roman army went. The question now is: What kind of place was Bewcastle/*Fanum Cocidii* after the Roman forces had quit? Did it continue or did it cease being a place? And, if it continued, what kind of place was it when the Anglo-Saxons recognized what was pre-given there and brought it close-to-hand (including, perhaps, something residual of its cult-centeredness), built and dwelled there, and erected the monument that provides us with whatever continuity we have with them, with their time and their place?

Those who have synthesized archaeological finds with the historical record so as to explain how and why Hadrian's Wall was abandoned have always had to make a little go a long way. Making do with the little we have, we should always push what we know to the limits of explanatory possibility, while avoiding illusion and make-believe. When new matter is brought to light, it may take the explanation further along the usual way or it may take it in a somewhat different direction. Various almost paradigmatic explanations have been given for why the primary and outpost forts were abandoned. Some might have been abandoned as an effect of Constantine's visit to Britain in AD 312. Others may have been abandoned as an effect of the Barbarian Conspiracy of AD 367 or as part of the reorganization of the frontier in AD 396. Others would not have been abandoned until the Romans withdrew from Britain in AD 410. It was once thought, as one authority teased, that "the end of the northern frontier saw the Roman soldiers packing up their bags and heading south, leaving their forts and their wives' hearts empty, at the mercy of the northern equivalent of tumbleweed blowing down the streets of a ghost town of the American West."[65] Given what has been excavated, analyzed, and synthesized over the last twenty years, however, it seems that at certain forts along the Wall—at Vindolanda, Housesteads, and Birdoswald for example, and at some related forts, such as at South Shields/*Arbeia* and Corbridge or at Binchester/*Vinovia* in the eastern Pennines—the theory of sudden and catastrophic abandonment will not quite hold.[66] These forts remained occupied until the late fourth or fifth century, some of them through to the mid-sixth century, and some perhaps continuously until their communities became Anglo-Saxon.

65. Iain Ferris and Rick Jones, "Transforming an Elite: Reinterpreting Late Roman Binchester," in *The Late Roman Transition in the North: Papers from the Roman Archaeology Conference, Durham 1999,* ed. Tony Wilmott and Pete Wilson, BAR British Series 299 (Oxford: Archaeopress, 2000), 1.

66. Convenient summaries of work in progress or overviews of work done can be found in *The Late Roman Transition in the North,* ed. Wilmott and Wilson. See especially Tony Wilmott, "The Late Roman Transition at Birdoswald and on Hadrian's Wall," 13–23, and Ferris and Jones, "Transforming an Elite," 1–11. But see also Ken Dark, "The Late Roman Transition in the North: A Discussion," 81–88, and Simon Esmonde Cleary, "Summing Up," 89–94.

At Birdoswald, just over seven Roman miles by Roman road from Bew-
castle, where the fort continued to be occupied during the late fourth century
and into the fifth, building certainly continued, at first in stone and then in
timber, and it followed on directly from the Roman buildings without a
break. Traces of two large well-constructed timber buildings have been
found, suggesting that though the community lost the skills necessary for
maintaining stone buildings in good repair, it was more than capable of erect-
ing substantial, habitable wooden structures that could still have been in use
in the sixth century, and possibly in the early seventh century. It is not known
whether the fort was continuously occupied during this period and thereafter,
or whether it was deserted and reoccupied. But the discovery, to the east of
the fort, of an eighth-century Anglo-Saxon disc-headed pin decorated with
a cross and four simple *triquetras* is, to say the cautious least, "intriguing."[67]

The Romans had been in Britain for over 350 years. That is, present-day
England and Wales had been part of the Roman Empire for more than three
centuries by the time it withdrew its military at the beginning of the fifth
century. During that period, the territories of the native tribes were taken
over and adapted to Roman rule as administrative units called *civitates,* each
one with its *civitas* capital, an urban center of government, tax collection, and
jurisdiction that was well equipped with public buildings.[68] The native tribal
aristocracies were also appropriated for this system of governance and contin-
ued to control their territories, now *civitates,* as Roman magistrates.[69] After
the Roman army withdrew, it seems likely that the old native aristocracies,
changed by so many centuries of Roman rule—and set alongside new classes
of non-aristocrats who had done well under the Romans and achieved some
economic power, if not the status of the aristocracy—now, if by default of
the imperial authority imposed on them, were once again in position to rule.
This time they would rule not as representatives of the ruling class, but as
what they had once been: overlords of the ruling class. Even so, this need
not have occasioned a reversion to pre-Roman tribalism, which would by
then have been the stuff of folklore and history. Some native aristocrats and
nouveaux riches would have tried to hang onto their Roman way of life, its

67. See Wilmott, "The Late Roman Transition at Birdoswald," 13–23, and Tony Wilmott, *Birdos-
wald Roman Fort: 1800 Years on Hadrian's Wall* (Stroud: Tempus Publishing, 2001), esp. chap. 7, "Change
and Decay," 113–26.

68. On the *civitates,* see Martin Millett, *The Romanization of Britain: An Essay in Archaeological
Interpretation* (Cambridge: Cambridge University Press, 1990), esp. chap. 4, "The Emergence of the
'Civitates,'" and chap. 5, "The Maturity of the 'Civitates.'"

69. Millett, *The Romanization of Britain,* 106, table 5.1, and 154–56, table 6.5, lists sixteen *civitas*
capitals (which is three fewer than the number of tribal territories he gives on 67, fig. 16).

pomp and signs of status and different kinds of power. At South Shields, for example, the courtyard house was maintained (even if not to previous Mediterranean standards) and occupied until at least the early fifth century.[70] At Binchester, in the middle of the fourth century, the fort was replanned to accommodate a large house that was subsequently rebuilt, redecorated, and generally maintained and used until some time in the middle of the sixth century, when an Anglo-Saxon woman and her grave goods were buried in the rubble collapsed from the roof and vault of its bathhouse.[71] To give one more example, in the fifth or sixth century, at Wroxeter/*Viroconium Cornoviorum*, a *civitas* capital far from the Wall, Roman stone buildings were replaced by timber buildings—if not in a classical style, then with something of the Roman about them.[72] There were sub-Roman people in a sub-Roman world living sub-Roman lives in sub-Roman places. Something more than groups of enslaved Britons survived from Roman Britain into Anglo-Saxon England.[73]

It may be that the area around Bewcastle and Birdoswald persisted in a sub-Roman way, perhaps as part of the territory of the Carvetii, the *civitatas Carvetiorum*. If so, Carlisle, about eighteen miles away from Birdoswald and about twenty-four miles from Bewcastle, may have been its *civitas* capital or, if not its *civitas* capital, a major town in relation to the surrounding territory. And more than that, it may be that the territory of the Carvetii was part of or would become part of Rheged, a British kingdom of uncertain extent that gradually, by a long process of colonization, came under Anglian dominion during the sixth, seventh, and eighth centuries.[74]

Carlisle, with its fort and town on the south bank of the river Eden and the fort at Stanwix—as we've seen, the largest on the Wall—some five minutes away on the north bank of the river, was one of the most densely populated places in the frontier zone. It was also the important hub of a system of roads going north, south, east, and west. Parts of the town, if not the fort at Carlisle, seem to have been occupied into the fifth or sixth century.[75] As one

70. Bidwell, ed., *Hadrian's Wall*, 81–82.
71. Ferris and Jones, "Transforming an Elite," 1–2, 3.
72. See James Campbell, *The Anglo-Saxons* (Oxford: Phaidon Press, 1982), 40 fig. 40.
73. Ibid., 38.
74. See most recently, for example, K. R. Dark, *Civitas to Kingdom: British Political Continuity, 300–800* (Leicester: Leicester University Press, 1994), 72; Charles Phythian-Adams, *Land of the Cumbrians: A Study in British Provincial Origins*, A.D. 400–1120 (Aldershot: Scolar Press, 1996), 48–63, 167–68, 103–4; and Mike McCarthy, *Roman Carlisle and the Lands of the Solway* (Stroud: Tempus Publishing, 2002), chap. 5, "*Luguvalium*, the Civitas Capital," 67–92.
75. For the traces of activity at the fort and in the town into at least the fifth century, see McCarthy, *Roman Carlisle*, 134–41.

of the Roman towns in Britain to have preserved its Roman name, we can assume that continuity of some kind was likely. Bede, writing in the eighth century, insisted on that continuity when he referred to Carlisle as "*Lugubalium ciuitatem.*"[76]

Carlisle probably retained its significance as a fortified place and center of communications in the northwest after the Roman garrisons abandoned it. If it lost that importance in the fifth and sixth centuries, which seems unlikely, it had certainly regained it by the time Cuthbert visited it as bishop of Lindisfarne in 685. By then, Carlisle was sufficiently important to contain a royal monastery headed by the queen's sister or sister-in-law. It was also sufficiently strong and secure for the queen to relocate there temporarily while she awaited the outcome of her husband's ill-advised campaign against the Picts. On what was perhaps the penultimate of several visits that Cuthbert made to Carlisle—he went to visit the queen, but it seems to have been a diocesan visit as well—Waga, the "*ciuitatis praepositus,*" gave him and his entourage of priests and deacons a kind of official tour. As the writer of the *Anonymous Life of St Cuthbert,* writing between 699 and 705, put it, during the tour Cuthbert was shown the "murum ciuitatis et fontem in ea a Roman mire olim constructum," which Bede in his *Life,* written around 721, gives as "moenia ciuitatis fontemque ea miro quondam Romanorum opere extructum."[77] But what did Waga show Cuthbert? What was that *murum ciuitatis,* and that *fontem*? As yet, archaeological evidence cannot prove that the town at Carlisle was enclosed with stone walls.[78] If it were defended, it would have been with walls made of earth and timber. Archaeology has revealed a "short stretch of an unfinished earth and timber rampart with signs of unfinished ditches"[79] at one site and, at another, "a wide earthen bank topped with a double row of posts," which could be interpreted as a bit of the Wall but could also be interpreted as a flood defense or an aqueduct.[80] If the town were defended by a still-standing Roman earthwork, it may not have been

76. See *Bede's Ecclesiastical History of the English People,* ed. Bertram Colgrave and R. A. B. Mynors (Oxford: Clarendon Press, 1969), IV.29. See also in *Two Lives of St Cuthbert,* ed. Bertram Colgrave (1940; Cambridge: Cambridge University Press, 1985), *Vita Sancti Cuthberti Auctore Beda/The Life of St Cuthbert by Bede,* chap. 27, pp. 242, 243.

77. In *Two Lives,* ed. Colgrave, *Vita Sancti Cuthberti Auctore Anonymo/The Life of St Cuthbert by an Anonymous Author,* chap. 8, pp. 122, 123, and *Vita Sancti Cuthberti Auctore Beda/The Life of St Cuthbert by Bede,* chap. 27, pp. 242, 244 and 243, 245. For further discussion of these passages to supplement what follows, see McCarthy, *Roman Carlisle,* 152–53. Cuthbert visited Carlisle again, shortly before his death, in AD 687. See *Bede's Ecclesiastical History of the English People,* IV.29.

78. Bidwell, ed., *Hadrian's Wall,* 175.

79. Ibid.

80. McCarthy, *Roman Carlisle,* 85.

very substantial. It seems odd that it would have been deemed worthy of note, even if it had been continuously or intermittently maintained. The walls of the fort, however, were made of stone. And though they would have begun to decay by the late fourth century, as had the stone walls at forts all along the frontier, they could have been more or less intact. We know that the southern defenses and the *porta decumana* were rebuilt,[81] that rebuilding within the fort in stone and timber was carried out in the fourth century, and that the *principia* and some of the other buildings were still in use in the fifth century.[82] The *via praetoria* and *via principalis* were maintained and used as well.[83] Perhaps the walls were considered worthy of note because they *had* been maintained.

It is likely, then, that Cuthbert was given a tour not of the town but of the fort, its walls, and a *fontem.* But what was that *fontem?* A thing of aquatic engineering, for sure. A well? Drain? Water pipe? Spring tank? Sewer? Aqueduct? Or fountain? Most *civitas* capitals had intramural wells, but, though it had at least one aqueduct and baths, thus far a well has not come to light.[84] We should not rule out the possibility that Cuthbert might actually have been shown a fountain. Running water was needed for flushing latrines, sewers, and streets, and it was usually obtained from the excess overflow from fountains.[85] One of the two aqueducts at Corbridge terminated at an impressive fountain in the center of the town, on the *via principalis,* between the granaries/*horrea* and the *principia.*[86] Cuthbert would probably have known about it, and may have seen it, but it may not have been working in the seventh century. Fountains, like drains, need maintaining if they are to function properly. As the fountain at Corbridge has been reconstructed, the water from the aqueduct flows into a large aeration tank where it is freshened and sweetened. It then spurts through an ornamental spout into a trough from which it can be drawn for public use before overflowing into the street drains. If Carlisle had such a fountain, and it was still working, it would have been a very impressive sight. Cuthbert, on his way to sainthood by the time of his visits

81. Ibid., 85, 134.

82. In ibid., 134, 136, McCarthy mentions that, 500 years after Cuthbert's visit, William of Malmesbury reported that he had seen a Roman vaulted building bearing an inscription dedicated to Mars Victor. See William of Malmesbury, *De gesta pontificum Anglorum,* ed. N. E. S. A. Hamilton, Rolls Series 52 (London, 1870), 208.

83. McCarthy, *Roman Carlisle,* 136.

84. Alfonso Burgers, *The Water Supplies and Related Structures of Roman Britain,* British Archaeological Reports 324 (Oxford: John and Erica Hedges, 2001), 61.

85. Ibid., 23.

86. See J. N. Dore, *Corbridge Roman Site* (London: English Heritage, 1989), 7–8, and 9 for a photograph of the remains as they are today and a reconstruction drawing.

to Carlisle, would have been well known for the way he was provided with a *fontem aquae* on Farne, almost entirely by prayer.[87] If Carlisle hadn't a well to show off, a fountain—as a metonym for something that figured in Cuthbert's blessed *curriculum vitae*—would have done the trick. The point is that there must have been some residual *Romanitas* and plenty of Rome's material imperial past in Northumbria, especially in the area around the Wall, and the much-traveled Cuthbert would probably have been familiar with most of it one way or another. So Carlisle in the seventh century must have been a pretty impressive Roman place if Waga the reeve thought that a tour of its *murum ciuitatis* and *fontem* was just what Cuthbert would appreciate under the "wonderful sky" of that Saturday toward the end of May 685.

If Carlisle and Birdoswald were occupied, either continuously or discontinuously, into the early medieval period and persisted as sub-Roman places, local centers closely related to tribal areas, then Bewcastle may have continued as a sub-Roman place as well—or as a place within a sub-Roman place. Its function, like that of the other forts and the *civitas* capitals, would have disappeared with the Roman military, but its stone buildings and defensive structures would have survived into the medieval period. Roofs may have caved in, towers collapsed, barred gates broken; houses may have been gaping, tottering, fallen, undermined by age. But it would have been there to be brightened by a mind quickened with a plan of what it was before fate altered it. Even if the fort did not persist as a sub-Roman place with a sub-Roman way of life, we can be sure that much of its material fabric and some of its ideology would have survived until it became an Anglo-Saxon place.

In the last period of structural change, about AD 273–312, the fort's defenses were altered, its internal area reduced, and several of its important buildings remodeled. Traces of demolition or partial demolition that were once put down to the fort's destruction by barbarians in the third century are now understood to have been occasioned by its total replanning. In the center of the fort, in the *principia,* the *sacellum* was filled in and a new floor added to the shrine room/*aedes.* In the northwest corner of the *retentura,* the *centuriae,* put outside the fort when the north wall was brought forward, were demolished. And in the southwest corner of the front portion of the fort/*praetentura,* the bathhouse was given a different function.[88] For reasons that

87. *The Life of St Cuthbert by an Anonymous Author,* chap. 3, pp. 98, 99; see also *The Life of St Cuthbert by Bede,* chap. 18, pp. 218, 219, which turns the anonymous author's *statim fontem aquae uiue* (definitely a fountainhead, a spouting or spurting of water) away from its Mosaic connotations into a *foueam quam in crastinum emanante ab internis unda repletam inuenerunt* (something more like a well).

88. Here I continue to follow Austen, *Bewcastle and Old Penrith,* 7–16, 48–49.

will become clearer in a moment, I want to take a closer look at the bath-house, which is the only building in the fort to have been sufficiently disen-gaged by excavation to make a graphic restoration possible.[89]

Of all the buildings in the fort, the bathhouse would have been the most robustly constructed and most likely to have resisted decay and demolition. Roman buildings were constructed using methods that we now regard as traditional.[90] They would have required major refurbishment after about sixty years or so. Walls would have needed repointing; roofs would have required stripping and their tiles or slates replaced as they and the nails, lathes, and timber frames deteriorated. A traditional stone building tends to collapse only when it is no longer watertight. The loss of the roof leads to the decay of the supporting timber frame and, thereafter, to the collapse of the building itself. Bathhouses, however, were not constructed quite like other buildings. Though they might have been covered with tile or slate roofs supported by timber frames, because of the risk of fire and the need to prevent loss of heat from the rooms of the heated suite, they were for the most part ceiled with various kinds of masonry vault. Apart from the disrobing room/*apodyterium,* which had masonry walls but a tile roof supported by a timber frame, the bathhouse at Bewcastle was ceiled with a combination of barrel vaults where the walls were strong enough to support them and groin vaults where they were not.[91] One or two separate barrel vaults of cut stone likely ceiled the cold room/*frigidarium* and cold bath, and one or two groined vaults, made of concrete supported by calcareous tufa voussoir arches, ceiled the hot room/ *caldarium* and first warm room/*tepidarium.*[92] At the site, "tufa voussoirs were found in abundance," though "there were rather more to the north-west, north and east of the heated suite than within the debris overlying it."[93] Calcareous tufa is an exceptionally lightweight bad-weather stone that was known to Roman architects and builders, including those in the military working on Hadrian's Wall, who valued it for its heat- and fire-resistant properties, among others.[94] Above these masonry vaults, "it seems in the

89. Gillam, Jobey, Welsby, et al., *The Roman Bath-house at Bewcastle,* 6, fig. 6, "Suggested recon-struction of the bath-house."

90. Taylor, *The Forts on Hadrian's Wall,* 13–26, provides a very useful introduction to the tech-niques of Roman building construction, but unfortunately does not discuss the construction of bath-houses.

91. Gillam, Jobey, Welsby, et al., *The Roman Bath-house at Bewcastle,* 10–11, 13–14, 20–22.

92. Ibid., 11, 14.

93. Ibid., 14.

94. On tufa, see Jean-Pierre Adam, *Roman Building Materials and Techniques,* trans. Anthony Mat-thews (London: B. T. Batsford, 1994), 21–22, and James C. Anderson Jr., *Roman Architecture and Society* (Baltimore: The Johns Hopkins University Press, 1997), 140–44. Eight different kinds of volcanic tufa (*cappellaccio, fidenae, grotta oscura, anio, monteverde, campidoglio, peperino,* and *sperone*) and one sedimentary

highest degree likely" that the bathhouse had a pitched timber roof that integrated with the one over the *apodyterium*.[95]

Masonry vaults not only reduce the risk of fire and insulate the *caldarium* and *tepidaria* but also keep a building watertight. Even if a bathhouse lost the tile or slate roof over its masonry-vaulted rooms, it would still resist the elements for a good while longer. And at Bewcastle (as elsewhere), the external walls of the bathhouse were rendered to provide a covering that protected

stone (*travertino*) provided the basic building stones of Rome and central Italy in ancient times. They were used as dressed stone and rubble. Although they are related and have certain characteristics in common, the two kinds of stone are different in origin. The tufas were deposited by volcanic activity. The calcareous sedimentary stone was formed as a precipitate around springs that had opened on the surface because of that volcanic activity. Geologists make a distinction between these two kinds of stone by referring to the former as "tuff" and the latter as calcareous tufa, or "tufa."

Vitruvius, *De Architectura Libri Decem*, book 2, chap. 7:1–7, opens his discussion of "stone" with a consideration of the properties of tufa/*tofum*. The tufas are soft stones that are easily worked. Some of them, as Vitruvius put it, "can be cut with a toothed saw, like wood." Some of them were valued for their heat- and fire-resistant properties. *Sperone* and *peperino*, for example, were used in the firewalls that formed the rear curtain of the Forum of Augustus and saved it from devastation during the fire of AD 64. Vitruvius especially recommends the stone from the region around Bolsena: neither frost nor fire could harm it; it remained solid and lasted to a great age; and, as well as building with it, you could make moulds for bronze casting out of it. He advises quarrying these stones in the summer, not in the winter, and then exposing them to the air in a covered place for two years so that they can lose their moisture and the builder can identify the good-weather stones.

Vitruvius, with his interest in fire resistance, points out that *travertino*, the calcareous tufa, is not resistant to fire. In Britain, however, when it came to building bathhouses, with no volcanic tufa—or no suitable volcanic tufa—to hand, it seems that the Roman architects substituted calcareous tufa as an easily worked, lightweight, and apparently heat-resistant equivalent.

On the calcareous tufa voussoirs found in the bathhouse at Chesters—and Parker Brewis's brilliant interpretation of how they formed the arched ribs supporting the vault above the *caldarium*—see George MacDonald, "The Bath-house at the Fort of Chesters (*Cilurnum*)," *Archaeologia Aeliana*, 4th ser., 8 (1931): 278–82. It was MacDonald who realized, contrary to the note on Sheriton Holmes's 1886 plan of the bathhouse at Chesters, that these voussoirs were not made of "concrete" but of calcareous tufa (ibid., 223, 280 and n41). He was told it could be quarried near Haltwhistle. Calcareous tufa was perhaps also used in the construction of the *caldarium* of the bathhouse at Great Chesters/*Aesica* (282–83). And, away from the Wall, several voussoir-shaped blocks of calcareous tufa were found in the primary construction debris of the fortress baths at Caerleon/*Isca*. It had also been incorporated in secondary structures. See J. David Zienkiewicz, *The Legionary Fortress Baths at Caerleon: I. The Buildings* (Cardiff: National Museum of Wales and Cadw and Sutton Publishing, 1986), 104.

Mindful that Roman builders used local stones wherever possible, it may be that the material for the voussoirs used in the construction of the bathhouse of the fort at Bewcastle, like the rest of the stone, was quarried not far from the fort. As mentioned above during my discussion of the geology of the district, volcanic activity in the area around Bewcastle is represented by a single basalt lava (around Kershopefoot) and a few thin bands of tuff. Calcareous tufa and tuff both outcrop not far from the fort: see Day et al., *Geology of the Country Around Bewcastle*, 243, 245. It is not known, of course, where the calcareous tufa used in the construction of the fort was quarried, but an area extending over about one acre is located less than two miles southwest of the fort near Bogside Farm. Gillam, Jobey, Welsby, et al., *The Roman Bath-house at Bewcastle*, 14, note that "the farmer at Bewcastle volunteered the information that tufa, which he called petrified moss, could be obtained a short distance from the fort, though the place was not visited."

95. Gillam, Jobey, Welsby, et al., *The Roman Bath-house at Bewcastle*, 14.

the masonry and delayed the need for repointing. With due care and atten-
tion given to the design of those structural members that were in tension,
and long-lived materials chosen for internal and external finishes, a bathhouse
would have a notional life of several centuries. The vaulted voussoir roof of
part of the later military bathhouse at Vindolanda survived until well into the
seventeenth century, when it was demolished by laborers clearing land and
building farmsteads.[96] The walls of the bathhouse at Vindolanda survive to a
height of six feet six inches, and those at Chesters, to ten feet. Those of the
bathhouse at Ravenglass/*Tunnocelum*—the most completely preserved build-
ing in Roman Britain—not only still stand to over ten feet but also, here and
there, retain their original render. The bathhouse at Bewcastle was a well-
designed, well-built structure. Like all Roman bathhouses, it was built to last.

As I interpret what the 1954 and 1956 excavations brought to light, the
likely end of the bathhouse at Bewcastle was by way of relatively careful
demolition when its stone, and the stone of the other buildings in the fort,
was taken away to build the church and castle in the twelfth or thirteenth
and fourteenth centuries.[97] Apart from the timber frame and tile roof of the
apodyterium, I doubt that much, *if any,* of the bathhouse had collapsed by the
time the Anglo-Saxons developed the fort as their place.

Perhaps I could go further, but I have essentially said what I have to say
about Bewcastle/*Fanum Cocidii.* The point is, of course, that the Bewcastle
monument, perhaps an obelisk at the moment of its production and first
use,[98] a very Roman monument—Ancient Roman in form and, in part, con-
temporarily of the Church of Rome in ideological content—was erected
inside the still-standing walls of a Roman fort. Not far away stood the head-

96. Andrew Birely, *Vindolanda's Military Bath Houses: The Excavations of 1970 and 2000* (Hexham:
Vindolanda Trust, 2001), 27.

97. Much depends on *how* one interprets what the excavations of 1954 and 1956 did and did not
bring to light. The final report, published in 1993 (more than thirty years after the excavations) posthu-
mously of J. P. Gillam, the original excavator, and completed by D. A. Welsby, is insufficiently clear
in outline, vague and confusing in details, and generally makes for very problematic reading. As I read
Gillam, Jobey, Welsby, et al., *The Roman Bath-house at Bewcastle,* esp. 22–23, there is nothing to suggest
that the bathhouse was demolished at the time the fort was once supposed to have been abandoned "in
the face of an enemy offensive." It seems to me that the roof superstructure, the masonry vaulting, and
the walls were removed before the floors, which would have been the last things to have left the site.
This, in turn, suggests that perhaps after the building had been partly demolished by the Romans (when
it went out of use as a bathhouse), or after a partial collapse (for as we've seen, it seems doubtful that
the whole building would have collapsed as a result of decay after the garrison had quit the fort), or
perhaps even before it had begun to collapse, the bathhouse was demolished in a more or less orderly
fashion and its stones used elsewhere. That "elsewhere" could only have been the church or the castle.

98. Fred Orton, "Northumbrian Identity in the Eighth Century: The Ruthwell and Bewcastle
Monuments; Style, Classification, Class, and the Form of Ideology," *Journal of Medieval and Early Modern
Studies* 34, no. 1 (Winter 2004): 111–14.

quarters building; commander's house; granaries; workshops; latrines; barracks that once accommodated units of between 800 and 1,000 men, with horses; and a bathhouse, *all* not yet robbed of their stone. And though, at present, we don't know where the monument was situated in relation to all the buildings in the fort, we do know that it was sited in the southern part of the *praetentura,* close to the *via principalis* and the *porta principalis dextra,* only about 100 feet away from the southwest corner of the bathhouse, perhaps in an area that the Romans had left free of buildings as fire precaution. This is a good place to stop. Among the centuries' derelictions, and alongside whatever contemporary timber structures the Anglo-Saxons erected there, the Bewcastle monument must have been and must have looked quite something.

Albert Camus may have said it best. "Sense of place," he wrote, "is not just something that people know and feel, it is something that people do." And that realisation brings the whole idea rather firmly down to earth, which is plainly, I think, where a sense of place belongs.

—KEITH H. BASSO, *WISDOM SITS IN PLACES*

In many instances, awareness of place is brief and unselfconscious, a fleeting moment (a flash of recognition, a trace of memory) that is swiftly replaced by awareness of something else. But now and again, and sometimes without apparent cause, awareness is seized—arrested—and the place on which it settles becomes an object of spontaneous reflection and resonating sentiment. It is at times such as these, when individuals step back from the flow of everyday experience and attend self-consciously to places—when, we may say, they pause to actively sense them—that their relationships to geographical space are most richly lived and surely felt. For it is on these occasions of focused thought and quickened emotion that places are encountered most directly, experienced most robustly, and, in Heidegger's view, most fully brought into being. Sensing places, men and women become sharply aware of the complex attachments that link them to features of the physical world. Sensing places, they dwell, as it were, on aspects of dwelling.

—BASSO, *WISDOM SITS IN PLACES*

At the end, before the Bewcastle monument, in place. Some afterwords about building, dwelling, thinking, and divinities, mortals, sky, and earth. We don't just come across a place. We're never merely in a place. We constitute it by our activity, give it an identity, and make it meaningful. At its beginning, "place" is an intentional intervention in the orohydrography, geology, topography, and so on of a region or in another place that is regarded *as if* it is without that necessary intervention, *as if* it has not already been made into a place. Man makes a place when he intervenes in nature or in a prior intervention in nature, modifying it and himself. Place making at Bewcastle continued after the Anglo-Saxons. It continues in our present. Following the

general lead provided by Martin Heidegger's essay "Building Dwelling Thinking," written in 1954, we can say that man makes places when he builds and dwells on earth.[99] Though not all buildings are constructed for human habitation, all buildings are determined by the need to dwell. All building is, then, determined by dwelling insofar as all buildings serve man's need to dwell. We build to dwell, but, Heidegger reminds us, "Building is really dwelling" ("Building Dwelling Thinking" 350). The verb "to build" means "to dwell . . . to remain, to stay in place" (348), and dwelling "is the manner in which we humans *are* on the earth" (349). It's how we produce our means of subsistence and ourselves, our relations with others, and so on, and how we make sense of and express our existence, how we bring it to practical consciousness. A place is somewhere human beings build and dwell, and dwell to build: "Building as dwelling unfolds into the building that cultivates growing things and the building that erects buildings" (350). Dwelling and building and building and dwelling is *being* on earth. The unity of the reciprocal pair characterizes what it is to be a human being. Then there's "thinking," the kind of thinking that is philosophical thinking, intrinsically poetic thinking, especially about being. Thinking belongs to dwelling in the same way that building does: thinking is really dwelling. We think to dwell, and thinking is an aspect of dwelling: "Building and thinking are, each in its own way, inescapable for dwelling" (362). Human beings have always thought about dwelling (about what it is to dwell) in order to learn about (to gain knowledge of) the essential character of being-in-the world.

In one very poetic section of "Building Dwelling Thinking," which brings the Bewcastle monument to mind, Heidegger writes:

> Earth is the serving bearer, blossoming and fruiting, spreading out in rock and water, rising up into plant and animal. . . . The sky is the vaulted path of the sun, the course of the changing moon, the wandering glitter of the stars, the year's seasons and their changes, the light and dusk of day, the gloom and glow of night, the drifting clouds and blue depth of the ether. . . . The divinities are the beckoning messengers of the godhead. Out of whose holy sway the godhead, the god appears in his presence or withdraws into his concealment. . . . The mortals are the human beings. They are called mortals because they can die. To die means to be capable of death *as*

99. Martin Heidegger, "Building Dwelling Thinking" (1954), in *Basic Writings*, ed. Krell.

> death. Only man dies, and indeed continually, as long as he remains
> on earth, under the sky, before the divinities. (351–52)

Thinking about the *earth* effects thinking about the *sky,* about that which
earth is not and is above it. To be "'on the earth' already means 'under the
sky'" (351). And thinking about mortality, about human beings as *mortals,*
effects thinking about immortality, about divinities, divine messengers of the
godhead, *god*—here, as they are represented on the monument, proffering
advice to kings and peoples. To think of any one of these is to think of the
others. This is the "fourfold," a unified primary interplay of earth and sky
(which achieve a presence that they could not have had before the thing was
built); mortals, recognizing the inevitability of death and developing a good
attitude toward it, and gods. (Man faces up to his mortality not as an animal
but as a human being; the human being needs gods and awaits their coming
because he is conscious of his peculiar finitude as being aware of beings as a
whole and of his specialness as a being.) Heidegger says that "dwelling . . .
keeps [preserves] the fourfold in that with which mortals stay: in things"
(353). It brings (gathers) the essence of the fourfold (its oneness) into *things*
by cultivating crops and constructing buildings. In this way, dwelling keeps
the fourfold in place so that it remains comprehensible. The Bronze Age
peoples, the Romans, and the Anglo-Saxons, as would those who came after
them, built what they had seen, made earth more precise, visualized their
understanding of nature and expressed their existential foothold by interven-
ing in it and piling it up, made for themselves a kind of *imago mundi* or
microcosmos that must have been, itself, an existential center—a concretization
of every aspect of their world. Still today, no *thing,* no building, at Bewcastle
does this so effectively as the monument. This, it seems, is what its produc-
tion and first use was intended to do: to gather and preserve the fourfold, and
to situate those who used it in a fixed relation with it in such a way that,
before it, they might glimpse something of the fundamental character of their
being-in-the-world. They looked from the earth to the sky; back to their
birth, and beyond to their historical past; ahead to their death, and to what-
ever was thought to be beyond it. The monument was their historically
and culturally specific response to and representation of what and who they
presently thought they were, of what and who they once were, and of who
and what they might become.

Heidegger's "fourfold" strikes me as a potentially useful notion with which
to try to come to terms with the Bewcastle monument as a built *thing,* before

we start to puzzle the historically and culturally specific ideology, the sociol-
ogy and theology, art and science, and so on, with which those who pro-
duced and first used it loaded it. There are many other things to be said about
the monument—but not here. Rather, I want to end where we began. Not
with Heidegger's "fourfold" nor with ideology but in "place," with the
monument's constant material base. Earth. Rock. Deep geology. Never
doubting all its faults. Faultless. Above the limestone core of a post-Carbonif-
erous, pre-Triassic anticline on which came to rest a flat-topped, low hill
of glacial sand, across the north side of a beck, and bog,
without which there would be
no place at this
place we call
Bewcastle.

BEDE'S JARROW

Ian Wood

Bede has left us a greater body of work, in scale and quality, than almost any other Anglo-Saxon. Jarrow, on whose estates he was born[1]—and where he spent much, if not most, of his working life[2]—boasts more standing fabric than almost any other pre-Viking Anglo-Saxon site, yet its importance as a place for Bede has rarely been considered in any detail.

One reason for this is the fact that Bede himself is largely silent on his immediate geographic situation. He must have been aware that his monastery lay at one end of one of the most important east-west axes in England. It ran up the valley of the Tyne, past Corbridge and Wilfrid's Hexham, and on across the Pennines to Carlisle and the Solway. It was effectively the line of the Roman Stanegate. Running just to the north was the line of Hadrian's

This paper builds on the arguments of a longer piece, *The Origins of Jarrow, the Monastery, the Slake, and Ecgfrith's Minster* (Newcastle, 2006), which should be consulted for fuller discussion of points of local topography and history.

1. Bede, *Historia Ecclesiastica*, V.24, ed. and trans. Bertram Colgrave and Roger A. B. Mynors as *Bede's Ecclesiastical History of the English People* (Oxford: Oxford University Press, 1969).

2. The debate as to whether Bede was more closely connected with Jarrow or Wearmouth is discussed in Bede, *The Ecclesiastical History of the English People,* ed. Judith McClure and Roger Collins (Oxford: Oxford University Press, 1994), xii–xiv. My own view is that he may well have moved between the two centers at different stages of his career, but that he certainly spent time in Jarrow.

Wall, which started on the Tyne almost directly across from Jarrow. Bertram Colgrave and Roger Mynors understandably expressed disappointment at Bede's failure to provide a firsthand account of the Wall, although it was only "on the other side of the river and not more than two miles from Jarrow."[3] Indeed, the description Bede does supply would seem to have been derived entirely from literary sources.[4]

The north-south coastal route, running from Dunbar (or even from Pictland) to Kent and beyond, had a more obvious impact on Bede's knowledge. Scholars have, of course, long known that the situation of Jarrow near the North Sea littoral is reflected in Bede's narrative: he tends to emphasize places and events on the eastern side of England.[5] To live so close to the sea means something more, however, than having access to information carried on maritime routes. Bede himself, in his discussion of the tides, commented that "we who live at various places along the coastline of the British Sea know that where the tide begins to run in one place, it will start to ebb at another at the same time."[6] Wesley Stevens has drawn attention to the fact that the monk could collect some of his data at his own doorstep.[7] Yet an awareness of tides would have been only one element of what Bede gained from his coastal situation. He would have known of shipping, fishing, trading, and a host of other activities that he could have seen from his monastery—and this would have been as true had he looked out from Wearmouth or from Jarrow. The first chapter of Bede's *Ecclesiastical History* has specific observations on marine animals and even on the catching of seals, dolphins, and whales.[8] Still, precise observation of the landscape in which the author lived and worked is not much in evidence in the *Ecclesiastical History* or his biblical commentaries. Admittedly, not many early medieval authors paused to comment on the world around them, but Bede's silence is nevertheless worth a moment's thought, once we sketch out some aspects of the environment in which he lived.

The physical setting of Jarrow and, more generally, the lower Tyne will concern us a good deal before the end of this chapter, but first we must

3. Colgrave and Mynors, eds., *Bede's Ecclesiastical History,* 26–27 n. 1.

4. Charles Plummer, ed., *Baedae Opera Historica* (Oxford: Oxford University Press, 1896), 2:16–17 (although Plummer does refer to Bede's local knowledge).

5. Richard K. Morris, *Churches in the Landscape* (London: Dent, 1989), 11, offers a useful map of Bede's places.

6. Bede, *De temporum ratione,* 29, trans. Faith Wallis as *Bede: The Reckoning of Time* (Liverpool: Liverpool University Press, 1999), 85.

7. Wesley Stevens, *Bede's Scientific Achievement,* Jarrow Lecture 1985, 13–15.

8. Bede, *Historia Ecclesiastica,* I.1.

attend to the context in which the monastery was created and flourished. In certain respects, the origins of Jarrow are well established. The date of foundation was 681/682.[9] The founder, according to Bede himself and to the anonymous author of the *Vita Ceolfridi,* was Benedict Biscop. There are reasons for thinking that this is at best a half-truth. Certainly the first abbot of Jarrow, Ceolfrid, came from Biscop's monastery of Wearmouth.[10] The land on which the monastery was founded came from King Ecgfrith.[11] The extent to which Biscop really had a hand in the foundation is questionable. Notably, he was not present in 685 at the dedication of the monastery's church, St. Paul's, having set off on one of his journeys to Rome.[12] It is equally notable that the dedication stone of the church proclaims Ceolfrid, and not Biscop, as founder, while recording the regnal year in which the church was dedicated. It is at least reasonable to see Ceolfrid and Ecgfrith as being more intimately involved in the early years of the foundation than Benedict Biscop was. It is also possible to see Jarrow's association with Wearmouth as being less close initially than Bede and the *Vita Ceolfridi'*s author imply. Indeed, the amalgamation of Wearmouth and Jarrow into a single foundation with two centers may have followed on from problems that arose almost immediately after the dedication of St. Paul's.[13] Within a month, Ecgfrith had been killed fighting the Picts at the field of Nechtanesmere.[14] His successor was to be his half-brother, Aldfrith, who was in exile at the time of the battle and who should doubtless be seen as hostile to Ecgfrith and his policies. Not surprisingly, Aldfrith's reign marked a significant political reorientation in a number of ways. He may have encouraged the amalgamation of Ceolfrid's foundation of Jarrow with Benedict Biscop's Wearmouth.

Whether Jarrow began as a house separate from Wearmouth need not detain us here. In any event, kings were certainly involved in Jarrow during its early years.[15] Jarrow was built on land that came from Ecgfrith; Ceolfrid subsequently bought the estate of Fresca from Aldfrith with a cosmographical codex that Biscop had brought back from Rome.[16] This royal input, how-

9. For the foundation date, see Plummer, ed., *Baedae Opera Historica,* 2:361.

10. *Vita Ceolfridi,* 6, 8, 12, in *Baedae Opera Historica,* ed. Plummer (where the text is given the misleading name *Historia Abbatum auctore anonymo*).

11. *Vita Ceolfridi,* 11; Bede, *Historia Abbatum,* 1, 7, in *Baedae Opera Historica,* ed. Plummer. The first reference in the *Historia Abbatum* is more fulsome than the second.

12. *Vita Ceolfridi,* 12; Bede, *Historia Abbatum,* 9. For a full discussion of this, see Wood, *Origins of Jarrow.*

13. See Wood, *Origins of Jarrow,* for a comprehensive discussion.

14. Bede, *Historia Ecclesiastica,* IV.24.

15. Ian N. Wood, *The Most Holy Abbot Ceolfrid,* Jarrow Lecture 1995.

16. Bede, *Historia Abbatum,* 15.

ever, was not unique. Wearmouth, too, was built on land that came from Ecgfrith.[17] It continued to be enriched with gifts from royalty,[18] while Bede specifically records that Biscop later purchased additional land from Ald-frith—this time in exchange for two silk *pallia*.[19] Wearmouth and Jarrow can thus both be seen as royal.[20] Such regal involvement in the foundation of a monastery may indeed have been inevitable. Bede's *Letter to Bishop Ecgbert* reveals that aristocrats regularly turned to the king for property on which to found monasteries.[21] (In his opinion, many of the monasteries were bogus, though some more so than others.) What is less than clear is whether all land in Anglo-Saxon England was initially under royal control.[22] Certainly the precise wording of Bede's letter implies that young nobles did not have access to hereditary land. We may question whether this really was the situation for every young aristocrat: it is hard to believe that no family had a hereditary claim to estates, particularly because there was more than one royal, or poten-tially royal, dynasty in Northumbria. On the other hand, Bede's statement cannot imply anything other than that most land was in the gift of the king. One can only argue about what percentage is implied by "most." In Bede's view, land ought to be given out to warriors who could protect the kingdom, or else to properly constituted ecclesiastical institutions. If, as therefore seems certain, the king theoretically had the right to apportion the majority of land in his kingdom, one can conclude that most, if not all, early Northumbrian monasteries were founded on property allocated by a ruler.

The simple fact of land acquisition from the king is thus not enough to prove that Wearmouth and Jarrow had particularly strong links with the royal court. Perhaps a better indication is the fact that Biscop and his relative and successor as abbot of Wearmouth, Eosterwine, had both been members of the court before entering monastic life.[23] Despite his decision to abandon the court of Oswiu, Biscop himself became an adviser to Ecgfrith, even after

17. *Vita Ceolfridi*, 7; Bede, *Historia Abbatum*, 4; Bede, *Historia Ecclesiastica*, IV.18.

18. *Vita Ceolfridi*, 7.

19. Bede, *Historia Abbatum*, 9.

20. For Wearmouth-Jarrow as a royal house, see also Wood, *The Most Holy Abbot Ceolfrid*.

21. *Epistola ad Ecgbertum episcopum*, 11–13, in *Baedae Opera Historica*, ed. Plummer.

22. Some central contributions to a long debate on the subject are Eric John, *Land Tenure in Early England* (Leicester: Leicester University Press, 1960), 67–73; Nicholas Brooks, "The Development of Military Obligations in Eighth- and Ninth-Century England," in *England Before the Conquest: Studies in Primary Sources Presented to Dorothy Whitelock,* ed. Peter Clemoes and Kathleen Hughes (Cambridge: Cambridge University Press, 1971): 69–84; Patrick Wormald, *Bede and the Conversion of Anglo-Saxon England,* Jarrow Lecture 1984, 19–23; Eric John, *Reassessing Anglo-Saxon England* (Manchester: Manchester University Press, 1996), 13, 20–21n26, 52; and most recently, David Rollason, *Northumbria, 500–1100* (Cambridge: Cambridge University Press, 2003), 188–90.

23. Bede, *Historia Abbatum*, 1, 8.

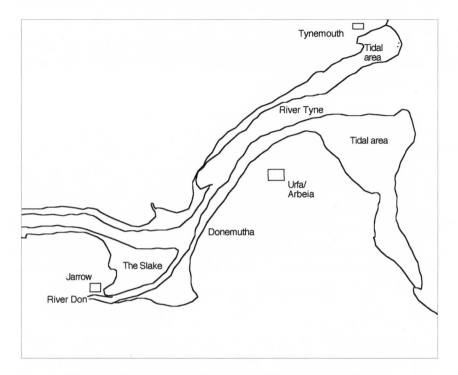

FIG. 12 The Lower Tyne, showing the course of the river and tidal levels in 1794, before the major industrial developments of the nineteenth century, with the Anglo-Saxon sites mentioned. Drawing by Ian Wood.

entering the ascetic life—a fact recorded by the anonymous author of the *Vita Ceolfridi*, but not by Bede.[24] (We might regard the omission as significant; as we shall see, the latter was not enamored of the king.) Links between the court and Wearmouth-Jarrow continued after Ecgfrith's death, as the very fact of Bede's dedication of his *Ecclesiastical History* to King Ceolwulf shows.

There are additional reasons for placing Jarrow within a royal context, some of them already mentioned. The monastery's church of St. Paul proclaims that it was dedicated in the fifteenth year of King Ecgfrith. Moreover, the king himself had provided the land. But that was probably not the sum total of his interest in the site and its surroundings. In an account of Viking activity in the year 794, Symeon of Durham glossed the words *portus Ecgfridi* as referring to Jarrow.[25] He also noted the sack of a monastery at the mouth of the river Don. The *Anglo-Saxon Chronicle*, apparently dealing with the

24. *Vita Ceolfridi,* 12.
25. Symeon of Durham, *Libellus de Exordio atque Procursu istius hoc est Dunhelmensis Ecclesie,* II.5, ed. David Rollason (Oxford: Oxford University Press, 2000).

same raid, states that the Vikings sacked *Ecgferthes mynster*,[26] which as a result
has also been identified as Jarrow. The identification has been queried in
recent years, not least because of the failure of Anglo-Saxon sources to com-
ment on the destruction of Bede's home monastery.[27] It may, nevertheless,
be possible to accept Symeon's statement. The *portus Ecgfridi* would not be
the monastery of Jarrow, but rather the harbor that lay below it on the mud-
flats of Jarrow Slake, which until the Industrial Revolution constituted one
of the largest and safest harbors in the north of Britain. In a period when
beaching boats was the norm, the long stretch of tidal mudflats, protected
from the open sea by the headland of South Shields, could hardly have been
bettered as a "winter mud-berth."[28] Unfortunately, the destruction of the
Slake in recent years has ensured that no proper archaeological investigation
of the area will ever be possible. On the other hand, there does seem to have
been some sort of mole running across the mudflats from Jarrow, which may
have had something to do with harbor access.[29] That the Vikings attacked
the *portus Ecgfridi* would seem to suggest that it was a site of some importance
at the end of the eighth century—and as a major harbor, it may well have
been a trading place, with goods worth looting. Of this Bede makes no men-
tion, unless it was here, rather than downriver, opposite Tynemouth, that
monks landed their cargoes of timber.[30] His silence, however, is no proof that
the harbor was not already a center of economic activity in his day.

One might further guess that it was from the Slake that Ecgfrith set off by
sea to Nechtanesmere and death. The journey must have taken place in the
month before 20 May[31]—in other words, at the start of the sailing season—
which tends to support the notion that the fleet could have wintered or at
least gathered on the Tyne mudflats. If it were from the Slake that Ecgfrith
set sail, that might be an explanation for the association of his name with the
site.

26. *The Anglo-Saxon Chronicle*, MSS D and E, s.a. 794, in *Two of the Saxon Chronicles Parallel*, ed.
John Earle and Charles Plummer (Oxford: Oxford University Press, 1892–99).

27. M. S. Parker, "An Anglo-Saxon Monastery in the Lower Don Valley," *Northern History* 21
(1985): 19–32; W. Richardson, "The Venerable Bede and a Lost Saxon Monastery in Yorkshire,"
Yorkshire Archeological Journal 57 (1985): 15–22. The problems are discussed in Wood, *Origins of Jarrow*.

28. Personal communication from Dr. Chris Grocock.

29. The evidence will be discussed in Rosemary Cramp's forthcoming publication of her excava-
tions at Wearmouth and Jarrow.

30. Bede, *Vita Cuthberti*, 3, in *Two Lives of Saint Cuthbert*, ed. Bertram Colgrave (Cambridge:
Cambridge University Press, 1940).

31. The date is determined by that of the battle of Nechtanesmere: see Bede, *Historia Ecclesiastica*,
IV.26; *Annals of Ulster*, s.a. 686 (= 685), ed. Sean Mac Airt and Gearóid Mac Niocaill (Dublin: Institute
for Advanced Studies, 1983).

If one accepts the identification of the *portus Ecgfridi* with the mudflats below Bede's monastery, it is reasonable to ponder the implications further. Of course, the suggestion that Ecgfrith's fleet gathered there in 685 before setting off for Pictland is no more than a hypothesis, but if the hypothesis is right, the implications for Jarrow are considerable. Here was a monastic house built on property given by Ecgfrith. It lay next to a harbor where the king's fleet was prepared for a major expedition. The king may well have attended the dedication of the monastery's church immediately before the fleet set sail. If this were the case, then the dedication must have been an occasion loaded with significance: the fact that it took place by the side of a harbor in which a war fleet was gathering would surely have been seen as an attempt to seek divine support for the campaign. The king must also have expected his monks to pray for him—for his victory, or, in the event of his death, for his soul. In all probability, they did the latter, though possibly not with much enthusiasm. The *Liber Vitae* of Durham may originally have been a Jarrow book, and Ecgfrith's name is listed in it, but so are the names of most Northumbrian kings.[32] He is certainly not remembered in Bede's *History* as he would have wished. It openly records criticism, not least by Cuthbert, of his policies toward the Irish and the Picts.[33] Bede also fails to be complimentary when he could have been. He does not make much of the king's involvement in the foundation of Jarrow, which effectively has to be inferred. He also ignores, as we have seen, the continuing close association between Biscop and Ecgfrith recorded by the author of the *Vita Ceolfridi*.[34]

The cluster of hypotheses suggested here, if correct, must say something of the religious culture of Jarrow, even if in subsequent years the house tried to distance itself from the king's memory. Whether or not these hypotheses go too far, it is clear that Bede's monastery overlooked not just the Tyne but also the best harbor on its lower reaches—one of the best in Northumbria. Bede's sense of the sea was not simply that of an inquisitive man who went down to the water's edge to measure tides, but that of a man who overlooked one of the centers of English shipping. On the one hand, this explains his knowledge of the sea and the information that could be gained from it; on the other, it poses the problem of why he said so little about it. Ecgfrith's failure and unpopularity may be part of the answer, but not the whole of it.

32. *Liber Vitae Ecclesiae Dunelmensis,* ed. Joseph Stevenson, Publications of the Surtees Society 13 (London, 1841), 1.

33. Bede, *Historia Ecclesiastica,* IV.26; P. Hunter Blair, *The World of Bede,* 2nd ed. (Cambridge: Cambridge University Press, 1990), 180–81.

34. *Vita Ceolfridi,* 12.

This problem will recur. For the time being, however, there is more to be said about Ecgfrith's interest in the lower Tyne. Chronicle sources speak not only of the *portus Ecgfridi* but also of *Ecgferthes mynster*.[35] This religious site presents a different issue, for no medieval source identifies it as Jarrow. It is probable, however, that it lay close to the *portus Ecgfridi* and that it suffered in the same Viking raid. It has been identified with the monastery at the mouth of the Don mentioned by Symeon, on the grounds that the stream that flows past Jarrow into the Tyne is called the Don. Presumably it is identical with a monastery known from other sources as Donemutha. Not surprisingly, this house has been thought to be Jarrow, but again, the identification has been challenged.[36] There is, in fact, good reason to believe that Donemutha was not Jarrow itself.[37] On early maps, before the development of the Tyne Dock at High Shields, the Don entered the Tyne on the eastern side of the Slake. In a well-known story, one that also happens to be the sole occasion when he describes the lower Tyne and the problems faced by those using it for the transport of goods, Bede himself mentions a monastery near the river's mouth on the south bank.[38] He explains that in Cuthbert's youth it had housed a male community, but that it was subsequently handed over to nuns. Bede alludes to the change in a somewhat wistful way, which may indicate that it was not well regarded among the inmates of Jarrow. He comments that the monastery "was filled with a noble company, in those days of men but now, changed like all else by time, of virgins who serve Christ." It is not impossible that the men had been transferred to Jarrow shortly after (or perhaps at the time of) its foundation.[39] This house would seem to be the most likely candidate for Donemutha. If it were handed over to nuns in Ecgfrith's day, that might explain its being called *Ecgferthes mynster,* for the king could well have refounded it.

One would like to know more about the refoundation of Donemutha. If it were indeed transferred to nuns by Ecgfrith, his queen, Iurminburg, might have had an interest in it. Although she received bad press during her husband's lifetime, after his death she became a nun in Carlisle.[40] Later she became an abbess. Nowhere is it stated that she was an abbess of a nunnery in Carlisle, though. Perhaps she took over her husband's foundation of Donem-

35. *The Anglo-Saxon Chronicle,* MSS D and E, s.a. 794.

36. Parker, "An Anglo-Saxon Monastery"; Richardson, "The Venerable Bede."

37. For a full discussion, see Wood, *Origins of Jarrow.*

38. Bede, *Vita Cuthberti,* 3.

39. Wood, *Origins of Jarrow.*

40. Stephanus, *Vita Wilfridi,* 24, 34, 39, 40, in *The Life of Bishop Wilfrid by Eddius Stephanus,* ed. Bertram Colgrave (Cambridge: Cambridge University Press, 1927).

utha and made it into a memorial for him. Even if she did not, the nunnery could have been entrusted with some sort of commemoration of the king; this could be a further reason for its alternative name of *Ecgferthes mynster.*

Such a reconstruction of sites along the lower Tyne's south bank implies a remarkable cluster of places associated with Northumbrian kings—and with Ecgfrith in particular. The great harbor of the Slake was flanked to east and west by Donemutha, or *Ecgferthes mynster,* and Jarrow. All three sites have connections with Ecgfrith or his memory. Jarrow would, therefore, seem to have been part of a complex developed by Northumbria's most aggressive king, where piety and naval power were closely associated. As for Ecgfrith's interest in ships, we should not forget that the attack he launched on Ireland in 684 also indicates the use of a fleet.[41] Not a hint of any of this is apparent in Bede's narrative. Had Ecgfrith's vision for the south Tyne died when he did, at Nechtanesmere? It would be strange if no later Northumbrian king noted the potential of Jarrow Slake or of its attendant monasteries. On the other hand, Jarrow would have had every reason to dissociate itself from its royal founder, not least because of the hostility between Ecgfrith and his successor. It is not difficult to conclude that Bede deliberately blanked out the reality of the strategic importance of the south bank of the Tyne when he came to write about his monastery and about the kings associated with it.

Jarrow, the Slake, and Donemutha may not have been the only places to reflect the combination of royal power and religion on the lower Tyne. On the summit of the South Shields promontory lay the great Roman fort of Arbeia. Unfortunately, nineteenth-century excavations there resulted in the destruction of the post-Roman levels over large sections of the site. A layer of burned material was observed, though, which, if accurately noted, might have been Anglo-Saxon.[42] Recent analysis of some of the early finds has produced "a very fine gilded mount in copper alloy, copper-alloy and bone pins, a pin beater, stylus and two gaming pieces,"[43] which indicate that the fort was used as a high-status dwelling in the Anglo-Saxon period. There is some written evidence to support this, although it can scarcely be said to be strong, as it comes from the sixteenth century. According to the antiquarian John Leland, there was "a city called Urfa" in the district of Tynemouth.[44]

41. Bede, *Historia Ecclesiastica,* IV.26; see the comments in John Haywood, *Dark Age Naval Power* (London: Routledge, 1991), 61.

42. Paul Bidwell and Stephen Speak, *Excavations at South Shields Roman Fort* (Newcastle-upon-Tyne: The Society of Antiquaries of Newcastle upon Tyne with Tyne and Wear Museums, 1994), 1:45–46. For what follows, see Wood, *Origins of Jarrow.*

43. Personal communication from Paul Bidwell.

44. John Leland, *De Rebus Britannicis Collectanea,* ed. altera, ed. Thomas Hearne, vol. 4 (London: apud Benj. White, 1774), 43.

As Urfa is plausibly an Anglo-Saxon place-name derived from the Latin *Arbeia,* this may be further evidence for the Roman site's being used in the pre-Viking period.[45] Leland goes on to remark that "there king Oswine was born."[46]

If we accept that the Roman site of Arbeia continued in use as a high-status site in the Anglo-Saxon period, and that it was a place where a king might have been born, we might push the hypothesis slightly further and ask whether the site continued as a palace into the second half of the seventh century and beyond. There is little to indicate where such kings as Ecgfrith, Aldfrith, and even Ceolwulf were to be found. Under Oswald and Oswiu, Bamburgh appears to be central (at least in Bede's narrative).[47] How long it remained the heart of royal power is an open question. It is unclear whether subsequent kings regarded it as being some sort of capital. It has been identified, although not with absolute certainty, as the *regiam civitatem* to which Cuthbert urged Iurminburg to flee in case Ecgfrith had been killed.[48] The young king Osred and his *princeps* Berhtfrith were certainly besieged there after the death of Aldfrith.[49] Even if one does see this as evidence that Bamburgh was a royal site, the evidence scarcely suggests that it was the exclusive residence of the Northumbrian kings. The cluster of other sites on the south bank of the Tyne associated with Ecgfrith would make Arbeia a plausible site for a royal residence in his day. Moreover, if Ecgfrith and his successors frequented the site, it would have been easy for Benedict Biscop to travel to court from his monasteries, as the anonymous author of the *Vita Ceolfridi* (though not Bede) tells us he often did.[50] Ceolfrid's contacts with kings would similarly have benefited from the proximity of a palace at Arbeia, and Bede's dedication of his *Ecclesiastical History* to Ceolwulf would take on an unexpected immediacy if the site were still royal in the 730s.

Traditions about Oswine add to and complicate our knowledge of the lower Tyne in Bede's day. Not only was Oswine supposedly born at Arbeia, but he was also buried, according to twelfth-century tradition, at Tyne-

45. Bidwell and Speak, *Excavations,* 1:42. See A. Breeze, "The British-Latin Place-Names *Arbeia, Corstopitum, Dictim,* and *Morbium,*" *Durham Archaeological Journal* 16 (2001): 21–25, at 21.

46. Leland, *De Rebus Britannicis Collectanea,* 4:43.

47. Bede, *Historia Ecclesiastica,* III.12, 16.

48. Bede, *Vita Cuthberti,* 27, with Colgrave's comments in *Two Lives of St Cuthbert,* 5–6, 352. Colgrave identifies several events as taking place in Bamburgh, even when the identification is not stated specifically in the sources.

49. Stephanus, *Vita Wilfridi,* 60.

50. *Vita Ceolfridi,* 12.

mouth, on the northern bank of the Tyne.[51] Bede reveals that there was a monastery there in his day,[52] and it is also referred to by *The Anglo-Saxon Chronicle,* where it is named as the burial place of the Northumbrian king Osred.[53] It is thus certain that by 792 there was a monastery on the north bank of the Tyne, almost visible from Jarrow, that had strong royal connections. Whether Leland had good reason to ascribe its foundation to Edwin is impossible to determine. He did, however, know of another royal burial at Tynemouth: that of the Deiran king Edred.[54] How far any of his information may be trusted is questionable, but the *Liber Vitae* of Durham boasts three Eadreds in its list of *reges* and *duces,* so a "king" of that name is not improbable.[55]

It is, then, fairly clear—even leaving Oswine to one side—that Tynemouth can be added to the evidence for a cluster of royal sites on the lower Tyne. We have here what David Rollason has termed a "royal heartland."[56] Given the importance of the river and the quality of its tidal harbor at Jarrow Slake, we should probably not be surprised, but the accumulation of evidence is striking. As we have seen, Ecgfrith left his mark on the south side of the Tyne. Royal interest on the mouth of the river would seem to have started at least a generation before. To the north side was a monastery that may date back to the days of Oswiu, if not before; on the south side, the Roman site of Arbeia would seem to have developed into an Anglo-Saxon royal residence. Oswine's birth would actually indicate royal interest already in the days of Edwin. Anyone approaching the Tyne from the sea would have looked up to see two sites associated with royalty, while beyond, and visible from Arbeia at least, were Ecgfrith's monasteries and harbor. Whether Northumbrian kings made use of Segedunum, a Roman site further upstream that marked the eastern end of Hadrian's Wall, is sadly unclear. It is not impossible that it, too, belonged to the "royal heartland" of the lower Tyne.

It is worth looking a little more closely at the evidence for Oswine and his association with the lower Tyne. There may be a problem in accepting that he was born at Arbeia and buried at Tynemouth. He was a Deiran king.

51. *Vita Oswini Regis,* 4, in *Miscellanea Biographica,* ed. James Raine, Publications of the Surtees Society 2 (London, 1838). The evidence is discussed by Plummer, ed., *Baedae Opera Historica,* 2:164. See also the discussion in Wood, *Origins of Jarrow.*

52. Bede, *Historia Ecclesiastica,* V.6.

53. *The Anglo-Saxon Chronicle,* MS E, s.a. 792.

54. Leland, *De Rebus Britannicis Collectanea,* 4:42.

55. *Liber Vitae Ecclesiae Dunelmensis,* 1–2.

56. Rollason, *Northumbria, 500–1100,* 45–52.

That is, we tend to associate him with the York region, or else with Gilling, where he was murdered.[57] Birth and burial on either side of the Tyne sort ill with the standard interpretation of the frontier between Deira and Bernicia, which most historians, at least since Peter Hunter Blair, have placed further south, on the river Tees.[58] The same problem holds, however, for the geographic placing of figures other than Oswine. Leland commented that Edred, who was also buried at Tynemouth, was Deiran as well.[59] In the twelfth century, Reginald of Durham placed the boundary between Deira and Bernicia on the Tyne.[60] At the same time, Richard of Hexham placed the boundary on the Tees.[61] His opinion has carried the day, not least because Bernicia would seem to have shared a boundary with the diocese of Hexham.[62]

The search for a fixed boundary may, however, be misguided. Certainly there are reasons for thinking that the words "Bernicia" and "Deira" are probably derived from British names and that they may represent ancient divisions.[63] On the other hand, there can be little doubt that in the Roman period, the obvious division within what was to become Northumbria lay on Hadrian's Wall or in the territory to the north of it. Regional units running from the Humber to the Tees and from there to the Firth of Forth make little sense for the centuries prior to the establishment of the Northumbrian kingdom. While the names Bernicia and Deira may be derived from older British topographical names, the regions are likely to be new, probably reflecting kingly power in the competing dynasties of Ælle and Ida.

Perhaps the best that one can do is not to look for hard and fast frontiers—which may have come to be fixed in the course of the eighth century, not least because of the establishment of diocesan boundaries—but rather to look at the associations of land and individuals. From this vantage, it soon becomes apparent that Deirans were occasionally associated with territory north of the Tees. Here the career of Hild is suggestive. As the daughter of a nephew of Edwin, she unquestionably belonged to the Deiran dynasty of Ælle, yet her

57. Bede, *Historia Ecclesiastica*, III.14. It may be relevant that Ceolfrid later began his monastic career at Gilling; *Vita Ceolfridi*, 2.

58. Peter Hunter Blair, "The Boundary Between Bernicia and Deira," *Archaeologia Aeliana* 27 (1949): 46–59, reprinted in Hunter Blair's *Anglo-Saxon Northumbria* (London: Variorum, 1984).

59. Leland, *De Rebus Britannicis Collectanea*, 4:42.

60. Reginald of Durham, *Vita Oswaldi*, in *Symeonis monachi opera omnia*, ed. Thomas Arnold, Rolls Series 75 (London, 1882), 339.

61. Richard of Hexham, *History*, prologue, ed. James Raine, Publications of the Surtees Society 44 (London, 1864).

62. Hunter Blair, "The Boundary Between Bernicia and Deira," 55–58.

63. Kenneth Jackson, *Language and History in Early Britain* (Edinburgh: Edinburgh University Press, 1953), 419–21, 701–5.

first monastery was on the north bank of the Wear.[64] One might even wonder
if Biscop's Wearmouth were later founded on the same site. It would make
a nice counterbalance to Donemutha, which was a male house refounded for
nuns. From the Wear, Hild moved progressively south to Hartlepool and
then to Whitby.[65] While established on the north bank of the Tyne, her
community might well have been regarded as Deiran. So, too, if Osric, Os-
wine's father, were established at Arbeia during the reign of his cousin Edwin
(as Leland implies), it is not hard to see how that site could have been re-
garded as Deiran. The burial of Oswine himself at Tynemouth could have
been a masterstroke by Oswiu. It would have been situated far enough to the
north—indeed, on the north bank of the Tyne—to avoid an easy focus for
Deiran sympathies but still close enough to Oswine's birthplace so as not to
seem inappropriate. The possibility that Oswiu was interested in Tynemouth
is also worth noting. As he was Ecgfrith's father, this would have had implica-
tions for the origins of the dynasty's interest in the region of the lower Tyne.

That we should see Bernicia and Deira initially as fluid entities associated
more with power groups than with fixed regions may be supported by the
simple point that Bede does not refer, as modern historians do, to Bernicia
and Deira. Instead he talks of the *provincia* or *gens Berniciorum* and the *provincia*
or *regnum Deirorum*.[66] That is, they are regions defined by people, not by
geography—although again, the tribal names may well have derived origi-
nally from British descriptive terms. While local boundaries may stay fixed
over long periods of time, those associated with tribal groups are likely to
shift as the tribes themselves increase their influence or lose it. To look for an
established line dividing the Deirans and the Bernicians could be as pointless
as looking for the precise edge of the sea.

If the border between Bernicia and Deira was not fixed, and if the lower
Tyne could be a focus of Deiran as well as Bernician interest, the region
should perhaps be seen as having additional importance. It would have been
territory where influence was disputed, which—in terms of Northumbria,
with its northern and southern political divisions—is another way of saying
that it was a central region. One might go a little further and ask whether for
a particular period of time it was not *the* central region of the kingdom. In
Edwin's day we know of royal association with York and with Yeavering.[67]
We have already noted the importance of Bamburgh in Oswald's and Os-

64. Bede, *Historia Ecclesiastica*, IV.23.
65. Ibid.
66. This point was noted by Hunter Blair, "The Boundary between Bernicia and Deira," 49.
67. Bede, *Historia Ecclesiatica*, II.14.

wiu's day, and, less certainly, thereafter. From the middle of the eighth cen-
tury, especially when King Eadbert was cooperating with his brother Ecgbert,
the archbishop, the center of power may have shifted to the York region—
although Rollason has warned against seeing the city itself as being a royal
center.[68] In the days of Ecgfrith, Aldfrith, and Ceolwulf (that is, the days of
Biscop and Bede), the lower Tyne may well have been the chief heartland of
the Northumbrian kingdom.

Historians have become increasingly aware of the need to see Bede as
being engaged with issues of kingship and the exercise of power, as well as a
drive for Church reform, but they have not perhaps placed Jarrow in a posi-
tion as central to the kingdom of Northumbria as I am suggesting here. It is
worth considering the implications for our reading of Bede's thought and
perhaps of his spirituality. The fact that the *Ecclesiastical History* is dedicated to
Ceolwulf has already been noted. If Jarrow is seen as lying at the center of
the kingdom, the address to the king perhaps takes on additional force. The
Letter to Ecgbert, too, comes to look yet more like advice from a figure at the
heart of Northumbria rather than the ruminations of an elderly scholar. In-
deed, Bede's program of reform, as it has been identified in his biblical com-
mentaries as well as his *Ecclesiastical History* and the *Letter,*[69] needs to be read
as the advice of a man living near the center of power, not on its fringes.
Jarrow has, admittedly, already been seen as a potential powerhouse for pasto-
ral reform,[70] but one might go further and argue that the monastery's very
centrality would have meant that issues of power and kingdom constantly
impinged upon its leading intellectual. It is not surprising that Bede found so
much to say about kingship when he commented on the Book of Samuel.
The commentary is, as Michael Wallace-Hadrill noted, "predominantly alle-
gorical,"[71] and the allegory surely extended to providing a metacommentary
on present political circumstances. It was certainly meant to have current
resonance. As a result, Bede "covers dangerous ground."[72] If he were close

68. Rollason, *Northumbria, 500–1100,* 202–7.

69. Alan Thacker, "Bede's Ideal of Reform," and Judith McClure, "Bede's Old Testament Kings,"
both in *Ideal and Reality in Frankish and Anglo-Saxon Society,* ed. Patrick Wormald (Oxford: Basil Black-
well, 1983), 130–53 and 76–98, respectively. See, most recently, Scott DeGregorio, " 'Nostrorum socor-
diam temporum': The Reforming Impulse of Bede's Later Exegesis," *Early Medieval Europe* 11 (2002):
107–22, and Scott DeGregorio, "Bede's *In Ezram et Neemiam* and the Reform of the Northumbrian
Church," *Speculum* 79 (2004): 1–25.

70. Alan Thacker, "Monks, Preaching, and Pastoral Care," in *Pastoral Care Before the Parish,* ed.
John Blair and Richard Sharpe (Leicester: Leicester University Press, 1992), 153; DeGregorio, "Bede's
In Ezram et Neemiam," 24.

71. J. Michael Wallace-Hadrill, *Early Germanic Kingship in England and on the Continent* (Oxford:
Clarendon Press, 1971), 76.

72. Ibid.

enough to political power to offer advice to the likes of Ceolwulf, kings were close enough to Jarrow to keep an ear open for what was being said there. The absence of any truly contemporary history in Bede's work may reflect the need for discretion. (The career of Wilfrid, after all, is a good example of the problems faced by an indiscreet critic of kings.) As for Ceolwulf himself, the fact that he was deposed, tonsured, and restored to the kingship in 731,[73] shortly before the completion of the *Ecclesiastical History,* must have been known to Bede and presumably had some bearing on the work's dedication, although what that was can only be conjectured.[74] That Ceolwulf may have sympathized a good deal with Bede's pastoral viewpoint is implied by the *Letter,*[75] and it might be further indicated by the fact that the king resigned the kingdom to Archbishop Ecgbert's brother, Eadberht, and had himself tonsured in 737.[76]

A close association of monastery and king would also have implications for Ceolfrid's letter to the Pictish king Nechtan, which was written, in all probability, by Bede himself.[77] Far from appealing to Wearmouth-Jarrow simply because of the monastery's intellectual preeminence, Nechtan might well have turned to it because of its association with Northumbrian royalty. The Pictish king's questions, on Easter and the tonsure, might look to us to be of solely theological interest, but a quick glance at Oswiu's role in the Synod of Whitby, which discussed exactly the same issues, is enough to show how much such questions concerned kings.[78] Bede could thus be seen as involved in an issue of high-level diplomacy.

The political and historical context in which Jarrow was situated was not simply a general one of royal associations. There were particular kings who impinged. The most obvious was Ecgfrith, the man who provided the lands for the initial foundation. As we have seen, to judge from a place-name (*Ecgferthes mynster*) and from an aside in Bede's *Life of Cuthbert,*[79] he may have refounded Donemutha, across the Slake, perhaps transferring its male community to Jarrow itself while turning the older house over to women.

73. Bede, continuations (from the Moore manuscript), s.a. 731, ed. Colgrave and Mynors.

74. Walter Goffart, *The Narrators of Barbarian History: Jordanes, Gregory of Tours, Bede, and Paul the Deacon* (Princeton: Princeton University Press, 1988), 295–96, offers some conjectures. I have doubts as to whether Acca was opposed to Bede and Ceolwulf.

75. Bede, *Epistola,* 9; DeGregorio, "Bede's *In Ezram et Neemiam,*" 14.

76. Bede, continuations, s.a. 737. DeGregorio, "Bede's *In Ezram et Neemiam.*"

77. Bede, *Historia Ecclesiastica,* V.21; Archibald A. M. Duncan, "Bede, Iona, and the Picts," in *The Writing of History in the Middle Ages: Essays Presented to R. W. Southern,* ed. Ralph H. C. Davis and J. Michael Wallace-Hadrill (Oxford: Oxford University Press, 1981), 1–41.

78. Bede, *Historia Ecclesiastica,* III.25.

79. Bede, *Vita Cuthberti,* 3.

He would certainly have been interested in the mudflats of the Slake itself. He surely supported the foundation of Jarrow, with the expectation that the monks would pray for him and for his sailors. That Bede failed to make any comment on a harbor just beyond Jarrow's walls is scarcely surprising, but his silences over Ecgfrith's association with his own monastery are much more likely to be significant—and critical.

If Oswine really were buried across the river at Tynemouth—and Bede is silent about the whereabouts of his burial—that, too, will have given the account of that king's reign and murder in the *Ecclesiastical History* a particular weight to any local reader. Here was Bede writing about a king from the Deiran dynasty, both born and buried within sight of Jarrow. The presentation of Oswine as a model monarch would have gained specific force, at least for those reading the *Ecclesiastical History* in the vicinity of its composition. As Bede tells it, the tale was scarcely one to delight the heirs of Oswiu.

Nowhere in the *Ecclesiastical History* or in Bede's *Lives of the Abbots* is it stated that Jarrow was situated at the center of the Northumbrian kingdom. From what Bede has to say, one could imagine that Jarrow was usually an isolated haven of calm, only occasionally drawn into the wider world by the arrival from distant parts of Benedict Biscop, or of a letter from the Pictish king Nechtan. To understand the mismatch between this impression and the reading of Jarrow suggested here, it is worth turning to the alternative vision of peace that Bede conjures up in his presentation of Inner Farne and, at least initially, of Lindisfarne.

At the end of his *Life of Cuthbert*, Bede sets out Abbot Herefrith's account of the saint's last days.[80] There is nothing equivalent in the anonymous *Life of Cuthbert*, so we can be sure that Bede was particularly keen to add the information provided by the abbot. No doubt in part he was anxious to set down an eyewitness account. At the same time, it is likely that he found the various messages of the passage useful. Among the particularly significant points is the discussion over what should happen to Cuthbert's remains. The saint himself intended that he should be buried on Farne: "I also think it will be more expedient for you that I should remain here, on account of the influx of fugitives and guilty men of every sort, who will perhaps flee to my body because, unworthy as I am, reports about me as a servant of God have nevertheless gone forth; and you will be compelled very frequently to intercede with the powers of this world on behalf of such men, and so will be put to much trouble on account of the presence of my body." Before Cuthbert's

80. Ibid., 38.

body was transferred to Lindisfarne, the monastic community had been rela-
tively isolated from the world, because the tides cut the island off from the
mainland twice a day.[81] Now the fame of Cuthbert would draw pilgrims and
fugitives there regardless.

It is worth wondering to what extent Bede considered the lessons of Lin-
disfarne. Jarrow was nowhere near as inaccessible. Its leaders had to deal
regularly with the powers of this world. If the lower Tyne had taken over
from the Bamburgh region as the heartland of the Northumbrian kingdom,
the community of Jarrow is even more likely to have been at the beck and
call of the king than Lindisfarne was in the days of Oswald and Aidan. The
one attraction that Lindisfarne had, which Jarrow did not, was a saint's cult.
Yet Wearmouth-Jarrow had its store of saints, as Bede's own account of the
Lives of the Abbots makes clear. None of the saintly abbots, however, seems to
have been the focus of a cult, and indeed Bede's presentation of his abbots
would not have encouraged one. He and his fellow monks seem to have
determined not to follow the example of Lindisfarne. Situated as they were
in a more accessible place, they would doubtless have been even more threat-
ened by pilgrims. If there was a pilgrim site on the lower Tyne, it may have
been the tomb of Oswine of Tynemouth. Again, however, Bede made no
attempt to popularize it. The region was doubtless busy enough. The quiet
that Aidan and Cuthbert had known on Lindisfarne and on Inner Farne, and
that Bede had recorded, had never been a possibility at Jarrow.

When Bede measured the tides on the mudflats below his own monastery,
he was not doing so on the margins of the Northumbrian kingdom but at
the edge of an important harbor. One could not guess so much from his
narrative. The one departure from the region that he describes, that of Ceol-
frid in 716, begins with the abbot's crossing the Tees.[82] Unlike the author of
the anonymous *Vita Ceolfridi,* Bede does not provide any detail on the first
stages of the journey from Wearmouth, when Ceolfrid went south by land
to the unidentified monastery of Cornu Vallis, apparently located in the
Humber basin.[83]

Overlooking the Slake, a harbor whose name was associated with King
Ecgfrith, were three important monasteries (one of them a nunnery), all with
royal connections. Perhaps also within view was a royal palace. In the closing
years of the seventh century and the beginning of the eighth, this was a
hub—possibly even *the* hub of the Northumbrian kingdom. All of this im-

81. Bede, *Historia Ecclesiastica,* III.3.
82. Bede, *Vita Abbatum,* 18.
83. *Vita Ceolfridi,* 29.

pinged on Bede as he tried to make sense of God's creation, but he expunged almost all of it from the record. Instead, he gives the impression of a region much more marginalized than it really was. Perhaps one should ascribe this to a "desert mentality." Despite the fact that he and his monastery were near the geographic heart of the Northumbrian kingdom, where kings were never far away, Bede could still write with apparent detachment—the detachment of a monk.

3

LIVING ON THE *ECG:*
THE MUTABLE BOUNDARIES OF LAND AND WATER IN ANGLO-SAXON CONTEXTS

Kelley M. Wickham-Crowley

Those who write about landscape frequently comment on the mutual
influences of the land and of the people who inhabit it, and this chapter
attempts to locate the effects of such influences. Instead of simply mapping
land or water, though, I want to look at what I have called "mutable
boundaries," to consider how water—especially through Alfred's time and
that of the Viking incursions—was an integral part of the Anglo-Saxon
perception of "landscape." The mutability of the "edge" between land
and water, as recorded in Anglo-Saxon texts and archaeology, fits with a
way of thinking that considered land/water intersections as a habit of
perception or vision, coloring and marking more than the physical envi-
ronment. Here, I will track this cultural perception, creating something of
a cognitive map for how vision translates into thought and perception,
and how the physical environment can reveal conceptual boundaries. My
essay is openly speculative, given the nature of the material examined, but
rigorous in intent. It takes as its inspiration Einar Pálsson's ideas on hypoth-
esis as a tool: "Some scholars seem to think that science is mainly—even
merely—a mechanized technique for collecting and analyzing objective
facts. If this were true, no knowledge would be arrived at through in-

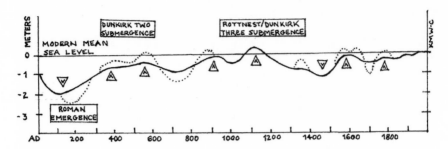

FIG. 13 Sea level changes in the North Sea area over the past two thousand years, with dotted lines showing possible extremes. To understand the labels, remember that when water levels rise, land submerges, and land emerges when water levels go down. Diagram by the author, after David Hill.

sight."[1] I therefore follow a question, hoping for such insight: if change is paradoxically taken as a constant, as a habit of vision, can we track how that view influences a culture defining or negotiating identities in new places? I invite a change of perception, a willingness to try imagining varieties of evidence from new vantage points. As a person of her own century, I cannot do otherwise in evaluating the past. But given that "as Anglo-Saxonists we cultivate the borders of prehistory,"[2] we should embrace interdisciplinary methods that break us out of our own habits of mind to see what, if anything, becomes clearer.

To begin with the environment, then: during the Roman period, sea levels fell, exposing more land in Britain for exploitation. The needs of the Roman army and bureaucracy would have demanded additional supplies from such exploitation, and evidence exists for expanded agricultural land use.[3] Their abandonment of Britain would likely have caused marginal agricultural areas to be vacated as well. When water levels began to rise again, large areas of Britain and the continent were flooded, creating a new landscape and new challenges in its use. Given the worldwide rise in sea levels in the migration period and after (fig. 13)[4]—a likely factor in the arrival of the Angles, Saxons,

1. Einur Pálsson, "Hypothesis as a Tool in Mythology," in *Words and Objects: Towards a Dialogue Between Archaeology and History of Religion,* ed. Gro Steinsland, Institute for Comparative Research in Human Culture Series 70 (Oslo: Norwegian University Press, 1986), 165.

2. This is Patrick Wormald's felicitous phrase from *How Do We Know So Much About Anglo-Saxon Deerhurst?* Deerhurst Lecture 1991 (Deerhurst: Friends of Deerhurst Church, 1993), 1.

3. "Under Roman rule, agriculture had been extended over the higher chalklands and limestones of southern and eastern England as population levels rose and as the army and towns required grain and other commodities for non-farming populations": see Della Hooke, *The Landscape of Anglo-Saxon England* (London: Leicester University Press, 1998), 39. See also her discussions in chapters 4, 6, and 8 on boundaries, field systems, and the use of marsh-, wet-, and moorland.

4. David Hill, *An Atlas of Anglo-Saxon England* (Toronto: University of Toronto Press, 1981), illus. 16. Hill adds, "In the Anglo-Saxon period there was a worldwide, eustatic rise in sea level as water

and others in Britain after land loss on the continent—the prevalence of fens, water meadows, and other waterlogged areas surely shaped the Anglo-Saxon imagination and response to landscape in a way that we have since noted but underemphasized. In addition, tectonic changes caused the southern part of the North Sea area to fall, while northern Britain rose.[5] The "triggers" for considering interpenetrations of water and land, then, are the historical, environmental facts of changed sea levels and tectonic plate movements and the resulting cultural adaptations. For the Anglo-Saxons, migration from the continent to Great Britain meant moving from a changed and flooded homeland across the sea to a new environment that, on its east coast, featured vast fens, islands, and reshaped coastlines.

Given that water levels were changing throughout Europe, the question of why moving from northern Europe to Britain constituted any change at all might be raised. We can begin by recalling Pliny the Elder's first-century eyewitness account of the European coastal Chauci, the Germanic tribes coping with fierce tidal changes.

> I myself have personally witnessed the condition of the Chauci, both the Greater and the Lesser, situate in the regions of the far North. In those climates a vast tract of land, invaded twice each day and night by the overflowing waves of the ocean, opens a question that is eternally proposed to us by Nature, whether these regions are to be looked upon as belonging to the land, or whether as forming a portion of the sea? [*sic*]
>
> Here a wretched race is found, inhabiting either the more elevated spots of land, or else eminences artificially constructed, and of a height to which they know by experience that the highest tides will never reach. Here they pitch their cabins; . . . and when the waves cover the surrounding country far and wide, like so many mariners on board ship are they: when, again, the tide recedes, their condition is that of so many shipwrecked men, and around their cottages they pursue the fishes as they make their escape with the receding tide. It is not their lot, like the adjoining nations, to keep

from the icecaps and glaciers returned to the sea. This, of course, was also linked to the general rise in long-term averages in temperature. . . . The subject is complex, as it also involves the questions of silting and man's interference with the shorelines" (11).

5. Ibid., 11: "Coupled to these changes in sea level are the tectonic changes in the land masses, with the southern part of the North Sea area tending to fall, whilst the North British area, centred on the West Grampians, tended to rise."

any flocks for sustenance by their milk, nor even to maintain a war-
fare with wild beasts, every shrub, even, being banished afar.[6]

But more fortunate and eventually even thriving examples of northern
German Wurt settlements (*Wurt,* hillock), sometimes also called *terps* (vil-
lages), provide a well-recognized context for a response to the question
raised. J. N. L. Myres and other scholars have referred to them as part of
the continental context for Anglo-Saxon migration. Sites such as Barward,
Fallward, and the especially well known Feddersen Wierde, south of Bremer-
haven, were built and rebuilt on increasingly higher mounds in response
to rising water levels. Feddersen Wierde, in particular, has produced rich
environmental evidence for animal husbandry and some farming. As noted
in a recent historical environmental study, the marshes between the Weser
and the Elbe "were formed under the influence of the rise in the sea level
after the last ice age and for the most part are barely raised above the mean
sea level." A line of Wurt settlements ran west of the marshes from north to
south in this region: "Villages which had originally been laid out on the flats
had to be raised on mounds to guarantee their continued existence, starting
in the 1st century. Richly adorned old Saxon graves from the Fallward under-
score the wealth of the settlements and the economic appeal of the marshes
in Roman times. In the course of the 5th century increased tidal flooding led
to the abandonment of the area."[7]

6. The 1855 translation of Pliny the Elder's *Natural History,* by John Bostock and H. T. Riley, is
found on the Web site of the Perseus Digital Library Project, ed. Gregory R. Crane. This section is
numbered differently from the Latin version below, but can be found as book 16, chap. 1, http://
www.perseus.tufts.edu/cgi-bin/ptext?lookup = Plin. + Nat. + toc (accessed 16 December 2004). The
Latin text follows, taken from Karl Mayhoff's Teubner editions as found on the University of Chicago
Web site of Bill Thayer, http://penelope.uchicago.edu/Thayer/L/Roman/Texts/Pliny_the_Elder/
16*.html (accessed 15 December 2004).

> 16.i.2 Diximus et in oriente quidem iuxta oceanum complures ea in necessitate gentes.
> sunt vero et in septentrione visae nobis Chaucorum, qui maiores minoresque appellantur.
> vasto ibi meatu bis dierum noctiumque singularum intervallis effusus in inmensum agitur
> oceanus, operiens aeternam rerum naturae controversiam dubiamque terrae [sit] an partem
> maris.
> 16.i.3 illic, misera gens, tumulos optinent altos aut tribunalia exstructa manibus ad experi-
> menta altissimi aestus, casis ita inpositis navigantibus similes, cum integant aquae circumdata,
> naufragis vero, cum recesserint, fugientesque cum mari pisces circa tuguria venantur. non
> pecudem his habere, non lacte ali, ut finitimis, ne cum feris quidem dimicare contingit
> omni procul abacto frutice.

7. Jan-Joost Assendorp et al., "The Lower Saxony Wadden Sea Region," in *LANCEWAD: Landscape
and Cultural Heritage in the Wadden Sea Region—Project Report,* ed. M. Vollmer, M. Guldberg, M. Ma-
luck, D. Marrewijk, and G. Schlicksbier, Wadden Sea Ecosystem, no. 12 (Willhelmshaven: Common
Wadden Sea Secretariat, 2001), 165, 172.

While similar "sea changes" affected both the continent and Britain, the availability of previously unsettled land constituted a major difference: as land shrank in Germany, the population did also, but in Britain, Anglo-Saxon evidence for settlement often occurs on previously unoccupied sites that share characteristics with those on the continent. The highlands of the continental marsh were "sandy, chalky soils, near the coast or the river banks,"[8] a geology and location that will sound familiar to anyone who knows Anglo-Saxon archaeology, from more obscure sites to the famous Sutton Hoo. Excavations show that the populations of Feddersen Wierde and of early settlements in Britain such as West Stow and Mucking also shared similar pottery, reinforcing the argument for direct migration from one region to another.

How do we get a sense of what Anglo-Saxon people felt toward the lands still new to them? We can trace some of their topographical terms in place-names, finding that often they were far more specific in their references to shapes and types of formations than we might be. For example, Della Hooke sketches the shapes referenced by various terms for what we might reduce simply to "hill": *cruc, hoh, ofer, beorg, dun.*[9] This specificity, based on particular shapes, derives from need. No visual maps existed for this landscape for most of the Anglo-Saxon period and peoples; maps were verbal instead. Even when recorded in written charters, the place-names and features listed are a sequence, each item encountered in the order in which a walker would meet it. To name the boundaries, one named the notable features of the environment as one walked them: discussions of legal issues, such as ownership, required a shared terminology. Thus, to walk the bounds by naming the shape of the land in a common language both marked it and made memory the map, transferring man's vision and judgment to the landscape in words even as the landscape itself took up residence in the mind's eye.

As an example of how such a term can record cultural change, the word *mere* and its occurrence in place-names will suffice. In his study of water terms, Mattias Jacobsson suggests that

> some of the hydronymic terms were adapted to specifically suit the English hydrology, while some were modified in meaning according to the development of Anglo-Saxon land-use and settlement patterns in England. . . . When the Old English hydronymic terms are compared to corresponding hydronymic terms found in other Germanic

8. Ibid., 165.
9. Della Hooke, *The Landscape of Anglo-Saxon England* (London: Leicester University Press, 1998), fig. 1.

languages and present-day English, the enormous effects that both the natural and cultural landscape can have on the lexicon become apparent. The loss of hydronymic terms or changes in their meaning are closely related to environmental changes, which demonstrates the close connection between the hydronymic vocabulary and the landscape.[10]

Jacobsson points out that in Old English, unlike other Germanic languages, *mere* does not generally mean sea or saltwater, but usually refers to freshwater ponds. (With sea levels rising, water tables also rose.) After correlating *mere* names with trackways and roads, following the work of Ann Cole, he rejects that link. He connects the names instead with the use of chalk uplands and with the eighth-century change to nucleated villages.

> This development was followed by a withdrawal from chalk-uplands which may still have retained an important role in the economy as they were suitable for husbandry. The suggestion made here is that *mere* was frequently applied to a pond used as a water-supply in husbandry, possibly in contrast to *wella,* applied to the water-supply of the settlement. This term [*wella*] becomes common in the 8th century. . . . The statistics suggest that *mere* was not associated with settlement to the same degree as *wella.*[11]

Thus the husbandry that was a key feature of sites such as Feddersen Wierde is again a factor here, with the luxury, perhaps, of terms that could now distinguish between water supplies for animals and those for humans. In a similar vein, Jacobsson's study of *sæ* produces the following suggestive development in light of water levels in the period: "The development of the English *sæ* can be summarized as lake/ocean > lake > landlocked sea-water > ocean."[12]

Here, I would like to look at what we consider more liminal sites, where water and land create traceable preferences and distinctive terms in Anglo-Saxon. That is, I am looking for aspects that tell us more about Anglo-Saxon choices regarding these "edges." (Fresh water is of course necessary to sur-

10. Mattias Jacobsson, *Wells, Meres, and Pools: Hydronymic Terms in the Anglo-Saxon Landscape,* Acta Universitatis Upsaliensis, Studia Anglistica Upsaliensia 98, (Uppsala: Reklam & Katalogtryck AB, 1997), 4.

11. Ibid., 214–15; his discussion of trackways and roads appears on 208–13.

12. Ibid., 182.

vival, but taking that as a given, I focus instead on a refinement of water/
land influences.) The range of terms depending on an interplay of water and
land includes *ecg,* meaning "edge" and "coast"; *garsecg,* "coast" or "gore's
edge";[13] *fen; iege* and *ealond,* "island" (occurring in Here*teu*/Hartlepool and
in Atheln*ey*); *mere; mersc;* and *mor.* Each of these terms depends on the inter-
penetration of water and land, on a varying edge or boundary, and on the
mutability or dynamic change involved in these terms. If change is the key
aspect of such a boundary or edge, the interplay of water and land deserves
another look as a clue to tracking Anglo-Saxon vision into thought. The
term "fluctuation," based on the Latin *fluctus* (waves), should remind us that
even in our Latinate English, the root of change and variability rests in water
and sea.

Today, after so much of the countryside has been radically altered, the
English still retain a keen sense of how place shapes them. The Berkshire
Downs, the Cotswolds, the Malvern hills, the Lake District, the Yorkshire
moors: all summon specific attributes not simply of land but also of regional
identities, of forms developed in response to the environment. Regionalism
is, in part, based on this mutual interaction of land and human. The work of
David Stocker on the siting of early monastic foundations in Lincolnshire
initiated my interest in Anglo-Saxon terms created from land and water.
Looking at the early church in Lincolnshire and the seven known or sug-
gested early monastic sites at Crowland, Barney, Partney, South Kyme, Hi-
baldstow, Barrow, and Louth,[14] Stocker notes first a preference for physical
isolation or enclosure, and second, the frequent choice of pre-Christian, and
usually pre–Anglo-Saxon, sites of ritual significance. His composite sketches
(see fig. 14) of seven other monastic sites in Northumbria (Alnmouth, Tyne-
mouth, Jarrow, Hexham, Whitby, Hartlepool, and Ripon)[15] show how often
higher land sites and promontories projecting out into water recur in the
sample. Using water to isolate or make a site less accessible exploits the higher
water levels of the period. But it is also notable as a choice by a seafaring
people: as *Beowulf* explains, Beowulf wished his people to build a barrow on

13. Tolkien translated this phrase several times in his scholarly articles, notably "The Monsters and
the Critics" and "On Translating *Beowulf,*" as "shoreless seas." This formulation implies that one stands
on land (or on a ship) and looks out at a horizon where sea meets sky, without a farther shore. J. R. R.
Tolkien, *The Monsters and the Critics and Other Essays,* ed. Christopher Tolkien (Boston: Houghton
Mifflin, 1984), 18, 60.

14. David Stocker, "The Early Church in Lincolnshire: A Study of the Sites and Their Signifi-
cance," in *Pre-Viking Lindsey,* ed. Alan Vince (Lincoln: City of Lincoln Archaeology Unit, 1993),
101–22.

15. Ibid., 105, fig. 9.3.

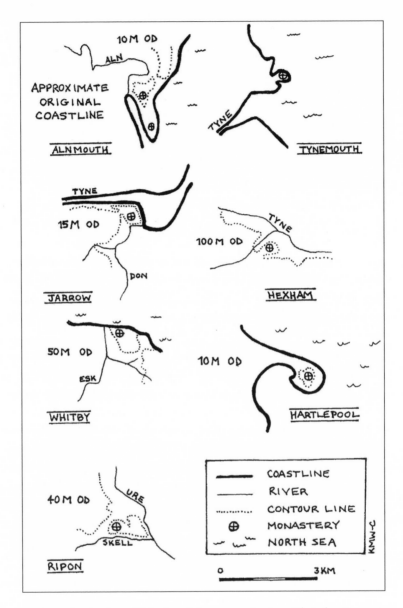

FIG. 14 A selection of Northumbrian monastic sites. Their locations are shown in relation to water and higher ground. Drawings by the author, after David Stocker.

a high headland so that sailors could use it as a landmark by which to steer (lines 2802–8). "Beowulf's Barrow" puts a name on a landscape feature, assuring that men will remember him by the land itself.

Whether these religious sites, whose character depends on the interaction of water and land, create a new value for such land is debatable, however; pre-Christian ritual sites occur there as well. While rising sea levels doubtless made such features more emphatic in the Anglo-Saxon period, according to Richard Morris's work on early churches in the landscape, the reuse of such sites is not uncommon for other reasons. He discusses the *friðgeard,* a sanctuary (from *frið,* "peace" or "protection"). It likely originated in Germanic custom, where families had their own local sites of worship as opposed to sites of regional or tribal status, perhaps for assemblies and not intended for continuous occupation.[16] As examples, *hearg* and *weoh, wih,* translated by a variety of terms such as "shrine," "temple," and "idol," exist in approximately twenty-seven place-names, eight of which have medieval churches. Anglo-Saxon gods' names occur in approximately twenty, with five still having churches today. Thus, St. Mary at Harrow-on-the-Hill, Middlesex, has the term *hearg* recorded in a charter of 767. The word formed the basis for "harrow," too, which occurs in Great Harrowden, Northamptonshire, located close to a Roman settlement. Roman evidence occurs, too, at Wye in Kent (based on *weoh, wih*), and it is described as a royal vill in a charter of 762. While these may be examples of the first, local type of site, Harrow-on-the-Hill is also associated with Farnham, Surrey, through two probably tribal groups: the Besinga and Gumeninga. A charter exists there for a monastery at Besinga-hearh, which again incorporates a word for "shrine." David Wilson discussed it as located on high land, possibly a communal place of worship for a special group, perhaps at particular times of year.[17] Morris also discusses possible associations of sites with sacred trees dedicated to gods and with Neolithic earthworks and henges, as at Rudston in East Yorkshire.[18] Reusing such sites, then, may not be, or not only be, in response to Pope Gregory's letter to Mellitus to assume and convert earlier ritual sites and customs. Morris comments on how urban centers fostered Christianity, whereas for rural populations, conversion was a continuing process, a point preserved in the term "pagan," from Latin *paganus,* "country dweller." Given that Anglo-Saxon England was, for over half its existence, based almost solely on nucleated villages, the survival of non-Christian preferences alongside Christian ones

16. R. K. Morris, *Churches in the Landscape* (1989; rpt., London: Phoenix Giant, 1997), 63–72.
17. Ibid., 65–66, 68, 69. He cites Wilson's article in *ASSAH* 4 (1985).
18. Ibid., 81–83.

becomes more likely. Early saints and hermits may well have wished to face paganism directly in the landscape they inhabited, but they may also have been laying a claim to a past, even if not their own. The idea that immigrant Anglo-Saxons tried to adopt as well as put down roots may have been an important aspect of choice and of negotiating their identity. Evidence of such choices and attitudes exists in the *Lives* of Cuthbert and, more strikingly, of Guthlac, two of the most famous early Anglo-Saxon saints. Their stories reveal how crucial water and the loss or submersion of previously occupied sites were to Anglo-Saxon identities and religion. I deliberately work here with well-known texts—even touchstones—rather than more obscure ones to show how the evidence is in plain sight.

Cuthbert (ca. 634–87) was the subject of three *Lives:* one anonymous version written by a monk (or monks) of Lindisfarne between 699 and 705, and two others by Bede, a metrical version and a prose one. Here, I mainly use the prose version of about 721, closely based on the anonymous *Life* as well as on the testimony of eyewitnesses. For our purposes, Cuthbert's choice of a place for his spiritual pursuits relies on the interplay of water and land as well as on the suggestion of earlier religious significance for the site. The anonymous *Life* states that having been part of the community on Lindisfarne, "after some years, desiring a solitary life he went to the island called Farne, which is in the midst of the sea and surrounded on every side by water, a place where, before this, almost no one could remain alone for any length of time on account of the various illusions caused by devils."[19] Bede's version expands on this description.

> There is an island called Farne in the middle of the sea which is not like the Lindisfarne region—for that owing to the flow of the ocean tide, called in Greek "rheuma," twice a day becomes an island and twice a day, when the tide ebbs from the uncovered shores, becomes again contiguous to the land; but it is some miles away to the southeast of this half-island, and is shut in on the landward side by very deep water and on the seaward side by the boundless ocean. No one had been able to dwell alone undisturbed upon this island before Cuthbert the servant of the Lord, on account of the phantoms of demons who dwelt there.[20]

19. "Post plures itaque annos ad insulam quam Farne nominant, undique in medio mari fluctibus circumcinctam, solitariam uitam concupiscens conpetiuit. Ubi prius pene nullus potuit solus propter uarias demonum fantasias aliquod spatium manere": chap. 1 of *Anonymous Life of Saint Cuthbert,* in *Two Lives of St. Cuthbert,* ed. Bertram Colgrave (1940; rpt., New York: Greenwood Press, 1969), 96–97.

20. "Farne dicitur insula medio in mari posita, quae non sicut Lindisfarnensium incolarum regio, bis cotidie accedente *aestu* oceani, quem *reuma uocant* Greci, fit insula, bis renudatis abeunte reumate

The choice of an island near a tidal island contrasts Cuthbert's choices with those of the monastic community. The monastery is sited on land that is sometimes linked to the mainland, and sometimes isolated, negotiating a hybrid identity of connection and retreat. Cuthbert, though, chooses a true island, one surrounded by deep water. He remains alone except for the phantoms of demons. He builds himself an oratory as well as a round house, cut down into the soil and rock (from which he can see only sky). Yet Bede notes that he has at a distance a landing place and a larger house, with a well, where other monks who visited him could stay,[21] showing some negotiation, even for Cuthbert: he wishes both to remove himself from others and yet still to be available to his brothers. Stories of how Cuthbert gains fresh water from the rock floor of his chamber, which allows him to drink and wash (chap. 18), and how he sows the island with barley after wheat fails to grow (chap. 19), indicate that such marginal land is nevertheless viable for crops and for drinking water. The key elements of retreat, isolation, accommodation, and confrontation of demons seem at first contradictory, but they offer clues that the physical landscape maps a personal or internal landscape as well. Cuthbert's architecture focuses his gaze upon the heavens, while his chosen landscape challenges him to map himself, to understand his own boundaries. In fact, though there is provision for visitors, eventually Cuthbert shuts himself away from them, opening his window to them only rarely. He confronts and exorcises the demons of the island, but not before they test his spiritual strength; they personify his triumph over his chosen landscape and his adaptation of it to his personal needs. Even more, the water- and landscape are the physical signs of his spiritual struggles and identity, of his still-readable mental map of self.

Perhaps in the same way, we can read such struggles in the separation of the two lovers in the setting of *Wulf and Eadwacer,* when the woman mourns,

> Wulf is on iege, ic on oþerre.
> Fæst is þæt eglond, fenne biworpen.
> Sindon wælreowe weras þær on ige;
> willað hy hine aþecgan, gif he on þreat cymeð.
> Ungelice is us.

litoribus contigua terrae redditur, sed aliquot milibus passuum ab hac semiinsula ad eurum secreta, et hinc altissimo, et inde infinito clauditur oceano. Nullus hanc facile ante famulum Domini Cuthbertum solus ualebat inhabitare colonus, propter uidelicet demorantium ibi phantasias demonum": Bede's *Prose Life,* chap. 17, in *Two Lives,* ed. Colgrave, 214–15.

21. Ibid., 216–17.

[Wulf is on one island, I on another.
Fast is that island, surrounded by fens.
They are bloodthirsty, the people there on the island.
They wish to oppress him if he comes with a troop.
We are different.][22]

Here, water and land stand in opposition, and each island, or person, seems an impermeable enclosure, set against penetration by outsiders: "fast is that island." The image is of a fen, itself flooded land, wound around and defining the island itself as fixed. Yet these two people fall in love, showing such boundaries to be illusions—negotiable, if only for a time, before human antagonism exacts its cost. If both are on islands, or are islands themselves, "we are different" can summon not only the differences between the lovers' peoples but also the lovers' shared identity against those who persecute them: they are bloodthirsty, but we are different. The water and land images here allow them to negotiate a "people" of their own, a mental remapping.

Similarly, in the Old English version of Felix's *Life of Guthlac*, Guthlac must confront personal challenge, making his mark upon his chosen place. He hears of

> a fen of immense size, which begins from the River Granta not far from the city of the same name, called Grantchester. There are immense swamps, sometimes dark stagnant water, sometimes foul rivulets running; and also many islands and reeds and tummocks and thickets. And it extends to the North Sea with numerous wide and lengthy meanderings. . . . Then a certain man called Tatwine said that he knew of a certain particularly obscure island, which many men had often tried to occupy but no man could endure because of various horrors and fears and because of the loneliness of the broad wilderness; and because of that everyone ran away from it. . . . Then he went on a boat and they both travelled through the wild fenlands until they came to the place which they call Crowland. . . . And as no man could ever live there before the blessed Guthlac came there, because of the dwelling-place there of the accursed spirits, very few men knew of it except the one who showed it to him.[23]

22. Richard Hamer, *A Choice of Anglo-Saxon Verse* (1970; rpt., London: Faber and Faber, 1988), 84, lines 4–8. The translation is mine.
23. Michael Swanton, trans. and ed., "The Life of Saint Guthlac," in *Anglo-Saxon Prose*, The Everyman Library (Rutland, Vt.: Charles E. Tuttle, 1996), 93. In Old English, it reads: "Ys on Bretonelande sum fenn unmætre mycelnysse, þæt onginneð fram Grante ea, naht feor fram þære cestre, ðære ylcan nama ys nemned Granteceaster. Þær synd unmæte moras, hwilon sweart wætersteal, and hwilon

Once again, the elements of conquering the challenge of this particular mar-
ginal and changeable landscape, of confrontation and of isolation, appear. As
with Cuthbert, Guthlac wishes to retreat into a difficult and solitary life,
though he has two boys as servants, a sign that his class still matters. Guthlac
also sites his dwelling in a suggestive place: "There was on the island a certain
great burial-mound built over the earth, which men of old had dug into and
broken up looking for treasure. On one side of the burial-mound there was
dug, as it were, a great reservoir. Over this reservoir the blessed Guthlac built
himself a house."[24] He makes a place for the living over the robbed bodies
of the previous inhabitants, and indeed his digging out a house reenacts the
actions of the robbers. Soon, others join him on the island, each with his
own living place. As his fame grows, in fact, many apparently find the pre-
viously difficult passage to his obscure island, enough that once again struc-
tures are built to accommodate visitors. The *Life* mentions three men who
came to a landing-stage and sounded a signal there (chap. 11).

There are also indications that we can map political realities onto this
spiritual and physical water- and landscape by considering Guthlac's confron-
tations with devils. He has several, but one in particular pointedly contextual-
izes this battle in the fens (chap. 6). It begins:

> It happened in the days of Cœnred, King of the Mercians, that the
> British nation, enemy of the English people, annoyed the English
> with many skirmishes and various battles. Then it happened one
> night when it was cock-crow and the blessed Guthlac fell to his
> morning prayers, he was of a sudden lulled into a light sleep. Then
> Guthlac started up from that sleep, and immediately went out and
> looked and listened. Then he heard a great host of the accursed

fule eariþas yrnende, and swylce eac manige ealand, and hreod, and beorhgas, and treowgewrido, and
hit mid menigfealdan bignyssum widgille and lang þurhwunað on norðsæ. . . . þa wæsTatwine gehaten
sum man, sæde þa, þæt he wiste sum ealand synderlice digle, þæt oft menige men eardian ongunnon,
ac for menigfealdum brogum and egsum and for annysse þæs widgillan westenes þæt hit nænig man
adreogan ne mihte, ac hit ælc forþan befluge. . . . Eode þa on scip, and þa ferdon begen þurh þa rugan
fennas, oþ þæt hi comon to þære stowe, þe man hateð Cruwland. . . . and hit swyþe feawe men wiston,
buton þam anum, þe hyt him tæhte; swylc þær næfre nænig man ær eardian ne mihte, ær se eadiga wer
Guðlac tocom, for þære eardunga þara awerigedra gasta." Paul Gonser, *Das angelsächsische Prosa-Leben
des hl. Guthlac,* Anglistische Forschungen Heft 27 (1909; rpt., Amsterdam: Swets & Zeitlinger N. V.,
1966) chap. 3, 113, lines 1–7; 114, lines 14–20, 23–25, 27–31.

24. Swanton, "Life of Saint Guthlac," chap. 4, 94. Old English: "Wæs þær on þam ealande sum
hlaw mycel ofer earðan geworht, þone ylcan men iu geara for feos wilnunga gedulfon and bræcon. Þa
wæs þær on oþre sidan þæs hlawas gedolfen swylce mycel wæterseað wære; on þam seaðe ufan se
eadiga wer Guthlac him hus getimbrode." Gonser, *Prosa-Leben des hl. Guthlac,* chap. 4, 117–18, lines
5–14.

spirits speaking in Celtic; and he knew and understood their speech because some time previously he had been in exile among them.[25]

He is then attacked by their spears and flown through the air on the spear tips, whereupon he banishes them with psalms and eventually is rid of them.[26] The text overlays politics and religion. Are these the spirits of the ancient burial mound? Or are they more recent battle victims, those killed in battle with the Mercian English? While modern archaeology might choose one over the other, the text leaves that identity open, allowing ancient and recent pasts to merge in the fens.

In any case, these spirits are clearly the previous occupants of the landscapes that are now points of contention both for the Mercians and for Guthlac. That the chapter begins with a precise reference to political power struggles between the Britons and the Mercians, and then displaces it to a spiritual conflict, shows whose side is approved and blessed—and layers the levels of significance. As a young man (and a member of the oldest and noblest house among the Mercians, according to the *Life*), Guthlac at fifteen formed a war band and, inspired by stories of past heroes, seized land, burned villages, and slaughtered enemies. Perhaps this is the "exile" mentioned. He gives it all up after a divine rebuke, returning one-third to those he attacked (his personal portion of the spoils?) and entering religious life. The political reinforces and even reclaims the status of the saintly Guthlac as Anglo-Saxon warrior and noble. Though Guthlac gave up the role of a war leader at twenty-four, the *Life* carefully notes that his name was given as if by divine dispensation, noting that "Guthlac" is, in Latin, *belli munus* (chap. 2), that is, "gift of war." His physical experience informs the spiritual battles he later fights as a Saxon saint against the Celtic/British devils, and the fight with the fen's previous or ghostly occupants echoes the larger political struggle for dominance in the landscape, something Sam Lucy has examined. In writing about the tradition of barrow burial in the North Yorkshire Wolds, Lucy looks at the issue of power in the landscape and the question of why the

25. Cœnred was king in 704–9; he abdicated and became a monk in Rome. Swanton, "Life of Saint Guthlac," chap. 6, 99. Old English: "Ðæt gelamp on þam dagum Cenredes Mercna kyninges, þæt Bryttaþeod, Angolcynnes feond, þæt hi mid manigum gewinnum and mid missenlicum gefeohtum, þæt hi Angolcynne geswencton. Ða gelamp hit sumre nihte, þa hit wæs hancred, and se eadiga wer Guðlac his uhtgebedum befeal, þa wæs he sæmninga mid leohte slæpe swefed. Þa onbræd he Guðlac of þam slæpe, and eode þa sona ut, and hawode and hercnode; þa gehyrde he mycel werod þara awyrgedra gasta on bryttisc sprecende; and he oncneow and ongeat heora gereorda, forþam he ærhwilon mid him wæs on wrace." See Gonser, *Prosa-Leben des hl. Guthlac*, chap. 6, 135–36, lines 1–10.
26. See the Swanton and Gonser versions of the *Life*, chaps. 1, 2.

barrow tradition comes and goes, appearing and reappearing especially in the Bronze Age, the later Iron Age, and the early Anglo-Saxon period.[27] She sees the "re-emergence of the barrow rite as an attempt to legitimate and natural-ize . . . power relations" and goes on to comment, "It is interesting to note that this burial rite makes heavy use of prehistoric monuments. Perhaps some of the legitimation is felt to come from this link with the past. . . . The use of monuments in this way may be a way of 'staking a claim', of establishing rights to control of the landscape."[28] Beyond the Christianization of a pagan site, therefore, Guthlac's claiming of a fen island and its burial mound may be an exercise of religious control over more than ghostly echoes: it asserts real power over the land, over the past, and over the imagination. For peoples who immigrated to Britain, staking such a claim links up with the mutable boundaries of water and land to extend their history in them, blending pasts and the present.

In an effort to trace further the markings of Guthlac's story on the land-scape, I return to Stocker. He details the evolution of Guthlac's site at Crow-land in light of his argument for a pattern of enclosed withdrawal and reuse of pre-Christian sites, but I would like to add a focus on variability, on dy-namic change over time. While we do not have the original boundaries at Crowland, a series of disputes over the centuries records changes in those boundaries. Stocker estimates that perhaps as early as 833, and quite likely by ca. 950, the boundary of Crowland's island was marked (figs. 15, 16). Eight boundary crosses have been identified, of which four survive, none dating earlier than the twelfth century. Stocker comments, "the identified sites de-marcate not the early topographical island, but the later-medieval parish. . . . Consequently, although the island was apparently marked out by marker posts and crosses from an early date, these markers were evidently moved outwards as the marshland edges of the island were reclaimed and brought into cultivation, the island reaching its present boundary by the 12th cen-tury."[29] This expansion is a direct response to the reduction in water levels, but it also represents on the land itself a statement about power, and the later expansion of control marks is a parallel to what the text of Guthlac's *Life* earlier negotiated.

The claiming of the marginal to make it central, and the subsequent colo-nization of nearby land when the opportunity arises (which I am tempted to

27. Sam Lucy, "The Significance of Mortuary Ritual in the Political Manipulation of the Land-scape," in *Archaeological Review from Cambridge* 11 (1992): 93.

28. Ibid., 97–98.

29. Stocker, "Early Church in Lincolnshire," 103.

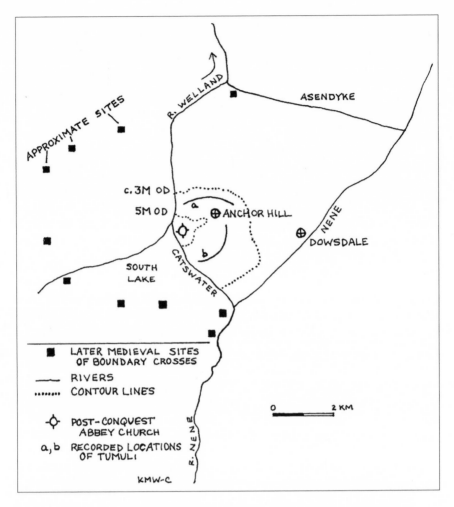

FIG. 15 The setting of Crowland Abbey. Map by the author, after David Stocker.

term "fluid expansion" simply for the pun), points not just to opportunism or greed but also to an attitude of adapting to what the landscape yields, a habit of mind that seems to incorporate mutability as central. It might also feature in the pattern of "wandering villages" that recent archaeology has established for early Anglo-Saxon settlement. Excavations at many sites, such as Riby Cross Roads, Lincolnshire, show that, instead of continuous occupation of single sites, villages shifted over time. Ken Steedman, the excavator at Riby Cross Roads, suggests that the site may finally have been abandoned in favor of migrating up the slope to the present Riby village from the southwest, as environmental conditions of windblown topsoil and sand during

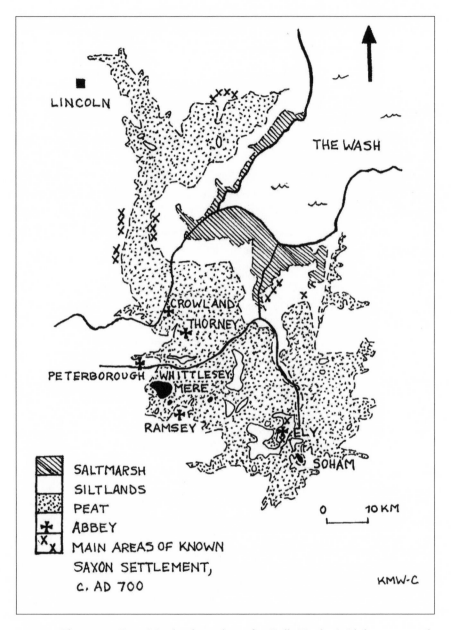

LINCOLN

THE WASH

CROWLAND
THORNEY

PETERBOROUGH WHITTLESEY
MERE

RAMSEY

ELY

SOHAM

SALTMARSH
SILTLANDS
PEAT
ABBEY
MAIN AREAS OF KNOWN
SAXON SETTLEMENT,
c. AD 700

0 10 KM

KMW-C

FIG. 16 The eastern Fens. Map by the author, after Della Hooke (with her own work based on that of Hall and Coles).

excavation demonstrated the upper site to be more desirable and comfortable than that excavated. Julian Richards argues that Cottom in Yorkshire had two areas of post-Roman activity: an Anglo-Saxon nucleus and another that shifted to the northeast during the Viking Age.[30] "During the post-Roman period," he states, "most archaeologists now believe that there was a shifting settlement pattern. The inhabitants of dispersed farmsteads practised infield-outfield agriculture and, once the fertility of the land was exhausted, periodically relocated their farms. This pattern is reflected by pottery scatters and short-lived structures, and occasionally is seen in large scale landscape excavation, such as at Mucking, Essex, or at Vorbasse in Jutland."[31]

But in some ways I am still privileging the land over the water, examining projections of viable land defined by watery incursions. Anglo-Saxon practice and imagination does manifest the valuing of water in other ways. If we reverse the direction, looking for efforts to bring water's significance to the setting, we would be looking for evidence of positive uses, treacherous as that might be to detect. Yet even the most cursory glance at the great Anglo-Saxon poems immediately yields, besides *Wulf and Eadwacer,* the longer poems *The Wanderer* and *The Seafarer.* While the Wanderer bemoans the loss of his lord and his subsequent wanderings in exile over a cold sea depict his desolation, the Seafarer presents us with a man who would not leave the sea even when life on it is hard. He muses,

> And yet the heart's desires
> Incite me now that I myself should go
> On towering seas, among the salt waves' play;
> And constantly the heartfelt wishes urge
> The spirit to venture, that I should go forth
> To see the lands of strangers far away.[32]

The sea becomes a road, or a bridge, to new experiences and peoples. He continues,

> Even now my heart
> Journeys beyond its confines, and my thoughts

30. Julian D. Richards, "Defining Settlements: York and Its Hinterland AD 700–1000," in *Courts and Regions in Medieval Europe,* ed. Sarah Rees Jones, Richard Marks, and A. J. Minnis (York: York Medieval Press, 2000), 71.

31. Richards, "Defining Settlements," 49–50.

32. Hamer, *Choice of Anglo-Saxon Verse,* 189, lines 33–38. Old English: "For þon cnyssað nu / heortan geþohtas þæt ic hean streamas, / sealtyþa gelac, sylf cunnige; / monað modes lust mæla gehwylce / ferð to feran þæt ic feor heonan / elþeodigra eard gesece" (188).

Over the sea, across the whale's domain,
Travel afar the regions of the earth,
And then come back to me with greed and longing.
The cuckoo cries, incites the eager breast
On to the whale's roads irresistibly
Over the wide expanses of the sea,
Because the joys of God mean more to me
Than this dead transitory life on land.[33]

The sailor previously contrasted the comfortable life on land and the hard-ships of being at sea. Here, his love of what he does and what it means for him in his mind and heart override the hardships of seafaring. The sea calls to him, especially as the spring thaw comes, and he clarifies its spiritual sig-nificance: to be on land is to see things pass, change and die. The sea and its movement are life itself, the journey both physical and part of his inner life, just as with Guthlac and Cuthbert. Yet the most common method of naviga-tion at this time was to hug the coastline, dropping anchor for the night to camp ashore. Deep-water navigation—working without that intersecting line of land and water—was much more dangerous. And even with the voices of the Wanderer and the Seafarer assuring us that they are solitary travelers, how likely was it that a man would take ship alone, especially in deep water, the whale's road? Again, the waterscape here images a habit of vision, of seeing, that cannot be mapped only onto the physical. Even the Seafarer needs the alternation and contrast of land and water to steer by.

But does this choice of water/land edges have earlier manifestations or a history even before or outside Anglo-Saxon Christianity? The first practice to come to mind is the rare but impressive burial of ships, such as the famous ones at Sutton Hoo or Oseberg or the less grand at Snape or in the stone outlines of ships in Scandinavian burials. Recent excavations at the Scandina-vian cremation cemetery at Ingleby, Derbyshire, located near Repton, have introduced further evidence of a practice that hints at bringing the sea to land, not surprisingly, in the Viking period.[34] Nails found in five of the fifteen mounds excavated over the years suggest that they held together or decorated wooden objects. From the evidence known, with three or fewer nails per

33. Ibid., 189–90, lines 58–66. Old English: "For þon nu min hyge hweorfeð ofer hreþerlocan, / min modsefa mid mereflode / ofer hwæles eþel hweorfeð wide / eorþan sceatas, cymeð eft to me / gifre and grædig; gielleð anfloga, / hweteð on hwælweg hreþer unwearnum / ofer holma gelagu, for þon me hatran sind / Dryhtnes dreamas þonne þis deade lif / læne on londe" (190).

34. Julian D. Richards, Marcus Jecock, Lizzie Richmond, and Catherine Tuck, "The Viking Bar-row Cemetery at Heath Wood, Ingleby, Derbyshire," *Medieval Archaeology* 3 (1995): 1–70.

find, the objects would have varied in size and positioning. Some have sug-
gested a shield as the piece represented, though one such burial was definitely
a female with numerous goods. Others have argued for chests or boxes, but
no hinges or clamps were found. Julian Richards and his colleagues make the
fascinating claim for sections of a boat.[35] They suggest that using parts of
older boats, undoubtedly around from Viking raids, allows for a previously
unrecognized type of boat burial, evoking the journey of the dead. The frag-
ments would have served as biers, and the authors note suggestions of clin-
ker-built construction that might confirm this. Certainly their brief reference
to the extensive finds of waterlogged timber coffins at Barton-upon-Humber
provides a parallel, though to inhumations, not cremations; there, surviving
timber clearly attested to a clinker-built technique, where boards overlapped
and were held by rivets. A boat burial was found under York Minster as well,
with three oak planks caulked with wool forming a clinker-built platform.
(The authors note that charcoal deposits from the Ingleby cremations are
almost entirely of oak.) Though the writers acknowledge the poor state of
survival and varying excavation quality, "regular association of nails with cre-
mation burials at Ingleby points to the use of some sort of crudely constructed
coffin or bier."[36]

They suggest that bands of Vikings in the second half of the ninth century
chose Ingleby and its proximity to Repton for the mounds because, "[w]ith
its tradition of royal Mercian patronage and its prestige as a focus of pilgrim-
age, Repton would have provided the perfect location for a demonstration
of new spiritual convictions combined with political/military subjugation."
The Vikings kept their own cemetery at Ingleby because of a "very definite"
commitment to paganism, and the burial form alludes to their homeland.
What seems hurried construction on many of the mounds reflects the insta-
bility of their position: ostentation marks insecurity,[37] which sounds much
like Martin Carver's claims for Sutton Hoo as a deliberate pagan manifesto.
Thus we have represented here the historical instance of two religious ideol-
ogies in opposition and gradual adaptation. When the Viking army spent the
winter at Repton, making it part of its fortifications, it began to practice
inhumation for legitimation. Yet the alternative tradition continued, as
shown by the empty mounds still raised as cenotaphs, commemorating those
given Christian burial at Repton. The use of ship planking is not simply
frugal; given the discussion here, it may do more than simply allude to a

35. Ibid., 64.
36. Ibid., 63.
37. Ibid., 65–66.

journey in the afterlife. Using the very ships that brought these people here offers a link to their past, their origins, as well as everything the sea could mean to them: opportunity, threat, new life, new identities. In this, the Vikings cremated at Ingleby share an attitude that Nicholas Howe studied in his book *Migration and Mythmaking in Anglo-Saxon England,* which considers "what the relations were between the insular Anglo-Saxons and their kindred on the European continent." He argues that "the Anglo-Saxons honored the ancestral migration as the founding and defining event of their culture. They turned to it so that they might identify their common nature as a people and understand their religious history."[38] A partial list of chapters will give an idea of how central the idea is, once noticed: "The Making of the Migration Myth" looks at Bede; *"Exodus* and the Ancestral History of the Anglo-Saxons" shows how images of the Israelites and the Promised Land take on political significance for the Anglo-Saxons; and "Conversion and Return: From Island to Continent" investigates the Saxon missionaries. Howe also addresses *"Beowulf* and the Ancestral Homeland." Yet what is remarkable here is the navigation—literal, mythic, and symbolic—of the water and land, the *connection* that water forms between the past, present, and future as the sea carries peoples to and from each other.

Where does all this negotiation of edges and boundaries lead us in considering traces of Anglo-Saxon attitudes? Boundaries distinguish differences on either side, yet have identities and characters of their own. Introducing water into landscape considerations gives us a variable that suggests permeable, dynamic boundaries; in some circumstances, such as the siting of religious foundations, their inherent uncertainty and ambiguity may be cultivated. Use of the environment demonstrates habits of the mind, of attitudes, influences, and choices. Embedded there is the history of human marks on the landscape: Anglo-Saxons as colonizers nevertheless interacted with the local populations in ways we still debate in migration theory. Should we understand that for every Anglo-Saxon name, there is a lost name in an earlier tongue? Should we think that notable landmarks were remarked by earlier peoples but colonized by Anglo-Saxon language? Is the "haunting" of fens in sources such as Guthlac's *Life,* or the siting of places in areas known to have importance to pre-Christian believers, a symptom of the return of the oppressed or suppressed? That Alfred cultivates the "betweenness" of fens to salvage England

38. Nicholas Howe, *Migration and Mythmaking in Anglo-Saxon England* (New Haven: Yale University Press, 1989), ix.

by retreating to Athelney is perhaps more resonant than we realized. The very mutability of the fens, their resistance to clear paths and boundaries, allows him to resist, negotiate, and reestablish the boundary of being Anglo-Saxon figuratively and literally in his treaty with the Danes, in his recording of travelers' voyages, and in his vision and re-visioning of English history and language.

I finish with a series of points to consider, to help begin the shift in perspective that may open up ways to see Anglo-Saxon attitudes and differences in perspective. My first takes the site of Whitby as inspiration. Excavations, both planned and rescue operations, occurred at Whitby from the 1920s through the new millennium. In addition to the well-known finds from the earlier twentieth century of stone foundations to the north of the abbey, understood by many as the habitations of the monastics living there in the Anglo-Saxon period, more recent excavations have shown neolithic, Roman, Viking, and Anglo-Scandinavian material, changing how we understand the site. Whitby Cliff may have been the site of a Roman signal station or even a Romano-British monastery, and neolithic finds have been recovered from south of the abbey, indicating that previous communities also found this a useful place to live.[39] Its identity continued to evolve. Was the abbey sited where the later medieval abbey ruins sit, which in Anglo-Saxon times would put it much further from the cliff's edge than the subsequent coastal erosion would suggest? Or, given Ian Wood's contentions about Donemuðe and Jarrow and connections to royal palaces—where Donemuðe becomes a nunnery possibly ruled by Ecgfrith's queen as abbess[40]—should we imagine the current abbey site as a royal and secular site, later paired with a monastery ruled by Hild, connected to two royal families? Burials recently discovered with physical trauma such as beheadings or hands bound behind backs may be an indication (as they seem to be at Sutton Hoo) of secular punishments or royal legal executions. These might imply a closer royal connection, perhaps of the late Anglo-Saxon period.

Christianity and a perspective of mutability and adaptation may also have provided Anglo-Saxon royalty with a new venue for extending power laterally, with Whitby as one example. Normally, a royal woman's marriage could produce problematic heirs—rivals, for example, for such a woman's brothers when it came to succession. Christian religious life offered another alternative, one that both solved problematic female reproduction while capitalizing

39. English Heritage, "Whitby Abbey Headland Project: Southern Anglian Enclosure" (1999), http://www.eng-h.gov.uk/projects/whitby/wahpsae/updates.htm (accessed 15 March 2004).

40. Ian Wood, "Bede's Jarrow," chapter 2 in the current volume.

on making women rulers of religious communities.[41] I would argue that this fact might explain the popularity in early Anglo-Saxon monasteries of the double house ruled by an abbess: the male royals would rule in secular venues, and the female royals could rule the religious, extending the power of the family without complicating succession. In effect, the women could function as males did, even within a religion based on a male hierarchy. From conversion accounts given in Bede, kings had religious status in their pre-Christian contexts, officiating at family altars and shrines and presumably expecting their people to follow their leads. The expectation of the people's conversion continued under Christianity, but with a much more separate hierarchy for religious power. The introduction of women ruling monastic houses may then be a fluid renegotiation of gender roles and an adaptation of political power. If, as Stocker argues, bishops were careful to site their palaces near but separate from royal palaces,[42] both to keep up connections (most were themselves noble) and to establish separate bases of power, the strategic extension of royal women's power into monastic foundations shows yet another reason why separate sites were maintained. Royal abbesses could reconfigure the exclusion, or at least the limitation, of royal power from religion without jeopardizing male kingship. The problem of where Hild's monastery of Streonaeshalch was sited figures in this extension of power. If the headland had a secular royal site, looking for Hild's monastery might suggest looking north, downslope. In fact, if the last element in the place-name is *healh,* it can mean a small hollow in a slope or hillside, suggesting that the monastery was sited off the highest ground. (Indeed, one way to interpret the place-name is as "headland property in the slope's hollow.")

Or perhaps the monastery is long eroded into the sea, a sad merging of land and water, meeting the same end as the double houses ruled by women. Living on the edge took a turn for the literal in Whitby in the autumn of 2000, when a section of the cliff north of the abbey fell into the sea. After emergency excavation and sorting of finds from the site, workers found what they termed "rich archaeological deposits dating from the eighth to twelfth centuries, it seems likely that the area formed part of a secular Anglican settlement."[43] If the original site was where the abbey is now, sited high on the

41. Lees and Overing, "Birthing Bishops and Fathering Poets: Bede, Hild, and the Relations of Cultural Production," *Exemplaria* 6 (1994): 35–65.

42. Stocker, "Early Church in Lincolnshire," 115–16.

43. Sarah Jennings, Liz Muldowny, and Tony Wilmott, "Excavation and Evaluation at Whitby, 2002: An Archaeological Response to Coastal Erosion," *CFA News* 4 (Winter 2003–4), 2; http://www.englishheritage.org.uk/upload/pdf/cfa_news_04 (accessed 22 December 2005).

cliff, access is clearly difficult, yet the location is certainly not obscure or hidden. The abbey would have been seen for miles from both sea and land.[44] Was this a place where the resources of the land—represented by wool woven by the nuns from sheep watched by the likes of Caedmon, or jet gathered on the shore or mined nearby—was traded or exchanged with other monasteries or secular sites available to the monastery because of Hild's royal connections? Is the siting part of her own or her family's political statement of power over the land- and seascape? Perhaps the installment of a male-female community, and the unease of some over such a mixing, represents another boundary negotiation by early Anglo-Saxon Christianity. But there are other statements that Christian practice makes in this place, puns in the language that suggest fluidity. While land can be *mearclond,* or "march," "mark," or "boundary" land, a person can be similarly marked or bounded by the baptism denoted by the term *mearcod,* "conferred with water." Such a dualism resonates with the other examples here. In turn, Christians marked the land at Whitby by placing headstones that put the names of their dead on the land in a very literal way: they themselves became landmarks, names in place.

I want to end by returning to the idea of perception, a word that has lurked behind my depiction of water and land as interpenetrating and mutable boundaries that influenced habits of mind. Ian Wood, discussing the Christian frontier of the early Middle Ages, gives an example of a missionary who crossed a treacherous boundary over the objections of his host and triumphed in his conversion efforts. Wood comments that "state boundaries apart, frontiers are essentially matters of perception," adding later, "the crucial conceptual boundary that appears time and time again is not the boundary between pagan and christian, but that between the culturally familiar and the 'Other'."[45] Julian Richards, writing on Anglo-Saxon symbolism, uses an example that compares the markings on cremation pots and ring brooches to make a related point (fig. 17):

> Superficially there appears to be little similarity between pots and brooches, and the specialisms have been vigorously defended. . . .

44. Rosalin Barker commented that from the sea, Whitby is visible for thirty-five miles (a landmark, indeed, to match Beowulf's desire that sailors remember him when navigating by his barrow). She added that this is undoubtedly why the Germans aimed for Whitby and Scarborough in World War II. Barker, address to the "Place to Believe in: Medieval Monasticism in the Landscape" conference (Whitby, England, 21 July 2003).

45. Ian Wood, "Missionaries and the Christian Frontier," in *The Transformation of Frontiers from Late Antiquity to the Carolingians,* ed. Walter Pohl, Ian Wood, and Helmut Reimitz (Leiden: Brill, 2001), 209, 211.

KMW-C

FIG. 17 Strikingly similar decoration on cremation vessels and annular brooches, made more striking if we shift our perspective on the pots from a side view to that from above. The pots (top) are Spong Hill 1776; Spong Hill 2777; Caister-by-Norwich, Myres 1905. The brooches (bottom) are all from Morningthorpe, nos. 397, 262, and 114. Drawings by the author, after J. D. Richards.

The problem is principally that of perception. It is conventional that Anglo-Saxon cremation vessels should be drawn in profile, as if they are symmetrical, with one side a repeat of another. However, by representing them in this fashion we make a nonsense of their intended appearance. The vessels were coil-built by a potter working from above; the need to lay out concentric circular fields of decorations demanded that they should also be decorated from above. And most importantly, when buried in a shallow urn pit as part of the mortuary ritual, they were designed to be viewed from above by the participants in the funerary ceremony. Once perceived as concentric bands of motifs then the parallels between pottery and metalwork become self-evident. One can see, therefore, a transformation of a coded message from one medium to another, and in some cases a substitution of one medium for another. . . . Symbols were used to construct a new reality.[46]

We imposed our own view, that of the technical drawing, on the artifacts of the Anglo-Saxons, and came up looking at them the wrong way round. Our

46. J. D. Richards, "Anglo-Saxon Symbolism," in *The Age of Sutton Hoo: The Seventh Century in North-Western Europe,* ed. M. O. H. Carver (Rochester: The Boydell Press, 1992), 145–46, 147.

technical and scientific views literally looked sideways, but an Anglo-Saxon, whether at the creation of the pot or at the burial itself, would have looked down on its top. The designs of pin and pot were not related until both were aligned as circular. When our vantage point shifted, we saw a new reality. Similarly, to consider landscape, especially of the *isle* of Britain, without factoring in the pervasive, changing, and influential presence of water and sea, is to skew how Anglo-Saxons responded to and imagined themselves in their environment—and how they changed.

PART 2 ❧ TEXTUAL LOCATIONS

The four essays by Stacy S. Klein, Ulrike Wiethaus, Stephanie Hollis, and Diane Watt are inflected by the various disciplines of Anglo-Saxon studies, religious studies, and English studies, yet each is concerned with the textuality of place in medieval writing. The authors examine cognitive, temporal, and geographic perspectives in the early and later medieval period via the various textual lenses of poetry, autobiography, and hagiography. Sharing a concern also with gender and subjectivity, these essays investigate both spiritual and geographic locations of and for medieval subjects. In so doing, they construct a space for the reader, a bridge between these worlds.

4

GENDER AND THE NATURE OF EXILE IN OLD ENGLISH ELEGIES

Stacy S. Klein

Non enim pro locis res, sed pro bonis rebus loca amanda sunt.

[For things are not to be loved for the sake of a place, but places are to be loved for the sake of their good things.]

I begin with this quotation from Gregory the Great because it highlights a sense of place found throughout Anglo-Saxon writings: place as a profoundly social entity. The "places" to which Gregory refers are the churches of early-seventh-century England; the "things" are the customs practiced within those churches; and the question at hand is that of spiritual unity in the face of geographic and practical diversity. Could there be a unified Christian faith when the customs observed in the churches of Rome and Gaul were so very different? Gregory's answer is premised on the idea that places do not possess a priori value but rather derive that value from the social practices and cul-

The epigraph to this chapter cites Gregory the Great as given in *Bede's Ecclesiastical History of the English People,* ed. and trans. Bertram Colgrave and R. A. B. Mynors (Oxford: Clarendon Press, 1969), I.27, pp. 82–83. Gregory's remarks are found in the so-called *Libellus Responsionem,* a document containing questions purportedly posed by Augustine of Canterbury and answered by Pope Gregory the Great, which Bede inserted into the *Historia Ecclesiastica.* The *Libellus* is not only known from its inclusion in the *Historia Ecclesiastica;* it is transmitted as a separate tract in more than two hundred manuscripts and survives in three different major versions. There has been much debate regarding its authenticity. For useful discussions, see Paul Meyvaert, "Bede's Text of the *Libellus Responsionem* of Gregory the Great to Augustine of Canterbury," in *England Before the Conquest: Studies in Primary Sources Presented to Dorothy Whitelock,* ed. Peter Clemoes and Kathleen Hughes (Cambridge: Cambridge University Press, 1971), 15–33, and Rob Meens, "A Background to Augustine's Mission to Anglo-Saxon England," *Anglo-Saxon England* 23 (1994): 5–17.

tural artifacts situated within them—a sentiment echoed in his famous in-junctions that the pagan temples of England should not be destroyed but simply stripped of their idols, restocked with altars and relics, and resuscitated for Christian worship.[1]

Yet, in Anglo-Saxon England, this sense of place as a social phenome-non—rooted in particular customs and cultural artifacts—coexisted with a radically opposing view: that the idea of place transcended cultural specificit-ies and could draw readers away from realms marked as literal, social, and human and toward those viewed as symbolic, spiritual, and divine. We have only to think of Elene's search for the Holy Cross or Guthlac's travels to the gates of hell to be reminded that literal journeys in Old English poetry almost always function as metaphors for spiritual quests. And we have only to con-sider Ælfric's biblical translations, and his frequent rendering of detailed de-scriptions of Middle Eastern places and topographical features by such generic terms as *þæt land* (that land) or *an dun* (a mountain), to remember that for Anglo-Saxon writers, the particularities of a place were usually subordinated to its broader symbolic implications.[2] Indeed, the places most often invoked in Old English literature are those heavily laden with iconic and mythological meanings: Jerusalem, Rome, Geatland. What mattered more to Anglo-Saxon writers was that their texts might provide spiritual maps, not geographic ones. Their intent was not to enable readers to traverse literal distances between different locales but to help them traverse the distance between the *nacede gerecednisse* (naked narrative) and its allegorical significance.[3] In so doing, readers would receive the necessary spiritual inspiration for closing the dis-tance between the earthly city and the heavenly home. One need not be able to find Jerusalem on a map, but it was absolutely crucial to understand the

1. *Ecclesiastical History* I.30, pp. 106–9.

2. See, for example, Ælfric's rendition of Kings, in which he frequently omits detailed descriptions of Middle Eastern land and water masses found in his Old Testament sources. He replaces them with such generic phrases as *þæt land* (58), *his eard* (his country, 73), or *an dun* (142). The result is rather hazy geography and a sense that the text could be set anywhere in Christendom. See *Ælfric's Lives of Saints,* ed. and trans. W. W. Skeat, Early English Text Society, o.s., 76, 82, 94, 114 (London, 1881–1900; rpt. as 2 vols., 1966), 1:384–413. Particularly in his later hagiographical writings, Ælfric attempted to make events symbolic rather than individual, using texts "to reveal basic patterns of action common to all periods and all regions" (Malcolm Godden, "Experiments in Genre: The Saints' Lives in Ælfric's Catholic Homilies," in *Holy Men and Holy Women: Old English Prose Saints' Lives and Their Contexts,* ed. Paul E. Szarmach [Albany: State University of New York Press, 1996], 261–87, at 281).

3. The phrase *nacede gerecednisse* appears in Ælfric's Preface to Genesis, in which he warns Æthel-weard of the text's complex spiritual significance. He has written, he says, "na mare buton þa nacedan gerecednisse" (no more than the literal narrative). See *The Old English Version of the Heptateuch,* ed. S. J. Crawford, Early English Text Society, o.s., 160 (London: Oxford University Press, 1922), 77, lines 42–43.

particular spiritual practices and habits of living that might allow one ulti-
mately to get there.[4]

These various understandings of place are vividly encapsulated in a group
of Old English poems traditionally referred to as elegies.[5] It is not surprising
that Old English elegies bear a special relationship to place, for such texts
chronicle its loss. In these intensely personal poems, individual speakers re-
flect on their experiences of exile and on the excruciating miseries attendant
upon physical and psychological alienation from the heroic hall and its inhab-
itants, which are themselves figured as ever on the verge of ruin. For the
exile, the loss of secular place—both the literal hall and one's social role
within it—enables revelation of its multiple meanings and vexed values
within Christian culture. As men and women reflect on the miseries of exilic
life, their laments reveal profoundly different senses of what it might mean
to inhabit the geographic and social margins of the world. The distinction
turns on their respective relationships to place. For such men as the Wanderer
and the Seafarer, exile is figured as a loss of place and consignment to perpet-
ual movement; the female speakers of *The Wife's Lament* and *Wulf and Ead-
wacer,* by comparison, envision exile as being trapped in place and consigned
to interminable stasis. For the male exile, place is unstable, yet productively
so: the world's instability impels him toward spiritual change as it simultane-
ously figures the ephemerality of earthly life and his own spiritual progress.

4. I have here outlined two very broad ways in which place was conceptualized by the Anglo-
Saxons, yet my remarks are not intended to be comprehensive or to reduce Anglo-Saxon attitudes
toward place to a strict social-spiritual binary. Anglo-Saxon senses of place were rich and varied, and
their complexities merit far more detailed investigation than I have been able to offer in this essay. For
insightful discussions, see Nicholas Howe, "The Landscape of Anglo-Saxon England: Inherited, In-
vented, Imagined," in *Inventing Medieval Landscapes: Senses of Place in Western Europe,* ed. John Howe
and Michael Wolfe (Gainesville: University Press of Florida, 2002), 91–112; see also Howe's 1999 Toller
Memorial Lecture, reprinted as "An Angle on This Earth: Sense of Place in Anglo-Saxon England,"
Bulletin of the John Rylands University Library of Manchester 82 (2000): 3–27. I am grateful to Nick for
sharing his ideas about place with me over the years.

5. Whether the elegies ought to be construed as forming a coherent generic category or whether
we might more accurately speak of an "elegiac tone" is a much-debated issue. Useful discussions
include Stanley B. Greenfield, "The Old English Elegies," in *Continuations and Beginnings: Studies in
Old English Literature,* ed. Eric Gerald Stanley (London: Nelson, 1966), 142–75; Joseph Harris, "Elegy
in Old English and Old Norse: A Problem in Literary History," in *The Old English Elegies: New Essays
in Criticism and Research,* ed. Martin Green (Rutherford, N.J.: Fairleigh Dickinson University Press,
1983), 46–56; Anne L. Klinck, *The Old English Elegies: A Critical Edition and Genre Study* (Montreal:
McGill-Queen's University Press, 1992), 223–51. For an insightful account of the ways in which
female-voiced elegies trouble standard definitions of Old English elegy, see Pat Belanoff, "*Ides . . .
geomrode giddum:* The Old English Female Lament," in *Medieval Woman's Song: Cross-Cultural Ap-
proaches,* ed. Anne L. Klinck and Ann Marie Rasmussen (Philadelphia: University of Pennsylvania Press,
2002), 29–46. Also helpful is Helen T. Bennett, "Exile and the Semiosis of Gender in Old English
Elegies," in *Class and Gender in Early English Literature: Intersections,* ed. Britton J. Harwood and Gillian
R. Overing (Bloomington: Indiana University Press, 1994), 43–58.

For the female exile, place is all too permanent, a space from which she can never escape and that does not prompt spiritual change but simply embodies her spiritual inertia and psychological torment. These very different configurations of gendered exile elucidate exile's close—and contingent—relationship to the social world. Although the exile inhabits the world's borders, both geographically and socially, exile in Old English elegies is figured less as a rejection or transgression of social norms than as a kind of overenthusiastic adherence to them.[6] Tracing the gendered logic that organizes representations of male and female exiles in Old English poetry reveals elegiac fiction as a medium whose vivid depictions of human misery allow forceful commentary on Anglo-Saxon gender roles, heroic life, and interpersonal relations between men and women.

STOPPED IN HER TRACKS

As we have seen, a major difference between male and female elegiac speakers is that the former are characterized by movement and the latter by stasis. Unlike the *eardstapa* (earth-stepper, *Wdr* 6a) and the Seafarer, whose identities are inextricably intertwined with their valiant efforts to cross land and sea, the female narrators in *The Wife's Lament* and *Wulf and Eadwacer* are notably unable to negotiate space.[7] Having been separated from her *freond*—either her male lover or husband—by his kinsmen, the Wife has been commanded "wunian on wuda bearwe" (to dwell in a grove of woods, 27). It is here that she "sittan mot sumorlangne dæg" (must sit the summerlong day, 37), the static nature of her body's position echoed in *Wulf and Eadwacer,* in which the speaker describes herself as one who "reotugu sæt" (sat wailing, 10b).[8] Significantly, the Wife describes exilic life as a *sið* (experience, 2a) or *wræcsið* (exile-experience, 5b, 38b). Unlike the Wanderer and the Seafarer, she never

6. For an important analysis of the exile's imbrication in social and cultural traditions, with particular attention to *The Wanderer,* see Robert E. Bjork, "*Sundor æt Rune:* The Voluntary Exile of the Wanderer," *Neophilologus* 73 (1989): 119–29; rpt. in *Old English Literature: Critical Essays,* ed. R. M. Liuzza (New Haven: Yale University Press, 2002), 315–27.

7. All citations from Old English poetry, except for *Beowulf,* are from George Philip Krapp and Elliott Van Kirk Dobbie, eds., *The Anglo-Saxon Poetic Records,* 6 vols. (New York: Columbia University Press, 1931–53), and are cited parenthetically by line number. *The Wanderer* is abbreviated as *Wdr; The Seafarer,* as *Sfr.* References to *Beowulf* are to Friedrich Klaeber, ed., *Beowulf and the Fight at Finnsburg,* 3rd ed. (Lexington, Mass.: Heath, 1950). All translations are my own.

8. Joseph Harris argues that "there seems to be a significant bond . . . between the scene of elegiac discourse and the verb 'to sit.'" See "Hadubrand's Lament: On the Origin and Age of Elegy in Germanic," in *Heldensage und Heldendichtung im Germanischen,* ed. Heinrich Beck, Ergänzungsbände zum Reallexikon der Germanischen Altertumskunde (Berlin: Walter de Gruyter, 1988), 81–114, at 96.

employs the more action-oriented term *wræclast* (path of exile, *Wdr* 5a, 32a; *Sfr* 57a).[9]

When female exiles do engage in physical or psychological motion, their experiences underscore a sense of their forced confinement. After the Wife learns of her lover's departure, she embarks on a voyage that will ostensibly allow them to be reunited. Yet her journey is abruptly halted when her lover's kin plot to separate them (9–14). Once installed in her new dwelling, the Wife is restricted to an endlessly repetitive cycle of movements dictated by her environment. She finds herself consigned to "ana gonge / under actreo geond þas eorðscrafu" (go alone under the oak-tree around the earth-cave, 35b–36). Similarly, when the female narrator in *Wulf and Eadwacer* attempts to imagine the *widlastum* (wide tracks, 9a) of her beloved Wulf that might bring them closer together, her mental journey is immediately arrested by Eadwacer, the "property-watcher" whose confining arms encircle her body and thus force her to redirect her thoughts from Wulf to himself.[10]

The physical and psychological stasis of female elegiac speakers is matched by their temporal stasis. The Wanderer and the Seafarer may look, Janus-faced, both to the former joys of the heroic hall and to the future bliss of the heavenly home, but female exiles remain firmly locked in an ineluctable present.[11] As Martin Green has demonstrated, both the syntax and the thematics of *The Wife's Lament* root the poem and its speaker in an ongoing present: through parataxis, apposition, verb tense usage, and imagery, the poem creates the sense of a "person suspended in time."[12] This sense of unrelenting "presentness" is shared by the female speaker in *Wulf and Eadwacer,* who, like the Wife, cannot fully experience either the past or the future. For both women, remembrance of times past is conditioned wholly by present miseries. Their anticipation of things to come centers on taking revenge on the men deemed responsible for their suffering.

9. To be sure, the term *sið* often carries the dual meanings of both "experience" and "journey." In the light of the Wife's physical, psychological, and temporal stasis, however, *sið* must be read here as "experience" rather than as a literal journey. For more on the terminology of exile, see Stanley B. Greenfield, "The Formulaic Expression of the Theme of 'Exile' in Anglo-Saxon Poetry," *Speculum* 30 (1955): 200–206.

10. In my reading of line 9, I follow the common practice of emending the unknown *dogode* to *hogode* and construing the verb with the dative *widlastum;* thus "I thought with hopes of my Wulf's wide tracks." An alternative is to view *widlastum* as an adjective modifying *wenum,* and hence "I thought with far-ranging hopes about my Wulf," a translation that lends the female speaker a greater sense of mental mobility. For further discussion, see Peter S. Baker, "The Ambiguity of *Wulf and Eadwacer,*" *Studies in Philology* 78 (1981): 39–51.

11. Martin Green, "Time, Memory, and Elegy in *The Wife's Lament,*" in *The Old English Elegies,* ed. Green, 123–32.

12. Ibid., 129.

The fact that female elegiac speakers are unable to negotiate space either literally or metaphorically takes on heightened significance when read in the light of one very common meaning attributed to movement in Old English elegies: spiritual progress. The Wanderer must tread the paths of earthly exile in order to recognize the essential mutability of the world, while the Seafarer must exchange the false *stabilitas* of life on land for the tumult of storm-tossed waters that will ultimately allow him to reach true *stabilitas* within the heavenly home. The ability to negotiate his environment—physically, psychologically, and intellectually—is figured as a crucial component of the male exile's spiritual awakening. Travel offers him an opportunity to send both body and mind on a kind of *peregrinatio pro amore Dei,* a voyage to another land for spiritual profit.[13] Although the sea is ice-cold (*hrimcealde sæ,* 4b) and "þas stanhleoþu stormas cnyssað" (storms beat against the rocky cliffs, 101), the Wanderer nevertheless trudges onward, the hardships of the natural world functioning as educative tools that help him recognize that "Eall is earfoðlic eorþan rice" (All is fraught with hardship on the kingdom of earth, 106). His ship is knocked about by the "atol yþa gewealc" (terrible rolling of the waves, 6a) and his extremities are "forste gebunden" (bound by frost, 9b), but the Seafarer nevertheless forges ahead, his anxieties regarding the dangers of seafaring a sign of his newfound awareness of the Lord's power (39–43).[14]

In male-voiced elegies, the natural world appears as a series of threatening forces that register human frailty in the face of social and spiritual alienation.[15] Cut off from the protective shelter of both the social world and God's love, the male exile must acknowledge his own vulnerability as a human and bodily being. The fierce northern hailstorms occasion deep terror in the Wanderer/wise man, while the frost's unrelenting grip drives the Seafarer to a fearful awareness of his own chilled hands and feet, as if recognizing his

13. On this theme, see Dorothy Whitelock, "The Interpretation of *The Seafarer,*" in *The Early Cultures of North-West Europe: H. M. Chadwick Memorial Studies,* ed. Cyril Fox and Bruce Dickins (London: Cambridge University Press, 1950), 261–72; rpt. in Jess B. Bessinger and Stanley J. Kahrl, eds., *Essential Articles for the Study of Old English Poetry* (Hamden, Conn.: Archon Books, 1968), 442–57; see also G. V. Smithers, "The Meaning of *The Seafarer and The Wanderer,*" and *Medium Ævum* 26 (1957): 137–53.

14. As Bruce Mitchell and Fred C. Robinson point out, these lines suggest a subtle shift in the poet's use of the term *dryhten.* The first *dryhten* (41b) clearly refers to the Seafarer's earthly lord, while the second *dryhten* (43a) is ambiguous and may refer to the Seafarer's fears about what the Lord has in store for him. This shift aids in the transition from a wholly secular to a more Christian understanding of seafaring. See *A Guide to Old English,* 6th ed. (Oxford: Blackwell, 2001), 279.

15. For further discussion of this point, see Jennifer Neville, *Representations of the Natural World in Old English Poetry,* Cambridge Studies in Anglo-Saxon England 27 (Cambridge: Cambridge University Press, 1999), 19–22.

body's limitations for the first time. Thus exposed to the vagaries of the elements, the male exile is reminiscent of the archetypal outcast, Adam, who was separated from God's love and forced to stand, as he put it, "baru . . . unwered wædo" (bare . . . unprotected by clothing, *Genesis* 811b–812a) while contemplating his and Eve's imminent expulsion from the "best of realms" and subsequent subjection to the merciless onslaught of the elements. Yet while physical struggles with the natural world symbolize the human weakness that both caused and resulted from Eden's loss, such struggles simultaneously register the profound emotional and intellectual challenges that can (and indeed must) be overcome in order to resituate oneself within heaven. Struggling against one's environment symbolizes the painful process of extricating oneself from the world's clutches and opening oneself to the Father's embrace. Thus, while the natural world constantly threatens to derail the exile's journeys, it also serves as a productive force that, if interpreted correctly, has the capacity to propel him on his journey and provide temporary comfort along the way. As the Seafarer points out, for all of the natural world's power, man nevertheless asserts hermeneutic control over this world: he interprets it as he wishes and forces it to signify according to his will. While he who has experienced the joy of life in the cities (i.e., the spiritually dead landlubber) might read blossoming groves and lovely meadows as some of the world's most beneficent attractions, the Seafarer sees these natural delights as a further impetus to seafaring:

> Bearwas blostmum nimað, byrig fægriað,
> wongas wlitigiað, woruld onetteð;
> ealle þa gemoniað modes fusne
> sefan to siþe, þam þe swa þenceð
> on flodwegas feor gewitan.
>
> (*Sfr* 48–52)

[The groves take blossom, the cities grow fair; the meadows become lovely, the world revives. All these things exhort the eager-spirited one, urge the mind to the journey, by which he thus intends to travel far over the flood-ways.]

While others less attuned to the productive possibilities of exile might read the cuckoo as simply a *sumeres weard* (guardian of summer, 54a), the Seafarer views the bird as a harbinger of sorrow whose exhortations impel him to send his mind over the whale-road.

The Seafarer's ability to interpret the natural world correctly enables him to turn it to his advantage. In his harsh environment, he finds comfort and additional strength for his journey. Birds become surrogates for his former human companions, their songs proxies for the former delights of the hall:

> Hwilum ylfete song
> dyde ic me to gomene, ganetes hleoþor
> ond huilpan sweg fore hleahtor wera,
> mæw singende fore medodrince.
>
> <div align="right">(Sfr 19b–22)</div>

[Sometimes I took my entertainment in the song of the wild swan, the cry of the gannet and the sound of the curlew in place of the laughter of men, the singing gull in place of the drink of mead.]

The male exile's ability to navigate his world intellectually reveals his capacities for other forms of nonliteral movement. Both the Wanderer and the Seafarer send not only their bodies but also their hearts and minds over the ocean road (Wdr 55b–57; Sfr 58–64a). Both men are also highly adept at temporal movement, their skills most visible in their capacity for traveling back into the past and dallying within the former bliss of heroic life. Just as his literal travels both enable and symbolize spiritual progress, the male exile's mental journeys back to the heroic world are also productive, allowing him to recognize that seledreamas (hall-joys) are merely transitory delights parading in the guise of true and everlasting dryhtnes dreamas (joys of the Lord, Sfr 65a). One ought not mistake the intense pleasure of these nostalgic forays back into the heroic world as lapses in spiritual progress. Rather it is these mental journeys back to the heroic world that enable the male exile to divest himself of its claims. Memorialization of the heroic world allows him to lay it to rest.

In the case of female-voiced elegies, the absence of any consolatory spiritual turn makes it impossible to read the female exile's stasis as analogous to that of her male cohort's travels, as a necessary stage in spiritual progress. Unlike the Wanderer and the Seafarer, who experience exile as a series of productive confrontations between self and environment, female elegists experience exile as a dissolution of the boundaries between their internal and external worlds. For them, the natural world is neither a necessary impetus nor a temporary comfort on the road to spiritual change but simply an externalization of their psychological torment. The dena dimme (gloomy valleys, 30a) and wic wynna leas (place lacking in joys, 32a) symbolize the Wife's own

gloomy and joyless outlook; the *renig weder* (rainy weather, 10a) in *Wulf and Eadwacer* mirrors the speaker's sorrow.[16]

Once externalized in the natural world, these feelings take on lives of their own, defying female will as well as Old English linguistic norms for expressing emotion. As Malcolm Godden has shown, the Anglo-Saxons typically figured emotions as acts of personal volition. In Old English one does not speak of feeling sad, angry, hostile, or affectionate; one speaks instead of *taking* various emotions, as in the Modern English expression "to take courage."[17] Yet the Wife perceives her own emotions as external forces that take hold of her, ceaselessly restricting her movement but never permitting real rest. Claiming that "eal ic eom oflongad" (I am entirely seized by longing, 29b), the Wife laments that she cannot escape from "ealles þæs longaþes þe mec on þissum life begeat" (all of that sorrow which has taken hold of me in this life, 41).

Far from encouraging motion for the female exile, the natural world appears to collude in her entrapment, imprisoning her within a landscape whose topographical features seem designed to hinder movement and restrict travel. The Wife dwells in an *eorðsele* (earth-hall, 29a) surrounded by "dena dimme, duna uphea, / bitre burgtunas, brerum beweaxne" (dim valleys, lofty hills, bitter protecting hedges, overgrown with briars, 30–31). The speaker in *Wulf and Eadwacer* is also separated from her lover by the landscape: he is *on iege* (on one island, 4a) and she *on operre* (on another, 4b).

As these places restrict the female exile's literal movement, they also concretize her earthbound spiritual state and her alienation from the divine. The Wife inhabits a *herheard* (15b), a term whose evocation of a "pagan temple" takes on further force when read alongside the twice-mentioned *actreo* (oak tree, 28a, 36a) that encases it. Groves, and especially oak trees, were associated with early Germanic pagan worship.[18] The Wife's *eorðscræf* (28b, 36b) or *eorðsele* (29a) further emphasize her rootedness in earthly life, particularly when these structures are read in their cultural context. If, as Paul Battles argues, the Wife's *eorðsele* is intended to evoke a subterranean shelter of the

16. That Old English elegies use the environment to help convey a sense of the elegiac speaker's moods and feelings is a fairly standard point. See, for example, Green, "Time, Memory, and Elegy," 125. Nicholas Howe has recently developed this idea in his perceptive discussion of the elegies in "The Landscape of Anglo-Saxon England," 103–8.

17. M. R. Godden, "Anglo-Saxons on the Mind," in *Learning and Literature in Anglo-Saxon England: Studies Presented to Peter Clemoes on the Occasion of His Sixty-Fifth Birthday*, ed. Michael Lapidge and Helmut Gneuss (Cambridge: Cambridge University Press, 1985), 271–98; rpt. in *Old English Literature*, ed. Liuzza, 284–314, at 299.

18. See Karl P. Wentersdorf, "The Situation of the Narrator in the Old English *Wife's Lament*," *Speculum* 56 (1981): 503–11.

sort used as a hideaway or for protection during Viking invasions,[19] it likely would have recalled one of the more common Anglo-Saxon rationales for those invasions—i.e., failed Christian worship.[20] The *eorðsele* thus underscores the Wife's alienation from Christian culture. Thus while the male exile's movement symbolizes his spiritual progress and affirms the transience of earthly life, the female exile's stasis symbolizes her spiritual inertia and asserts the permanence of life within the world—a world that is, indeed, too much with her.

HEROIC PROBLEMS

Another striking difference between male and female elegiac speakers is that the former exhibit acute ambivalence toward the heroic world, while the latter view it as a more straightforward cause of their misery. Although the Wanderer is "earfeþa gemyndig, / wraþra wælsleahta, winemæga hryre" (mindful of hardships, of cruel slaughters, of the deaths of kinsmen, 6b–7), his remarks are nevertheless balanced by poignant memories of former *sele-dreamas* (hall-joys, 93b) and the hope that his journey will lead him to new ones (25–29a). And for all of the Seafarer's claims to scorn "þis deade lif, / læne on londe" (this dead transitory life on earth, 65b–66a) in favor of the "dryhtnes dreamas" (Lord's joys, 65a), his obsessive interest in detailing "ealle onmedlan eorþan rices" (all of the magnificence of the earthly kingdom, 81) and the great days of yore, when "cyningas . . . caseras . . . goldgiefan . . . þonne hi mæst mid him mærþa gefremedon / ond on dryhtlicestum dome lifdon" (kings, emperors, and gold-givers performed among themselves the greatest of glorious deeds and lived in the most lordly splendor, 82–85), attests to his sincere regard for the heroic world and his deep sorrow at its demise. Although both speakers acknowledge the heroic life's darker side, its feuding and deaths, each offers moving reflections on its brighter aspects as well. For the male exile, emotional turmoil is located as much in the painful process of decathecting from the heroic world and witnessing its passing as in acknowledging the pain, death, and loss that were so endemic to it.

19. Paul Battles, "Of Graves, Caves, and Subterranean Dwellings: *Eorðscræf* and *Eorðsele* in the *Wife's Lament,*" *Philological Quarterly* 73 (1994): 267–86. See also the important discussions by Joseph Harris, "A Note on *eorðscræf /eorðsele* and Current Interpretations of *The Wife's Lament,*" *English Studies* 58 (1977): 204–8, and Wentersdorf, "The Situation of the Narrator," 498–503.

20. Malcolm Godden, "Apocalypse and Invasion in Late Anglo-Saxon England," in *From Anglo-Saxon to Early Middle English: Studies Presented to E. G. Stanley,* ed. Malcolm Godden, Douglas Gray, and Terry Hoad (Oxford: Clarendon Press, 1994), 130–62, esp. 130–42.

By contrast, female exiles grant these very literal miseries center stage in their laments. Dwelling on their forced separation from their male lovers, the female speakers in both *The Wife's Lament* and *Wulf and Eadwacer* attribute their misery to broader social structures that interfere with male-female relations and require men to collude in their own physical and emotional alienation from women. Although the specific causes of the Wife's exile are notoriously difficult to ascertain, her laments repeatedly return to one very broad explanation: the exigencies of heroic culture, specifically, feuding between kin groups.

The Wife first experiences the loss of her lover when he travels overseas with his retainers (*leodfruma*, "people-leader," 8a), and again when his people plot to separate them (11–14). The Wife's subsequent claim that her lover has commanded her to dwell in her present abode (15) suggests his collusion with his kin, while her characterization of him as "mod miþendne, morþor hycgendne" (concealing his mind, plotting murder, 20) underscores his emotional likeness to them. The lover's kin are said "hycgan / þurh dyrne geþoht" (to plot with secret thought, 11b–12a). Similarly, while we cannot be sure why the female speaker in *Wulf and Eadwacer* has been parted from her beloved Wulf, her characterization of him as a *lac* (gift, 1b) given to her people and her repeated claims that they *willað hy hine aþecgan* (they will kill/receive him, 2a, 7a) strongly suggest that interfamilial strife is responsible for their separation. The Wife's statement that "Sceal ic feor ge neah / mines felaleofan fæhðu dreogan" (I must far and near suffer the enmity of my beloved, 25b–26) illustrates the sense that blood feuds between families pose a serious threat to interpersonal relationships between men and women. Although *fæhð* is a fairly standard term for "feud" or "enmity," it is unclear whether the phrase *felaleofan fæhðu* refers to a military feud that engages the lover (and thus forces the Wife to suffer its consequences) or to a personal rift between the Wife and her lover that is figured in the language of heroic warrior culture. Clearly, though, the Wife's claim forges a powerful link between heroic violence and the sundering of male-female interpersonal relations. It suggests the hostility between the two realms as well as the impossibility of trying to conceive of them as discrete entities.

Given that female elegiac speakers closely connect their misery to heroic culture, it is not surprising that they neither mourn its demise nor long for its return. Unlike their male-voiced counterparts, female-voiced elegies contain no references to lost treasures, cups, harps, feasts, war-gear, or generic hall-joys. On the very few occasions that these speakers do recall the happier times of the past, their focus is on personal interactions rather than the com-

mon delights of the heroic world. When the Wife looks back on the past, for example, she remembers that

> ful oft wit beotedan
> þæt unc ne gedælde nemne deað ana
> owiht elles

<div align="right">(21b–23a)</div>

[Very often we two boasted that nothing but death alone would separate us.]

For the Wife, female happiness resides neither in the heroic hall nor in a heavenly home forged in its image but in an imaginary private space cut off from the encroachments of heroic life. This intensely personal space of male-female relations is more reminiscent of late medieval romances in which the world temporarily recedes and leaves the lovers alone in bed. Comparing her own misery to those whose lot is better, the Wife asserts:

> Frynd sind on eorþan,
> leofe lifgende, leger weardiað

<div align="right">(33b–34)</div>

[Friends are on earth, lovers living, occupy(ing) their beds.]

Indeed, it is telling that the sole reference to pleasure in *Wulf and Eadwacer,* however ambivalent, occurs when the speaker imagines herself in Eadwacer's arms: "wæs me wyn to þon, wæs me hwæþre eac lað" (there was joy for me in that; there was also pain, 12). Unlike the male elegiac speaker who imagines exile as estrangement from the hall, female elegiac speakers characterize exilic life as a separation from their lovers. These women do not mourn loss of place but loss of person.

This is not, however, to claim that male-voiced elegies fail to recognize the importance of interpersonal bonds. Some of the most memorable passages in male-voiced elegies center on the acute misery occasioned by the loss of one's war-lord. Yet the lost *hlaford* is imagined less as an absent friend or fallen leader than as a metonym for the lost hall and the heroic world that the male exile has left behind. When the Wanderer envisions himself in exile, he characterizes himself as "sele dreorig" (sad for the lack of a hall, 25a) and in search of a new "sinces bryttan" (treasure-giver, 25b) who might offer him

comfort and joy "in meoduhealle" (in the mead-hall, 27a). The lord and the hall are linked later on, too, in an *ubi sunt* lament in which the speaker (either the Wanderer or the wise man) successively mourns the lost *maþþumgyfa* (treasure-giver), *symbla gesetu* (seat of feasting), and *seledreamas* (hall-joys, 92b–93). Thus unlike the female exile, who views the heroic world as a threat to her relationship with her beloved *hlaford,* the male exile views that world as a haven for those bonds of love.

Because male and female elegiac speakers maintain very different attitudes toward the heroic world, their respective reflections on the impossibility of nostalgic return take on different meanings. Both *The Wanderer* and *The Wife's Lament* suggest that the pleasures of the past may never really have existed at all. Following his passionate *ubi sunt* lament for the demise of the heroic world, the Wanderer (or wise man) ultimately acknowledges that that time has departed "swa heo no wære" (as if it never were, 96b). Likewise, when the Wife reflects on her former *freondscipe* with her beloved, she claims that their current separation makes it seem as if that relationship never existed at all ("swa hit no wære," 24). Because the Wanderer/wise man gestures toward an awaited heavenly future, his assertion that the joys of the heroic past may never have truly existed reminds the reader of the ephemerality of earthly pleasures and evokes the greater stability of heaven's future joys. The Wife's lament, though, lacks any such consolatory turn. Her foreclosure of nostalgia thus focuses the reader squarely on her present misery.[21] Unable to find happiness either in memories of the heroic past or in anticipation of the heavenly future, the female exile demands an intense reckoning with the present, urging readers to recognize that human misery is caused not by separation from God but by social systems that separate men and women from one another.

Unlike both *The Wanderer* and *The Seafarer,* then, which dismiss male-female interpersonal relations as ephemeral worldly pleasures ideally relinquished in the pursuit of higher spiritual goals, female-voiced elegies assert the importance of physical and emotional connections between men and women and lament the inadequacy of a social world that disallows them.[22]

21. For more on these lines, see Belanoff, "*Ides . . . geomrode giddum,*" 32, 36.

22. In *The Seafarer,* women are grouped with such earthly pleasures as the harp, ring-receiving, and generic world-joys, all of which are voluntarily relinquished by the Seafarer for a higher, more difficult goal: "Ne biþ him to hearpan hyge ne to hringþege, / ne to wife wyn ne to worulde hyht, / ne ymbe owiht elles, nefne ymb yða gewealc" (44–46). In *The Wanderer,* women are mentioned as part of a catalogue of transitory worldly things that include possessions, friends, and other men: "Her bið feoh læne, her bið freond læne / her bið mon læne, her bið mæg læne" (108–9). I construe *mæg* here as "woman" rather than the more standard "kinsman." Although both are viable translations, I am

These elegies simultaneously point to the dangers, though, of locating female identity solely in those relationships. As they voice this warning, they join forces with their male-voiced counterparts to articulate a broader social truth. Whether one experiences the lost *hlaford* as one's war-lord or as one's lover, Old English elegies powerfully assert that misery proceeds from the absence of men—and remind us that in Anglo-Saxon England, the most valued relationships were indeed those forged with men.

THE SOCIAL LIFE OF EXILE

Given that female elegiac speakers attribute their misery to the strictures of heroic culture, one might expect their laments to encapsulate a wholesale rejection of that world. Yet far from rejecting heroic culture, these women persistently replicate its social norms, using exile as a space to re-create the very culture deemed responsible for their misery.

As several scholars have noted, the Wife's *eorðsele* recalls the mead-hall, the heart of the heroic world; her endless walk around that space reenacts the ritualized, restricted movement of the good *hlæfdige* circling the hall to serve male guests.[23] Moreover, in taking the lament as their preferred genre, the female speakers in both *The Wife's Lament* and *Wulf and Eadwacer* situate themselves squarely within the norms of heroic femininity. As Joyce Hill has shown, the *geomuru ides* (sad woman) is a stock figure within heroic poetry. Her wails highlight the miseries intrinsic to heroic culture and lend meaning to the lives lost in its name.[24] In turning to any form of speech as a means of self-expression and social critique, female elegiac speakers adopt a culturally acceptable and even obligatory form of power granted them within heroic society. We have only to think of the allusive (and elusive) speeches of such female figures as Wealhtheow, Elene, and Judith to be reminded that the

convinced by Anne L. Klinck's argument that "woman" provides a better balance with *mon* in the a-verse: Klinck, *The Old English Elegies*, 126.

23. On the *eorðsele* as a parodic inversion of the mead-hall, see Jane Chance, *Woman as Hero in Old English Literature* (Syracuse, N.Y.: Syracuse University Press, 1986), 92, and also Marilynn Desmond, "The Voice of Exile: Feminist Literary History and the Anonymous Anglo-Saxon Elegy," *Critical Inquiry* 16 (1990): 572–90, at 586.

24. Joyce Hill, "'Þæt Wæs Geomuru Ides! A Female Stereotype Examined," in *New Readings on Women in Old English Literature*, ed. Helen Damico and Alexandra Hennessey Olsen (Bloomington: Indiana University Press, 1990), 235–47. For more on the cultural work performed by female mourning, see Patricia Clare Ingham, "From Kinship to Kingship: Mourning, Gender, and Anglo-Saxon Community," in *Grief and Gender, 700–1700*, ed. Jennifer C. Vaught with Lynne Dickson Bruckner (New York: Palgrave, 2003), 17–31.

half-gnomic, half-prophetic declarations that conclude both *The Wife's La-
ment* and *Wulf and Eadwacer* are fairly standard fare for women in heroic
poetry.

Yet the speech found in female-voiced elegies is also, in many ways, dis-
tinctly antiheroic. As the examples of Hildeburh or the nameless Geatish
woman at Beowulf's funeral demonstrate, women in heroic poetry are gen-
erally charged with the duty of mourning not only lost men but also lost
worlds. When Hildeburh places the bodies of her brother and son alongside
one another on the funeral pyre, she mourns the loss of male kin and also the
loss of tribal unity between the Danes and the Jutes. Similarly, when the
Geatish woman foresees a future filled with heavy days, a great number of
slaughters, the terror of invading armies, humiliation, and captivity, she points
to the misfortunes that lie in store for her entire community. In contrast, the
female narrators in both *The Wife's Lament* and *Wulf and Eadwacer* mourn
solely for themselves. To be sure, elegy is partly defined by its confessional
and personal nature. Nevertheless, the fact that female elegists wholly elide
any mention of social ruin or communal dissolution is striking, particularly
when this poetry is read alongside *The Wanderer, The Seafarer,* and *The Lament
of the Last Survivor* (*Beowulf* 2247–66). Their male speakers insistently focus
the gaze on the sorrows of communal demise.

Female elegists also sharply depart from the heroic mode in their intense
desire to occasion misery among men. We have only to recall such figures as
Hildegund, for instance, urging her lover to heroic valor, or Wealhtheow,
desperately seeking to preserve loyalty and concord among her husband's
retainers, to remember that female voices in Old English poetry are generally
pressed into the service of energizing, inspiring, and assisting men.[25] Whether
as public mourners, whetting women, or trusted counselors, women in Old
English poetry are typically charged with the responsibility of furthering the
goals of their male relatives.

Female elegists, however, end up using their voices to destroy men and
disrupt the heroic world. Both *The Wife's Lament* and *Wulf and Eadwacer* end
with their female narrators aiming prophetic, curse-like statements in the
direction of their male lovers.[26] Although the curses issued by the two speak-
ers differ in their respective details, they nevertheless share a remarkable num-
ber of themes. Most notably, both speakers hope to perpetuate male exile
(and thus prevent men from participating in the heroic world) and to break

25. See, for example, *Waldere,* lines 1–32, and also *Beowulf,* 612b–31, 1168b–91, 1215–31b.
26. See Barrie Ruth Straus, "Women's Words as Weapons: Speech as Action in 'The Wife's La-
ment,'" *Texas Studies in Literature and Language* 23 (1981): 268–85.

down or eradicate the boundaries of sexual and gender difference. A number of scholars have pointed out that the most notable feature of the Wife's curse upon her lover is that it condemns him to a life of exilic misery that mirrors her own.[27] Just as she has endured great sorrow ("ful geomorre," 1b), so, too, will he be always sad in mind ("A scyle geong mon wesan geomormod," 42). She has been forced to live alone, without friends (16–17a, 33b–35), and he, too, will be forced to depend solely on himself (45b–46a). She has suffered ceaseless *modcearu* (grief of heart, 40a), and he will endure similar mental torment ("Dreogeð se min wine / micle modceare," 50b–51a). She has inhabited a "wic wynna leas" (an abode lacking in joys, 32a), and he will "gemon to oft / wynlicran wic" (remember too often a happier abode, 51b–52a). And just as she is forced to sit in an *eorðsele* (29a), so, too, will he be forced to sit in a hall filled with sorrow: "þæt min freond siteð . . . on dreorsele" (47b–50a). Yet what has not been adequately remarked on is that the Wife condemns her lover to an exile in which he will be forced not only to suffer but also to sit. In cursing her lover with a form of exile in which he must sit rooted, earthbound, and longing for his beloved rather than forging ahead in wandering or seafaring, the Wife enacts a feminization of her lover. By the end of the curse, in fact, the fates of the Wife and her lover have merged to the point where they are virtually—though not completely—indistinguishable. The Wife imagines her lover enduring an exilic life that is not wholly feminized. Rather, her curse calls up the worst traits of feminine *and* masculine exile: the physical stasis characteristic of female elegiac speakers and the emotional reserve demanded of exiles like the Wanderer and the Seafarer. Straitjacketed within the bonds of female lament and heroic maxim, forced to live by the strictures of both feminine stasis and masculine stoicism, the cursed lover's experience will be a bizarre conflation of gendered exilic life.

The speaker in *Wulf and Eadwacer* introduces a similar break in the heroic order by threatening her current lover, Eadwacer, with the loss of a child who is either his or Wulf's:

> Gehyrest þu, Eadwacer?　　Uncerne earne hwelp
> bireð wulf to wuda.
>
> (16–17)

> [Do you hear, Eadwacer? Wulf will bear our wretched offspring to the woods.]

27. Ibid., 278.

As Anne Klinck points out, the wolf was both a symbol of exiles and their companion.[28] When the speaker claims that Wulf will carry off the child, she marks it as destined for exile. The narrator's apparent complicity in her child's exile suggests a desire to disrupt the heroic world by refusing to produce children who would ensure its continuance. While the Wife works to extinguish gender difference by condemning her husband to a kind of androgynous exile, the narrator in *Wulf and Eadwacer* seeks to annihilate one of the more potentially positive fruits of sexual difference: a child fully equipped to participate in society.

Perhaps the strongest way in which female elegiac speakers use exile to re-create as well as critique social norms is in their depiction of stasis. Scholars such as Roberta Gilchrist and Jane Tibbetts Schulenburg have shown that the active and passive enclosure of early medieval women religious was a vast material (and immaterial) cultural enterprise.[29] The physical structuring of early medieval female monasteries and the language of contemporary monastic writings all worked to create a sense that the ideal female body was one that was restricted in movement.[30] Indeed, ideologies of female enclosure were not applied solely to female religious, nor were they relegated only to monastic discourse. Boniface's letter to the archbishop of Canterbury (747), for example, advises against travel for both secular women and female monastics. According to Boniface, the Frankish churchmen agreed that

> it would be well and favorable for the honor and purity of your
> church, and provide a certain shield against vice, if your synod and
> your princes would forbid matrons and veiled women [*mulieribus et*

28. See *Maxims I,* lines 146–51, cited and further discussed in Belanoff, "*Ides . . . geomrode giddum,*" 41–42. See also Klinck, *The Old English Elegies,* 171.

29. See Roberta Gilchrist, *Gender and Material Culture: The Archaeology of Religious Women* (London: Routledge, 1994), esp. 63–91 and 150–69, and also Jane Tibbetts Schulenburg, "Strict Active Enclosure and Its Effects on the Female Monastic Experience (ca. 500–1100)," in *Medieval Religious Women,* vol. 1, *Distant Echoes,* ed. John A. Nichols and Lillian Thomas Shank (Kalamazoo, Mich.: Cistercian Publications, 1984), 51–86.

30. Injunctions for the enclosure of women religious were so pervasive throughout the early and later Middle Ages that Shari Horner has argued for female-voiced elegies as manifestations of a "discourse of enclosure derived from the increasingly restrictive conditions of early medieval female monasticism." In Horner's view, the profound emphasis these poems place on female enclosure marks them as part of a discursive system that seeks to "legislate female enclosure" as a social norm. See Shari Horner, *The Discourse of Enclosure: Representing Women in Old English Literature* (Albany: State University of New York Press, 2001), with discussion of the elegies at 29–63 and quotations at 6 and 14. In response to Horner's argument, it is worth noting that monastic discourse tends to depict female enclosure as spiritually beneficial to women, while the elegies equate the enclosed female self with separation from God and lack of spiritual progress. The elegies do not work to legislate female enclosure; rather, they suggest that it is socially and spiritually dangerous.

velatis feminis][31] to make these frequent journeys back and forth to Rome. A great part of them perish and few keep their virtue. There are very few towns in Lombardy or Frankland or Gaul where there is not a courtesan or a harlot of English stock. It is a scandal and a disgrace to your whole church.[32]

The gnomic collection *Maxims I* contains similar injunctions against female travel, enjoining wives to remain at home and defining travel as the rightful domain of men:

> Fæmne æt hyre bordan geriseð;
> widgongel wif word gespringeð . . .
>
>
>
> leof wilcuma
> Frysan wife, þonne flota stondeð;
> biþ his ceol cumen ond hyre ceorl to ham,
> agen ætgeofa, ond heo hine in laðaþ,
> wæsceð his warig hrægl ond him syleþ wæde niwe,
> liþ him on londe þæs his lufu bædeð.
> Wif sceal wiþ wer wære gehealdan
>
> (63b–64a, 94b–100a)

[A woman belongs at her embroidery. A woman who roves widely gives rise to words. . . . The beloved one is welcome to the Frisian wife when the ship comes to rest. His ship has come and her man is home, her own provider, and she leads him in, washes his stained garments and gives him fresh clothing, grants him on land whatever his love demands. A wife ought to keep faith with her husband.]

As in Boniface's letter, female travel here appears to border on sexual licentiousness. The good wife is depicted as the Frisian wife—or the stay-at-home seamstress who waits, Penelope-like, for her husband's return. Travel seems synonymous with uncontrolled sexuality; stasis is viewed as a precondition for marital fidelity, wifely continence, and emotional steadfastness.

Yet as the ensuing verses in *Maxims I* make clear, female stasis cannot serve

31. M. Tangl, ed., *Die Briefe des heiligen Bonifatius und Lullus,* 2nd ed. Monumenta Germaniae Historica: Epistolae Selectae 1 (Berlin: Weidmann, 1955), 169.

32. Ephraim Emerton, ed. and trans., *The Letters of Saint Boniface* (New York: Norton, 1976), 140; quoted in Schulenburg, "Strict Active Enclosure," 67.

as a guarantor of sexual fidelity. The woman who is left behind while her
lover embarks on his travels may likely seek solace in "entertain[ing] strange
men while the other journeys away" ("freoð hy fremde monnan, þonne se
oþer feor gewiteþ," *Maxims I*, 102). This anxiety is borne out in *Wulf and
Eadwacer:* the female speaker, abandoned by one man, finds temporary plea-
sure in the arms of another. Moreover, female-voiced elegies suggest that
abandoned women may well engage in behavior that is far more threatening
to men than brief lapses in sexual fidelity. The unrelenting sorrow expressed
in these poems powerfully reminds readers of women's capacity for enduring
devotion to their lovers. Both the *The Wife's Lament* and *Wulf and Eadwacer*
dramatize, in fact, precisely the kind of emotional steadfastness enjoined by
such texts as *Maxims I*. Yet the result of such limitless continence is rather
frightening. Denied the chance for physical, psychological, or temporal
movement, and left only with the power of speech, female exiles turn their
energies toward the destruction of those for whom they wait. Their elegies
represent the abandoned woman as one who refuses to sit and industriously
prepare for her husband's return. Instead, she seeks solace in cursing her
male beloved. Female-voiced elegies thus urge a reconsideration of social
imperatives for female enclosure.

To be sure, resistance to enclosure is unsuccessful at an individual level.
The narrators in both of the female-voiced elegies remain locked in place,
undeniably rooted to either *eorðsele* or *iege* and consigned to reenact, in perpe-
tuity, the gender roles prescribed by the societies that have occasioned their
misery. Yet in pointing to the literal dangers that female stasis poses to men
and the spiritual dangers it poses to women, these texts ask readers to recog-
nize female enclosure as indicative of social breakdown—not, as Boniface
would have it, of church honor and purity. Female stasis signifies the inherent
problems of heroic culture, of political relations between tribes gone awry.
These texts invert Bede's depiction of a once-ideal society, a time during
Edwin's reign when men ruled well and women walked freely: "It is related
that there was so great a peace in Britain, wherever the dominion of King
Edwin reached, that, as the proverb still runs, a woman with a new-born
child could walk throughout the island from sea to sea and take no harm."[33]
In female-voiced elegies, women cannot roam; interfamilial feuding immo-
bilizes the female exile. Thus restrained, she is neither socially beneficial to
men nor spiritually productive to herself. Rather, she becomes a dangerous
force—lending truth to the Wife's claim that not good things, but woe, will
come to those who wait.

33. *Ecclesiastical History*, II.16, p. 193.

5

SPATIAL METAPHORS, TEXTUAL PRODUCTION, AND SPIRITUALITY IN THE WORKS OF GERTRUD OF HELFTA (1256–1301/2)

Ulrike Wiethaus

"Mystics are happier. Ecstasy is good for you." So concludes Andrew Greeley's famous 1975 study on the correlation between mystical experiences and mental health, corroborated in numerous clinical and sociological studies comparing mystical experiences and psychopathology.[1] My essay explores the adaptive value of mystical experiences and the self-reflective exploration of monastic life in the writings of the Cistercian author and teacher Gertrud of Helfta. Attention to the ways in which Gertrud evoked place and space offers us fresh insights into the creativity of the "new mysticism" of the thirteenth century.[2] In her main works, the co-authored *Legatus divinae pietatis* (*Herald of Divine Love*) and the *Exercitia spiritualia* (*Spiritual Exercises*), concrete spatial references demarcate changes in states of consciousness and state-specific

I wish to thank Wake Forest University and King's College London for their generous financial support and the organizers and participants *(sans peur et sans reproche . . .)* of the 2003 Sneaton Castle Centre conference, "A Place to Believe In: Medieval Monasticism in the Landscape," for their stimulating insights and gracious feedback.

1. Quoted in David M. Wulff, "Mystical Experience," in *Varieties of Anomalous Experience: Examining the Scientific Evidence,* ed. Etzel Cardena, Steven Jay Lynn, and Stanley Krippner (Washington, D.C.: American Psychological Association, 2000), 411.

2. The helpful term "new mysticism" has been coined by Bernard McGinn. See volume 3 of his study of Western Christian mysticism, *The Flowering of Mysticism: Men and Women in the New Mysticism (1200–1350)* (New York: Crossroad Herder, 1998).

mystical knowledge. These references create a certain coherence and communicability between mystical and non-mystical states—and between the mystical teacher and her students. References to familiar spaces anchor spiritual practices and affirm the sacral character of local communities and local knowledge, if not the nuns' spiritual autonomy. Specific techniques, such as imaginatively superimposing architectural maps onto the human body during times of devotional reverie, could even generate new devotional practices.[3]

Much of Gertrud's particular type of mysticism is built upon personal experiences of divine love within liturgical and communal frameworks. Replicating familial networks of protection, she presents the divine as gentle father, brother, and bridegroom. Her spiritual states of consciousness are consistently described as blissful and aesthetically pleasing, with only a few references to demonic or otherwise fearful experiences. In her optimistic and joyous affirmation of life and a benevolent divinity, one might think of her as the German Julian of Norwich (ca. 1343–after 1416).

Gertrud was placed in the monastic community at Helfta at the age of five. Dedicated to the Virgin Mary, the original Cistercian house, near Halberstadt, was founded in 1229 by Count Burchard of Mansfeld and his spouse, Sophie. Community life began with seven nuns who transferred to the well-endowed foundation from Halberstadt. The monastery's location proved to be highly unstable: within five years, the nuns moved to Rodarsdorff. Forced to relocate again due to water shortage, the community eventually settled in Helffede, know today as Helfta, by 1258 (fig. 18). The Helffede buildings were destroyed in 1342, and the community was forced to resettle once more, this time in Eisleben. The final destruction of the Helfta monastery occurred in 1525 during the so-called Peasant War.[4]

The Helfta nuns were educated and literate, and Gertrud benefited greatly from her monastic schooling. She excelled in the study of the seven liberal arts. As she self-effacingly put it, she had built "a tower of vanity and worldliness" in her youthful pride.[5] The anonymous author of Book I of the *Legatus*

3. For feminist implications and theoretical reflections that can be applied to Gertrud's innovative use of spatial frameworks, see *Bodyspace: Destabilizing Geographies of Gender and Sexuality,* ed. Nancy Duncan (London: Routledge, 1996).

4. See Johanna Lanczkowski's summary of the Helfta monastery's history in *Gertrud die Große von Helfta, Gesandter der göttlichen Liebe [Legatus Divinae Pietatis],* trans. Lanczkowski (Darmstadt: Wissenschaftliche Buchgesellschaft, 1989), 567.

5. "Nitebaris turrim vanitatis et curialitatis meae, in quam superbia mea excreverat." See Pierre Doyère, ed., *Gertrude d'Helfta: Oeuvres spirituelles,* Tomes I–V, *Le Heraut; Les Exercises,* Sources chrétiennes, vols. 127, 139, 143, 255, 331 (Paris: Editions du Cerf, 1968–86). Translation by Margaret Winkworth, *Gertrude of Helfta: The Herald of Divine Love* (New York: Paulist Press, 1993), II.1. Unless noted otherwise, all Latin and English quotations are from the Sources chrétiennes series and Winkworth's edition; references to the *Legatus* are by book and chapter number.

FIG. 18 Map of Helfta. From Emilie Zum Brunn and Georgette Epiney-Burgard, *Women Mystics in Medieval Europe* (New York: Paragon House, 1989). Courtesy Brepols Publishers.

testified to Gertrud's intelligence and learning with less deprecation, noting, "She was so amiable, clever, and eloquent, and so docile that she was admired by all who heard her. As soon as she was admitted to the school, she showed such quickness and intelligence that she soon far surpassed in learning and knowledge all the children of her own age. . . . gladly and eagerly she gave herself to the study of the liberal arts."[6]

Her visionary life seems to have been precipitated by a crisis of faith in her secular studies and intellectual accomplishments; as she saw it, her single-minded focus on her intellectual work kept her from fulfilling her monastic duties. Not unlike the French intellectual Heloise (ca. 1098–1164), she lamented her failures as a nun: "I uselessly wore the habit and meaninglessly called myself a nun."[7] Gertrud recounted the beginnings of her visionary life with almost mathematical precision. If we can trust her account as literal and not metaphorical, Gertrud experienced her first vision around 1282, at the age of twenty-six, and thus during the Beguine writer Mechthild of Magdeburg's (ca. 1212–ca. 1282) decline and death at Helfta. The vision is preceded by the description of a severe personal crisis.[8]

Eight years later, now aged thirty-four, Gertrud began to write about her incrementally gained mystical knowledge by trying her hand at different devotional genres. She was able to pursue her literary work for about a decade. (Gertrud eventually died of what was diagnosed as liver disease, although the *Legatus* mentions other serious illnesses as well.) Gertrud's Latin works comprise most books of an unusual collection of co-authored Helfta texts, the *Legatus,* and the *Exercitia,* a tightly structured collection of prayers and meditations. Three prayers in the *Exercitia* survived in Middle High German; a number of Gertrud's poems and other works have unfortunately been lost. Following the orders of Abbess Sophie, Gertrud also secretly transcribed the visions and mystical experiences of her teacher, Mechthild of Hackeborn, in a work known as the *Liber specialis gratiae.*[9]

6. "[E]rat siquidem annis et corpore tenera, sensibus cana, amabilis, habilis, et facunda, et ita per omnia docilis ut omnes audientes admirarentur. Nam cum ad scholas poneretur tanta sensuum velocitate ac intellectus ingenio praepollebat, quod omnes coaetaneas . . . omni sapientia et doctrina longe superabat . . . avidaque liberalium atrium delectatione transgrediens" (I.1).

7. "Heu! Inaniter nomen et vestem religionis gestarem" (I.1).

8. A post-adolescent onset of visions is also noted for her teacher, Mechthild of Hackeborn (1241–1299), who received her first visions and mystical experiences at the age of fifty, around 1291–92, which is also the time of Abbess Gertrud of Helfta's death. If these dates are accurate, in both instances, the onset of visions may have marked a transition of spiritual leadership through divine transferral of mystical powers on behalf of the Helfta community.

9. The German prayers are preserved in Doyère, ed., *Oeuvres spirituelles,* Tome I: *Les Exercises,* 54–55. For Mechthild of Hackeborn, see Solesmes Abbey, *Revelationes Gertrudianae ac Mechthildianae* (Poitiers: H. Oudin), 1875.

The abrupt onset of her mystical life and her decision to shift from oral to textual communication of her ecstatic experiences fit contemporary psychological assessments of mystical experiences. Ecstasies and visions often occur as creative and constructive responses to severe crises. Visionaries cope well with complex and ambiguous (i.e., perceptually confusing) situations, are drawn to new experiences, and display a breadth of interests. They also depend on a supportive environment.[10] Generally speaking, religious experiences in literacy-driven religious traditions may be defined as "shifts in the perceptual field brought about by the taking on of roles learned from religious texts."[11] No doubt, Gertrud's mysticism certainly was shaped by already existing texts, given her education and lifelong duties as a choir nun. In terms of actual role models, she might have learned much from the presence of Mechthild of Magdeburg, who lived at Helfta in her old age. Ironically, Mechthild complained that the nuns, asking questions about theology and spirituality, would not leave her alone.[12] Propelled by her experiences, learning, and talents, Gertrud's production of new texts in turn modeled new roles and experiences for other nuns. Her distinct spatial and geographic vocabulary of ecstasies and visions moved beyond the spiritual discourse of courtly love as developed by Bernard of Clairvaux (1090–1153) or Mechthild of Magdeburg in her magnum opus *The Flowing Light of the Godhead*.[13] By recording *where* she experienced ecstatic pleasures and insights, Gertrud in turn filled the literal spaces and thus daily routines of her monastery with the promise of spiritual encounters with the divine. Her experientially based teachings—expressed through what was recognizable to her readers—spiraled beyond the physical-material world of Helfta into supernatural dimensions and looped back again into profane space, sacralizing and "cosmologizing" it in the process.

Gertrud's choice to depend on the architectural mise-en-scène of her experiences, especially the actual spaces of her monastery, authorized and legitimized both text and teaching. For example, when she traces the beginning of her spiritual experiences, she locates emotions in kinetic and spatial frameworks that lend credence to the dramatic cognitive change soon to follow: "One day between Easter and Ascension, I entered the courtyard before

10. See Wulff, "Mystical Experience," 408.
11. Ibid., 426.
12. See Margot Schmidt's discussion of Mechthild's influence in Helfta in *Mechthild von Magdeburg: Das fliessende Licht der Gottheit,* trans. Schmidt (Stuttgart–Bad Cannstatt: Frommann-Holzboog Verlag, 1995), xv.
13. Mechthild of Magdeburg, *Das fließende Licht der Gottheit. Band I: Text,* ed. Hans Neumann (Munich: Artemis Verlag, 1990).

Prime [i.e., before sunrise], and, sitting down beside the fishpond, I began to consider what a pleasant place it was. I was charmed by the clear water and flowing streams, the fresh green of the surrounding trees, the birds flying so freely about, especially the doves. But most of all, I loved the quiet, hidden peace of this secluded retreat."[14] For the Helfta nuns, the boundaries between Gertrud's descriptions and their own bodies' kinetic memories of these spaces must have been difficult to define. The courtyard, the green trees, the dove, and the seclusion of the pond were known and recognized by her community. Perhaps the description was even meant to evoke Augustine's conversion scene in an enclosed garden. Yet what renders an intimately known space (such as the fishpond) noteworthy is not only its familiarity but also its distance and difference from the ecclesiastically designated sacred space, the church itself. Gertrud's precise recording moves the spiritual event beyond liturgical temporal sequence as well. In this key scene of conversion and the literary birth of her mystical persona, Gertrud is not only "off duty" but also "out of place."[15] As she tells it, she is up and about before everyone else, situated in an enclosed but nonetheless extraliturgical landscape.

As much as the charm of the private place acted upon her, in writing about it, Gertrud also changed the site's meaning for her community. It has ceased to be an ordinary courtyard with a fishpond and has become the locus of a spiritual conversion. Chosen by Gertrud as what may be termed a spatial psychogram and then given fixed textual existence, this secret place now begins to function as the first station of a paradigmatic nun's spiritual journey, a sacred space that, through every reading of the *Legatus,* may evoke new spiritual insight and spiritual transformation. The forces of sacrality—like the fresh waters of their fishpond—spill out of a church building and into the private and secular spaces inhabited by the nuns. Space, as much as cognition, defines roles: a nun's actions and cognitive process are fixed in the choir by stable and consistent expectations and standards. Marginal spaces, however, encourage her theological and spiritual experimentation and innovation.

14. "[A]nte primam curiam intrassem et prope piscinam sedens intenderem ameonitatem loci illius, qui mihi placebat ex aquae perfluentis limpiditate, circumstantium arborum viriditate, circumvolantium avium et specialiter columbarum libertate, sed praecipue ex absconsae sessionis secreta quiete" (II.2). The translation follows Winkworth, *Gertrude of Helfta,* 97.

15. On the construction of liturgical spaces proper, see the survey essay by Elizabeth C. Parker, "Architecture as Liturgical Setting," in *The Liturgy of the Medieval Church,* ed. Thomas J. Heffernan and E. Ann Matter (Kalamazoo, Mich.: The Consortium for the Teaching of the Middle Ages, 2001), 273–327. For a study of the intersection between theological presentation and spatial representation, see Michal Kobialka, "Staging Place/Space in the Eleventh-Century Monastic Practices," in *Medieval Practices of Space,* ed. Barbara A. Hanawalt and Michal Kobialka, Medieval Cultures 23 (Minneapolis: University of Minnesota Press, 2000), 128–49. Neither Parker nor Kobialka, however, considers gender as a category of analysis in the religious construction of space.

FROM ORAL TO TEXTUAL COMMUNICATION: EXPERIMENT AND INSPIRATION

The *Legatus* is a complex co-authored set of five texts written in the gradually emerging genre of testimonial auto/biographical accounts of spiritual experiences and reflections. It was produced with the manifest goal of giving praise to the divine and comforting the community of the faithful. Both in structure and authorial pluralism, it anticipates the so-called German Dominican *Sisterbooks*.[16] One or more anonymous nuns wrote Book I and part of Book V; Gertrud wrote all of Book II, and she dictated Books III, IV, and part of V to one or more fellow nuns. The compilation, though perplexing at first sight, constitutes a well-organized logbook chronicling and commenting on mystical aspects of community life that seemed worth preserving and documenting.

Book I records Gertrud's sanctity through testimonies and detailed eyewitness accounts of her decline during the last five and one-half months of her life and her death. It describes her intercessions on behalf of her community; her ability to read hearts; her virtues; her power of prayer, especially in influencing the weather; and her struggle to legitimize her decision to write. The fact that this book was composed anonymously after Gertrud's death perhaps underscores, more than anything, the novelty of her choice to write under her own name and the anxiety it provoked. Because the Helfta nuns were all too familiar with Mechthild of Magdeburg's struggles to defend her books from charges of heresy, Book I may have been intended as a preemptive strike against Gertrud's critics as much as an appreciative recognition of her holiness. Helfta nuns assured themselves of ecclesiastical approval by submitting the *Legatus* to both Dominican and Franciscan officials in at least seven instances.[17] Through the omission of potentially dangerous themes in the *Legatus,* the community perhaps tried to protect their own prominent author's (and thus their community's) safety. Critical commentaries on the conduct of priests and clerical administrators, for example, are noticeably absent, although we briefly learn that the monastery was placed under an

16. On the *Sisterbooks,* see the magisterial studies by Gertrud Jaron Lewis, *By Women, for Women, about Women: The Sister-Books of Fourteenth Century Germany* (Toronto: Pontifical Institute of Mediaeval Studies, 1996), and Leonard P. Hindsley, *The Mystics of Engelthal: Writings from a Medieval Monastery* (New York: St. Martin's Press, 1998). Hindsley's study of the Dominican communities confirms my view of Gertrud's use of space. In a chapter entitled "The Monastery as *Locus Mysticus,*" he notes that "every part of the monastic complex served the goal of spiritual perfection of the nuns" (14). A comparative study of the Helfta canon and the *Sisterbooks* would be very worthwhile.

17. See the nuns' list, "Approbatio Doctorum," in Doyère, ed., *Oeuvres spirituelles,* Tome II, 104–7.

interdict (II.26). The interdict is met with unusual coping strategies. During a vision, Gertrud receives the priestly power to prepare a person for Mass. On another occasion, she is given to know that in the absence of a confessor, Christ himself can hear confession (III.60).[18] Noticeably absent, too, are reflections on the state of the Church, the end of time, or any other matter related to ecclesiastical shortcomings that figured so prominently in Mechthild's *Flowing Light of the Godhead*. Reading the *Legatus* and the *Exercitia* in the context of *The Flowing Light of the Godhead* and its biting polemics on the corruption of the Church, one might get the impression that the nuns' community was an exclusively female island unto itself—with just a few lay brothers at the periphery, lending a helping hand when needed, and gratefully commemorated in the necrology of Book V.

Book II contains Gertrud's lengthy autobiographical account of her spiritual transformation and mystical experiences between 1282 and 1290, explicitly written to praise the divine and to comfort her readers. Book III, dictated by Gertrud to a fellow nun, is divided into two parts with ninety short chapters. The first section details her gifts of grace—divine answers to specific problems, often received during times of severe illness or emotional distress. The chapters accumulate much like diary entries and are connected in format only. Each chapter repeats a threefold internal structure that includes a description of a spiritual problem or question, an oral response by Christ, and a concluding commentary by Gertrud or her scribe with a description of the problem's resolution. The problem or question is usually accompanied by a temporal marker and brief note on her health (e.g., "a short while later, she was weak with illness for the seventh time. One night, she focused intensely on the Lord and said . . .").[19] Christ's responses, too, are sometimes accompanied by a gesture or mystical interaction. Gertrud or her scribe concludes a section with a commentary and a description of the problem's resolution. Book III closes with a compilation of Gertrud's successful interventions in prayer for the sake of her community.

Book IV, also dictated, is a systematic calendrical account of spiritual experiences and visions received during specific holy days of the church year that reveal the mystical levels of meaning of each liturgical celebration. Book V

18. Christ assures her, "Quid turbaris, dilecta? Nam quotiescumque a me desideras, ego ipse summus sacerdos et verus pontifex, tibi adero et singulis vicibus simul septem sacramenta efficacius in anima tua renovabo, quam ullus sacerdos vel pontifex septem vicibus perficere posset." On Gertrud's priestly authority, see IV.23.

19. "[P]raeoccupata infirmitate, dum die quadam communicatura sentiret magnum virium defectum ac exinde minorem habere posset devotionem" (III.50).

contains an extended necrology in the form of a detailed record of the dying processes of nuns and some lay brothers—and their fate after death. The chapters of Book V are not ordered according to dates but according to the social importance of the dying. The first and longest chapter is dedicated to Abbess Gertrud; the book closes with Gertrud of Helfta's general reflections on death and dying.

More homogenous in style and choice of topics than Mechthild of Magdeburg's *Flowing Light of the Godhead,* the *Legatus* still contains traces of a transition from oral to textual transmission of mystically received knowledge. Gertrud expressed unease about shifting from one mode of communication to another and commented, "Since in my view, I am unworthy of writing down [my mystical experiences], I had delayed writing until the feast of the elevation of the cross. . . . I thought to myself that although I had not written about the graces granted to me, I at least had talked about them for the salvation and benefit of those around me."[20] At least rhetorically, she rejects her academic studies as lacking in spirituality, yet in the uneasy transformation of her mystical experiences into textual existence, she can continue her intellectual work even more actively and intensely. She admits her desire to gain fame through her writing.[21] God assures her that her soul will benefit from the spiritual progress every reader of her works will make, even from readers to be born a thousand years after her death (IV.13). Perhaps in response to such self-conscious ambivalence, Gertrud described the act of writing as an intricate, methodical process of inspiration and replication: "For four days, each morning at the most favorable hour, you [God] infused me with a part of the said words [they had all been received during an overwhelming vision] so clearly and tenderly that without any effort, I could write them down as if I had memorized them."[22] Unlike the more formal *Exercitia,* the *Legatus* has preserved several characteristics of oral communication, such as repetition, formulaic descriptions, and a lack of overarching textual structure and design in favor of episodic accumulations of short narratives.[23]

Although references to her immediate monastic environment are frequent,

20. Winkworth, *Gertrud of Helfta,* 30.
21. Ibid., 32.
22. "[C]um singulis diebus mane in convenientissima hora per quatuor dies simper mihi partem praefati sermonis tam luculenter tamque suaviter influxisti, ut absque omni labore, velut quod multo tempore memoriter retinuissem, impraecogitata scribere potuissem" (II.10).
23. See Walter J. Ong, *Orality and Literacy: The Technologizing of the Word* (1982; rpt., New York: Routledge, 1999), 31–57. It would take a longer essay to demonstrate that Gertrud's struggle to convey spiritual knowledge through spatial signifiers marks her culture's transition from what Ong defines as "verbomotor" cultures to high-technology or literacy-based cultures (68–69).

Gertrud moves in and out of more than one perceptual and kinesthetic dimension. Supernatural and natural worlds coexist on a continuum of experiences and signs; the sacred and the profane intersect and overlap in multiple ways. In terms of natural environments, the interior and exterior spaces of Helfta function as personal refuges, transitions, and settings for shared or individual religious and recreational activities. Second in relevance are the spatial dimensions of the horticultural environment surrounding the monastery buildings. With very few exceptions, urban areas, secular domestic spaces, and landscapes are absent from her mappings.[24]

Altered states of consciousness allow access to the spatial dimensions of sacred infinity. They include the cosmos, heaven, and hell, but also the interior spatiality of the human body, imagined as an architectural domain to be experienced and explored during visions and ecstasies. If we acknowledge that for the nuns of Helfta, natural and supernatural spaces existed on an open continuum and were perceived as a composite multidimensional whole, we cannot hold that because Gertrud and her community lived a life of strict physical enclosure, the boundaries within which they could move, feel, and think were indeed as narrow and limited as the enclosure itself.

Rather, Gertrud and the Helfta nuns prayed, thought, and moved in the ever-shifting and unpredictable expansion and contraction of several spatial dimensions. The microcosmic physical dimensions of her convent were indeed narrow, yet its rooms, hallways, staircases, and gardens always and everywhere opened up to macrocosmic spaces of infinity and eternity and again narrowed to the microscopic dimensions of the mystical body. These three spatial dimensions were pulled together through and in liturgical time and, even more so, through and in the cognitive interface of physical bodies and non-physical souls, particularly during times of ecstasy, illness, and the process of dying. As the episode at the fishpond cited above demonstrates, the boundaries between sacred and profane spaces were fluid and shifted according to experientially unpredictable disclosures of divine presence. The minutely detailed observations of the dying process of nuns and lay brothers—and interactions with them, as recounted in Book V—are a key example for engineering transitions between spatial dimensions. They differ in setting and occasion, but not heuristic value, when compared to Gertrud's personal visions and ecstasies.

The acknowledgment of ecstatic and visionary multidimensionality, based on the literal mapping of Gertrud's experiential worlds, thus demands a re-

24. For examples, see II.8, III.12.

definition of female monastic enclosure, which has been typically seen as removal from the world into isolation. Rather, mystical life in a monastery should be likened to time spent in a stargazing observatory also endowed with high-powered microscopes, a launching pad for journeys into other spatial dimensions. The second point I wish to make is that a close study of spatial markers also reveals a surprisingly independent and creative process of acculturating Christianity to the needs of religious women—and here, in particular, to the medieval world of female nobility, asserted and legitimized through an exploration of the new technology of textual production and of Gertrud's emerging status as a female author recognized by name. Clerical teachings on the necessity of female obedience and humility clashed with Gertrud's (and many other medieval religious women's) active roles as intercessor and teacher as well as her community's efforts to elevate and solidify her status. Gertrud's statements about her mission to write, to intercede, and to teach are so stunningly self-confident that the first German translation of her work omitted them.[25]

VIRTUAL REALITY: LEARNING TO SWIM IN THE STREAM OF DIVINE GRACE

Gertrud closed the *Legatus* with extensive reflections about her use of metaphor, the "shadow" thrown by "corporeal images" (V.36) for use by the mystically inexperienced. Still unable "to swim in the stream of divine grace," novices can nonetheless learn to do so by immersing themselves in the act of reading. Her book thus becomes a vehicle; the sites it evokes, like a Hindu or Buddhist mandala, open a path to practicing mystical cognition.[26] Gertrud's autobiographical perambulations mark spiritual growth in the paradigm of new mysticism. Identifying the spaces mentioned in the *Legatus* on a map of an ideal architectural design for a Benedictine monastery, such as St. Gall (fig. 19), highlights the areas most frequented by a choir nun such as Gertrud as well as those that were either off-limits or of no interest to her. For example, Gertrud describes how she walked past the altar to the Virgin Mary on the way to the cloister (II.20). She recounts sharing her mystical experiences with another nun in a refectory conversation (II.4), and she re-

25. See Johanna Lanczkowski's discussion in her study "Gertrud die Große von Helfta: Mystik des Gehorsams," in *Religiöse Frauenbewegung und mystische Frömmigkeit im Mittelalter,* ed. Peter Dinzelbacher and Dieter R. Bauer (Cologne: Böhlau Verlag, 1988), 153–65, 161–62.

26. V.36 refers to "legentes in libello isto simpliciores, qui per se non sufficient nature in profluvio divinae pietatis" [less experienced readers of this book, who are not able to swim in the flood of divine grace on their own accord]. Translation mine.

ceives her first vision in the dormitory at dusk (II.1; see below). One of her central metaphors of spiritual growth, that of healing and medical treatments, is anchored in the spatiality of a bathhouse, where she takes a much-relished steam bath (II.14). She lets her own blood, perhaps in the special house designed to this end. On the St. Gall map, it is located next to the infirmary (II.66). Spaces that hold provisions are singled out several times, always with positive connotations. These include the wine cellar, once associated with the Abbess Gertrud (V.1), once with the male head of a family (IV.59), and once with the divine (II.9); the barn in which fruit is stored (V.26); and the treasury filled with jewels (II.9).

Of the spiritually charged spaces important to her, two stand out as denoting a strong sense of privacy, a "place of her own": her personal seat in the choir, located in a corner (II.1), to which she retreated even outside of the liturgical hours (II.13), and her own bed, in either dormitory or infirmary, the most frequently cited location in her writings.[27] Most likely, the dormitory and the choir were close to one another. Due to the demands of singing the liturgical hours, a monastic dormitory tended to be built adjacent to the church, with easy access to the choir. Gertrud retreated frequently to her bed to rest or to avoid company, a reason she also cited for escaping to her prayer seat in the choir (II.47).

In stark contrast to the relative intimacy and privacy of her bed and her place in the choir, Gertrud's references to public streets and spaces appear to have been assigned metaphorically to masculinity and the lower classes. Only servants walk through streets and public places (IV.14). Her own talkativeness is critically compared to roaming across fields, forests, and meadows (II.20). The privacy of the home is much preferable to public spaces, especially for women (II.16, 22). Engaged couples and friends especially enjoy the intimacy of their homes (II.23, 26). In one vision, angels reinforce the seclusion of her monastery with a protective bulwark (IV.9). Only a few references depict nuns in public spaces, as when the monastery schedules public prayer processions to ward off bad weather (II.31). On only one occasion, Gertrud mentions the possibility of travel, which seems to have caused her a certain degree of excitement (III.44).

As noted above, seemingly ordinary spaces take on spiritual meaning during extraliturgical ecstasies and visions. The prologue to Book II painstakingly delineates the origin of Gertrud's writing career. Key events of her

27. The references are too numerous to cite; for examples, see IV.23, 48, 54. She notes how much another nun liked the colorful blanket on her bed in V.9.

dedicatory inscription

PLAN OF ST GALL WITH BUILDINGS IDENTIFIED BY NUMBERS KEYED TO INDEX ▶

FIG. 19 Plan of St. Gall. Drawing and index by Lorna Price, *The Plan of St. Gall in Brief* (Berkeley and Los Angeles: University of California Press, 1982).

INDEX

TO BUILDING NUMBERS OF THE PLAN

1. Church
 a. Scriptorium below, Library above
 b. Sacristy below, Vestry above
 c. Lodging for Visiting Monks
 d. Lodging of Master of the Outer School
 e. Porter's Lodging
 f. Porch giving access to House for Distinguished Guests and to Outer School
 g. Porch for reception of all visitors
 h. Porch giving access to Hospice for Pilgrims and Paupers and to servants' and herdsmen's quarters
 i. Lodging of Master of the Hospice for Pilgrims and Paupers
 j. Monks' Parlor
 k. Tower of St. Michael
 l. Tower of St. Gabriel
2. Annex for Preparation of Holy Bread and Holy Oil
3. Monks' Dormitory above, Warming Room below
4. Monks' Privy
5. Monks' Laundry and Bath House
6. Monks' Refectory below, Vestiary above
7. Monks' Cellar below, Larder above
8. Monks' Kitchen
9. Monks' Bake and Brew House
10. Kitchen, Bake, and Brew House for Distinguished Guests
11. House for Distinguished Guests
12. Outer School
13. Abbot's House
14. Abbot's Kitchen, Cellar, and Bath House
15. House for Bloodletting
16. House of the Physicians
17. Novitiate and Infirmary
 a. Chapel for the Novices
 b. Chapel for the Sick
 c. Cloister of the Novices
 d. Cloister of the Sick

18. Kitchen and Bath for the Sick
19. Kitchen and Bath for the Novices
20. House of the Gardener
21. Goosehouse
22. House of the Fowlkeepers
23. Henhouse
24. Granary
25. Great Collective Workshop
26. Annex of the Great Collective Workshop
27. Mill
28. Mortar
29. Drying Kiln
30. House of Coopers and Wheelwrights, and Brewers' Granary
31. Hospice for Pilgrims and Paupers
32. Kitchen, Bake and Brew House for Pilgrims and Paupers
33. House for Horses and Oxen and Their Keepers
34. House for the Vassals and Knights who travel in the Emperor's Following (identification not certain)
35. House for Sheep and Shepherds
36. House for Goats and Goatherds
37. House for Cows and Cowherds
38. House for Servants of Outlying Estates and for Servants Travelling with the Emperor's Court (not certain; cf. No. 34)
39. House for Swine and Swineherds
40. House for Brood Mares and Foals and Their Keepers
W. Monks' Cloister Yard
X. Monks' Vegetable Garden
Y. Monks' Cemetery and Orchard
Z. Medicinal Herb Garden

transformation into a religious author take place in domestic, not sacral space. One occurs in an unspecified general area of the convent: "She stood in the convent; it was Maundy Thursday, the day of the celebration of the Last Supper; it had been nine years after she had received grace. The sisters waited until the body of the Lord was brought to a sick nun. Then, the Holy Spirit grasped her as if by lightning. She took the writing tablet by her side and began now, gratefully, to write down what she felt in her heart when she had been speaking with her Beloved in secret."[28] Gertrud then proceeds to describe her first experience of grace in the form of a visionary interactive event that had taken place nine years earlier. She received her first vision at dusk, standing this time in the dormitory, again in the company of other nuns. In this instance, spatial dimensions collapse instantaneously. She writes that upon seeing Christ next to her in the dormitory, "I stood hesitatingly, burning with desire and almost fainting. Suddenly, he clasped me without difficulty, lifted me up high and placed me next to him."[29] Changes in self-understanding are marked and thus remembered by shifting from one spatial dimension to another and from one state of consciousness to another.

The monastery's "corners," its nooks and crannies, spaces with little traffic going through and probably also with very little lighting, offer intriguingly ambiguous and psychologically indeterminate spaces. Gertrud suggests that her preferred forms of bodily prayer, new to Helfta, could be practiced in certain corners (IV.16). Snakes and toads live in other corners—which was very likely, if these corners were indeed damp and dark—and if snakes and toads found shelter there, then certainly demons would be found as well (V.32). Equally ambiguous in meaning are the transitional spaces of bridges and staircases. A purple staircase leads to heaven in a vision received during the interdict (II.17); a lay brother named Johannes has to ascend a swaying staircase after death; evoking a familiar folklore motif, a thin beam, suspended above the abyss of hell, needs to be crossed (V.22). Mechthild of Hackeborn's heart is a bridge over which the faithful may travel safely (I.14).

The most metaphorically evocative space of all is the monastic garden, not least, perhaps, because of its biblical connotations as *hortus conclusus* and paradise. If we use St. Gall as an ideal prototype, we may assume that a monastery

28. See the prologue to Book II, here cited in full: "Post acceptam gratiam anno nono, de Februario usque ad Aprilem, revoluto die sancto Coenae Dominicae, dum inter Conventum staret expectans quousque corpus Domini deferretur ad infirmam, compulsa violentissimo impetus Spiritus Sancti, lateralem tabulam arripiens, quod corde sentiebat cum dilecto in secreto confabulans, haec ex superabundantia gratitudinis ad laudem ipsius et manu describebat in haec verba."

29. "Et cum hinc haesitans et desiderio aestuans et quasi deficiens starem, ipse repente absque omni difficultate apprehendens me levavit et juxta se statuit" (II.1)

included several green spaces, all with specific practical functions: vegetable gardens, medicinal gardens, and cemeteries. The cemetery could be planted with fruit and nut trees. The *Legatus* only mentions the Helfta cemetery once in regard to the earth burial of Abbess Gertrud (V.1). Did Christ place Gertrud in a virtual cemetery's nut tree so that she could pick nuts (II.15)? Christ himself takes a nap in the garden after having had too much wine (II.21). As the fishpond episode demonstrates, blooming trees gave Gertrud great pleasure. Both Christ and Mary (II.6, 16) are compared with trees in bloom, as is Gertrud's soul (II.18).

The *Legatus* mentions that the Helfta garden had flowers (V.1), perhaps used specifically for the decoration of the altar. Gertrud describes a bed of roses (III.56), spring flowers in a garden (III.21, 30), and the Virgin Mary planting a bed of flowers (III.21). The body of St. Benedict sprouts roses (IV.11). At the beginning of her own spiritual healing, Gertrud resembles a flower in the swamp (II.9). She makes a clear distinction between a flower garden and a vegetable garden, which she identifies as a typically masculine space, perhaps because of the lay brothers' work in the monastery (V.13).

Gertrud's virtual maps provide guides to interior spaces as well as cosmic realms. In psychological parlance, the shamanic ability to shuttle back and forth between psycho-spiritual dimensions has been termed "transliminality," an openness to the subliminal and supraliminal self and its processes with a concomitant weak sense of conscious self and identity.[30] In this multidimensional universe, the mystic does not perceive death, for example, as a threat to the self and material existence, but as a positive transformation—indeed, an expansion and liberation of self. The *Legatus* itself transmits divine presence directly to a reader open to receiving it. Divine presence permeates every single letter of the book, and, in the form of divine breath, extends to the reader's soul in the act of reading (V.34).

To accommodate and then expand a beginner's limited ability to perceive supernatural reality, the author's soul metamorphoses into diverse animate and inanimate identities—child, bride, author, teacher, oracle, plant, dwelling place. During mystical states, Christ's human body is conceived as so malleable that it becomes, among other permutations, architectural space open to exploration and inhabitation, much like the monastery buildings themselves. Once, while at vespers, Gertrud hears Christ speak to her: "Look at my heart, it shall remain your temple. And now explore different parts of my body, and choose other rooms for you to live in regularly. My body shall be your future

30. See Wulff, "Mystical Experience," 408–9.

monastery.''[31] Choosing to remain at the periphery of Christ's body, Gertrud selects his feet as a place to walk around in and to wash herself; his hands as her work space; his mouth as the chapter and audience room; his eyes as the schoolroom where she can read; and his ears as her confessional.

The mystical body, the very act of reading and writing, and domestic and horticultural spaces flow into each other as in a hallucination. Mystical perception can effortlessly replace one with another. Christ's wounds are perceived to be a book (II.4). Christ writes with blood into her heart, and she herself can physically reach into Christ's heart; she wishes to remain in this mystical enclosure, the central interior space of the mystical body. An exhausted Christ, in turn, rests in Gertrud's heart. In later chapters, her heart becomes a bed of flowers and a place in which to live (III.19). Her body, like Christ's, offers living quarters, though they are narrower than his (II.14).

Moving from the body's interior far into cosmic space, Gertrud is especially indebted to biblical vocabulary. Human intellect cannot describe infinity per se, she writes, and she thus needs images and similitudes to communicate at least fragmentary spiritual knowledge (IV.55). All images of infinity convey a sense of joy and ease, tinged with a reaffirmation of noble class privilege. The divine is the place of all happiness (II.8); Gertrud feels that she can rule with Christ over the realms of heaven and earth, because the soul is in the image of the divine (IV.14). Similarly, the Virgin Mary is the queen of heaven and earth (V.31). She sees an infinite river of crystal-clear water flowing across heaven, which reflects a thousand suns (IV.59). Ecstatic joy flows from her heart into the heart of God, the origin of all of creation (IV.59). And she perceives the trinity itself, infinite, overflowing with love and bliss (IV.55). Infinity denotes not fear or indifference, but positive emotion and sensation. Her spiritual equation reads "God equals infinity plus bliss."

CONCLUSION

Less combative and conflict-ridden than the pioneering texts of Mechthild of Magdeburg, the co-authored *Legatus* documents one monastery's efforts at fashioning a community of female writers and a communally useful spiritual canon. With admirable complexity, focus, and thoughtfulness, its five books

31. "Respice ad cor meum, hoc manebit templum tuum: et nunc quaere per caeteras corporis mei partes et elige tibi alias officinas in quibus regulariter vivas, quia corpus meum de caetero erit tibi pro claustro" (III.28).

delineate the community's transition from the role of passive consumers of Christian writing to that of active producers of locally used and useful texts and spiritual teachers. Working collaboratively, anonymous female authors, scribes, and individually named authors write for an intimately known audience, at times even under the abbess's strict orders. This feat in itself constitutes a memorable act of female autonomy—and the authors do not only have "a room of their own," but a group of buildings, with adjacent gardens, ponds, and fields. In her archaeological study of medieval women's monasteries, Roberta Gilchrist reminds us that "space as a form of material culture is fundamental in constituting gender," and she presents material evidence for women's enforced liturgical passivity and their choice to replicate domestic architectural spaces in convent architecture.[32] No archaeological trace of the Helfta community has survived, but we do have Gertrud's ample textual references. Counter to Gilchrist's findings, the *Legatus* and the *Exercitia* tell a story of literary experimentation and liturgical agency, even innovation. In the context of writing, they demonstrate a sophisticated use of whatever space was available to the nuns.

For the Helfta nuns, the authority of new texts becomes anchored in the textualization of domains specific to the writing community, whether interior or exterior. Rooms, hallways, sleeping quarters, and gardens serve as building blocks for constructing new religious meaning, much as Christine de Pizan imagines women building the "City of Ladies" with mortar and bricks: the textual presence of well-known spaces helps engineer a transition from the concrete to the abstract, from the local to the universal, from inherited spiritual models to new patterns of prayer, cognition, and teaching. And midway between abstraction and concreteness, mystical perception expands and contracts ordinary scale and dimensions, allowing the nuns to travel deep within the mystical body and far out into cosmic space. Looking over the walls of a women's monastery, we might indeed find more than meets the eye.

32. See Roberta Gilchrist, *Gender and Material Culture: The Archaeology of Religious Women* (New York: Routledge, 1994), 17.

STRATEGIES OF EMPLACEMENT AND DISPLACEMENT:
ST. EDITH AND THE WILTON COMMUNITY IN GOSCELIN'S LEGEND
OF EDITH AND *LIBER CONFORTATORIUS*

Stephanie Hollis

In the prologue to his Legend of Edith (ca. 1080), Goscelin dwells upon the continuing posthumous presence of St. Edith at the Wilton nunnery where she spent most of her short life (ca. 961–984): "Her pure character indeed, and her life, spreading sweetness far and wide through the land and the churches, but especially toward her own people, diffuse so immediate a fragrance of virtues as if she herself were still here today; and often in visions among the sisters she is seen as if still alive and embodied. Her own special places and her occupations are also well known: 'Here she was accustomed to read, here to pray; she achieved such and such things in the Lord.'"[1] Towards the end of the Legend, too, in the concluding chapters of the *Translatio,* he affirms her continuing presence both visible and visionary in the place where she lived and died, and which still possessed her earthly remains: "Not only in corporeal sights and external miracle working, but she is also

1. A. Wilmart, ed., "La légende de Ste Édith en prose et vers par le moine Goscelin," *Analecta Bollandiana* 56 (1938): 5–101, 265–307 (at 37); hereafter abbreviated as LSE. Translations throughout are from Michael Wright and Kathleen Loncar, "Goscelin's Legend of Edith," in *Writing the Wilton Women: Goscelin's Legend of Edith and Liber confortatorius,* ed. Stephanie Hollis (Turnhout: Brepols, 2004), 23–93. Their translation of the *Vita* is based on Cardiff, Public Library, MS I.381, which in Wilmart's edition is printed as variations on his base text (Oxford, Bodleian Library, MS Rawlinson C 938); see note 9 below.

radiantly visible to the spiritual eyes of pure minds, and is observed to pass among the sisters as if still present in her body. She declares in pious visions that she still keeps watch with maternal affection over the sleeping sisters pledged to her" (LSE 294). There is nothing visible now to corporeal sight of Wilton as it was when Goscelin evoked the benignly haunting presence of Edith a century or so after her death. And in some respects at least it had, of course, already changed by the time that Goscelin saw it. The paintings that adorned the interior of the wooden chapel that Edith had built—the place that she had often marked out "with a prophetic mind" as the site of her burial—could still be seen, "radiant to this day" (LSE 50, 96). But the chapel itself had either been replaced by or incorporated into the main church, and this had in turn been rebuilt in stone on the eve of the Norman conquest by Queen Edith, wife of Edward the Confessor.[2] Some twelfth-century stonework is dimly visible below ground, enough at any rate to serve as an obvious metaphor for the reconstruction of the past—reflected in a carefully positioned mirror beneath a plate of glass is what looks like a carved capital, and if you lie face down and peer through the glass, you can make out something that looks like a column, or perhaps there are several of them.

The nunnery was given at the dissolution to the Earl of Pembroke. It is said that the nuns returned to reclaim it in the reign of Mary, but that, after her death, they were driven out again by the earl, who, according to this report, used language not normally employed in the hearing of nuns.[3] This is not generally regarded as a true story, but some such resurgence of conventual life at Wilton would explain why it was so comprehensively dismembered and reconstituted as Wilton House, which is still very visibly occupying the site. In these reassembled stones, in some remote sense, the Wilton convent, if not St. Edith herself, has a continuing existence.[4] The same cannot be said,

2. Queen Edith's rebuilding of the church at Wilton—formerly dedicated to Mary and rededicated by her to St. Benedict—is not explicitly mentioned by Goscelin. See Frank Barlow, ed., *The Life of King Edward Who Rests at Westminster*, 2nd ed. (Oxford: Clarendon Press, 1992), 70–75.

3. Richard Barber, ed., *John Aubrey: Brief Lives* (London: Folio Society, 1975), 152–53.

4. See Elizabeth Crittall, "The Abbey of Wilton," and R. R. Darlington, "Anglo-Saxon Wilt-shire," both in *A History of Wiltshire, Vol. II,* ed. R. B. Pugh and Elizabeth Crittall, Victoria County History (London: Oxford University Press, 1955), 240 and 2, respectively. Both dismiss Aubrey's story of a Marian resurgence, and both deny that Wilton Abbey was demolished in order to build Wilton House. Crittall contends that the abbey buildings were in a ruinous state at the time of the dissolution (though she is more doubtful of the claim, found in the same source, that stone from the abbey was used to build Wilton House). Darlington argues that the construction of Wilton House was already in progress in 1543. Only one of the abbey's buildings survives: a two-storied building dating from the fourteenth century known as "the Almonry." Crittall suggests that this may have been the abbess's court of the Bellhouse. Darlington (who gives a map of the site as at 1960 at p. 3) observes: "The hospital of St Mary Magdalene [demolished 1831] stood opposite the abbey gate and the abbess's house

unfortunately, of the contents of the Wilton library, which in Goscelin's time included a prayer book written in Edith's hand (LSE 55). The leaves of its manuscripts were, fairly certainly, among those that "flew about like butterflies" in Wiltshire when John Aubrey was growing up there in the early seventeenth century and served so handily for such a wide range of purposes, such as cleaning guns and stopping bungholes and wrapping up gloves.[5] Goscelin's Legend of Edith is the closest we can come to the recovery of what has been not merely lost but wantonly and deliberately destroyed.

In Goscelin's Legend of Edith and in the *Liber confortatorius* that he wrote for Eve after she had departed from Wilton, to his extreme distress, Wilton is already not so much a literal edifice as a place transformed by memories of the past and visions of eternity, although a few features at the heart of the life of the nunnery—the church that housed the remains of Edith and her mother, Abbess Wulfthryth—are repeatedly delineated. For Goscelin Wilton was a lost paradise, though not perhaps for Eve, who left it in order to become an anchorite in France. For him, what was lost was ultimately recoverable not by imaginatively re-creating the past—though he seems to have done that in the Legend of Edith by depicting the convent's saint in the image of the absent Eve—but by imagining an apocalyptic future. Yet the two endeavors are akin, for they rest on the belief that what is not visible nevertheless exists in non-material form.

A specific location, particularly the built environment, gains significance and meaning from the lives lived within it. A habitation is a tangible link with its departed inhabitants, the place where we may most vividly recall or imagine them as present in the past, where we may believe in the continuing presence of those who lived their lives there. Home can be a metaphor, but home is not just where the heart is; home is a concrete location in which one feels one belongs, and the *domus* is a material vehicle as well as a metaphor for social inclusion or exclusion. The Wilton nunnery had significance for Goscelin because it was the habitation of Eve, the place where he found "the delight of life" in being together with her in the circumambient presence of St. Edith.[6] A "place" in the most obvious and immediate sense of the word can be photographed or mapped, represented by a visual illustration or a

stood to the south of the hospital, so that there is little difficulty in estimating the approximate site of the abbey, although its extent is not known."

5. Barber, *Brief Lives,* 26. Four manuscripts owned by Wilton that survived the dissolution—the earliest dating from the thirteenth century—are gazetted by David N. Bell, *What Nuns Read: Books and Libraries in Medieval English Nunneries* (Kalamazoo, Mich.: Cistercian Publications, 1995), 213–14.

6. C. H. Talbot, "The *Liber confortatorius* of Goscelin of Saint Bertin," *Studia Anselmiana* 37 (1955): 1–117, at 34; cited hereafter as *LC.*

diagram. As a physically existing place, the Wilton nunnery was as lost to Goscelin as it is to us when, exiled from Wiltshire, he discovered that Eve had left Wilton to become an anchorite in France. Goscelin's Wilton is an accumulation of textual meanings generated by absence and loss. In medieval Christian belief, existence continues in eternity in a non-corporeal form, unconstrained by the limitations of specific place and time; the lost earthly paradise will be restored as the heavenly abode of the New Jerusalem. In the conclusion to the *Liber confortatorius,* Wilton is displaced and de-reified, transmuted and resituated in the eternal realm, as Goscelin envisages Eve's attainment of a heavenly home as a return to the Wilton nunnery.

The strategic deployment of St. Edith began thirteen years after her death, when her remains were translated at the instigation of her half-brother Æthelred ("the Unready") from the altar of the Holy Trinity in the chapel that she had built into the south porch of the main church (LSE 267–69). This chapter traces some of the ways in which she was deployed by the Wilton community and by Goscelin in writing about her. There is first a biographical note, as Goscelin's representations are to a high degree shaped by his personal circumstances, by the fact that he had lost his place.

Goscelin (d. 1114) began life as a monk at Saint-Bertin. He emigrated to England as a young man in about 1060 and became a member of the household of Herman, bishop of Ramsey and Sherborne. He was probably one of the chaplains at Wilton. Eve (d. 1120) was a child when he first met her; she was about seven years old in 1065, the year she was dedicated to the community. Between about 1065 and 1078, Goscelin visited Eve frequently at Wilton, exchanging letters with her when (for reasons not explained) he was prevented from seeing her. His adoption of the role of spiritual mentor and teacher from his first meeting with her—a role he continues to assume in the *Liber confortatorius*—suggests that he had been employed as her tutor.[7] He was also commissioned by the community to write the *Vita* and *Translatio* of its patron saint. Goscelin, however, procrastinated, "either out of bashfulness or negligence," and the Legend was not completed until after 1078, the year that Herman died (LSE 36–38). Goscelin fell foul of Herman's Norman successor and was forced to leave Wiltshire. He took temporary refuge at a number of monasteries until about 1090, when he found a permanent home at St. Augustine's in Canterbury. He was, then, already a spiritual orphan and

7. Goscelin gives a somewhat elusive account of the history of his relationship with Eve; see *LC* 28–30. For a summary of what is otherwise known or can be surmised about his life, see Barlow, ed., *Life of King Edward,* 133–49.

a homeless exile when he discovered, some time after his departure from Wiltshire, that Eve had left Wilton to become an anchorite in Angers, without informing him of her intentions, without so much as a word of farewell. The *Liber confortatorius,* written to Eve at the church of Saint-Laurent at Angers where she was enclosed, is addressed "to one shut in from one shut out; to one solitary from the world from one solitary in the world."[8] In this letter Goscelin seeks to perpetuate and also to reconfigure his relationship with Eve.

For most of his literary career Goscelin commemorated the saints of the monasteries where he was resident. The Legend of Edith and the *Liber confortatorius,* both written about 1080, are works written to absent recipients from whose society he had been shut out. For Goscelin, Eve was inextricably connected with Edith and the Wilton community. We can assume that he was gathering material for the Legend while he was visiting Eve at Wilton, since it is based on the oral traditions of the nuns (LSE 37, 39). The *Translatio* concludes with visions of Edith reported by members of the community that took place during the period of his visits to Eve. The portrait of Edith in the *Vita,* if not actually modeled on Eve, appears to have been written with her in mind. Like Eve, Edith entered the Wilton community as a child. Edith was the daughter of Wulfthryth, who took Edith with her when she returned to Wilton as its abbess after the dissolution of her marriage to King Edgar in about 964 (LSE 41–43). Edith died at the age of twenty-three, much the same age as Eve was when she left for France. But unlike Eve, Edith refused to leave Wilton; despite an attempt by her father to make her the abbess of three other monasteries, and despite an attempt to make her queen of England by the faction opposed to Æthelred's succession, Edith chose to remain a member of her mother's community for the whole of her short life. Edith dwelt as a "flower of Christ" within the "rose garden of virgins." She "could not be torn away from her loving mother nor transplanted from the home in which she had been given to God and had fixed her roots, intending by the providence of God to stay there forever," and she "continued to dwell in the paradise of the cloister, where her own place is still remembered" (LSE 47, 77, 51). In the opening to the *Liber confortatorius,* Goscelin urges Eve to imagine, as she reads his epistolary book, that she is again sitting with him at Wilton in the presence of "our lady St Edith." In the conclusion he holds out to her a vision of heaven as the goal of her spiritual quest; it takes the

8. *LC* 26. Translations throughout are from W. R. Barnes and Rebecca Hayward, "Goscelin's *Liber confortatorius,*" in *Writing the Wilton Women,* ed. Hollis, 99–207.

form of a return home to a transfigured Wilton and reincorporation into the community of Edith (*LC* 27, 114–15).

Goscelin dedicated the first version of his Legend to Archbishop Lanfranc. It was simultaneously a belated fulfillment of the community's request and a bid for employment as a hagiographer in the archbishop's service.[9] In order to recommend Edith and her community to the protection of the new Norman archbishop it was necessary to present her as a national or universal saint.[10] Goscelin's dedicatory prologue accordingly describes Edith as "famous throughout the whole land," bestowing her benefits upon native inhabitants as well as strangers—which presumably meant the Norman invaders (LSE 36). But, as the passages from the dedicatory prologue quoted above show, Goscelin is no less insistent on Edith's particular presence at Wilton and the special favor she manifests in caring for her community. (To what extent Edith was actually felt to be present beyond the precincts of the convent is difficult to determine. She rescued Cnut when he was caught in a storm on his way to Denmark; the golden shrine that held her remains, depicting the angel's announcement to the women at Christ's tomb and the Slaughter of the Holy Innocents, expressed his gratitude. The archbishop of York was similarly rescued by her on his way to Jerusalem at a later date.[11] But it is perhaps characteristic of a community made up of women of noble birth, seemingly prone to direct their gaze inward and up, that almost all of the instances Goscelin reports of Edith's supernatural intervention—less than a dozen, all told—take place inside the nunnery, and only one of them involves a layman of humble birth.)

The polemical purpose of Goscelin's insistence on Edith's particular exercise of her protective care at Wilton becomes apparent in the concluding chapters

9. LSE 34–39. Only the Rawlinson version of the Legend (see note 1 above) contains Goscelin's prologue, in which he dedicates the work to Lanfranc. Wilmart, LSE 24–31, argued persuasively that the version preserved in Cardiff represents Goscelin's revision of Rawlinson. Cardiff differs chiefly in containing more concrete details concerning the lives of Edith and her mother; Hollis, in *Writing the Wilton Women*, 238–44, argues that the revision represented by Cardiff was made by Goscelin for the Wilton community.

10. Notoriously, Lanfranc initially doubted the sanctity of Elphege, but was subsequently persuaded otherwise by Anselm, and his opposition to Anglo-Saxon saints is now generally considered to be both less sweeping and less motivated by ethnic prejudice than it once was. See, for example, Margaret Gibson, *Lanfranc of Bec* (Oxford: Clarendon Press, 1978), 171, and Richard W. Pfaff, "Lanfranc's Supposed Purge of the Anglo-Saxon Calendar," in *Liturgical Calendars, Saints, and Services in Medieval England*, Variorum Collected Studies Series 610 (Aldershot: Ashgate, 1998), 95–108.

11. LSE 279–81. The account of Edith's cure of one of the dancers of Colbek, recorded in the vernacular in the reign of Abbess Brihtgifu, does, however, suggest an attempt to popularize her cult among the laity (292).

of the *Translatio*. Her cult was not the creation of the Wilton community, but was instigated by her half-brother Æthelred, with episcopal support, for reasons that had far more to do with regnal politics than with the Wilton community's regard for Edith.[12] Wulfthryth, whose reign as abbess continued for perhaps two decades after Edith's death, appears to have inspired much greater reverence, and her importance to the community was marked by the position of her tomb, directly in front of the main altar. Edith's cult does not seem to have taken root within the community until the 1040s, when her usefulness in recovering stolen land and in supporting claims to the abbatical succession became apparent. Her cult attained a brief and belated flowering in the reign of Abbess Ælfgifu (1065–67), in whom the convent had for the first time an abbess conspicuously devoted to Edith. (She was "the votive censer of the blessed Edith herself" and wept whenever she thought of her, having once been miraculously cured of an eye disease by her [LSE 296, 294–95].) Ælfgifu's reign fulfilled the prophecy made by Edith twenty-five years earlier in dreams experienced both by Ælfgifu and by Ælfhild (who, as "a worthy and famous lady of Wilton," was evidently of high standing in the community). These dreams clearly served to establish Ælfgifu as a successor to Wulfthryth who had been chosen by Edith as her mother's heir apparent. In these dreams, Edith was seen descending the steps that led from her shrine on the altar dedicated to Gabriel in the south porch, which, Goscelin explains, was separated from the main church by a wall with a passageway in it. Making her way on foot to the high altar (dedicated to Mary), where Wulfthryth was buried in the midst of the three abbesses who succeeded her, Edith took up a position at the right hand of her mother's tomb in the space that separated it from the tomb of Abbess Brihtgifu, where Ælfgifu stood in supplication (and where, presumably, Edith herself would have been buried had she lived to succeed her mother). Edith invested Ælfgifu with her own veil and ring and entrusted the community to her care. Prophesying that Ælfgifu's reign would be short, but that she would be buried in the space that Edith had measured out beside her mother's tomb, Edith returned to the place from which she had come. Ælfgifu, in her dream, also saw Wulfthryth lying above the altar of Gabriel in the south porch, very splendidly dressed. She invited Ælfgifu to lie beside her, and, when Ælfgifu protested her unworthiness, Wulfthryth grasped hold of her and placed her by her side. Where to

12. LSE 265–66. For its relation to the politics of Æthelred's reign, see Susan J. Ridyard, *Royal Saints of Anglo-Saxon England: A Study of West Saxon and East Anglian Cults* (Cambridge: Cambridge University Press, 1988), 158–71; Barbara Yorke, *Nunneries and the Anglo-Saxon Royal Houses* (London: Continuum, 2003), 171–74.

bury Ælfgifu when she died in 1067 became a matter for debate. Some of the nuns wanted to bury her in the south porch next to Edith, others elsewhere; but the south porch was evidently very small ("it had too little space for prayer"), and Ælfgifu in due course, in death as in life, took her place in the line of Wulfthryth's successors in accordance with Edith's prophecy and Wulfthryth's express wishes, "close to her with whom the provident love of the virgin and the very suitability of the place had united her."[13]

Edith's conventual cult declined sharply in the years that followed the conquest. In the successional conflict that surrounded Ælfgifu's death, in which her sister Thola lost out to Godiva, Edith's intercessory powers were called into question. One nun reported, as Ælfgifu lay dying, that she had heard a voice announcing in a dream that Mary, through the intercession of Edith, stood ready in her high tower with a great company of virgins to receive her soul. But another nun reported, after Ælfgifu's death, that Edith herself had appeared to her in a dream and had exhorted all the community to pray for Ælfgifu's soul, saying: "My Lord, the most kind in his favours, has put into my hand all her offences except one, and I will not desist from the presence of him who is known as the father of mercies, until I obtain her a full pardon" (LSE 296–97). Edith was also criticized for being "so prompt to help any outsiders, on land and sea" yet failing to protect her own community during a plague. Edith, defending herself in another unattributed dream, asserted her responsibilities as a universal saint; it was her custom to help everyone who called upon her aid, and no one who was close to Christ was an outsider to her. Nevertheless, she assured the community, they were in her special care, and she was laboring to ensure their eternal well-being as spotless brides of the Lord (LSE 297–98).

Subsequently, a young nun called Ealdgyth complained to Bishop Herman, in Goscelin's presence, that Edith could have no power at all when she failed to avenge the theft of her lands. Edith immediately appeared to Ælfgifu's sister Thola in a dream. Above the voices of virgins "singing in the accustomed way around St Edith" (nuns or angels?), Thola heard the saint call her name. As she approached Edith's shrine, it opened at her feet to reveal the saint. Reclining on a magnificent wedding bed, splendidly adorned, and radiant in her beauty, Edith again defended herself. "Why," she inquired, "did Ealdgyth say lately that I can do nothing? Look at my hands, and the services rendered by my virtues, what control I have, how effica-

13. LSE 295–97; the wall with a passageway separating the place of Edith's burial from that of Wulfthryth is mentioned by Goscelin in his account of the entombment of Wulfthryth (275).

cious, generous, energetic, and strong I am; indeed, whatever I wish I can do, by divine power" (LSE 298–99). Like the defense she offered during the plague, this exhibition of her essentially latent powers carried no assurance that Edith was prepared to exert herself as the community wished her to and assist them with their earthly problems. Goscelin ends the *Translatio* with a triumphant vindication of Edith's powers, describing a miraculous cure that she accomplished. It appears, however, from its setting, to have taken place before the conquest, during Queen Edith's rebuilding program, and the beneficiary of the miracle is an "outsider." He is, indeed, the only ordinary villager who figures in the Legend's miracle stories, and the story is also unusual in that, although the miraculous cure takes place at Edith's shrine, Edith makes an appearance outside the nunnery walls, in a nearby meadow that belonged to the community, where the villager had taken his oxen to graze (LSE 300–302).

Goscelin's insistence on Edith's particular and continuing presence at Wilton is, in part, an attempt to restore the community's flagging faith. What the community wanted of its patron saint was a protector dedicated to their concerns who was palpably present, and in their dreams they envisaged Edith and Abbess Wulfthryth spending their afterlife not in a remote eternity but resting in their tombs at Wilton. Goscelin, in his accounts of the death of Edith and her mother, affirmed in an entirely orthodox manner that their souls ascended immediately into the eternal realm and that their bodies lay at Wilton awaiting the resurrection. Wulfthryth "passed to Jerusalem, the blessed city of the saints" and "the church of the holy Mother of God received her body" (LSE 275). The ascent of Edith's soul at her death is celebrated at great length in one of the metrical passages that adorn the Legend; from their "gem-bedecked bridal chambers," throngs of virgins summon her into the New Jerusalem. Ascending above the stars beyond the wheel of time, Edith "looks upon her Wilton, and grieves at our errors, being freed of them," and after the translation of her earthly remains, Goscelin says, "the inhabitant of heaven became in the Lord as free a messenger of her own glory as she was free of temptation."[14] So, too, the soul of Ælfgifu (though this was contested) was believed to have passed into an immortal abode at her death. But in the prophetic dreams of Ælfhild and Ælfgifu, and in the dream vision of Ælfgifu's sister Thola, the bodies of Wulfthryth and Edith appear to live on in their tombs, taking their rest and dressed as the brides of the Lord that their souls had become in heaven, somewhat in the manner of

14. LSE 96–98 (metre IX), 265.

the Icelandic chiefs who went on feasting in their burial mounds, which occasionally opened to admit members of their families.[15] These might reflect heterodox ideas of the afterlife harbored at Wilton (though they are, after all, dreams). But Goscelin's depiction of the chapel that Edith built is transfigured by the light of eternity, already transformed—in anticipation of its appearance in the apocalyptic conclusion to the *Liber confortatorius*—into an eternal mansion in which Edith and her community will celebrate their mystic marriage to Christ. In these dreams of the Wilton nuns, there is perhaps a parallel intimation of the Wilton church where Edith and her mother lay buried as the celestial habitation it would become when heaven and earth ceased to be separate realms and became one.

In the post-conquest dream of the unnamed nun who was a kinswoman of Brihtric, the south porch that housed Edith's relics is more evidently conflated with the kingdom of heaven. Her dream echoes a visionary experience that took place in the reign of Cnut; a thane called Agamund who had appropriated land belonging to the nunnery came back to life on his deathbed, mortally afraid because a ferociously angry Edith was barring his soul from entry to every part of heaven and earth (LSE 281–82). But when, at a later date, Brihtric's kinswoman asked him on his deathbed to return the land that he had taken from the nunnery, Brihtric angrily refused to give it back and, spurning the aid of St. Edith, had himself buried in some other church. In his kinswoman's dream of his inevitable fate he, too, appeared cowering with terror, begging her to hide him from the sight of Edith and gain her forgiveness, but his exclusion from grace is marked in the nun's vision by his inability to gain entry to the south porch—she saw him "in that doorway in the corner that gives access to the altar in sight of the virgin's earthly remains" (LSE 283–84).

Goscelin's insistence on the presence of Edith at Wilton countered her felt absence on the part of the community. For him loyal adherence to the patron saint of a monastery was a definition of identity—Eve first endeared herself to him by praising "his" St. Bertin, and even after his death he was remembered at Canterbury as a monk of Saint-Bertin.[16] The vision of Edith in the apocalyptic conclusion to the *Liber confortatorius* rests on the assumption that Eve—despite having chosen to leave Wilton, and despite the disillusionment

15. Hermann Pálsson and Paul Edwards, trans., *Eyrbyggja Saga* (Harmondsworth: Penguin, 1989), chap. 11.
16. *LC* 28. He is described as *monachus S. Bertini* in a Christ Church, Canterbury, obituary (cited in Barlow, ed., *Life of King Edward*, 143 n. 76).

with Edith expressed by her contemporary, young Ealdgyth—felt the same way about the patron saint of her community. Writing the Legend of Eve's patron saint was a means of perpetuating the presence of Eve herself.

Goscelin depicts Edith in lyrically ecstatic terms as a contemplative bride of Christ seeking union with her heavenly bridegroom; every stage of her life from her "betrothal" at the age of two is presented in terms of this metaphor (LSE 43–46). This aspect of the portrait is Goscelin's invention. It has no discernible basis in the Wilton traditions he reports; it is, in fact, noticeably at odds with them. Edith was probably not a professed nun but a secular member of her mother's community. She was chiefly remembered for her habit of dressing like the princess that she was (thus provoking the criticism of Bishop Æthelwold), and one of the many signs of the luxurious ethos of Wilton at this time is the memory of the large metal cauldron Edith had for heating her bath water. It figured in her prophetic vision of her impending death and, suitably transformed—as all things ultimately shall be—it was refashioned into the casket in which she was buried (LSE 92). She was also remembered for the influence she brought to bear at her father's court and for her artistic accomplishments.[17] These accomplishments found their culminating expression in the chapel that was built to her design. Edith herself helped to build it, using the flowing sleeves of her royal garment to carry stones for the foundations, and the paintings that decorated the interior, executed by an eminent continental artist, Benno of Trier, whom her father Edgar had employed as her tutor, were inspired and conceived by Edith (LSE 86–87, 50).

Completed shortly before her death and marked out by Edith as the place of her burial, Edith's chapel is a focal symbol in the Legend; it is the marriage chamber in which her quest for union with the heavenly bridegroom attains its earthly consummation. Its literal appearance is difficult to discern amidst Goscelin's transformative vision of it as a perfected manifestation of the temple of Solomon and a prefiguration of the New Jerusalem as seen by St. John the Divine. It can be said with reasonable certainty, however, that the chapel was three stories high with many pillars and, less certainly, that some of the glass that filled its many windows may have been colored blue.[18] (In his allusion to Wulfthryth's building projects, too, the allegorical construction of her activities makes it certain only that she "built a stone wall around sun-

17. LSE 62–63, 68–69. For the Wilton nunnery's proximity to a royal palace, see Jeremy Haslam, "The Towns of Wiltshire," in *Anglo-Saxon Towns in Southern England,* ed. Haslam (Chichester: Phillimore, 1984), 87–147, at 123.

18. LSE 89–90 (metre VIII).

blessed Wilton.")[19] Prosaically described, Edith's church suggests the skeletal outline of a body covered with skin: "She constructed it of wooden material, but fashioned it in the form of an elaborate and beautiful temple. She made it broad with a triple side-chapel in the form of a cross, strengthened the foundations with stone and upon these erected posts and walls, covered them all with horsehide, and covered over the whole regal building with wooden vaulting" (LSE 86–87). The paintings within, however, employing every available color and covering the entire surface, walls, ceiling, and arcading, endowed the interior with the mystic beauty of Edith's contemplative inner life, for Benno, "like a bee," sought to discover and give form to "the thoughts of the flower-bearing virgin."[20] (Goscelin, unfortunately, regarded these paintings as "more striking when seen than in any description," but they included representations of the Passion, which he portrays as central to Edith's devotional life.) In the metrical celebration that follows this account, Edith's seemingly rather modest construction, magnified and gloried as a pre-figuration of the New Jerusalem, makes manifest and embodies at Wilton the Church in its mystical and eschatological sense as the site where the bride of Christ is made one with the glorified body of the bridegroom: "Here, in our place, was Christ and his life-giving temple, serene, perceptible, made of living, evident, eternal stones without disorder. Such did Wisdom, the virgin queen, give to her king; thus the virgin Edith shone out to her own virgin, Christ" (LSE 90). It is puzzling, then, that Edith's chapel, which has such culminating significance in the *Vita*—and which, in the apocalyptic conclusion to the *Liber confortatorius,* stands for the Wilton nunnery, having apparently subsumed the whole nunnery into itself when it is re-created as a heavenly mansion—disappears from Goscelin's narrative as soon as he has related Edith's translation from it to the south porch of the main church. Perhaps, like her ascended soul, it has assumed an unearthly existence.

In contrast to the specificity that characterizes Goscelin's account of Edith's activities (more secular than saintly), his celebration of her as a contemplative bride of Christ is conducted in rhetorical generalities. He did, however, find a concrete form for this in the Wilton nuns' memories of Edith's menagerie.

19. "Among the other works she performed in her dutiful stewardship, this lady built a stone wall around sun-blessed Wilton; she put the church of the virgins on a foundation of faith, like the castle of Sion and the tower of David, built it up in hope, enlarged it in love, surrounded it with the virtue of self-control, a better builder and warrior than Semiramis of Babylon" (LSE 274).

20. Ibid., 87; the painted ceiling figures in an earlier allusion to Benno's painting of the chapel (50).

She kept a collection of native and exotic animals (given to her by foreign ambassadors wishing to gain her favor at court) in an enclosed courtyard outside the south wall of the nunnery. Standing in the doorway, she would "call by a pet name the ferocious, branching-antlered stag," feeding it with bread from her hand, and stroking the "wild animals" who came running at her call. Here, by the transformative power of Goscelin's imagination, Edith sought refuge from the uproar of the world, "with the mind of a recluse," striving for the part of Mary; Goscelin also likens her to the desert saints, Antony and Macarius, and to Christ in the wilderness. "Wounded with love," she gazed towards the heaven with the eyes of Stephen, communing with God whose glory she discerned in all of his creation.[21] Literally outside the precincts of the nunnery, Edith's enclosed menagerie assumes the aspect of an anchoritic retreat in the wilderness set apart from the distractions of the world ("for she loved the rush mat of the anchorite Paul better than the robe of her father's royal power" [LSE 71]). Its prelapsarian harmony also manifests the paradise within herself that Edith attains inside "the paradise of the cloister," which is subsequently imaged on the walls of her chapel.

Goscelin's construction of Edith's inner life—her deeply inward and intense quest for union with her spiritual bridegroom from her earliest years—embodied the spiritual life that Goscelin had ardently desired Eve to pursue from the time of her dedication at Wilton. Writing to her from "Burg" (either Peterborough or Bury St Edmunds), he recalls that the sight of her at that time, trembling with emotion as she approached her marriage with God, moved him to tears; it was from that moment he dated the "birth" of his love for her. At that time he urged her to make only one petition to the Lord—that, "wounded by love," she might seek him only as her husband with her whole heart and soul. And now, so that she may have only him, he writes in the *Liber confortatorius,* she has entered an anchorite's cell alone; may she carry out now "the advice that at that time I was pouring into your ears as if I were giving birth" (*LC* 28–29). But if she wanted to live a solitary religious life, why could she not have become an anchorite in her own homeland?

> This truly I always wanted, and to this end I gave birth to you and loved you, that you should pass into the bowels of Christ, and become wholly a sacrifice to Christ. But I desired this elsewhere than

21. LSE 64–67. Goscelin's description of Edith's animals as "the gifts of the mighty" is explained by his earlier account of her influence at her father's court, where he relates that "foreign kingdoms and principalities also gave her respect with greetings, letters, and gifts" (62–63).

> where you are and by another path, namely that you might live holily and be a useful vessel in the house of the Lord, a dove in the cloister, not a solitary turtledove, or, if you preferred, you might become a turtledove in your homeland. And why? So that I might mourn my desolation less, if you were close to me. (*LC* 36)

Goscelin's portrait of Edith as a bride of Christ withdrawn in solitary contemplation within the precincts of her enclosing community may thus be read as an image of Eve as he wished she had remained. (Likewise, his invocation of the continuous presence of the departed saint in the places she once occupied—"Here she was accustomed to read, here to pray"—gains further resonance from his remark that, to him, all the ways and places frequented by Eve at Wilton had "smelt of nectar and balsam" [LSE 29].) As Goscelin's Edith chooses to remain "cut off from the enticements of the world in the bosom of her mother" and continues to dwell "in the paradise of the cloister," so Goscelin (whose "giving birth" to Eve marks his transformation into her spiritual mother) had presumed to hope that he "might cherish [her] in [his] bosom in the paradise of God." He resigns himself, at the end of Book I of the *Liber confortatorius,* to the hope that he might deserve to see her "in the more worthy bosom of father Abraham" (*LC* 45). He is obliged to accept that he must help her to take root in the place where she has been (trans)-planted by writing her a "book of encouragement," but "if it could have been done in the will of God," he would have preferred to tear her away (*LC* 36).

Goscelin's will and God's will do not accord. Book I of the *Liber confortatorius* enacts a struggle between his emotions and the doctrinal consolations to which he intellectually assents ("reason approves of the path of virtue indeed, but love . . . has no measure . . . and cannot bear desire for something that has been lost" [*LC* 29, 31]), and his resignation to the loss of Eve is incomplete and reluctant. He does not immediately give expression to his overwhelming grief, sense of betrayal, and fear that her unannounced departure to Angers signifies that she has deliberately severed their relationship. He begins serenely, as if he is fully reconciled to the loss of her—as if, indeed, he believes that it is she who needs consolation for his absence. It is not until he is well into the work that he acknowledges explicitly that he is attempting to console her when he is himself inconsolable (*LC* 35).

He greets her with a version of the consolation that Christian letter writers conventionally offered. Because his love for her is not of the body but of the soul ("that better part of himself"), no physical distance can separate her

from him. And as it is the will of God that they have been separated on earth, God will inseparably join them in heaven, making "one soul of two people":

> O soul dearer than light, your Goscelin is with you in inseparable presence of soul. He is with you in that better part of himself, with which he could love you, one with you, from which no distance may separate you. He greets you in Christ with eternal greetings. Behold, he has touched us with his hand, and he has determined and allotted all those things with wisdom. Although he has separated us for the time being, he has also given us higher counsels, so that of course we will pant and hasten to be united in that homeland where we can never ever be separated. The more distance he has put between us physically, the more inseparably at some time he will join together again one soul of two people. (*LC* 27)

And even here and now, Goscelin's letter can unite them in absence. But although he gestures toward the belief that as the soul is superior to the body, so union in the spirit at a distance is superior to physical proximity and constitutes a foretaste of the immaterial union of souls in heaven, his continuing desire to be with her in actuality is evident in his development of this trope. He wishes his letter to convey the image of his physical presence to her so that she will perpetuate in her imagination their togetherness at Wilton:

> And your affection will be able to see by reading the one whom it has left in the body, and will be able to drink in my voice and my sighing words with your eyes instead of your ears. So, lest you think that I have been cut off from you, as often as, mindful of me in Christ, you deign to look upon these remembrances of me, consider that I am seated with you at Wilton in the presence of our lady St Edith . . . that I speak to you, that I exhort you, that I console you, that I pour Christ into your heart with the sighs of the feelings of wounded love.[22]

In the attempt to perpetuate what has been lost, his present grief overwhelms him, and though he cannot complain against her choice of a higher religious vocation, he can and does complain against the cruelty of her unan-

22. *LC* 27. The phrase omitted in the translation above, *aut etiam in hac pudica serie,* is somewhat obscure ("or even in this chaste order"?). Goscelin is probably proposing that Eve might, alternatively, go so far as to imagine that he is present with her at the anchorite community she has joined.

nounced departure; she has become "the slayer of [her] father in place of his daughter" (*LC* 30). But, accepting that their relationship is irrecoverably changed, he appeals to her to intercede for him so that he may be reunited with her in eternity—so that in place of the temporal sufferings he now endures in her absence he may possess eternal joy with her: "I entreat you, bring it about that although I now lament having lost someone, as if she were the delight of life, I shall rejoice at some time to have found her again, as one who intervenes for me, since the Lord is able to make out of our losses a profit of greater value. May I now have a patron in place of a daughter, of whose prior claim I am as unworthy as I am unequal to her in life" (*LC* 34).

As Goscelin seeks consolation for himself in the belief that God will restore in eternity what has been lost on earth, he offers the same consolatory encouragement to Eve. All that she has sacrificed, he assures her—homeland, parents, friends and relations, the nuns at Wilton, her abbess, and her *magistra* (female teacher)—will be restored to her in their "true" form. His own inclusion among the sacrifices that Eve has made is obliquely hinted at in his mention of the "charming letters" that she has foregone by her departure, presumably the ones he wrote to her at Wilton (*LC* 37). He is, seemingly, confident that Eve will regard all that she has left behind her as a painful sacrifice: "I believe," he writes, "if I know well enough that heart of yours, the abode of love, that nothing is heavier for you to bear than separation from loved ones and friends" (*LC* 42). Not surprisingly, he encourages her to dwell on that grief. It is a form of martyrdom, and the more grief she feels at her separation from those she loves in the spirit, the more joy she will feel in meeting them again in the eternal mansion.

If Hilary of Orléans is to be believed (he wrote a commemorative poem in her honor shortly after her death) Eve left the Wilton community "abhorring that multitude like the offence of sin."[23] Eve, presumably, did not find Wilton conducive to a life of contemplation; whether Goscelin himself was an obstacle to her pursuit of a contemplative life is not a question he raises in his letter. He does, however, doubt that he is among the earthly joys lost for which Eve needs to be consoled: "As to a certain person who was formerly special, against whom alone you have been able to harden yourself, who having been left so far behind, and as though dead, has been given to oblivion by your heart, why should I care that a heart is closed? Or shall I offer consolation for hardness and anoint flint with oil?" (*LC* 42). But towards the

23. Nicholas M. Häring, ed., "Die Gedichte und Mysterienspiele des Hilarius von Orléans," *Studi Medievale,* 3rd ser., 17 (1976): 927, lines 71–72.

end of Book 1, more calmly—as he is about to affirm that whereas he had once presumed to suppose that he might cherish her in his bosom in the paradise of God he now hopes to see her "in the more worthy bosom of father Abraham"—he expresses also the hope that *if* she ever feels grief for her separation from him, she will comfort herself with the prospect of their union in eternity: "which comfort indeed I do not deserve by the unworthiness of my way of life, but may you obtain it by the kindness of your love and prayers" (*LC* 45).

In the opening of the *Liber confortatorius,* Goscelin attempts to perpetuate his relationship with Eve by the imagined re-creation of the past when they sat together at Wilton in the presence of St. Edith, her intermediating presence sealing and spiritualizing their union, as from afar they are now joined by having "Christ in the middle."[24] In the apocalyptic conclusion of the work Edith offers the potential means of his future reunion with Eve. In Goscelin's vision of the New Jerusalem, God will establish "households . . . nations and kingdoms, cities and rural estates," uniting the inhabitants of heaven with their leaders and glorifying them with mansions. There he will join together all of "the teachers and propagators of the churches with their flocks and herds," St. Bertin with his community, and St. Edith with hers (LSE 113). Eve will be reincorporated into the company of Edith, and through that she will participate in Edith's nuptial union with her bridegroom. Goscelin envisages Edith, descending like the New Jerusalem itself as it appeared to St. John the Divine ("coming down from heaven . . . prepared as a bride for her husband").[25] He holds out to Eve a vision of Edith triumphantly leading her spouse into the wedding chamber of Wilton, which now assumes the form of the heavenly city of John's revelation, but to John's heavenly city Goscelin has added towers and turrets, which also figure in his celebration of Edith's chapel in the Legend. The golden wall that surrounds it (also not in John's revelation) is perhaps a transformation of the stone wall that Wulfthryth erected around the nunnery:

> Then your Wilton will be a huge and broad city, lit far and wide
> with a golden wall, with a citadel shining with turrets of gems, raised
> up not for battle, but as a watch-tower of glory, from where the
> daughters of Zion may see more broadly all their England. Its gates

24. *LC* 44; see also 26, 31, 40.
25. Rev. 21:2.

will be of pearl, and all its houses are golden. The temple will shine with jasper, chrysolite, beryl, amethyst, and all precious gem-stones, as far exceeding the glory of the old Solomon, as it is more finely constructed by the new art of our new Solomon. Here, as often as she wishes, your queen Edith will descend in power, proud in the chamber of the great Christ. Here she will lead her beloved spouse with her very great friends, the angels and archangels, apostles and martyrs, with Roman and English kings and counsellors, with her father Edgar and her brother Edward, with Thecla, Agnes, Cecilia, and Argina, Catherine, and a great crowd of virgins, and all her household of the people of Wilton, as many as the Lord made worthy in their lot. (*LC* 114)

There are problems here no less perplexing than those experienced by the dreamer in *Pearl*. Here, it seems, Mary is not *the* bride of Christ, because Goscelin depicts her as vicariously participating in the mystical marriage union of Edith and her bridegroom as the greatest of all mothers-in-law, singing the new song together with "all . . . who love the Lord," as Eve herself will do. There will be "one bride made perfect from all" (*LC* 110), but Edith, we may deduce, both is and is not she. It is in the nature of eternity, as Goscelin evokes it, that individual distinction will be both preserved and obliterated. Every individual entity will be simultaneously part of a greater whole and yet partake fully, according to its own capacity, of all the eternal joys; "each good will belong to each and all goods will belong to all" (*LC* 115). Thus, as the company Edith leads into her wedding chamber is united in her and through her to Christ, Edith herself must be a part of a greater whole, a member of the body of believers that constitutes the Church as well as a representative of it in her unification of the company of Wilton. So perhaps Mary, as mother of all the brides, is after all *the* bride.

Eternal joy, as Goscelin depicts it, will be the fulfillment of each individual's desire ("our Lord will distribute the kingdom to each one severally, according to the distinction of merits and according to the capacity and desires of their hearts"), but in the peace that passes understanding, individual desires will be consonant, like gems in a necklace (*LC* 113). His image of the Wilton community eternally incorporated into Edith, vicarious participants in her nuptial union with the heavenly bridegroom, is an apt image of heaven for a female community (though the procession accompanying her to her wedding chamber does include her father, Edgar, and her brother Edward, both raised to sainthood in the Legend of Edith). He also describes Wulfthryth at her

death as participating in Edith's marriage with Christ through her union with her daughter ("she passed . . . to the eternal embraces of her beloved daughter in Christ, with whom she rejoices in the immortal spouse himself" [LSE 275]). Ælfgifu's dream of being drawn into the embrace of Wulfthryth despite her protestations of unworthiness, confirming Edith's prophecy that she would as Wulfthryth's successor be buried at her side, may be similarly construed as incorporation into her community in the kingdom of heaven. But was reincorporation in the community of St. Edith at Wilton what Eve most deeply desired? Goscelin's culminating vision is, of course, in a strikingly literal way, the restoration of all that Eve had left behind to enclose herself as an anchorite at Angers. But it is not the culmination toward which he appears to be tending in Books 2 and 3 of his epistolary instruction. His figurative transformations of the anchorite cell that Eve had chosen as her home— conceived as the tomb from which she will be resurrected and the place where she dines alone with Christ and his angels in anticipation of the eternal marriage feast—might be expected to find their fulfillment in a celebration of Eve's individual beatification as a bride of the Lord in her own right (LC 79, 90). And when the image of the city of the New Jerusalem first makes its appearance, at the beginning of Book 4, it is, initially, a transcendental version of Eve's anchorite cell, which he has earlier encouraged her to imagine as the tabernacle made by Moses (although the ultimate identity of Eve's tabernacle with the apocalyptic transfiguration of Edith's church at Wilton is indicated by the fact that the tabernacle—unlike the tent from which Moses's tabernacle was constructed—has the appearance of translucent colored glass, and Eve's inner life, like Edith's, is represented by the many-colored images that cover its interior).[26] Fleetingly, on his way to depicting Eve's incorporation into the company of Edith at Wilton, Goscelin glances at the possibility that, having chosen a solitary religious vocation, she might prefer to spend eternity in her cell. As a glorified body, he explains, she will be entirely unconstrained by space and time, instantly present in the body wherever her spirit wishes to go, so that "with your holy lady Edith and all choirs of sisters, all whom their place has formed for Christ, you will revisit from heaven your Wilton, or this cell of yours, now not a cell but a distinguished palace" (LC 114). As the distinctness of individual beings will be both maintained and obliterated, so, too, presumably, individual places will remain distinct even as the New Jerusalem subsumes them—Eve's cell will contain in microcosm the mystic marriage of Edith and will in turn be contained within the Wilton nunnery in its transcendental state.

26. LC 69; cf. Exod. 25–27.

Goscelin's imaging of the culminating goal of Eve's spiritual quest, then, graphically fulfills his assurances to her in Book 1 that all that she has sacrificed will be restored to her. But there is in this no fulfillment of his own reunion with Eve which he repeatedly appealed to her to bring about by her prayers—even though the mystic union of Edith and her bridegroom is celebrated by (or represents the summation of) a multitude of other chaste marriages between resurrected souls and their glorified bodies: "There will be a great joining of angels and virgins, inseparable company, inestimable love, unspeakable sanctity of holy embraces and kisses. The gathering together of young men and virgins, men and women, the married and the celibate, will be as perfect and inoffensive as it is holy and blessed in their celibacy, as it is exempt from all desire for corruption, free from all contagion of sin" (*LC* 115). Amidst all this marrying in heaven (cf. Matt. 22:29–32), Goscelin is like the wedding guest without a garment; he envisages no place for himself and closes with a final appeal to Eve to intercede for his salvation:

> Have pity for the bereavement of Goscelin, whom you have loved as the home of your soul in Christ, but whom by your departure you have shaken completely from his foundations, and . . . beg for me, I beseech you, the mercy of the Lord that is ready to be appeased for eternity, and forgiveness for my sins, so that although you are very far removed from my unworthiness, I may have the happiness of seeing you in your highest happiness, in the blessed light. So may you have all the desires of your soul. (*LC* 117)

Humbly conscious of his unworthiness, he asserts finally his dependence on Eve for a place in heaven, but he appears, too, in the light of the doubts and uncertainties he expresses in Book 1, unsure what degree of union she might wish to share with him in the New Jerusalem. She is, very nearly, lost to him by her adoption of a way of life that will bring her closer to God, but in this vision he has restored her for all eternity to the Wilton that he himself had lost.

7

FAITH IN THE LANDSCAPE:
OVERSEAS PILGRIMAGES IN *THE BOOK OF MARGERY KEMPE*

Diane Watt

> From a single point at Lynn, one can still observe key points of Margery's life: the
> Guildhall, the church of St Margaret, and the lane leading down to a river that suggests—
> through the particular bowing of its horizon—the allure of the beyond.
>
> —DAVID WALLACE, *CHAUCERIAN POLITY*

In this evocative sentence, David Wallace conjures up the landscapes that dominated Kempe's perspective and experience. These were the urban and mercantile centers of Norwich and Lynn; the cathedrals, churches, chapels, and monasteries in England and abroad; and the pilgrimage sites that drew Kempe on her travels around the country and overseas. The natural world—here, the river—is reduced to its function as a route along which women and men, pilgrims as well as traders, can journey. Indeed, the hills, fields, and woodlands, the waterways and managed estates, have little place in Margery Kempe's world, except insofar as they connect with her religious life and spiritual journey. In this respect, as in many others, Kempe's *Book* differs markedly from the letters of those other fifteenth-century Norfolk women, the Pastons, which sometimes vividly evoke the landscapes in which they lived and worked.[1] Previous studies have noted the influence of medieval drama, religious processions, and (to a lesser extent) saints' legends on Kempe's perception of her homeland. Anthony Goodman, for example, ob-

I am grateful to Anthony Smith of the Map Library/Drawing and Cartographic Unit, Institute of Geography and Earth Sciences, University of Wales, Aberystwyth, for producing the map of Margery Kempe's overseas pilgrimages.

1. See *The Paston Women: Selected Letters,* ed. and trans. Diane Watt (Cambridge: D. S. Brewer, 2004).

serves that "Margery's England had an imagined Middle Eastern landscape repetitively powdered over it," and he registers how "the transformation of Lynn and other cities into simulacra of sacred environments" affected Kempe's meditations.[2] In a similar vein, Nicholas Watson comments that Kempe reacts to people she encounters "as though Lynn was the permanent scene of a cycle of mystery plays."[3] *The Book of Margery Kempe* is simultaneously a visionary and devotional treatise and a travel narrative. In this chapter, I consider the ways in which its foreign landscapes are constructed using religious and monastic (specifically Brigittine) models; I also assess the impact of the environment on Kempe's piety and religious certainty.[4] I will do so by focusing on *The Book*'s accounts of Kempe's pilgrimages overseas (especially the details she offers about the countries and towns through which she travels), the sites she visits, and the natural world. At the same time, remembering that the body also furnishes a landscape to be viewed, traversed, and interpreted, I will pay attention to the ways in which the body and the pilgrimage landscapes intersect in *The Book*. Finally, I will examine space in *The Book*— its gendering, its meanings, its uses—especially in relation to penance and performance.[5]

JERUSALEM AND THE CITY OF THE SOUL

Kempe's chronicle of her visit to the Holy Land is concentrated in three chapters of her *Book* (Liber I, chaps. 28–30).[6] In the buildup to her arrival in

2. Anthony Goodman, *Margery Kempe and Her World* (London: Pearson, 2002), 155, 107.

3. Nicholas Watson, "The Making of *The Book of Margery Kempe*," in *Voices in Dialogue: Reading Women in the Middle Ages,* ed. Linda Olson and Kathryn Kerby-Fulton (Notre Dame, Ind.: University of Notre Dame Press, 2005), 416. I am grateful to Professor Watson for providing me with a copy of this article prior to publication.

4. St. Bridget's influence on Margery Kempe has been extensively documented. For an introduction, see Clarissa W. Atkinson, *Mystic and Pilgrim: The Book and the World of Margery Kempe* (Ithaca, N.Y.: Cornell University Press, 1983), 168–79. Julia Bolton Holloway argues that Kempe's foreign pilgrimages were a form of *imitatio Brigidae:* see "Bride, Margery, Julian, and Alice: Bridget of Sweden's Textual Community in Medieval England," in *Margery Kempe: A Book of Essays,* ed. Sandra J. McEntire (New York: Garland, 1992), 203–22. See also Naoë Kukita Yoshikawa, "Margery Kempe's Mystical Marriage and Roman Sojourn: Influence of St Bridget of Sweden," *Reading Medieval Studies* 28 (2002): 39–57.

5. Studies of landscape, territory, place, and space that I have found particularly useful in researching this article include Rita Copeland, "Introduction: Gender, Space, Reading Histories," in *New Medieval Literatures,* vol. 2, ed. Rita Copeland, David Lawton, and Wendy Scase (Oxford: Clarendon Press, 1998), 1–8; Sylvia Tomasch, "Introduction: Medieval Geographical Desire," in *Text and Territory: Geographical Imagination in the European Middle Ages,* ed. Sylvia Tomasch and Sealy Gilles (Philadelphia: University of Pennsylvania Press, 1998), 1–12; and the editors' introduction to *Medieval Practices of Space,* ed. Barbara A. Hanawalt and Michal Kobialka, Medieval Cultures 23 (Minneapolis: University of Minnesota Press, 2000), ix–xviii.

6. *The Book of Margery Kempe,* ed. Sanford Brown Meech and Hope Emily Allen, Early English Text Society 212 (Oxford: Oxford University Press, 1940). All in-text references are to this edition.

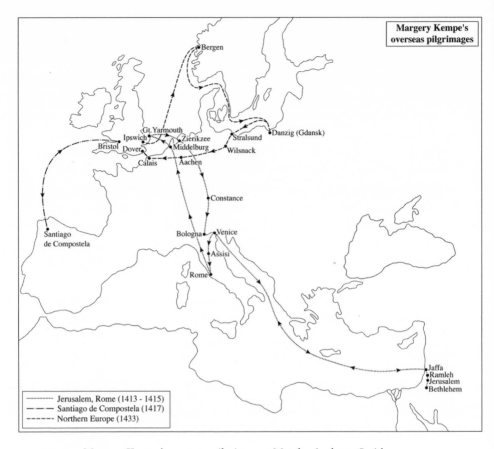

FIG. 20 Margery Kempe's overseas pilgrimages. Map by Anthony Smith.

Jerusalem (Liber I, chaps. 26 and 27), she provides her readers with scarcely enough detail to allow us to plot her journey. Kempe tells us that she set out from Yarmouth and sailed to Zierikzee in Zeeland, from whence she journeyed across mainland Europe to Venice. After a thirteen-week delay, she set off in a ship for the Holy Land. The cities and towns in which she stayed or through which she passed are of little interest to her, except insofar as they provided churches and convents in which she could worship and receive communion—or housed pious clerics who could listen to her confession. No mention is made of the journey Kempe must have made along the Rhine, possibly by boat, or of her crossing the Alps.

Kempe is most concerned with recounting her spiritual tribulations and physical privations, especially those caused by her fellow English pilgrims, who found her fasting, weeping, and constant talking about the Gospel intolerable. She dwells on the isolation she endured as she traveled, which she

contrasts to the spiritual fellowship provided for her by God. Valerie I. J. Flint's study of the penitential function of spatial separation in monastic communities throws considerable light on this section of *The Book*.[7] According to Flint, authorities would punish monks for minor faults by making them eat apart (or on a stool at the end of the table) and by keeping them at a distance in the oratory. For more serious faults, monks might be left to perform their tasks on their own, ignored or even insulted. Obdurate monks would be excluded altogether from the monastery.[8]

Similarly, Kempe's companions and her maidservant initially left her to fend for herself for a night, then humiliated her by cutting short her dress and forcing her to sit at the bottom of the table. They eventually abandoned her altogether in Constance, no doubt hoping that she would be unable to continue further without them. They only invited her to rejoin them when, to their great surprise, they encountered her in Bologna. In Venice, they refused to eat with her and clearly intended to sail without her, if possible, but they changed their minds on discovering that she had received a revelation that she should not leave in the ship in which they planned to travel. In enforcing this sort of isolation on Kempe, her fellow pilgrims must have intended to make her aware of the faults they perceived in her behavior, punish her for them, and encourage her to reform. The severity of the punishment intensified as she repeatedly offended. Kempe, however, represents her endurance of the penance imposed upon her as a testimony to her piety and obedience to God's will. At the same time, the punishment inflicted upon her was frustrated by divine intervention. Separated from her traveling companions, Kempe was offered the friendship and patronage of a papal legate in Constance and the protection of an elderly Englishman named William Weaver, who acted as her guide and helped her continue on her way. More importantly, Christ offered her consolation and comfort. Rather than reflect on the error of her ways, as her companions intended her to do, Kempe remained unchastised. She refused to be coerced into abandoning her pilgrimage, and she resisted her companions' control over her movements and actions, over the space she occupied, and over the countries through which she traveled. Moreover, she challenged their understanding of those lands. Near the beginning of her journey, her confessor and companions reprimanded her, telling her that they would not tolerate her religious practices as her husband did at home. Kempe retorted that her spiritual landscape tran-

7. Valerie I. J. Flint, "Space and Discipline in Early Medieval Europe," in *Medieval Practices of Space*, ed. Hanawalt and Kobialka, 149–66.

8. Ibid., 151–57.

scended her physical surroundings: "'Owyr Lord al-mygty God is as gret a
lord her as in Inglond, & as gret cawse haue I to lofe hym her as þer, blyssed
mot he be'" (61).

In *The Book,* Kempe's relatively long (three-week) stay in the Holy Land
is handled rather differently from her European journey. The first site visited
by Kempe and her fellow pilgrims on their arrival was the Church of the
Holy Sepulchre. (It was also the last place she visited, as she returned there
just before her departure.) There she stayed for a night and a day, climbing
Mount Calvary, taking communion, and weeping in the Chapel of the Holy
Sepulchre. Afterward, Kempe and her companions were guided along the *via
dolorosa.* They then traveled to the Franciscan convent at Mount Zion to see
the location of the Last Supper and the Holy Spirit's descent upon the apos-
tles. She returned through the Valley of Kedron, where she specifies that she
attended two consecutive masses at the Church of the Tomb of the Virgin.
On another trip, she rode on an ass to Bethlehem, where she worshiped at
the Church of the Nativity. She also went to Bethany to see Mary and Mar-
tha's house and Lazarus's tomb. Her longest pilgrimage was to the river Jor-
dan, where Christ was baptized; thence to "Mownt Qwarentyne," or the
Mount of Temptation (74); and then to the Franciscan monastery of St. John,
which marks the birthplace of John the Baptist. Not surprisingly, given
Kempe's spiritual vocation, her description focuses on the Christian signifi-
cance of everything she saw. In portraying her arrival in Jerusalem, riding on
an ass as Christ himself did, she records that the view in the distance enrap-
tured her. She prayed to the Lord that "lych as he had browt hir to se þis
erdly cyte Ierusalem he wold grawntyn hir grace to se þe blysful cite Ierusa-
lem a-bouyn, þe cyte of Heuyn" (67). Kempe was oblivious to everything
except the landscape of the New Testament and the Gospel scenes she saw
reenacted in her mind—and her own mystical responses. In fact, as Goodman
points out, Kempe's account is so narrowly focused that it even omits Old
Testament locations.[9] And while Kempe does mention the Saracen as well as
Franciscan guides who offered her help when her own companions rejected
her, most of the Muslim context vanishes. (In the fifteenth century, the
Mameluke sultans of Egypt controlled Palestine; Jerusalem was a predomi-
nantly Muslim city. The Franciscans were granted privileges in many of the
pilgrimage sites in the Holy Land.) Likewise, except for scattered references
to masses and relics, even the monasteries and chapels fade into the back-
ground.

9. Goodman, *Margery Kempe and Her World,* 186.

The visit to Jerusalem is the climax of *The Book of Margery Kempe,* the high point of her spiritual journey. While taking part in a candlelit procession in the Church of the Holy Sepulchre, Kempe received a revelation of the Passion: "Whan þei cam vp on-to þe Mownt of Caluarye, sche fel down þat sche mygth not stondyn ne knelyn but walwyd & wrestyd wyth hir body, spredyng hir armys a-brode, & cryed wyth a lowde voys as þow hir hert xulde a brostyn a-sundyr, for in þe cite of hir sowle sche saw veryly & freschly how owyr Lord was crucifyed" (68). This intellectual and physical reenactment of the Crucifixion goes far beyond mere affective piety. Kempe's loss of control over her body—her physical collapse, her weeping and crying—reveals the extent to which she identified with Christ's anguish and suffering. Paradoxically, this display of physical failure also signifies the recovery of Kempe's bodily unity and intactness. Her pilgrimage to Jerusalem only became possible after she and her husband had agreed to live chastely (Liber I, chap. 11).

Katie Normington offers a perceptive analysis of Kempe's Jerusalem vision of the Crucifixion by drawing our attention to the theatricality of Kempe's performance. She points out that Kempe "sets the scene . . . identifies her audience . . . [and] then performs her script."[10] Normington's study as a whole is concerned with the (admittedly limited) extent to which women were able to participate in medieval religious drama in England. This participation was closely linked to the control of civic space. Women, who were marginal to theatrical space, were also excluded, at least metaphorically, from civic centers. Normington explains that "women at liberty within the city" were perceived as dangerous because they "escaped social and sexual control."[11] For Kempe, the fact that her vision was perceived "in þe cite of hir sowle" and enacted in the Church of the Holy Sepulchre—the theological core of Jerusalem, itself the city at the heart of Christendom—rather than in a marginal feminine space validates her controversial piety. At the same time, her visionary experience reaffirms the status of Jerusalem as the center of the world, a position challenged in the fifteenth century by the rediscovery of Ptolemaic cartography.[12] Ian Macleod Higgins's comments on *The Book of John Mandeville* are pertinent here: "Unlike a circular world map, a text is necessarily linear and its readers or hearers eventually have to leave Jerusalem behind for other places. . . . What a text must offer in compensation, there-

10. Katie Normington, *Gender and Medieval Drama* (Cambridge: D. S. Brewer, 2004), 76.
11. Ibid., 81.
12. See Ian Macleod Higgins, "Defining the Earth's Center in a Medieval 'Multi-Text': Jerusalem in *The Book of John Mandeville,*" in *Text and Territory,* ed. Tomasch and Gilles, 38.

fore, is a fuller experience of the center."[13] Kempe's emotional Crucifixion vision presents us with just such a "fuller experience."

Kempe's crying, her particularly extreme and troublesome form of religious expression that made its first appearance at this time, would continue for about ten years after she left the Holy Land. Kempe interrupts her pilgrimage narrative to elucidate its characteristics as well as its effect on the people who witnessed it. She records where and how often it took place:

> Fyrst whan sche had hir cryingys at Ierusalem, sche had hem oftyntymes, & in Rome also. &, whan sche come hom in-to Inglonde, fyrst at hir comyng hom it comyn but seldom as it wer onys a moneth, sythen onys in þe weke, aftyrward cotidianly, & onys sche had xiiij on o day, & an-oþer day sche had vij, & so as God wolde visiten hir, sumtyme in þe cherch, sumtyme in þe strete, sumtym in þe chawmbre, sumtyme in þe felde whan God wold sendyn hem, for sche knew neuyr tyme ne owyr whan þei xulde come. (69)

Kempe brought her pilgrimage performances home with her. In fulfillment of Matthew 25:13 ("Watch therefore, for ye know neither the day nor the hour wherein the Son of man cometh"), God's favor is made manifest in Kempe's body at divinely appointed times, not according to human convenience. Kempe inhabited multiple topographies (Jerusalem, Rome, England) and diverse spaces through this continuing physical expression of her spirituality. These spaces were sanctified as well as secular (the church, the street), public as well as private (the street, the chamber), urban as well as rural (the street, the field). She thus defied repeated attempts to restrict her revelations and devotions.

At the same time, because much of the everyday reality of Kempe's visit to the Holy Land is sacrificed in *The Book* to make way for her imaginary reconstruction of and engagement with the events of Christ's life, the impact of monastic teaching on her mental world is clearly visible. Kempe's emphasis is selective: she concentrates on places relating to Christ's birth, death, and resurrection and to his relationship with women. At Calvary, for example, Kempe saw a vision of the Virgin Mary and Mary Magdalen with St. John standing in mourning at the foot of the Cross (68). At the site of Christ's tomb, Kempe describes how she shared the sorrow of Our Lady (71). Experiences such as these reveal the influence of St. Bridget, who described in her

13. Ibid., 50–51.

writings her revelations of the Lord and his Mother with which she was blessed during her own pilgrimage to the same sacred spots.[14] Indeed, Bridget's example must have influenced Kempe's decision to visit the Holy Land in the first place. Of course, Kempe was also indebted to mystical texts in the English tradition. Kempe's image of Christ's body pierced with holes like a "duffehows," or dovecote (70), for example, famously echoes Richard Rolle's *Meditations on the Passion*.[15] A series of visions of the Crucifixion and Resurrection recorded later in *The Book* (Liber I, chaps. 79–81) reprise Kempe's affective responses to the pilgrimage sites in what David Lawton calls "an ingenious and densely textured combination" of the *Revelations* of St. Bridget and the *Meditationes Vitae Christi*.[16] The latter was a key text in the English vernacular tradition; originally written for a Franciscan nun, it was translated by the Carthusian Nicholas Love in the first decade of the fifteenth century and approved by Archbishop Arundel in his stance against the Lollards. In visiting Jerusalem, Kempe was in fact *revisiting* a place she knew intimately, an already imagined and textually constructed (one might even say monastically constructed) landscape to which she had deep emotional attachments. It could offer her no real surprises.

With this in mind, then, *we* should not be surprised that "as regards the Holy Land, *The Book* displays [a] characteristic authorial indifference to the physical environment," as Goodman expresses it.[17] One exception to this rule occurs when Kempe describes Mount Zion as in the "gret hyllys" (72); Goodman notes that the inclusion of even such an inconsequential topological detail is unusual.[18] Likewise, Kempe barely alludes to the physical hardships she must have endured in such an unforgiving climate. Admittedly, she suffered from burned feet and terrible thirst as she struggled up the Mount of Temptation in the great heat, but this is represented as another indication of the continuing callous neglect of her own countrypeople. The environment no more intrudes on Kempe's visit to the Holy Land than does the contem-

14. Atkinson, *Mystic and Pilgrim,* 171–72, 172n16. For a recent and more developed discussion of the Brigittine influence on Kempe's visions and piety, see Nancy Bradley Warren, *Spiritual Economies: Female Monasticism in Later Medieval England* (Philadelphia: University of Pennsylvania Press, 2001), 92–108, esp. 100–103.

15. *The Book of Margery Kempe,* ed. Meech and Allen, 291–92, note to 70/10 sq.

16. David Lawton, "Voice, Authority, and Blasphemy in *The Book of Margery Kempe,*" in *Margery Kempe: A Book of Essays,* ed. McEntire, 99. In this context, see also Gail McMurray Gibson, *The Theater of Devotion: East Anglian Drama and Society in the Late Middle Ages* (Chicago: University of Chicago Press, 1989), 47–65. Warren also argues for a Franciscan influence on Kempe's spiritual landscape: see *Spiritual Economies,* 97–99.

17. Goodman, *Margery Kempe and Her World,* 186.

18. Ibid., 192–93.

porary political and social situation. There is no real sense of danger in this already overwritten landscape. Once again, Kempe's isolation and distress was less of a test of her faith than a reaffirmation of it: she was mirroring the experience of her Savior, who fasted for forty days on this very mountain.

ROME, THE HOLY PLACE

Two chapters of *The Book* deal with Margery Kempe's journey from Jerusalem to Rome: she traveled back to Venice by ship, and then by land, via Assisi, to her destination (Liber I, chaps. 30–31). At that point, Kempe offers a twelve-chapter chronicle of her visit to Rome, where she remained for half a year (Liber I, chaps. 31–42). These chapters conform far less to the pilgrimage-narrative mode employed in the preceding ones. Given the length of her sojourn in Rome, it is striking that only a handful (relatively speaking) of churches and religious sites are actually named or even alluded to indirectly.[19] In Assisi, Kempe visited the Lower Church of St. Francis, where she viewed the veil of the Virgin Mary; at the Portiuncula Chapel, she was granted remission for her sins and for those of others. In Rome, she attended Mass at the Church of Santa Caterina in Ruota and the Church of Saint John Lateran. She also visited the Church of the Santi Apostoli, the Church of San Marcello, the Church of Santa Brigida, and the Basilica of Santa Maria Maggiore. Despite the presence of some of the most remarkable and revered relics in Rome (such as the Holy Prepuce and the vernicle), Kempe shows fairly little interest in the memorials preserved in the churches she visits. Exceptions to this rule were the sites associated with St. Bridget and the tomb of St. Jerome. Kempe states that on one occasion, when she intended to visit the "Stacyowynys," she was prevented from so doing by a revelation that the Lord "xulde sendyn gret tempestys þat day of leuenys & thunderys" (95–96). As we will see, stormy weather and atmospheric disturbances become something of a leitmotif in this section of *The Book*.

The Roman pilgrimage is structured around hagiographic and visionary themes and topoi. The second spiritual climax of *The Book* occurs in the description of Kempe's mystical marriage to the Godhead in the Church of the Santi Apostoli (Liber I, chap. 35). Although this revelation occurs in a public place, it is far more internalized and private than Kempe's earlier vision of the Crucifixion. The mystical marriage is not accompanied by any physical

19. Ibid., 196.

theatrical display, and although it echoes the form of the medieval wedding ceremony, it is not inspired by and does not disrupt any services or religious rites taking place in the church. Indeed, there appear to be no human witnesses, only divine ones (Jesus Christ, the Virgin Mary, and the saints in heaven). In other respects, however, the mystical marriage does mirror the Passion vision. Kempe specifies the day on which it occurred—the Feast of St. John Lateran—as well as the location. In chapters 35 and 36, she describes not only the revelation itself (in which God the Father took her as his bride) and her emotional response to it, but also the supernatural sensations that followed it and continued for many years after her return to England. Unlike Kempe's cryings, these sensations did not manifest themselves in bodily display. Instead, they took the form of sweet smells, beautiful melodies, and other sounds (bellows, the song of a dove or a redbreast), white flickering lights, and the feeling of a fire of love burning in her breast. This revelation provides further evidence of St. Bridget's influence on Margery Kempe's mysticism: the Swedish saint also experienced a mystical marriage, tokens in her breast, and the heat of love.[20] But again, Kempe seems to draw on a combination of traditions, some insular. The fire of love she recalls echoes that described by Richard Rolle in the prologue to his *Incendium Amoris*.[21]

The context of the account of Kempe's mystical marriage is important. Kempe records at some length how, on the journey to Rome and in the city itself, her compatriots rejected her. Left alone in Venice, she again had to place her trust entirely in God and was provided with another unlikely guide, a broken-backed Irish man named Richard. At Assisi, she joined a wealthy Italian woman and her entourage. As on her pilgrimage to Jerusalem, she was punished by her companions, who ostracized and deserted her. In Rome, an English priest cast her out of the Hospital of St. Thomas of Canterbury, the hospice for English pilgrims. Kempe was eventually invited to return to the hospice, but even her former maid—who was employed at the hospice after having left her—would give her alms but not rejoin her. Yet by receiving divine revelations in the churches of Rome, Kempe established her right to remain in the Eternal City. Furthermore, Kempe stresses, she found herself spiritually at home both among the Italian people and among the German residents and visitors. She challenged her own exclusion from the Hospital of St. Thomas when she sent her guide to request that she be allowed to receive communion in the Church of Santa Caterina, which was, significantly, lo-

20. For a recent comparison, see Yoshikawa, "Margery Kempe's Mystical Marriage," esp. 44–45.
21. *The Book of Margery Kempe,* ed. Meech and Allen, 302, note to 88/30 sq.

cated "a-ȝen þe Hospital" (80); in other words, this holy space was adjacent to the space from which she had been expelled. Even as those close to Kempe rejected her, her fame traveled far and wide. One English priest, having heard reports of her piety, traveled to Rome to join her and offered her support and the means to return to England.

In the chapters surrounding the description of her mystical marriage, Kempe also describes the life of voluntary destitution and abjection she led in the Roman slums. Toward the end of the chronicle of her stay in Rome, Kempe received a revelation concerning the sanctity of the decaying semi-rural city, stricken as it was with indigence and penury:[22] "Þan owr Lord Ihesu Crist seyd to þe creatur, 'Thys place is holy.' And þan sche ros up & went forth in Rome & sey meche pouerte a-mong þe pepyl. & þan sche thankyd God hyly of þe pouerte þat sche was in, trostyng þerthorw to be partynyr wyth hem in meryte" (94). Kempe's self-inflicted penance is implicitly contrasted with that imposed upon her by her company. But it is also an extension of that punishment: banished from the spaces inhabited by the other pilgrims, like Christ, she found solace among the poor and needy. In choosing a life of self-sacrifice in this city, Kempe also followed the example of St. Bridget, who had lived in Rome for the last twenty years or more of her life and who had also humbled herself among the Italian beggars.[23] During that time—which coincided with the end of the so-called Babylonish Captivity, when the papal court was based in Avignon, France—St. Bridget had uttered many prophecies urging the papacy to return. In the English translation of St. Bridget's *Liber Celestis,* Christ condemns the city for its inner corruption, which is reflected in its forlorn and crumbling exterior:

> Bot nowe mai I speke to Rome as þe prophet spake to Jerusalem "þat sometime dwelled in rightwisenes, and þe princes þareof luffed pees." Bot nowe it is turned to rusti colure, and þe princes of it are menslaers. Wald God, Rome, þat þow knewe þi daies. Þan suld þou morn and noght be glad. Sometime was Rome wele colourde with rede blode of martires, and set togidir with þe bones of saintes. Now are Rome ȝates desolate, for þe kepers are all bowed to couetise. Þe

22. Kempe's Roman prophecies are discussed further in my "Political Prophecy in *The Book of Margery Kempe,*" in *A Companion to* The Book of Margery Kempe, ed. John H. Arnold and Katherine J. Lewis (Woodbridge: D. S. Brewer, 2004), 145–60.

23. Yoshikawa, "Margery Kempe's Mystical Marriage," 47. Again, Warren draws our attention to the Franciscan as well as Brigittine aspects of this act of piety in *Spiritual Economies,* 98–99.

walles are pute done. . . . And þe holi place . . . is nowe turned to luste and vanite of þe world.[24]

By the time of Kempe's visit, papal rule had been reinstated—but Pope John XIII was absent, and Neapolitan opposition continued. Nevertheless, the prolonged period of division in the Western Church was coming to an end. Rome was, for Kempe, a blessed city (as Christ's words to her confirmed), no doubt largely because St. Bridget had resided there for so long.

Kempe's revelation about the blessed status of Rome introduces a series of recollections designed to demonstrate further her spiritual affinity with St. Bridget. The most important of these are her reminiscences of the Church of Santa Brigida on the site of St. Bridget's former home: "Sche was in þe chawmbre þat Seynt Brigypt deyd in, & herd a Dewche preste prechyn of hir þerin & of hir reuelacyonys & of hir maner of leuyng. & sche knelyd also on þe ston on þe whech owr Lord aperyd to Seynt Brigypte and telde hir what day sche xuld deyn on. & þis was on of Seynt Brigyptys days þat þis creatur was in hir chapel, whech befor-tyme was hir chawmbre þat sche deyd in" (95). Though Kempe was overcome with crying when she saw the marble slab on which Christ's body was laid after it had been taken down from the cross (71, 72), seeing the stone where St. Bridget had experienced her last revelation did not elicit such extreme emotion. Still, she does relate conversations she held with Bridget's former servant and with a man who had known the saint, in which she was told about the saint's cheerful demeanor. The particularity of such records foregrounds the importance of St. Bridget in Kempe's Roman landscape. To reinforce this, Kempe follows up her account of the Church of Santa Brigida with a pronouncement intended to validate Bridget's sanctity: "Owr Lord sent swech tempestys of wyndys & reynes & dyuers impressyons of eyrs þat þai þat wer in þe feldys & in her labowrys wyth-owtyn-forth wer compellyd to entyr howsys in socowryng of her bodijs to enchewyn dyuers perellys. Þorw swech tokenys þis creatur supposyd þat owr Lord wold hys holy Seyntys day xulde ben halwyd & þe Seynt had in mor worshep þan sche was at þat tyme" (95). As Joëlle Rollo-Koster explains, "supernatural occurrences defined space and place as they admonished humans."[25] Kempe's divine warning was particularly timely: her visit to sites in Rome dedicated to St. Bridget coincided with the Council of

24. *The Liber Celestis of St Bridget of Sweden,* ed. Roger Ellis, Early English Text Society 291 (Oxford: Oxford University Press, 1987), 1:238–39.

25. Joëlle Rollo-Koster, "The Politics of Body Parts: Contested Topographies in Late-Medieval Avignon," *Speculum* 78 (2003): 85.

Constance, which debated the authenticity of St. Bridget's revelations and confirmed her canonization.[26]

Kempe's interpretation of the tempestuous weather resonates with a prophecy recorded earlier in *The Book*, which also includes a defense of Bridget and her *Revelations*. At the end of Liber I, chapter 20, the unmistakable voice of the vengeful God of the Old Testament speaks of the "pestylens & bataylys, hungyr & famynyng, losse of her goodys wyth gret sekenesse" he inflicts on a world that will not heed his messages or acknowledge his messenger (48). This declaration is preceded by a vision of a dove hovering above the Eucharist during the celebration of the Mass. When Kempe prays for clarification of the meaning of her vision, Christ tells her that it signifies that vengeance will befall the people in the form of an "erdene" or earthquake. He explains, "'For I telle þe forsoþe rygth as I spak to Seynt Bryde ryte so I speke to þe, dowtyr, & I telle þe trewly it is trewe euery word þat is wretyn in Brides boke, & be þe it xal be knowyn for very trewth'" (47). In both revelations concerning St. Bridget, disturbances in the natural world are interpreted as signs. Storms and earthquakes function as the voice of God, to be translated by Kempe herself. In her report of the strange atmospheric conditions in Rome, Kempe goes on to describe the tempests in greater detail, telling the reader that she sometimes had foreknowledge that they would occur. She also tells how, in response to the pleading of the Roman people, she interceded with God on their behalf and how he subsequently abated the storms. But while Kempe appears to exert some control over the elements, she can only offer her *understanding* of God's message; as with all prophecy, some instability in meaning remains. In the case of Kempe's prediction concerning the earthquake, this uncertainty is more marked. The prophecy and its attendant vision are difficult to date. From the narrative context, they would seem to precede Kempe's Jerusalem pilgrimage and her visit to Rome, though neither the narrative of *The Book* nor contemporary historical records indicate that any such earthquake ever took place. Still, the importance of these revelations lies less in whether the prophecies were fulfilled than in the way they function to legitimize Rome's holiness, Bridget's sanctity, and Margery Kempe's authority as St. Bridget's follower. To cite Rollo-Koster once again, in the Middle Ages, "visions defined certain spaces, certain territories, and thus offered a topographic definition of power."[27]

26. Diane Watt, *Secretaries of God: Women Prophets in Late Medieval and Early Modern England* (Cambridge: D. S. Brewer, 1997), 34–36.

27. Rollo-Koster, "The Politics of Body Parts," 84.

NORTHERN EUROPE AND THIS DEADLY LAND

Two other foreign pilgrimages are described in *The Book of Margery Kempe:* one to Santiago de Compostela in 1417 (Liber II, chap. 45), and one to various shrines in Northern Europe some sixteen years later. Despite the fact that Kempe stayed in Galicia for two weeks, the pilgrimage to the shrine of St. James is given extremely cursory treatment. Kempe does not provide any information about either the landscape she saw or the churches in which she worshiped. She merely comments that during her fortnight-long stay, "þer had sche gret cher, bothyn bodily & gostly, hy deuocyon, & many gret cryes in þe mende of owr Lordys Passion, wyth plentyuows terys of compassyon" (110). This pilgrimage account is completely overshadowed by the difficulties Kempe faced in England, both before she set sail and after she returned, when she found herself repeatedly examined about the orthodoxy of her beliefs. Even the journey itself proved uneventful. While Kempe's fellow travelers initially threatened to throw her overboard, like Jonah, if any storm blew up, Kempe's prayers for a peaceful crossing were granted: "God sent fayr wynde & wedyr so þat þei comyn to Seynt Iamys on þe seuenyth day" (110).

While atmospheric disturbances gained significance in Kempe's recollections of her stay in Rome, geography and urban topography remained fairly incidental. In Liber II of *The Book,* however—much of which is devoted to her 1433 pilgrimage to Northern Europe—the environment intrudes much further into Kempe's consciousness, contributing to a sense of spiritual crisis. Once again, in undertaking her last recorded pilgrimage, Kempe emulated St. Bridget, who in her old age and shortly before her death responded to a similar call from God in setting off from Rome to Jerusalem.[28] Kempe's religious motivation for making this journey and her exact spiritual destination are unclear, but she may well have set off to Danzig (Gdansk) with the idea of visiting the Brigittine convent of Marienbrunn, where the bones of St. Bridget rested on their final journey from Rome to Vadstena.[29] In returning via Aachen (a shrine St. Bridget visited) to the English Brigittine convent of Syon Abbey, Kempe traced a spiritual route that would seem to lead inexorably to her own apotheosis.

It is perhaps somewhat surprising that Kempe makes no mention of Marienbrunn—and she passes quickly over the six weeks she spent in Danzig as well. This silence is the more marked because Kempe does provide informa-

28. Atkinson, *Mystic and Pilgrim,* 171–72.
29. Bolton Holloway, "Bride, Margery, Julian, and Alice," 203, 207–8.

tion about other places and sites, emphasizing the rural areas through which she traveled rather than the cities in which she stayed. She records the Norwegian practice of raising the cross at midday on Easter Sunday (231), rather than in the morning, as would happen in England. She also describes the holy blood of Christ and miraculous hosts at Wilsnack (232, 234–35), the sacrament exhibited at a house of the Friars Minor (235), and the Virgin Mary's smock in Aachen (237). Kempe may have been aware that criticisms of St. Bridget's visions and teaching were once more reaching a peak. She undertook this pilgrimage just one year before the start of the Council of Basel, in which St. Bridget's opponents argued that parts of her *Revelations* were in fact heretical.[30] Kempe may have intended this journey as a final act of devotion. In 1436, however, the presiding judge at the Council decided against the *Revelations,* dismissing them as unreliable and lacking in authority. Although this ruling was subsequently overturned, it coincided with the final revisions to Kempe's *Book.* When Kempe and her clerical scribe began writing Liber II in 1438, they may have felt less confident about harnessing Kempe's cause to that of the Swedish saint.

Although St. Bridget does not actually figure in Liber II—and no mention is made of the continuing controversies about the status of her *Revelations*— other political events do intrude into the narrative. Kempe's final pilgrimage was disrupted by international discord. She was afraid to leave Danzig and travel by land "for þer was werr in þe cuntre þat sche xulde passyn by" (232). She goes on to mention further difficulties caused by hostilities between England and the countries through which she had to journey. There are indirect references to the Polish invasion of the Duchy of Pomerania, which belonged to the Teutonic Order of Prussia, and to conflicts between England and the Teutonic Order and Hanseatic cities (232, 233). Her journey was equally disrupted by natural and environmental disturbances. The sea voyage from England to Germany was traumatic: two nights of "swech stormys & tempestys þat þei wendyn alle to a ben perischyd" (229). The weather was so bad that the sailors gave up trying to steer their ship, which was then driven onto the coast of Norway. On this particular voyage, Kempe was troubled less by her fellow travelers than by the elements themselves.

A clear parallel emerges between Kempe's emotional, physical, and spiritual life and the turmoil she encountered externally. After the deaths of her husband and the son to whom she was closest, Kempe decided spontaneously

30. See Claire L. Salin, *Birgitta of Sweden and the Voice of Prophecy* (Woodbridge: The Boydell Press, 2001), 221–23.

to undertake this voyage. She was now an elderly woman and suffered from a foot injury. Initially intending to accompany her German daughter-in-law only as far as Ipswich, Kempe then resolved (without her confessor's authorization) to travel on to Prussia. Her unexpressed grief at the loss of two of her closest relatives, her aging and physical decline, and her defiance of her religious advisor and the anxiety it caused her are all reflected in the world around her. Kempe describes her inner torment at finding herself commanded by God to undertake this journey; she anxiously searched for authorization from the words of a preaching friar near Walsingham and from a Grey Friar in Norwich. She also reports the rumors that circulated about her after she had departed: some people claimed that "it was womanys witte & a gret foly . . . to putte hir-self, a woman in gret age, to perellys of þe see & for to gon in-to a strawnge cuntre wher sche had not ben be-forn ne not wist how sche xulde come a-geyn," but others acknowledged it to be an act of charity, or a miracle and an act of grace (228). Like an early Christian pilgrim putting to sea in a rudderless boat, actively seeking exile and renouncing the world, Kempe placed herself entirely in divine hands.

Once in Danzig, she heard of the shrine at Wilsnack in Brandenburg and immediately resolved to visit it, but again her journey proved difficult and the weather problematic. She was stricken by seasickness and other afflictions. Kempe and her scribe provide one possible explanation for the lack of geographic specificity: "Yf þe namys of þe placys be not ryth wretyn, late no man merueylyn, for sche stodyid more a-bowte contemplacyon þan þe namys of þe placys, & he þat wrot hem had neuyr seyn hem, & þerfor haue hym excusyd" (233). Nevertheless, Kempe writes less about her spiritual inner life than about her fear and suffering as she makes her way across harsh alien territory. We find a particularly memorable passage in her account of the long trek from Wilsnack to Aachen. An enfeebled Kempe, abandoned by her guide and other traveling companions, was forced to join a band of beggars. She tells of the extent of her humiliation: "Whan þai wer wyth-owtyn þe townys, hir felaschep dedyn of her clothys, & sittyng nakyd, pykyd hem. Nede compellyd hir to abydyn hem & prolongyn hir jurne. . . . Thys creatur was a-bauyd to putte of hir cloþis as hyr felawys dedyn, & þerfor sche thorw hir comownyng had part of her vermyn & was betyn & stongyn ful euyl boþe day and nyght" (237). Here culture almost gives way to nature; God's creature is on the verge of being reduced to little more than an animal. How remarkable is this? Certainly, the natural world had penetrated Kempe's consciousness during her earlier travels. Throughout *The Book,* stormy weather not only functions as a sign but also serves—like illness and seasick-

ness—as a tribulation to be endured and a test of faith. Occasionally it is even a blessing in disguise: on the way to Wilsnack, bad weather prevented Kempe from being forced to travel when she was ill, and she remained sheltered in "a lityl ostage fer fro any towne" (234). At other times (as in Rome), when her prayers proved sufficient to stop them, such tempests served to indicate her sanctity. Yet in these chapters, leading as they do to *The Book*'s conclusion, Kempe's body—which she had dedicated to God through her vow of chastity and displayed in His name and to His glory—begins to fail her. The difficulties and perils of the journey itself become overwhelming—the cold, the hunger, the thirst, the lack of shelter. They dominate the descriptions not only of the cities, churches, shrines, and relics that are Kempe's ostensible destinations but also, as I have suggested, of Kempe's "dalyawns" with Christ. Even the final stages of Kempe's continental trek "in dep sondys, hillys, & valeys" (241) to Calais prove almost impossible.

There are a number of explanations for Kempe's weariness. The first is simply her greater age; at the time of undertaking this pilgrimage, Kempe was sixty years old. No longer young and vigorous, she clearly felt more vulnerable to the threats from robbers and rapists and more susceptible to the environment. Though there is a sense that this elderly woman can neither cope with the weather nor reconcile herself fully with the reality of her own aging, nature's hostility is no mere symbol of Kempe's physical and mental decline. There is also an intimation of spiritual entropy: Kempe's faith, her confidence in her own salvation, struggles to keep her going. Despite the references to the liturgical calendar that punctuate the narrative, Kempe's mystical and hagiographical landscapes strikingly fade into the background, while her natural surroundings close in on her. The somewhat abrupt ending of *The Book*—with Kempe's return to Lynn via Dover, Canterbury, London, and Sheen and her reconciliation with her confessor—may contribute to the reader's sense of unease. With no satisfactory resolution and closure, we may well start to wonder whether Kempe herself ever successfully made the final journey from "þis dedly lond" to "þe lond of leuyng men, wher deth xal neuyr aperyn" (225).

To read the ending of *The Book* in this way, however, would ignore the series of prayers attributed to Kempe that are appended to the manuscript.[31] In one remarkable passage, Kempe envisages having "as many hertys & sowlys closyd in my sowle" as the inhabitants in heaven, or

31. I am grateful to Ruth Evans for drawing my attention to the significance of these prayers. Hope Emily Allen believed that the prayers were composed by Kempe, "long ante-dating the composition of the book in any version": see *The Book of Margery Kempe*, ed. Meech and Allen, 349, note to 248/1–2.

[d]ropys of watyr, fres and salt, cheselys of grauel, stonys smale &
grete, gresys growyng in al erthe, kyrnellys of corn, fischys, fowelys,
bestys & leevys up-on treys whan most plente ben, fedir of fowle er
her of best, seed þat growith in erbe, er in wede, in flowyr, in lond,
er in watyr whan most growyn, & as many creaturys as in erth han
ben & arn er xal ben & myth ben be þi myth, and as þer arn sterrys &
awngelys in þi syght er oþer kynnes good þat growyth up-on erthe.
(252)

This invocation of God's plenitude relocates Kempe in the cosmos, placing
her back into the created world. Kempe is part of the universal order, and
we are effectively reassured of her salvation. Her final pilgrimage, undertaken
as it was when she was at her most vulnerable, served as the greatest test of
her faith—and she ultimately won the struggle against doubt and despair and
made her way to her home in this world, just as *The Book* seems to promise
that she will reach her home in the next.

PART 3 ❧ LANDSCAPES IN TIME

These three essays move the reader from medieval past to modern present from very different perspectives: a contemporary contemplation of the landscape of war, an assessment of the Cistercian settlement through the lens of environmental science, and a view from the Pacific Northwest. The essays by Sarah Beckwith, Kenneth Addison, and Ann Marie Rasmussen cross continents as well as cultures and create cross-temporal perspectives, opening up new ways to think about place and belief. Each finds ways of locating the medieval in the modern. Cumulatively, they manifest this volume's commitment to studying place in space and through time.

8

PRESERVING, CONSERVING, DESERVING THE PAST:
A MEDITATION ON RUIN AS RELIC IN POSTWAR BRITAIN
IN FIVE FRAGMENTS

Sarah Beckwith

I

I first began to think about monastic ruins when I was working on the York Corpus Christi cycle and its revival for my book *Signifying God*.[1] In 1951, after a gap of nearly four hundred years, the plays were revived in a still bomb-scarred city—amid the ruins of St. Mary's Abbey—for the Festival of Britain. The setting of the ruins became a passionately defended locale for subsequent performances of the cycle in the triannual York Festival. The ruins were sacred space, but the archbishop of Canterbury and the lord chamberlain agreed to the staging (which otherwise would have transgressed the Blasphemy Laws) on the grounds that the play was understood as a religious and not a theatrical event. In the first chapter of *Signifying God,* I wondered what versions of the medieval past were required of the ruins—and what this ruined history implied for contemporary medievalism.

In the Middle Ages, St. Mary's Abbey was the archenemy of the civic authorities who controlled the production of the plays. Indeed, the abbey

1. *Signifying God: Social Relation and Symbolic Act in the York Corpus Christi Plays* (Chicago: University of Chicago Press, 2001). A fuller account from which the following details are excerpted is given in chapter 1, "The Present of Past Things."

had its own competing procession to the civic dramas, and territorial and judicial conflicts were endemic over the course of the medieval production of the plays. Furthermore, St. Mary's Abbey was commandeered as the headquarters of the Northern Council, which oversaw the demise of the very plays revived in the ruins of this former Benedictine abbey. "At the dissolution of the monasteries by Henry VIII," writes Francis Drake in his 1736 topography of York, "the site of this noble and rich abbey with all its revenues fell to the crown. And here it was that the prince ordered a palace to be built, out of its ruins, which was to be the residence of the lords presidents of the North, for the time being, and called the King's Manor. That the very name and memory of the abbey might be lost for ever."[2] So even though the abbey, both before and after the dissolution, set its face against the civic authorities' putting on the plays, this link with a verifiable past is immaterial in the history of the post-1951 productions of the medieval cycle play. The mobile, fluid, processional drama, which was a complex mutual mapping of city and play, of York, Calvary, and Jerusalem, was rendered in monumental chiaroscuro as God sat in massive shadow in the ruined nave.

After the huge success of the 1951 production, the plays were always, until 1992, produced in the ruins. The locale indeed became something of an obsession in the history of performance. When Tyrone Guthrie was asked to direct the plays, he refused to do so in the "petrified past of the ruins." He was forced to resign over the issue. For the Festival Committee, it was the abbey's ruins or nothing. In 1976, Joan Littlewood was asked whether she would direct the plays. She agreed, on the condition that she could do them on wagons in the street and that they would be free. The pageants were not done in the streets, however—and that year the plays were not free. When they were brought inside and put behind the proscenium arch in the Theatre Royal in 1992, the outrage was palpable. The *Yorkshire Evening Post* records letter after irate letter protesting the lack of tragedy, reverence, and power of the production, and many of the letters were exclusively concerned with the absence of the abbey ruins as set and backdrop. Ruin seemed built into revival, then, in the history of these plays.

If I were writing *Signifying God* now, I would probably spend more time talking about the conjunction of ecclesiastical ruin with the ruins of the Second World War. There were ruins all around York in 1951 and long afterwards—the evidence of the massive, widespread destruction by German

2. Francis Drake, *Eboracum: or, The History and Antiquities of the City of York, From Its Original to the Present Times* (London, 1736), book 2, chap. 4, p. 574.

bombs in sites that were grown over but still visible reminders of the war. These new ruins were wounds, new and raw, and they must have provided a complex context for the august, ancient, but brutally truncated history exemplified in the ruin of St. Mary's Abbey. Indeed, part of the attraction of the abbey's ruins for the denizens of York in 1951 was their longevity as well as their picturesque nature. It was less obvious that these old ruins were once man-made, created through vandalism and willful destruction; time had made them a quasi-natural part of the landscape.

During the Second World War, 1.5 million houses and countless other buildings and monuments were destroyed in England. German bombers deliberately targeted not only public and militarily strategic buildings but also historic cultural monuments. (English fighters did the same with the churches of Dresden, Leipzig, and Cologne.)[3] Both historical contexts—of dissolution and war—rendered the setting for these plays, then, "a place to believe in."

The conjunction of ruin with sacred space and war was neither a convenient evasion of the Blasphemy Laws nor a director/producer's quasi-sacramental understanding of the Corpus Christi plays. Rather, the connection was already embodied in the landscape. Old churches, ruined in plenty during the bombing raids, had often been preserved as war memorials. In a letter to the *Times* of 15 August 1944, several cultural figures (including T. S. Eliot and John Maynard Keynes) had proposed that a number of bombed churches should be preserved as ruins to serve as war memorials and as places to assemble for open-air services.[4] Christopher Woodward calls this the last fling of the British Picturesque. According to the letter's authors,

> It will not be many years before all traces of war damage will have gone, and its strange beauty vanished from our streets. No longer will the evening sky be reflected in the waterpools which today lie dark and quiet between torn and gaping walls. Soon a pockmarked parapet or a broken cornice will be to future generations the only sign of former shock and flame. The shabby heap of stones, flowering with willow-herbs as pink and lively as the flames which earlier sprouted from their crevices, will disappear, and with their going the ordeal which we passed will seem remote, unreal, perhaps forgotten. Save us, then, some of our ruins.[5]

3. For an important meditation on the striking absence of writing (in fiction, not testimonial) about the utter devastation wreaked by "Bomber Harris" on German cities, see W. G. Sebald, *On the Natural History of Destruction,* trans. Anthea Bell (New York: Random House, 2003).

4. Cited in Christopher Woodward, *In Ruins* (London: Chatto and Windus, 2001), 212.

5. Ibid., 214.

The writers propose the paradox of the preserved ruin and its rationale:

> Preservation is not wholly the archeologist's job: it involves an understanding of the ruin as ruin, and its re-creation as a work of art in its own right. . . . A ruin is more than a collection of debris. It is a place with its own individuality, charged with its own emotion and atmosphere and drama, of grandeur, of nobility, or of charm. These qualities must be preserved as carefully as the broken stones which are their physical embodiment.[6]

In 1953, Rose Macaulay published a book entitled *The Pleasure of Ruins* in which she reflected on broken beauty, fallen shrines, and phantom towns.[7] The book is a fascinating and haunting evocation of ruins, nearly all elegiacally ancient: the ghosts of Nineveh and Babylon, the Mayan temples, the Greek Acropolis, and the "fallen shrines" of Fountains and Rievaulx. In the book, begun in 1949, she pioneers the notion of ruin as a way of seeing, not simply as something seen. She dwells, too, on the fascination with ruins, including the "morbid pleasure in decay," "righteous pleasure in retribution," "egotistic satisfaction in surviving," and "masochistic joy in common destruction" that play a part in that fascination.[8] In her 1950 novel *The World My Wilderness,* written after the war (and after her own house had been utterly destroyed by bombs in the Blitz), she explores ruin as a landscape of waste and loss, of dereliction and healing. The first edition of *The Pleasure of Ruins* ended, in fact, with some paintings of war ruins by John Piper, one of the artists directed by the War Artists Advisory Committee to record war damage.[9]

On 14 November 1940, 449 German bombers dropped 500 tons of explosives and more than 40,000 firebombs on Coventry. After the attack, Goering, the Luftwaffe chief, assessed the devastation with grim satisfaction,

6. Ibid., 215.

7. Rose Macaulay, *The Pleasure of Ruins* (London: Thames and Hudson, 1964). The book was first published in 1953. The Thames and Hudson edition that I use here is a lavish coffee-table book with loving, melancholy, gorgeous photographs taken by Roloff Beny in line with the discussions they had in the last few years of Macaulay's life.

8. Ibid., 26.

9. The War Artists Advisory Committee employed nearly 260 artists. The bulk of their work went to the Imperial War Museum. See, for this and further information, Michael Felmingham and Rigby Graham, *Ruins: A Personal Anthology* (London: Hamlyn, 1972), 117. In his little book on Piper published by Penguin in 1944, John Betjeman notes that "at the age of twelve he was tracing stained glass in Surrey churches and in his teens he was secretary to the County Archeology Society." See Betjeman, *John Piper* (Harmondsworth: Penguin, 1944), 8.

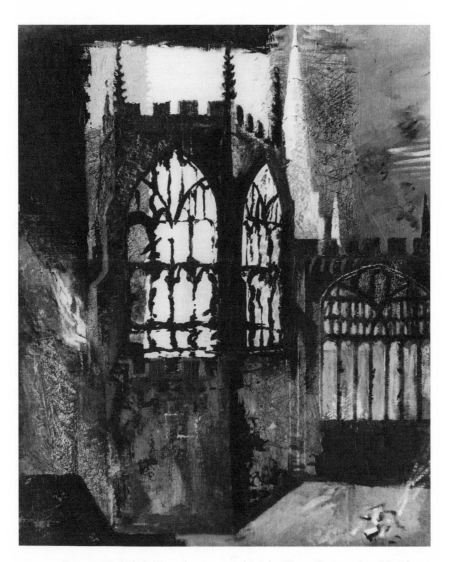

FIG. 21 *Coventry Cathedral, November 15, 1940,* by John Piper. Presented to Manchester Art Gallery by H.M. Government War Artists Advisory Committee, 1947. Photo © Manchester Art Gallery.

declaring that from now on targeted cities would be "Coventrated." Piper was dispatched to paint the damage done to the cathedral at Coventry (his first painting of a bomb site). One of his paintings was reproduced as a postcard published by the Ministry of Information in November 1940. It became to the British what Picasso's *Guernica* had been to Spanish loyalists. He painted many of the bombed buildings destroyed in the "Baedeker raids" of 1940–43—so called because the Luftwaffe chose targets from Baedeker guides. Of the destruction of Bath, his favorite city and the site of Roman ruins, he wrote in a letter to his friend John Betjeman:

> I never was sent to do anything so sad before. I was miserable there indeed to see that haunt of ancient water drinkers besmirched with dust and blast. 3 houses burnt out in Royal Crescent, bomb in middle of Circus, and 2 burnt out there; Lansdowne Chapel direct hit, 10 bombs in front of Lansdowne Crescent, Somerset Place almost completely burnt out; a shell . . . 326 killed, 1800 houses made uninhabitable. . . . My God I did hate that week.[10]

Piper's painting makes the shattered cathedral look like a modernist building. There are no people in his paintings, but here, the gutted building stands in for a wounded body. Indeed, his paintings register infinitely more of this pain than his lordly discourses on ruin and decay. In 1948, in fact, he found that he could appreciate "decay," as seen in his article "Pleasing Decay." There he pitted the artist against the architect in the envisioning of ruins. He wanted to prophesy beauty as well as horror, and he found that beauty in bomb damage: "Bomb damage has revealed new beauties in unexpected appositions."[11] Ruin had been his subject long before the bombings, and he painted nearly all the ruins of the great dissolved monastic houses in the 1940s. Moreover, in the Shell Guides founded by Betjeman, he photographed many more.

The old ruined cathedral was rebuilt. Basil Spence's modernist design was a monument to the new postwar architecture, and Piper designed a stunning stained-glass window. This new building incorporated the ruined apse painted by Piper in 1940 as a fire-blackened memento into the new concrete-and-glass construction. The ruin, then, is set off as a fragment, a trace in the high modernist design of Spence's cathedral. As a painter of England's old

10. Cited in Woodward, *In Ruins*, 218–19.
11. "Pleasing Decay" appeared in *Buildings and Prospects* (1948); cited in Woodward, *In Ruins*, 221.

ruins, Piper found ways to link old and new, to show the man-made and not merely the natural images of ruin. It was perhaps this conjuncture that informed the special meaning of ruin for the spectators of the Corpus Christi cycle in York in 1951.

Having incorporated Piper's paintings in her *Pleasure of Ruins,* Macaulay ended with her own juxtaposition of old and new.

> New ruins have not yet acquired the weathered patina of age, the true rust of the barons' wars, nor yet put on their ivy, nor equipped themselves with the appropriate bestiary of lizards, bats, screech-owls, serpents, speckled toads and little foxes which, as has been so frequently observed by ruin explorers, hold high revel in the precincts of old ruins. But new ruins are for a time stark and bare, vegetationless and creatureless; blackened and torn, they smell of fire and mortality. . . . It will not be for long. Very soon trees will be thrusting through the empty window sockets, the rose-bay and fennel blossoming within the broken walls, the brambles tangling outside them. Very soon the ruin will be enjungled, engulfed, and the appropriate creatures will revel. Even ruins in city streets will, if they are left alone, come, soon or late to the same fate. . . . Shells of churches gape emptily; over broken altars the small yellow dandelions make their pattern. All this will presently be; but at first there is only ruin; a mass of torn prayer books strew the stone floor; the statues, tumbled from their niches, have broken up pieces; rafters and rubble pile knee-deep. . . . Ruinenlust has come full circle: we have had our fill.[12]

The context, then, of the York revivals of Corpus Christi plays was one in which ruined churches were already understood to be places to believe in. Macaulay mined and extended this understanding in *The World My Wilderness;* there, ruins become a complex place of memory, loss, and recovery.[13]

2

These reflections already imply that ruins offer a way of seeing and of engaging our feelings at the deepest affective level—where we see ourselves in

12. Macaulay, *Pleasure of Ruins,* 283–84.
13. Rose Macaulay, *The World My Wilderness* (London: Collins, 1950). The book was reissued by Virago in 1983 with a new introduction by Penelope Fitzgerald. Further references to *The World My Wilderness* will include page numbers from the Virago edition.

history.[14] I have intimated that the ruin of St. Mary's Abbey is an elegy for a
past decisively finished: the past of monasticism, itself dissolved, suppressed,
but surviving in physical remains, as well as a more recent history, the sacred
space attacked in war, ruined, and now to be preserved. Such spaces provide
new relics. Perhaps this somewhat fanciful analogy is worth pursuing a little
further: if monasteries had been ransacked, pillaged, and marauded countless
times during their long histories, what distinguished their dissolution (or their
suppression, as contemporaries called it) were the systematic and deliberate
acts that destroyed monasteries as icons that presenced a way of life. Icono-
clasm, as David Freedberg has observed, testifies to the power of the icon,
and the icon embodies—rather than merely represents—an object.[15] It was,
says Margaret Aston, "the first time that religious foundations had been thor-
oughly attacked and stripped with the deliberate intention of effecting a phys-
ical and institutional break with the past. It was the first time that it had
seemed possible to wipe out forever a whole department of religious life."[16]
The monasteries were deliberately degraded and desacralized. Destroyed so
that they could never be used again, these buildings were gutted in order to
reveal them as just so much "stuff." Geoffrey Chambers's letter to Oliver
Cromwell suggests just such a desacralization of the famous Boxley Rood:

> My singular good Lord, my duty remembered unto your Lordship,
> this shall be to advertise the same that upon the defacing of the late
> monastery of Boxley, and plucking down of the images of the same,
> I found in the image of the Rood called the Rood of Grace, the
> which heretofore hath been held in great veneration of people, cer-
> tain engines, and old wire, with old rotten sticks in the back of the
> same, that did cause the eyes of the same to move and stare in the
> head thereof like unto a living thing; and also the nether lip in like-
> wise to move as though it should speak. . . .
>
> Further, when I had seen this strange sight, and considering that
> the inhabitants of the county of Kent had in times past a great devo-
> tion to the same, and to use continual pilgrimage thither, by the

14. The notion of ruin as a "way of seeing" is brilliantly explored in Robert Harbison, *The Built,
the Unbuilt, and the Unbuildable: In Pursuit of Architectural Meaning* (London: Thames and Hudson,
1991), 99.

15. David Freedberg, *The Power of Images: Studies in the History and Theory of Response* (Chicago:
University of Chicago Press, 1989).

16. Margaret Aston, "English Ruins and English History: The Dissolution and the Sense of the
Past," in *Lollards and Reformers: Images and Literacy in Late Medieval Religion* (London: The Hambledon
Press, 1984), 313.

advice of others that were with me, (I) did convey the said image unto Maidstone this present Thursday, then being market day, and in the chief of the market time, did show it openly unto all the people there being present, to see the false, crafty, and subtle handling thereof, to the dishonour of God, and illusion of the said people.[17]

In England, the very notion of ruin and the dissolution seem to bear almost an internal relation to one another.[18] Says Macaulay, "The larger ruins are more sad. Nothing can have been more melancholy than the first shattered aspect of the destroyed abbeys before they took on the long patience and endurance of time."[19] These decayed buildings could have been put to any number of uses; Hugh Latimer had, in fact, suggested that some monasteries be preserved as houses of learning for the new Protestant order.

Now they are deliberately preserved, indeed framed, as ruins. Their conservation is managed and marketed under the rubric of English Heritage. By "framing," I mean that the ruin is "something constructed by a beholder as a decayed trace of the past."[20] Its survival as decay is essential to our fascination: it is the image of both loss and survival, of permanence and transience. And once the building has been framed as a ruin, its survival is no mere accident of time; it is actively, consciously reclaimed from further decay and oblivion. The heritage industry must simultaneously preserve the process of decay and arrest time in order to preserve the decaying trace.[21] Yet if we care for them too much, ruins will no longer be ruined.

Conservation philosophy has changed in its own contemplation of ruins. Up until the 1960s, the governing philosophy on the repair of ruins dictated that they remain as such, with "honest" repair in keeping with the style of

17. Geoffrey Chambers to Oliver Cromwell, *Letters to Cromwell on the Suppression of the Monasteries,* ed. G. H. Cook (London: John Baker, 1965), 144.

18. Influential recent histories of the Reformation stress the destructive, top-down, state-led aspects of iconoclasm. See, for example, Christopher Haigh, *English Reformations: Religion, Politics, and Society Under the Tudors* (Oxford: Oxford University Press, 1993), and Eamon Duffy, *The Stripping of the Altars: Traditional Religion in England, 1400–1580* (New Haven: Yale University Press, 1992). Interestingly, both of these histories of the Reformation give very short shrift to the dissolution. Ethan Shagan, *Popular Politics and the English Reformation* (Cambridge: Cambridge University Press, 2003), 163, makes this point and also argues for widespread popular participation in the dissolution—a perspective likely to disrupt the rhetorical and melancholy tones of absolute loss.

19. Macaulay, *Pleasure of Ruins,* 285.

20. Michael Roth with Claire Lyons and Charles Merewether, *Irresistible Decay: Ruins Reclaimed,* Bibliographies and Dossiers 2 (Los Angeles: The Getty Research Institute for the History of Art and the Humanities, 1997), xii.

21. Ibid., xii.

the building. But as one report indicates, massive intervention was usually involved in the maintenance of these sites—specifically, the removal of anything "out of period." An in-depth discussion of the philosophy of conservation took place during the planning of the Mont Orgueil project. This discussion, part of a conference on conservation philosophy, can be seen as symptomatic of a shift in policy away from a homogenizing national project toward conservation in line with individual sites.[22] It is no longer the case, this report states, that ruins need remain as ruins; only if the ruin is historically significant should it remain so. Some sites, it adds—such as Fountains Abbey—will of course have to remain ruinous forever, because this is how the public enjoys them. Even given the change in conservation philosophy, the notion of fidelity to historical epoch seems to remain paramount. And, as before, the sense of layering or accretion seems to suffer.[23]

3

In Oradour-sur-Glane in the Limousin, on 10 June 1944—four days after the Allied landing in Normandy—642 villagers were rounded up by the ss authorities and massacred. Men were separated from women and children and marched off to the barns to be shot; women and children were locked in a church, shot, and incinerated inside it. Two years later, the government appropriated the ruins of Oradour—all forty acres of its shops and farms and villages—and decided to preserve it as a commemoration, a "martyred village."[24]

I mention Oradour here because it exposes some particular paradoxes and problems with ruins as a form of commemoration. In her book *Martyred Village,* Sarah Farmer gives a detailed account of how the ruins' physical deterioration causes dilemmas for the survivors, their descendants, and the architects of the Historical Monuments Service. How do you preserve the appearance of devastation as the growing grass softens the edges, concealing the desolate nakedness of the cracked and split buildings? How do you stop

22. Mont Orgueil is a major defensive site in Gorey in Jersey, and a conference on conservation philosophy used Mont Orgueil as a pilot project. The full report offers fascinating insights into the most recent thinking around conservation. The Web site is http://www.montorgueil.org/report/10appen dix1.html.

23. See M. W. Thompson, *Ruins: Their Preservation and Display* (1983).

24. A detailed account of the appropriation and commemoration of Oradour is given in Sarah Farmer, *Martyred Village: Commemorating the 1944 Massacre at Oradour-sur-Glane* (Berkeley and Los Angeles: University of California Press, 1999).

the rain from washing away the smoke and soot that betokens the appalling conflagration, the incineration of so many human beings? "As the old town crumbled," Farmer writes, "the outline of ruins became softer, smoothed like a seashell washed by the tides."[25] Now there is a bird's nest on the parapet of the ruined church, and an old child's pram has been placed on the altar. Christopher Woodward, a recent visitor, comments: "In the crypt below are displayed the relics of ordinary lives: charred banknotes, saucepans whose handles have dropped with the heat, wrist-watches with their hands stopped at the moment when their wearers were shot. Outside in the marketplace is the oxidized husk of the saloon car driven by the local doctor."[26] Woodward suggests that no artistic intervention could create such images as the doctor's rusted car or the melted pram. Still, preserving the car as a ruin requires a great deal of intervention: in 1992, the wreck of the car was dismantled and the body sanded, painted with tar, and waxed on the outside to repel moisture. It is as if, once located in place, the impossibility of halting physical decay will render even loss lost to us. But even as Oradour's ruin is artificially maintained, even as technologies allow us to preserve the geography of desolation, the town's surroundings change to such an extent that it can no longer function in the same way. Monuments are supposed to preserve memory, but in this paradoxical attempt at changelessness, they only seem to embody decay more poignantly. For the survivors, this is terrible. "After us, who will remember?" said one survivor at the funeral of the local doctor—the owner of the preserved saloon car.[27] All the veterans, citizens, and survivors of the generation who lived through the war are dying. There will soon be no more firsthand witnesses, but only monuments, archives, and places of memory.

4

Macaulay's novel *The World My Wilderness* was published in 1950, a year after she began her ruminative and elegiac *The Pleasure of Ruins*. It is an extraordinary examination of the psychic and social landscape of the ruins created by the protracted London Blitz. The novel is worth considering in detail, for it contains not only a complex social history of the postwar ruined landscape, along with a uniquely precise topography of east London's devastated terrain, but also a veritable grammar of ruin: ruin as mnemonic, as oblivion, as salve

25. Ibid., 195.
26. Woodward, *In Ruins,* 211.
27. Quoted in Sarah Farmer, *Martyred Village,* 205.

and negation, as redemption and disappearance, as sacred and profane, and
finally as barbarism and civilization.

The Blitz on London, part of Hitler's strategy to break the will and morale
of the nation prior to occupation, officially began on 7 September 1940.
After the first devastating attack, which concentrated largely on the docks in
the East End, London was bombed almost nightly for a period of about
three months until a three-nights' reprieve over Christmas; the bombing then
resumed until the following May. Later in the war, the "doodlebugs" fell
between June and September 1944 and again from September to March 1945,
making London look, in Elizabeth Bowen's words, like the "moon's cap-
ital."[28]

Macaulay's novel is set in 1946, in the new ruins created by bomb damage
near St. Paul's in the City. Almost all of the buildings around Aldersgate,
Moorgate, and Cheapside were completely destroyed. Most of the guildhalls
went up in flames, as did many of the churches erected by Christopher Wren
after London's other great conflagration of 1666, to which Macaulay al-
ludes.[29] (In his book, *London at War, 1939–45*, Philip Ziegler comments that
churches were often used as shelters; though they were hit as often as any
other building, "the conviction lingered that somehow they would be im-
mune.")[30] This entire area became a wasteland. Across its newly forged paths,
makeshift signs with the names of former streets—Watling Street, Friday
Street—were ghost-ways, pointing out directions back to a more familiar,
recognizable world.[31]

St. Paul's, featured on the cover of the first edition of Macaulay's novel
and again in its final chapter, survived the prolonged bombing. Indeed, the
old cathedral's fate and future became the focus of enormous anxiety in war-
time London. An outsized bomb, certainly large enough to have made a ruin
out of St. Paul's, landed just short of its steps on 12 September 1940 but never
exploded.[32] On V-E and V-J Days, searchlights lit up the cathedral's dome.[33]
Subsequent months and years saw the wastelands around St. Paul's become

28. Cited in Jerry White, *London in the Twentieth Century: A City and Its People* (London: Viking,
2001), 39. The phrase is from Elizabeth Bowen's book *The Demon Lover and Other Stories*.

29. *The World My Wilderness*: "they sat, though they did not know it, and nor had Messrs. Johnson
and Brown, and nor did anyone in that year of 1946, in the garden of the great house of stone and
timber anciently belonging to the Nevilles; a great gabled house over against a bastion of the Wall,
perished nearly three centuries since in another great fire" (71).

30. Philip Ziegler, *London at War, 1939–1945* (London: Pimlico, 1995), 133.

31. Peter Ackroyd, *London: The Biography* (New York: Doubleday, 2001), 729.

32. Ziegler, *London at War*, 122. The men who removed the bomb, exploding it in the Hackney
Marshes, were given new medals: the George Cross and the George Medal.

33. See the plate in ibid., 277.

home to an astonishing plethora of plants and wildlife. One of London's naturalists, in fact, located 269 varieties of wildflowers, grasses, and ferns and numerous other kinds of flora and fauna there, including mammals, birds, and insects.[34]

The World My Wilderness is preeminently a meditation on ruins, especially ecclesiastical ruins, as "places to believe in." In the novel, such ruins become a place of exile and, simultaneously, of refuge for the novel's central character, Barbary. Barbary is the daughter of Gulliver Denniston and Helen Michel, now divorced. Neglected by her pagan and sensual mother, Barbary literally runs wild in the hinterland behind the town of Collioure; she is raped by a German soldier and possibly tortured because of her involvement with the French maquisards, in whose company she spent her childhood in France during the occupation. She fails to prevent—and is thought by her mother even to have been involved in—the betrayal and perhaps the death by drowning of the collaborator Maurice Michel, Helen's second husband. This intensifies her mother's neglect and creates an unspoken barrier between them, though it later appears that they had once been lovingly and exceptionally close. Deprived of her mother's love, Barbary is then moved to London to be "civilized" by her father, an esteemed barrister, and his new and very conventional wife. But Barbary begins to frequent the bombed-out area near Cripplegate, meeting up with deserters, shoplifting and stealing, and painting the ruins on postcards that she sells.

In the ruins, Barbary invents rituals of judgment and dreams of forgiveness and reconciliation, partly drawn from scraps and remnants of Catholicism and partly from literal fragments—torn hymnbooks and prayerbooks, toppled bells, and statues from the bombed churches. The ruins in this novel are her place of belonging; they are outside the law. They interrogate law's status as the vehicle for social healing and reintroduction into the civilized world from the barbarism of the war. The ruins are the remnants of the war: they represent the discovery of the past and a possibility for the future, the literal space in which the older archaeological layers of London are laid bare. (At the end of the novel, the ruins provide the literal ground of London's reconstruction.) They are also seen as the alternative to the "talking cure" proposed by the book's only psychologist, Gulliver's brother Angus, from whose putatively therapeutic but probing questions Barbary escapes to the landscapes of ruin. The book also introduces the language of remorse, and even redemption, into the dialectic of loss and recovery staged by and in the ruins.

34. Ackroyd, *London,* 731.

The book begins with an epigraph from T. S. Eliot's *Waste Land,* which evokes the "voices singing out of empty cisterns and exhausted wells." It ends with another allusion to Eliot's poem: "I think we are in rat's alley / Where the dead men lost their bones."[35] The ruins are the twentieth century's wasteland, making a wilderness of the world. Barbary is initially understood as a childish wild thing, constantly associated with the savagery and shyness of an untamed animal. Her manners are "farouche beyond reason" (20); she moves with the slinking step of a jungle creature. She is sent to live with her father in England to be "civilized," and Gulliver, the man of the law, seems the ideal person to do this, to take her away from her highly educated, sybaritic, and indolent mother. Barbary is herself the victim of both the interest and the neglect of her parents; her father sees her as part of the "wreckage" of his first marriage. Wartime has constituted the entirety of her childhood, and she has spent it with the maquisards in the south of France whose activities, unequivocally heroic during the war, are seen as socially disruptive after it. They are "committed by their pasts to desperate deeds" (61).

American tourists may visit the ruins, and old ladies who "love them" are only too happy to buy the postcards Barbary begins to paint of them, but for Barbary, the ruins are her only real habitat. Deserters and those without identity papers come there—those who live, and need to live, outside the reach of the government, making a living by stealing and black marketeering.[36] For Barbary and Raoul, her childhood friend from occupied France, all forms of authority are identified with fascism and collaboration, and resistance is natural. The ruins become their "maquis": "This is the maquis that lies all about, the margins of the wrecked world . . . that you have known elsewhere" (73).

The ruins are a place in which there is no justice to be invoked, "in which the only safety—and how incomplete—from betrayal was the universal guilt, in which the hated enemy, pacing ominously heavily, on the jungle margins, integrated its citizens into a wary solidarity, defensive yet precarious" (163). In these sites from the old commercial city, the inhabitants exchange "love and coupons" (71). To Raoul and Barbary, that other, more solid world outside the ruins seems fantastic, inaccessible, and certainly uninhabitable: "where streets were paved and buildings stood up, and a solid, improbable world began, less real, less natural than the wasteland" (74).

35. Both quotations are from *The Waste Land:* the first from the fifth section of the poem, "What the Thunder Said," and the second from the second section, "A Game of Chess."
36. Ziegler, *London at War,* says that nearly a tenth of London's crime was attributed to deserters toward the end of the war (230).

The ruins are the antithesis of upper-class civilization, the place where even its members are inducted into crime and dishonesty (Gulliver tells his daughter that it is unusual for "people like her to steal" [134]) and a prototype for the criminalization that has taken over all classes and all reaches of society. Richie, Barbary's elder brother, tells Helen that he and all his friends are crooks, smuggling and cheating the customs (91). Helen responds, "one had so much practice in lying during the occupation. It became the right thing to do" (92). Now, she adds, "the crook in all of us is bursting out and taking possession like Hyde" (93).

Ruins also offer a different kind of temporality, haunted as they are by the ghosts of all the previous people who have been there (193). They reveal deeply buried layers of the past. In this reading, ruins are synchronous, not diachronic. They pose a ghostly presence and represent history as perpetually anachronistic; they cannot be fixed in the time of their origin. Toward the end of the novel, the narrator offers this description of the ruins' synchronicity: "Excavators had begun their tentative work, uncovering foundations, seeking the middle ages, Londinium, Rome. The Wall was being examined, its great bastions identified and cleared, their tiles and brickwork redated; Roman and medieval pots and coins were gathered up and housed: civilized intelligence was at work among the ruins" (252).

Notably, they also provide a place where "no questions are asked" (110). This is part of the ruins' attraction for Barbary, for whom any self-disclosure, any confession, is seen as a betrayal. Because all authorities are contaminated, Barbary resists talking to them. Silence offers the only form of safety. Not surprisingly, then, Barbary regards the talking cure as a self-betrayal and a reminder of more complex betrayals of the past: "Before pain she told nothing, it was during pain, after pain that she had spoken, and told—What?" (107). Two never fully revealed incidents block and blur Barbary's past, linking her to the negation of time, to ruin's desired oblivion. The first is the obscure incident with the German (later killed by the maquis), an event mentioned when she rebuffs Jock's halfhearted sexual advances. She is beaten and raped and warned by the German; she then arranges an entrapment of her rapist, and he is murdered by the resistance. The second block is whatever passed between her and Raoul and the maquis that led to, or failed in preventing, the murder of Raoul's father (her stepfather and Helen's husband). Barbary hates to hear his name mentioned: "that genial collaborator, of whom they had perhaps disapproved, had slipped out of their memories when he was drowned in Collioure bay, leaving a chill and haunting phantom in his place" (38). Indeed, it is this incident that, at the end of the book,

is portrayed as having been the cause of the breach between Barbary and her mother, after which she enters a desolation of loss and guilt. Barbary finally acknowledges the event ("'Mummy . . . Raoul and I weren't there'" [230]), but in a way that explicitly abjures healing through talk: "And now we won't ever talk of it again" (242).

Barbary and her mother are reunited in Gulliver Denniston's house after the daughter, attempting to elude a policeman's "friendly" warning, trips and falls down to the medieval foundations of Foster, Crockatt, and Porter's warehouse. During Barbary's subsequent serious illness, Helen returns to nurse her. Though her mother also inhabits a world in which trust is impossible—and though Barbary herself turns out to be the offspring not of Denniston, but of a Spanish artist with whom Helen had a brief, adulterous fling—it is by means of the reestablished bond with her mother that she can return to "sunshine, geniality, laughter, love," if not necessarily to "civilization." If she goes to the devil, her mother asserts, "she shall at least go happily, my poor little savage" (251).

During her illness, Barbary dreams of running through ruins, and the landscapes of her fearful dreams make it clear why they have been natural habitats for her: "she ran down rocky corridors, leapt chasms, climbed steep stairs up high towers, from which she sprang into space" (227). The weird defamiliarized landscapes of the ruins lay bare the internal structures of people's most intimate environments. In the Blitz people spoke of the utter oddness of an open living room, of a stairwell going nowhere, of a doorway opening onto nothing. Barbary's dreams leave her "trapped deep in ruins, fearing death, fearing hell, trying in agony to repent and be saved" (227). These dreams conjure up images of her torture by the Gestapo, but above all, they represent a negation of time: "since there was no time where she was, she did not know how it passed" (227). Like the ruins, these absent memories are at once a mnemonic and an oblivion. Like the ruins, they uncover and conceal.

The ruins constitute Raoul and Barbary's "spiritual home" (57), and Macaulay, an Anglo-Catholic, contemplates the past in the context of a particularly Catholic discourse of forgiveness, confession, and absolution. In this respect, Barbary's rituals in the old bombed-out church spaces become particularly important. Raoul and Barbary have "taken a house" (52) in Somerset Chambers in the ruins. And from this place they can look into a church that still serves as a place of worship (55), at least for "prayer and private devotion." "If *I* went to church," declares Barbary, "I should go to one of these" (56). The "tall towers, broken windows into which the greenery sprawled, the haunted, brittle beauty" were their "spiritual home" (57). It is

here that Barbary begins a mock sermon on repentance, inspired by the Dies Irae on the charred hymn pages scattered about the belfry floor. Although Barbary is fascinated by the idea of forgiveness, which she perceives as available only to Catholics, she wants to make a distinction between a past that can be forgiven and a past that can be undone. She cannot see why a past whose effects cannot be undone—a past with whose ineradicable consequences we still live—should be forgiven. At this point, forgiveness is understood as an obliteration of the past and a denial of its most painful, lasting effects. But she is then left only with the image of judgment: "you can repent because you were brought up a Catholic. I can't, because I'm a heretic, and heretics can't undo what they've done" (66). Barbary paints an image of the Last Judgment onto the walls of the church and develops her own rites of worship, some borrowed from the local practice of Collioure. One day, in the middle of her own "service," a priest enters the church and proceeds to give a hellfire sermon. It turns out that his own church was bombed in 1940. He was trapped in the wreckage and unable to move for two days; he now thinks that he is in hell, and that hell is that perpetual moment perpetually relived. Mephistopheles's text, from Marlowe's *Dr. Faustus,* constitutes a part of his sermon:

> Hell hath no limits, nor is circumscribed
> In one self place; for where we are is hell,
> And where hell is, must we ever be.[37]

This version of religion stands in opposition to the complacent anxiety of the abbé, concerned merely with appearances and decency, who visits Helen in Collioure. The novel also juxtaposes it with the snobbish high Toryism of Richie, whose tastes are all for ancient, unaffordable luxuries and for great-house Catholicism, for the "smells and bells" of the past.

The ruins, then, perform a complex landscape of memory in the novel. They stand for the impossibility of undoing the past, for they are its ineradicable physical trace. Moreover, they offer a complex commentary on forms of religiosity and redemption in the wilderness made in the postwar world. For Macaulay, the ruins are, above all, an image of spiritual dereliction. The most her characters appear to be able to hope for, theologically, is a world in which hell has a place. If there is such a place, there must also be a place from which

37. Christopher Marlowe, *Dr. Faustus,* ed. Roma Gill (London: A&C Black, 1989), scene 5, lines 121–23 (p. 30).

its lineaments can be discerned as hellish—and better that discernment than ignorance or cynicism. Macaulay imparts a view here a little like Marco Polo's discussion of empire and inferno at the end of Italo Calvino's *Invisible Cities:*

> The inferno of the living is not something that will be; if there is one, it is what is already here, the inferno that we live every day. . . . There are two ways to escape suffering it. The first one is easy for many: accept the inferno and become such a part of it that you can no longer see it. The second is risky and demands constant vigilance and apprehension: seek and learn to recognize who and what, in the midst of the inferno, are not inferno, then let them endure, give them space.[38]

Barbary has read the old Catholic rituals superstitiously. She thinks they cause forgiveness rather than expressing a desire for it. They have become a magic action from which she nevertheless feels excluded. But her return is not effected by magic. Rather, she returns via a remorse that can change her relation to the past—though not alter the past itself.

5

Daniel Libeskind, the brilliant architect of the Jewish Museum in Berlin—whose designs were also accepted as the blueprint for the World Trade Center's reconstruction after 9/11—has pioneered a new way of thinking about architectural commemoration. His is a distinctly post-Freudian notion. Discussing the option of leaving ruins or excavating them, Freud had argued that ruins could neither be left alone nor artificially preserved as intact. "Stones speak," he said. They have to be worked on and through—and the sifting and searching reveal fragments of a larger story or meaning in the rubble.[39]

Libeskind believes that building over ruins would suppress and deny the past. In Charles Merewether's words, he seeks to "frame what is missing—a

38. Italo Calvino, *Invisible Cities* (New York: Harcourt Brace, 1974), 165, cited in Svetlana Boym, *The Future of Nostalgia* (New York: Basic Books, 2001), 302.

39. Sigmund Freud, "The Aetiology of Hysteria," in *The Standard Edition of the Complete Psychological Works of Sigmund Freud,* trans. under the general editorship of James Strachey (London: Hogarth Press, 1953–74), 3:192. Cited in Charles Merewether, "Traces of Loss," in *Irresistible Decay,* 25.

void or the space of loss."[40] In this sense Libeskind's commemorations are anti-monuments, "countersigns.." Unlike the numerous monuments to resistance in France or Poland, they offer no heroic image with which to identify, and they display no link to a place of origin that is no longer what it was. Libeskind's negative monuments create a space for the ruins that remain. The ruins become "suspended fragments," keeping alive a sense of "something at the threshold between the impossibility of remembering and the necessity of forgetting."[41] He won a commission to build an extension of the Berlin Museum that would link with the Jewish Museum, which houses collections of Jewish culture and history. The new extension is connected to the old museum by three underground paths, such that the connection between the two buildings is invisible. The paths traverse a void—and it is in this void that Libeskind condenses a new experience of ruin, for ruin is now not a numinous structure but a place of emptiness and negation. The first path represents the end of Berlin as it was once known: the path leads to the "Holocaust Tower," a windowless structure inscribed with the names of all the Berliners who were exterminated. The second path leads to a garden with columns filled with earth and vegetation growing downward—the garden of exile. This symbolizes emigration and the formation of Israel. The third path traverses a void by a bridge. The only access to the void is through the galleries housing objects from the Jewish community of Berlin. For Libeskind, the Holocaust was "an event across which no connection of an obvious kind can ever be made again." He explains:

> The void and the invisible are the structural features which I have gathered in this particular space of Berlin and exposed in architecture. The experience of the building is organized around a center which is not to be found in any explicit way because it is not visible. In terms of this museum, what is not visible is the richness of the former Jewish contribution to Berlin. It cannot be found in artifacts because it has been turned to ash. It has physically disappeared. This is part of the exhibit: a museum where no museological function can actually take place.[42]

So here, ruins do not necessarily remain visible. The confrontation with absence and void is an attempt to "refuse the completion of mourning."[43]

40. Merewether, "Traces of Loss," 33.
41. Ibid.
42. Daniel Libeskind, "Traces of the Unborn," *Kenchiku Bunka* 50, no. 59 (1995): 40, cited in Merewether, "Traces of Loss," 34.
43. Merewether, "Traces of Loss," 36.

In New York, the design chosen to memorialize the 9/11 attacks is entitled "Reflecting Absence." Two voids mark the footprints of the demolished Twin Towers. As a *New York Times* editorial noted, "To get down to the lower levels of the memorial, visitors will walk down along the face of the slurry wall, as though they were descending through geological time. . . . In the depths of the memorial, one comes to bedrock, the very foundation of the twin towers that were destroyed on 9/11."[44] The very bedrock of this new memorial (and the new memorialism) is a void, an absence. It is ruin not as something finished, but as an interminable mourning.

On 11 September 2001, rescue workers approached a businessman, covered in ashes, who appeared to be sitting hunched over his briefcase in shock. But the man in question was not a man immobilized in grief, but a stone. It was the statue *Double Check,* designed by J. Seward Johnson Jr. and placed in Liberty Park in 1982.[45] In the days after 9/11, the figure became plastered with notes and memorial candles. The commemorative objects have now been bronzed by the artist onto the sculpture, and some New Yorkers argue that *Double Check* should have a role in the redesigned site of the former World Trade Center. An article in the *New York Times* argued that this "would give designers the opportunity to incorporate within the site an important element of the world that existed before 9/11."[46]

Two images, then, of the ruin as a memory. One insists on void, on absence; the other insists that even in the horrifying new landscapes formed by the sheer contingency of destruction, new meanings are made out of old ones. In the landscape of ruin, the survival of a past monument is a work in progress in which every finding is a refounding: not obliterating the present in the past, but giving to the past a new and transformed meaning.

44. "Reflecting Absence" [editorial], *New York Times,* 15 January 2004.
45. Further details about this sculpture and its fate on 9/11 can be found at the Web site http://www.commemorateWTC.com, currently still under construction.
46. Stuart Miller, "A Second Chance for 'Double Check,'" *New York Times,* 16 January 2004.

9

CHANGING PLACES:
THE CISTERCIAN SETTLEMENT AND RAPID CLIMATE
CHANGE IN BRITAIN

Kenneth Addison

Cultural landscape studies—embracing iconological, ideological, and many representational strands within a symbolic rather than objective framework—diverge widely, and often completely, from the empirical, analytical, and modeling frameworks of physical environmental studies. Nevertheless, the importance of understanding and managing human-environment interaction and shaping future landscapes encourages some disciplinary overlap. As the hugely influential work of Hubert Lamb and others has shown, medieval documents—including those of monastic land tenure, management, and economic productivity—can and have facilitated a partial reconstruction of European medieval climate, augmenting incremental proxy environmental data prior to the development of meteorological instruments and records after ca. 1650.[1] But modern environmental records and analytical techniques now

I would like to acknowledge the inspiration of Frank Vivyan Emery, Historical Geographer and Fellow and Tutor in Geography at St. Peter's College, Oxford, from 1957 to 1987. His untimely death prevented this essay from having been written earlier, perhaps, and in partnership. I also wish to thank Christine Kenyon, Photographic Librarian of Cadw: Welsh Historic Monuments, for her assistance in sourcing the low-elevation air photograph of Tintern Abbey (see fig. 23).

1. See H. H. Lamb, *Climate, History, and the Modern World*, 2nd ed. (London: Routledge, 1995), and his earlier work *Climate: Past, Present, and Future—Volume 1: Fundamentals and Climate Now* and *Climate: Past, Present, and Future—Volume 2: Climatic History and the Future* (London: Methuen, 1972 and 1977, respectively).

have even greater potential for extending our understanding of the later Middle Ages. Global Climate Models (GCMs) and Environmental Impact Analysis/Assessment (EIA), for example, offer environmental diagnostic, forecasting, and management tools. Newly intensified and sophisticated climate reconstruction, driven by international concerns about rapid climate change and subsequent landsurface effects, can assist as well in clarifying the nature, timing, and extent of medieval climate-landscape impacts.

My professional engagement with these physical processes and reconstructions of Quaternary climate and environmental change, together with my interest in medieval monasteries and monastic landscapes, prompts this essay on the impact of the medieval climate oscillation on the Cistercian Settlement—and the latter's response.[2] The Cistercians substantially changed the places they occupied in the landscape, while the climate changed the environmental rules under which they operated. Here, I explore the scope and relevance of combining modern rapid climate change analysis and environmental impact assessment methods with the documentary and proxy environmental records of the Cistercian impact in Britain.

CHANGING PLACES: RELIGIOUS AND SECULAR FOOTPRINTS IN THE LANDSCAPE

The very nature, extent, and durability of the Cistercian Settlement afford an invaluable and hitherto underestimated resource for our understanding of later medieval environments. Abbey ruins have occupied a special place in our collective perception of medieval landscapes and sense of the past since at least the Age of Romanticism, when authors, poets, and artists alike glori-

A *proxy record* refers to any form of evidence that provides an indirect measure of former climates, environments, and their age from such materials as organic fossils and incremental layers of snow and ice, tree rings, laminated lake sediments, and volcanic ash (tephra). The same could be said of the long runs of grain prices—from the thirteenth century onwards—and similar documentary records from which weather as well as socioeconomic conditions are inferred.

2. The Quaternary Period spans the past 1.6–2.4 million years of Earth history, dominated by global-scale, rapid climate and landsurface change, which provides the essential environmental context of human history. It is widely recognized that Europe and elsewhere experienced asynchronous climate change during the past millennia, consisting of a period of warming known as the Medieval Warm Epoch or Medieval Warm Period (MWP), from ca. 900–1300, followed by cooling from ca. 1400–1850, known as the Little Ice Age (LIA). The greater part of this Medieval Climate Oscillation (MCO) thus brackets the medieval period.

The development of the vast geographical spread and institutional size of the Cistercian Order is described as the Cistercian Plantation in R. A. Donkin, *The Cistercians: Studies in the Geography of Medieval England and Wales* (Toronto: Pontifical Institute of Medieval Studies, 1978) and as the Cistercian Settlement by, for example, David H. Williams in *The Welsh Cistercians* (Leominster: Gracewing, 2001). The latter term is preferred here.

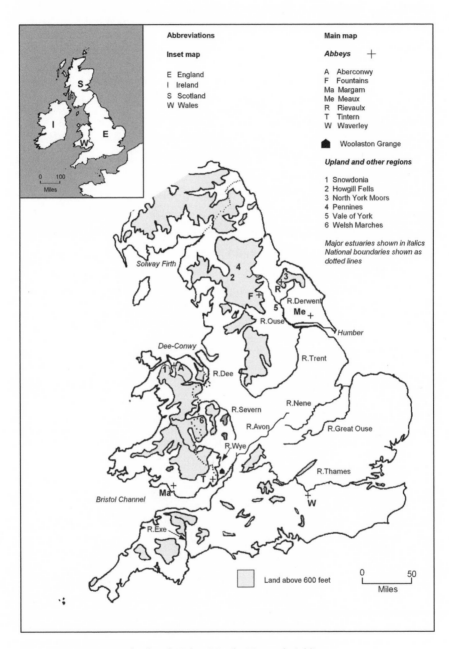

Abbreviations

Inset map

E England
I Ireland
S Scotland
W Wales

Main map

Abbeys +

A Aberconwy
F Fountains
Ma Margam
Me Meaux
R Rievaulx
T Tintern
W Waverley

■ Woolaston Grange

Upland and other regions

1 Snowdonia
2 Howgill Fells
3 North York Moors
4 Pennines
5 Vale of York
6 Welsh Marches

Major estuaries shown in italics
National boundaries shown as
dotted lines

Land above 600 feet

0 50
Miles

FIG. 22 Cistercian England and Wales. Map by Kenneth Addison.

fied their soaring architecture and the abbots and monks who built and worshipped in them. After early asset-stripping of usable lead, worked timbers, and masonry in the aftermath of their dissolution in Britain after 1536, the ruins entered a period of slower, natural weathering and vegetation overgrowth. This enhanced their romantic appeal prior to the heritage agencies' conservation, which has been particularly active during the past few decades. Heritage interest focuses primarily on the abbey church and conventual or claustral buildings; it diminishes progressively with respect to adjacent precincts and distant granges and thus reinforces the principal role of the religious personnel and purpose in illuminating medieval life and landscapes. The broader socioeconomic significance of monasticism, the abbeys, and granges has received substantial attention from a number of scholars—preeminently R. A. Donkin, Colin Platt, L. Pressouyre and David H. Williams[3]—and relies heavily on documentary records kept by the abbeys themselves or sponsored by the feudal state.

Much has been written on the phenomenal rise and geographic extent of the Cistercian Settlement, so the emphasis here is on its key environmental features. Among the reformist monks of the late eleventh century were the small band who left the Abbey of Molesme in 1098. They settled at Cîteaux, in a remote, marshy, wooded valley in Burgundy on the edge of the Côte d'Or. This was the environmental type-site[4] of the new Order's return to the simpler, more austere lifestyle codified in the Cistercian "mission statement"—Stephen Harding's *Carta Caritatis* of 1119. The Order's development was profoundly catalyzed by Bernard de Fontaines, who spent his novitiate at Cîteaux in 1113, served as founding abbot of Clairvaux in 1116, and became the Order's inspirational spiritual and administrative leader between 1126 and 1151. The Order developed two further vital and novel attributes that helped secure its success. The Chapter General, meeting annually at Cîteaux, formed an executive board that implemented the essence of *Carta Caritatis* and developed religious and secular policy (although with some variation toward the spatial and temporal margins of the Settlement). The grange economy—designed to support required independence from

3. Donkin, *The Cistercians;* Colin Platt, *The Monastic Grange in Medieval England: A Reassessment* (London: Macmillan, 1969); L. Pressouyre, *L'espace cistercien* (Paris: Congrès national de Sociétés historique et scientifique, 1994); and David H. Williams, *The Welsh Cistercians* (Tenby: Caldey Island Press, 1984).

4. I adapt here the geological term that defines a site with all of the characteristics of a particular (stratigraphic) unit and provides the reference standard against which other sites are compared. Tintern and Rievaulx would be suitable Cistercian monastery type-sites for Wales and England.

FIG. 23 Tintern Abbey seen from the southeast. The abbey church and precinct is shown at the Welsh Cistercian type-site on a narrow terrace within the tidal gorge of the lower River Wye. Low walls to the right of the church form the base of the infirmary cloister, infirmary, and abbot's residence. To the right again, a temporary arena is set up for a historical reenactment. Low walls to the left of the church once supported metal-working and other workshops. Cadw (Crown Copyright).

feudal agriculture and servile labor—became a pioneering, revolutionary agent in land development and large-scale estate management.[5]

The solitary statistic of the foundation of 740 Cistercian abbeys between 1098 and 1675 gives no hint of the early explosion, geographic spread, and loci of the Settlement. Between 1098 and 1124, 26 daughter houses were founded, and then a further 303 in a similar period up to 1151—a total, that is, of 329 houses in just fifty-three years. The rate of growth slowed thereaf-

5. The grange economy is referred to, specifically or in effect, in a number of sources, including Williams, *The Welsh Cistercians,* and Donkin, *The Cistercians.* Donkin concludes his chapter on the granges and estates with the statement, "The *grangia* was the most important single contribution of the new monastic orders, and particularly of the Cistercians, to the landscape and economy of the twelfth and thirteenth centuries. Throughout Europe it formed the basis of their agrarian operations. The emphasis upon the consolidation of holdings, some of the means employed to achieve this, and the importance of the grange in a system of agriculture, had no contemporary parallel. And the activities for which the Cistercians are perhaps best known, land reclamation and sheep-farming, were closely connected with the formation and management of such estates" (67).

FIG. 24 Rievaulx Abbey, the Yorkshire type-site, in the narrow, enclosed floodplain of the River Rye, showing half of the remodeled and enlarged thirteenth-century church (right rear) with other, large conventual buildings (center) all now partially ruined but conserved by English Heritage. Photo: Kenneth Addison.

ter, partly through the pause ordered by the Chapter General in 1152 to retain control, the loss of some momentum after Bernard's death in 1153, and an eventual reduction of spiritual interest and secular gifts of property. Nevertheless, 313 were added in the century up to 1251, a further 61 by 1351, and just 34 in the remaining three centuries up to 1675.[6] Almost 50 monasteries were founded in the British Isles (including Ireland) by 1151 and another 50 prior to 1300.[7] Eighty-six of these were located in Britain (excluding Ireland), as were more than 30 Cistercian nunneries,[8] about which much less is known. The first monastery, now poorly preserved, was built at Waverley, thirty-five miles southwest of London, in 1128; it was followed by the Welsh and English type-sites at Tintern in 1131 and at Rievaulx the following year (figs. 23, 24). Their loci generally reflected those of the type-sites and

6. Donkin, *The Cistercians*, 21–29.
7. Ibid., 29.
8. Glyn Coppack, *The White Monks: The Cistercians in Britain, 1128–1540* (Stroud: Tempus Publishing, 1998), 11.

requirements of the Chapter General and were concentrated in Wales, south-west England, and northern England—upland Britain and its fringes, essentially—in marked contrast to the concentration of Benedictine monasteries in lowland central and eastern England (see fig. 22).

The accretion of Cistercian lands came about through grants, gifts, and sponsorship from secular powers as well as purchase, rent, and exchange (and in some instances even seizure, eviction, and the engrossment of holdings within the surrounding feudal demesne). Most of these acts went contrary to the rules of the Order and Chapter General and reflect the growing wealth, power, and acquisitive nature of the Settlement during its first two centuries based on the grange economy. The monastery occupied a relatively small proportion of the total landholding, including the immediate site of the abbey church and precinct and a local resource area providing construction materials and so forth. By comparison, the granges' footprint covered hundreds of thousands of hectares of Britain and their impact indirectly extended far beyond, because of their exemplary style of farming and estate management and because of the impact of their operations on the energy flows and material cycles of the physical landscape. The grange was initially the home farm, providing a subsistence living for the abbot and choir monks—the *grangia juxta abbatiam*.[9] It extended to many other sites supposedly within one day's journey of the monastery, though as it became the Cistercians' typical system of land utilization, it required a workforce of residential lay brothers *(conversi)* and seasonal laborers *(homines mercenari)*.

Although many granges were relatively modest in size, others were large even by modern estate standards, with quite substantial building infrastructure. Williams notes that some assumed the size of a small monastery and others acquired full monastery status.[10] In addition to basic farm buildings and barns, there might be a dairy, water (or wind) mill, tannery, workshops, forge, woolshed, and kitchen garden; many also acquired an oratory or chapel. A number of individual British granges exceeded 4,000 hectares in area. At its peak, the total grange area of Rievaulx, for example, exceeded 7,200 hectares; Meaux (East Yorkshire), 7,900; Fountains (North Yorkshire), 7,670; Margam (South Wales), 9,700; and Aberconwy (North Wales), a massive 16,000 hectares.

Much of the Aberconwy grange area consisted of montane grassland pastures in the mountains of Snowdonia. Larger granges tended to be upland

9. Donkin, *The Cistercians,* 51.
10. David H. Williams, *Atlas of Cistercian Lands in Wales* (Cardiff: University of Wales Press, 1990), 6.

pastoral units, but arable units averaged several hundred hectares. In a few instances, up to 2,000 hectares of land was under arable cultivation by a single monastery—a scale that matches institutional arable landholding today. (I discuss the landsurface and landscape impact of the Cistercian grange economy, which would have been multiplied by the other monastic orders that adopted the Cistercian land management system, later in this chapter.)

The first two Cistercian centuries coincided with the Medieval Warm Period[11] (MWP) and saw the development of 90 percent of the Settlement. Extending across and to the frontiers of Europe, with a locus particularly in remote and more difficult terrain, the Settlement justifies Williams's view that the White Monks were in every sense frontiersmen and pioneers of landscape development.[12] The remaining two centuries in Britain—and three elsewhere—coincided with climatic deterioration and the onset of the Little Ice Age (LIA), environmental degradation, and the social depredations of malnourishment and the Black Death.

Characterizations of the Cistercian Order in terms of modern business and of the environment are deliberate. They are reflected, for example, in an English Heritage mural at Rievaulx Abbey that depicts a fifteenth-century manuscript illustration of Bernard leading a chapter meeting. Half of the original illustration is shown, with its choir monks in their habits. In the mural, the monks morph into executive directors via Bernard at the center, half-habited and half-besuited. Due to its size, spread, impact, and enduring presence across Europe, the Cistercian Settlement amounted to one of the first truly multinational corporations: it operated under a president and single board of executives, was driven primarily by a religious mission, and featured an elaborate infrastructure providing economic self-support and trading. The secular footprint of the abbeys and grange economy therefore represented one of the largest organized and sustained agencies for European environmental change prior to the Industrial Revolution—one that simultaneously experienced and responded to climatic oscillation of a magnitude similar to that estimated for the period 1750–2050. Though the Settlement was em-

11. The MWP was the most recent period, prior to twentieth-century warming, when the proxy evidence of northern hemisphere temperatures records a positive anomaly of maybe 1–2°C from the eleventh to the fourteenth centuries. Warming commenced in the Arctic-Atlantic region and spread asynchronously across the North Atlantic and Europe, reaching its peak in the British Isles around 1300. Cooling followed a similar temporal and spatial pattern. The event was probably induced by hemispheric-scale (rather than global) perturbations in the coupled ocean-atmosphere circulation system.

12. Williams writes, "During this period of expansion the white monks reached much of the then civilized world, and they did not shrink from settling in difficult and truly 'frontier' zones. . . . The monks thus encountered the Moor in Spain, the Mohammedan in Syria, and the pagan Slav in Poland and the Baltic littoral" (*The Welsh Cistercians* [1984], 2).

placed during a relatively short time span over a geographical area of unprec-
edented size in a generally favorable climate phase, the climate soon
deteriorated. The abbeys and granges of the Settlement are thus, for environ-
mental reconstruction purposes, important index fossils of the Middle Ages,[13]
reflecting internal and external influences on their evolution before the sup-
pression and eventual dissolution of the British monasteries under Cardinal
Wolsey and Henry VIII between 1520 and 1540.

CHANGING PLACES: ENVIRONMENTAL IMPACT AND SENSITIVITY

The grange economy is inevitably the principal focus of interest here, but the
Cistercians' environmental impact began with the siting and construction of
the abbeys themselves. The few hectares occupied by the abbey church and
precinct would draw on the resources of a hinterland two to four orders of
magnitude larger for timber, aggregate and stone construction materials for
initial capital construction and long-term maintenance, wood or peat for fuel,
other woodland products, water, and eventually crops for renewable con-
sumption. The site itself would require leveling, drainage, and even reclama-
tion prior to building, and the necessary resource base would expand in due
course to include mined coal and minerals. The Chapter General, and usually
the local secular power, required what would have passed for a medieval
form of site evaluation and planning guidance prior to construction and ex-
tended this to a rudimentary environmental impact assessment with respect
to possible impacts on adjacent landholdings. For these reasons, daughter
houses were generally designed and built by an abbot and team of monks
who had acquired the appropriate skills at the mother house. Inevitably, these
processes were not always successful; more than a third of British monasteries
were re-sited, and sometimes more than once, at various times after their
initial foundation. Some moves were precipitated by property disputes or
other civil causes but, in most cases, inadequate impact assessment or site
sensitivity to climate change (and what Lamb has termed "parameteorological

13. This refers to the geological term that describes the most valuable characteristics of a fossil for
environmental reconstruction: "Widely distributed, abundant and easily recognised remains of former
living organisms that occur over a narrow span of geological time are called index fossils. These fossils
are normally of species, the narrowest major classificatory grouping of organisms and basic to biostrati-
graphical investigations. However, other members of the taxonomic hierarchy (genera and families in
particular) are also used for biostratigraphical purposes." See *The Oxford Companion of the Earth*, ed.
P. L. Hancock and B. J. Skinner (Oxford: Oxford University Press, 2000), 75.

events"[14]) were probably responsible. Most abbeys were redesigned during their lives, and as monastic or sponsors' wealth was ploughed back into real estate, a substantial number were considerably enlarged into the magnificent edifices whose partial ruins we see today (fig. 25). For reasons of re-siting, rebuilding, and enlargement, intensive capital resource consumption associated with building phases was repeated several times over during the life of the monasteries. Moreover, site disturbance and the interruption and reorganization of local and hinterland natural energy flows and material cycling would have had significant local and usually harmful impacts on the medieval environment.[15]

The perceived scale of impact increases dramatically, however, when we assess the extent and efficacy of the granges. From a number of perspectives, it is quite clear that the grange economy as a whole was eminently successful,[16] even if yields fluctuated and the system experienced a progressive decline paralleling that of the monasteries themselves for environmental, political, and social reasons after 1300. Painstaking research among abbey, civil, and crown documents, including the two major crown assessments of monastic wealth and landholding—the *Taxatio Ecclesiastica* of 1291 and *Valor Ecclesiasticus* of 1535—has provided tremendously detailed portrayals of the grange economy. None are more scholarly or informative than the accounts of the granges' character, hectarage, arable and pastoral productivity, cattle and sheep headage, economic yields, land acquisition and release, land management, and so on by Donkin and Williams.[17] I propose to review here the environmental impact of the grange economy from a modern environmental and scientific perspective. The requirement to settle in remote places, applicable to the granges as much as the abbeys, frequently meant that the Cistercians were clearing virgin land, land that was marginal to (or had passed out of) feudal cultivation, or, in some cases, deliberately depopulated land.

14. Lamb, *Climate, History, and the Modern World,* includes floods and parched ground as well as storm-driven shipwrecks and coastal damage, to which we might add drought, fire risk, landslides, and the like—that is, any damaging event with a meteorological cause or trigger (82).

15. The natural environment consists of a series of interactive material cycles whereby Earth's atmosphere, lithosphere, hydrosphere, and biosphere exchange biogeochemical constituents with each other (often with interchangeable gas, liquid, and solid forms), driven primarily by solar radiation and flows of materials induced by gravity. Human activity impinges on and alters these flows and cycles, often with damaging or irreversible results.

16. Note the evident wealth of the monasteries, reflected in unconstitutional land purchases and the conspicuous aggrandizement of many abbeys during the thirteenth century; the persistence of the grange economy over several centuries and the scale of its adoption by other Orders; and the documentary record.

17. Donkin, *The Cistercians,* and Williams, *The Welsh Cistercians* (1984).

FIG. 25 Rievaulx Abbey. Conspicuous abbey wealth, reinvested at the start of the thirteenth century, is evident in the fine, decorative Gothic architecture of the rebuilt and enlarged nave. Photo: Kenneth Addison.

Siting in generally low-lying, remote, and riverine locations[18] did not only reflect Cistercian preference. Much of the best land had already been settled in the more populated areas of Europe and, at political frontiers, the pioneering and civilizing influence of the monks might have been distinctly advantageous to the secular power. It cannot be a coincidence that the relatively high concentration of monasteries and granges in Yorkshire, and across Wales and the Welsh Marches, are located at the margins of the Anglo-Norman colonial power. Nor, indeed, is it surprising that the Cistercian Settlement was so extensive in Britain in the wake of the Norman conquest and the French connection. William I confronted the invasion threat to his emergent English state from its Celtic neighbors in Scotland and Wales with a scorched-earth policy that laid waste to much of Yorkshire in 1069–70—and with grants of land there and in the Welsh Marches to some of his powerful military commanders and earls. Many of these commanders' and earls' descendants were conspicuously generous to the Cistercians, giving them land and financial grants and consequently strengthening military and political buffer zones.[19] (This gave another dimension to the concept of "wasted" or neglected land,[20] which probably constituted the largest land reserve for potential grange development.)

An inventory of the abbeys and grange lands reveals two distinct but interlinked geographic patterns, based on location with reference to the "Humber-Exe" line—the generalized boundary between upland (northwest) and lowland (southeast) Britain—and the Cistercian family to which each daughter house belonged.[21] The majority of abbeys located in the uplands and upland fringe of the Pennines, North York Moors, Wales, Cumbria, and the Southern Uplands of Scotland are of Clairvaux descent; those of lowland England are primarily of Cîteaux descent, almost entirely through its daughter house of L'Aumône (see fig. 22). This permits some further characterization of the grange loci developed during the twelfth- and thirteenth-century expansion. The lowest-lying wastes were located within range of the large

18. Williams, *Atlas of Cistercian Lands,* 4.

19. David Robinson noted in *The Cistercian Abbeys in Britain: Far from the Concourse of Men,* ed. Robinson (London: Batsford, 1998), 24, that the Welsh abbeys fostered and maintained close Welsh dynastic links, notwithstanding the need from time to time to support English ventures. The surplus yield of Tintern granges, for example, sustained English armies for three years during the "intestine commotions" of the Wars of Welsh Independence during the 1260s.

20. Donkin, *The Cistercians,* refers to evidence of "waste" or "largely waste" land in the Domesday Book with respect to Yorkshire and other areas (56).

21. Ibid., 82: "All Cistercian Houses belonged to one or other of five main families presided over by Cîteaux, La Ferté, Pontigny, Clairvaux and Morimond." This is also shown in map form in Robinson, ed., *The Cistercian Abbeys,* 23.

and strongly tidal estuaries of the Bristol Channel (South Wales sites), the Humber estuary (East Yorkshire), Solway Firth (North Cumbria and South-west Scotland), and the Dee-Conwy estuaries (North Wales), where coastal wetland reclamation was a major source of grange land. Inland abbeys were usually located where large tributary rivers exited confined valleys in the upland fringe into floodplains of major rivers such as the Severn and Dee (Wales and the Marches) or Ouse and Derwent (Yorkshire), mostly guaranteeing continuous water supply but also requiring flood protection and drainage. Granges at most of these low-lying estuarine or riverine sites were also within easy reach of uplands into which their granges expanded, and they differed significantly from most of the English lowland sites of the Cîteaux family. The latter group also favored floodplain sites in the Thames, Avon, and Nene–Great Ouse catchments, but in the absence of significant upland/montane landsurfaces, granges spread into the dry interfluve on well-drained limestones and chalk. These were easier to work for arable purposes, but they were also more populous.

A considerable amount of preparatory work—such as draining marshland, irrigating drier areas, and clearing woodland—was often necessary before the Cistercians could fully utilize their lands.[22] Wetland reclamation, hydraulic engineering, and deforestation simultaneously reflect the core expertise and impacts of Cistercian land management (as opposed to farming per se) at the heart of the grange economy. Coastal wetland reclamation involved not merely draining inner marsh areas but also winning new land.[23] The Cistercians achieved this by enclosing embankments and by "warping"—a technique developed during Roman times, whereby longitudinal barriers trapped sediment in the intertidal zone, leading to marsh aggradation that was then drained. There is also evidence that modest global warming and associated glacier ice melt during the MWP forced twelfth- and thirteenth-century sea levels higher, providing the Cistercians with a taste of changes similar to those that now threaten twenty-first-century coastlines.[24]

22. Williams, *The Welsh Cistercians* (2001), 227.

23. Michael Reed refers, in *The Landscape of Britain: From the Beginnings to 1914* (London: Routledge, 1990), to "the Abbey of Meaux, almost entirely surrounded by marshes in the middle of the Hull River, [which] was ditching and draining during the course of the 13th century. All of this work was difficult and expensive, whether to excavate, build, or maintain. It all had to be done with spade and shovel, and there were no mechanical means of pumping water away" (120).

24. In *The Welsh Cistercians* (2001), Williams writes, "Those abbeys with lands lying next to the Severn estuary and the Bristol Channel found a need—particularly with the continuing post-glacial rise in sea-level—to take protective measures, by banking (to keep sea water out) and ditching (to drain excess water away) their coastal marshlands" (230). Reed notes that "gales and storms could undo the work of decades in a single night. Flooding destroyed the works of the monks of Meaux at Salthaugh Grange and Tharlethorpe" (*Landscape of Britain,* 120).

Hydraulic engineering capability and water management to safeguard water supply, remove surplus water, and flush the domestic and farming waste stream were fully recognized by the White Monks as essential for life.[25] By proper management, water could also help drive machinery, aid transport, and sustain fisheries; its usefulness went well beyond the virtuous spiritual concept that "cleanliness is next to godliness." This is admirably illustrated, for example, by works based on monastic archaeological investigations by C. J. Bond (with a useful schematic diagram)[26] and by Mick Aston's summary:

> it is clear that a good water supply was regarded as an essential basic requirement of most new monastic foundations. Two supplies were needed: one for drinking water, preferably from a spring, and one for cleansing and drainage, which could come from a river or stream. Sites often seem to have been chosen with this as the paramount determining factor; the availability of springs and streams not only influenced where the house would be placed within its estates, but was also reflected in the exact orientation of the buildings on a particular site. Whilst water for drinking could have been obtained from rivers, streams or wells (or even off the roof), invariably elaborate and costly conduits were built to ensure a good, clean, constant and adequate flow.[27]

Cistercian water management demanded an unparalleled understanding of the hydrometeorologic and hydrogeologic controls on water budgets and quality; hydraulic engineering ensured that water reached required places and was removed from undesirable ones.

To appreciate this, one needs access to subsurface as well as surface watercourses and a hydrologically dynamic site—and Tintern Abbey provides such an example. Interested visitors can familiarize themselves with the partial diversion and on-site channeled dispersal of the Angidy Brook from topographic and site-heritage maps, surviving surface watercourses, and the occasional but invaluable view of subsurface conduits through temporary as

25. The Cistercians were formally known as the White Monks, according to Coppack (*The White Monks,* 11), although the epithet was used widely and informally. It referred to their undyed wool habit.

26. C. J. Bond, "Management in the Urban Monastery," in *Advances in Monastic Archaeology,* ed. R. Gilchrist and H. Mytum, British Archaeological Reports, British Series 227 (Oxford: Tempus Reparatum, 1993).

27. Mick Aston, *Monasteries in the Landscape,* 2nd ed. (Stroud: Tempus Publishing, 2000), 25.

well as permanent gaps in the architecture. From these, it is clear that parts of the abbey principally using fresh water were built upstream of most waste effluent sources; side channels and sluices could be used to manipulate discharge to respond to the abbey's needs and the flow stage of the brook. The most remarkable hydrologic feature of all is that Tintern is built on the lower tidal reach of the river Wye, just a few kilometers upstream of its confluence with the Severn estuary, which experiences Earth's second-highest tidal range (12.4 meters). On one occasion, while I addressed an undergraduate group facing the river, the students grasped the significance of Tintern Abbey's placement in a dramatic way. Our group had clearly arrived at the site at the top of the tide; the river, flowing upstream just minutes before, was suddenly in fast ebb. The monks' ability to adjust internal water flows to prevent salt-water ingress and sewage reflux on the rise, and yet continue to service the abbey without backup flooding from the freshwater downflow—*and* to respond to climate-driven changes of sea level and terrestrial water balances—was extraordinary.

If reclamation and hydraulic engineering represent two of the Cistercians' most arduous and technically accomplished achievements,[28] deforestation had the greatest landsurface and landscape effects. The monks used woodlands sustainably, to some extent, through the harvesting of dead timber, fruit, herbs, nuts, browse and pannage (nuts and fruits, such as acorns and beech mast, browsed by swine on the woodland floor), and forest animals. They also practiced woodland conservation and reforestion, especially in later decades. But Williams confidently asserts: "Valuable as their woodlands were, one of the chief claims to fame of the White Monks lay in the zeal with which, reputedly, they cleared them—often as a necessary concomitant to the preparation of their land for farming, and grants of permission to monks to fell trees were frequently accompanied by the corollary 'and to bring the land into cultivation.'"[29] In this respect, the Cistercians were probably the largest single agent accelerating rather than merely contributing to medieval woodland clearance. In addition to arable and livestock farming, which deforestation facilitated, the Cistercians also grew vines (indicative of the warmer climate as well as social preference); operated fisheries, mills, and tanneries; and engaged in mining along with metallurgical and other industries.

The maintenance, sustainability, and eventual degradation of farming and

28. Williams, *Atlas of Cistercian Lands,* 6.
29. Williams, *The Welsh Cistercians* (2001), 227.

FIG. 26 Stone-walled arable fields on former abbey grange land above Wharfedale in north Yorkshire. Modern land use is now entirely pastoral, but arable farming was abandoned by the monks as the upper limit of arable farming fell during the Little Ice Age, probably in the fifteenth century. The field terraces probably date to an earlier Anglian phase of the Anglo-Saxon period prior to AD 1000. Photo: Kenneth Addison.

FIG. 27 Rievaulx Abbey. A decorative stone frieze showing a mule bearing grain sacks being led to a post-mill by a *conversus;* windmills were less common than water mills. Monastery artwork and manuscript illumination frequently depicted economic activity and sources of monastic wealth. Photo: Kenneth Addison.

the landsurface on abandonment complete this review of the grange land-scape. That the Cistercians were apparently no great innovators of farming practice (as opposed to land management), compared with later agrarian rev-olutions, probably reflects the extent to which they brought new lands into production as pioneers and the favorable climate of the MWP in sustaining cultivation at higher altitudes (fig. 26). Nevertheless, the area, yield, and per-sistence of the grange economy—particularly before the later fourteenth cen-tury—and the records of their farming practices suggests that the monks were good stewards of what they farmed and grew (fig. 27). This was due in part to crop and livestock husbandry, a due regard for soil fertility, and good drainage and maintenance of land enclosures for crop protection. Williams attributes much of their agricultural success to the "careful planning and cen-tral control system of their land management, accompanied by the keeping of detailed records,"[30] and their interest in estate management not merely to increase acreage but also to consolidate into large and more easily managed units.[31] He concludes that the Cistercians' later forays into woodland conser-

30. Ibid., 216.
31. Williams, *Atlas of Cistercian Lands,* 6.

vation were paralleled by a similar concern for the good order of their prop-
erties in general.[32] But the Cistercians were no more capable than later
medieval society in general of avoiding the impact of climate change—or the
socioeconomic and political turbulence in the later Middle Ages that was
itself driven, in part, by climate change. Their vulnerability to climate-land-
surface deterioration and subsequent loss of soil fertility and structure is out-
lined below, but the labor force of *conversi* and *homines mercenari* was also
dwindling, both for social reasons and because of direct losses attributable to
the Black Death after 1348.[33] This would have also disrupted markets for
their produce. Williams refers to a considerable decline that set in after 1350,
one exacerbated by the Black Death, the Hundred Years War, the holding of
abbacies *in commendam,* and other nonspecific factors that sapped the Order's
strength and vitality.[34]

So how may we summarize the impacts driven by Cistercian land manage-
ment, and how resistant or sensitive to change were the diverse landscapes
thus managed? The answer is complex, and this essay's scope will allow me
to point only to the sources of a detailed response. Three principal impact
stages and two styles of impact are recognized. The stages are the initial
preparation of land for agriculture by clearing, ground improvement, or rec-
lamation; maintenance during productive use; and degradation after aban-
donment. "Style of impact" distinguishes between deliberate changes sought
and their inadvertent consequences—stimulating feedbacks in the system that
may require further remedial actions. Aspects of the ecosystem, geosphere,
hydrosphere, and atmosphere are involved. Clearance and reclamation tem-
porarily disrupt the vegetation and dependent fauna, leading to permanent
changes in species composition and structure that are often inversely propor-
tional to the extent and duration of disruption. Because the principal purpose
of agriculture is to direct an ecosystem's productivity toward human con-
sumption, directly (via arable farming) and indirectly (via pastoral farming),
there is a reduction of plant diversity and productivity that may only recover
partially, as a "secondary" vegetation succession, upon abandonment. In
practice, once lost, woodland rarely recovers, especially as sheep and cattle
graze tree seedlings. The arboreal desert that is upland Britain owes much to

32. Williams, *The Welsh Cistercians* (2001), 234.

33. In *Atlas of Cistercian Lands,* Williams states that the "decline in their numbers was under way
by 1274 when the General Chapter drew attention to the considerable shortage of them, whilst the
changing social conditions of the early fourteenth century, accelerated by the Black Death, caused
further and rapid diminution of conversi totals in many houses" (7).

34. Ibid., 10.

FIG. 28 The dramatic impact of upland sheep grazing is shown by the effects of trial sheep exclusion for just five years (to the left of the fence), compared with continued grazing (to the right). One of the culprits can be seen beyond the enclosure. The recovery of a natural, flower-rich, thick sward and the survival of wind-derived tree seedlings reveal the extent to which sheep grazing reduces biodiversity and protective plant cover and compacts soils—all of which accelerate soil erosion during intense rainfall. Photo: Kenneth Addison.

Cistercian clearance (as fig. 28 graphically illustrates). Loss in overall productivity is offset by increased food or forage productivity—the crop—unless other supporting systems are degraded. These impacts also characterize woodland clearances driven by monastic iron and lead smelting industries and salt production as well as those for agriculture.[35]

Changes to environmental composition and structure are also experienced by the geological substrate (soil and underlying rock), usually in association with other impacts. With the removal of the buffering effect of vegetation, especially after deforestation, the substrate encounters greater exposure to weathering and erosion. Specific nutrient leaching under the upland areas'

35. Ian Simmons observes that "taken together, the environmental impact of all these enterprises was considerable for much woodland was felled, much converted to sustainable coppice rotation, and the ratio of sheep to cattle changed the mix of plant species on moorlands. There was as well the lasting effect of the granges which passed into private hands after the dissolution: these were often higher and more remote than ordinary settlements of the same period and so maintained a frontier of relatively intensive land use." See Simmons, *An Environmental History of Great Britain: From 10,000 Years Ago to the Present* (Edinburgh: Edinburgh University Press, 2000), 89–90.

typically higher precipitation levels may reduce natural fertility; vegetation removal also interrupts the nutrient cycle and reduces soil stability by diminishing organic content, often leading to accelerated soil erosion and wholesale soil loss. There are many examples of these complex impacts in upland Britain, wholly or partly attributable to monastic grange activities. Blanket peat formation overlying acid, nutrient-poor podsolic soils, and blanket peat erosion and slope instability involving irreversible gulleying or landsliding, have led to progressive landsurface and landscape degradation over several thousand years of human occupation. These changes have a negative (damping or detrimental) effect on agricultural productivity, perhaps leading eventually to abandonment, and then often a positive (or accelerating) effect on erosion. The Pennine and North York Moors may have been particularly affected by grange development in the twelfth century, following the Norman landscape degradation, or wasting, a century earlier. The eight Yorkshire Cistercian abbeys, lying near the crossroads between these northern uplands on the fringe of the Vale of York, are particularly implicated, as they held 120 granges by 1200. Figure 29 shows one of the suspected sites in the Howgill Fells. Radiocarbon dating indicates that gulleying commenced 940 ±95 yrs BP (that is, ca. 1010), attributed initially to the Viking introduction of sheep grazing "and then expansion under monastic influence."[36] Rates of geomorphological activity in Britain may have approached those of early-to-mid-Holocene levels (as Earth emerged from its most recent ice age from ca. 10,000 to 7,000 years ago) on newly cleared land and, coinciding with the climatic disturbances of the MWP, may have reached up to 1,000 times the sediment yield of natural forest.

The erosion products of gulleying and slope instability led to sediment aggradation downstream, demonstrating the interactions between biosphere, geosphere, and hydrosphere. Land disturbance drives hydrological responses in the form of accelerated runoff, leading to shorter river lag-time responses and inevitably higher flood peaks and flood frequency. These, in turn, can further accelerate soil erosion and slope instability and hence progressively and often irreversibly degrade the landsurface. We can now infer these wider hydrogeomorphic landsurface disturbances from numerous reports of flood damage at monastic sites, though initial interpretations implicated overbank

36. D. L. Higgitt, J. Warburton, and M. G. Evans, "Sediment Transfer in Upland Environments," in *Geomorphological Processes and Landscape Change: Britain in the Last 1000 Years,* ed. D. L. Higgitt and E. M. Lee (Oxford: Blackwell Publishers, 2001), 191. Note that radiometric dates annotated as BP (before the present) are calculated from the baseline year of 1950.

FIG. 29 Deep gulleying, reminiscent of badland development, in the Howgill Fells of eastern Cumbria, with sheep for scale. Gulleying developed as a result of Viking sheep grazing after the tenth century and was exacerbated and extended by monastic sheep grazing on extensive upland granges. It accentuated downstream sediment transfers. Photo: Kenneth Addison.

river discharge alone.[37] In addition to alterations to water budgets and river discharge, water quality is also inevitably altered by higher suspended sediment and bed loads and increased water turbidity. Along with potentially deleterious effects for aquatic life and fisheries, potable water quality is also impaired.

There are many single instances of a range of impacts in the biosphere, geosphere, and hydrosphere in the documentary record, and many others in the landscape and proxy record. The frequency and extent of both may sometimes be cross-correlated. Impacts on the atmosphere are less readily observed and recorded and, through the very nature of the atmosphere, they

37. Exploratory excavation and geophysical survey at Grace Dieu Abbey in Southeast Wales revealed substantial foundations buried under younger alluvial sediments. Williams interprets these as a product of repeated flooding once monastic drains failed (*The Welsh Cistercians* [2001], 14), but the alluvium suggests high sediment discharge events.

tend to be more easily dispersed and externalized. A growing body of opinion, however, suggests that human forcing of climate change may predate what is known as the preanthropogenic warming (that is, before the Industrial Revolution). Cistercian and other monastic and secular landsurface activity and alteration must be some of the more substantial preindustrial causes of these impacts, and it is easy to see why. The atmosphere, like any other Earth system, consists of material cycles driven by energy flows. Solar radiation receipt and climate change may drive atmospheric and landsurface changes (known as "radiative forcing"), but so, too, do large-scale landsurface changes alter surface albedo (reflectivity) and hence radiation absorption and earth-atmosphere radiation budgets. Similarly, we have identified many instances of anthropogenic disruption to apparently stable material cycles, and most of these also interact with the atmosphere. Thus, vegetation changes alter CO_2, CH_4, and H_2O gas exchange with the atmosphere (and all three are "greenhouse gases"). Deforestation leading to surface soil dessication increases atmospheric dust, or particulate, concentrations.

Science tells us that landsurface degradation is usually severe but often localized and short-lived during land clearance, reclamation, and construction phases and may be reduced or stopped with appropriate remediation. It is likely to become more widespread and much less severe, often becoming manageable, during sustained (and sustainable) modified land use, especially with appropriate stewardship. Perhaps surprisingly, such degradation may then accelerate and become runaway after abandonment: although damaging practices may cease, so too will management practices. Land degradation continues when drains, watercourses, walls, fences, and managed biological components fall into disrepair—which is why risk assessment and end-of-use remediation measures and restoration plans are required by advanced planning and environmental impact assessment processes today. The Cistercians were simply not equipped or required to follow such procedures.

The impacts discussed above also reveal much about the sensitivity of the landsystems involved. Every disturbance or stress applied to a stable system or one in dynamic equilibrium (if we could assess these in an absolute sense) moves or forces the system toward change, but the process-response relationship is far from linear or predictable. A system may be close to a threshold, requiring little disturbance to cross it, or distant from that threshold, with little or no perceptible response to sustained disturbance. Environmental scientists also recognize metastable systems, which may be inherently stable in one state and catastrophically (irreversibly) unstable in another, and some scientists dabble in chaos theory! Certainly, in occupying marginal landscapes

by choice, the Cistercians also inevitably exposed their system to greater eco-
nomic and environmental risk, sensitivity, and (inevitably) fragility. This
makes their achievement all the more remarkable. (Environmental sensitivity
could also be triggered by socioeconomic forcing, as when the worsening
shortage of mercenary labor after 1350 led to the retrenchment of upland
farming or less labor-intensive sheep ranching.) We can now turn, finally, to
the impact of climate change on the Cistercian Settlement.

MEDIEVAL CLIMATE VARIABILITY AND CHANGE: A MODERN SYNTHESIS

Until recently, our knowledge and understanding of the existence and extent
of medieval climate variability came from the documentary and proxy envi-
ronmental evidence described at the beginning of this chapter. Assembled by
scholars from a number of disciplines, this material demonstrated some de-
grees of comparability and correlation among climate conditions in different
places—largely through their human socioeconomic impact. Although cli-
matic events were often short-lived and asynchronous, evidence of a Medie-
val Climate Oscillation (MCO) in Europe emerged: approximately three to
four centuries of warming (the MWP), with a peak around 1200–1300, fol-
lowed by nonlinear climate cooling to a new low, the LIA, around 1650–
1750. We now appreciate that such climate oscillations—often rapid, short-
lived, and of relatively low magnitude, but sometimes enduring and of high
magnitude—occur naturally in the global climate system. Measured against a
notional millennial-scale average temperature, the magnitude of the medieval
oscillation appears to have ranged between 2° and 4°C, almost evenly spread,
in relation to the millennial average, between $+1$–2°C during the MWP and
-1–2°C during the LIA. This is based, of course, on proxy environmental
evidence with considerable spatial and temporal variability and more gaps
than records. Modern research suggests that peak warmth in the MWP may
have been no greater than mid-twentieth-century warmth.[38] Compared with
mean day-night temperature shifts of 4–8°C, more enduring net warming
and cooling of 1–2°C may seem insignificant—until we appreciate that cur-
rent mean global temperature is just 18°C.

Recent advances and geopolitical imperatives are revolutionizing climate
forecasting and reconstruction in ways unavailable to Lamb and other climate
historians writing as recently as a decade ago. Much of this progress derives

38. T. J. Crowley and T. S. Lowery, "How Warm Was the Medieval Warm Period?" *Ambio* 29,
no. 1 (2000): 51–54.

from the increased resolution of stable isotope stratigraphy in extracting palaeoclimatic evidence from the Earth's ice sheets and oceans and greater sophistication in atmosphere–ocean–ice sheet modeling. Five major new ice cores between 1987 and 2006 drilled in the Arctic and Antarctic can now provide *annual* proxy climate data for the past 150,000–450,000 years. We are crossing a threshold of scientific investigation that may radically alter our understanding of medieval climate, landsurface, and cultural landscape change. Even if some of his dates are wrong, Platt's work from two decades ago provides a flavor of the range of climatic variability during the MCO and its effects on monastic settlements from the conventional side of that threshold. Referring to abbeys as far apart as Devon and Yorkshire, he wrote:

> In each case it held much property in the upland moors, on the very frontier of viable cultivation. In each case, the first major expansion of the community's lands had occurred during the climatically favourable conditions of the warm epoch now known to have lasted for about a century from its onset in approximately 1150. Well before 1300, the warm dry summers and mild wet winters of this exceptional climatic optimum were a thing of the past. They had been succeeded characteristically by cool wet summers and cold dry winters in a general cooling phase which, while not as pronounced as it would be much later in the nadirs of the late sixteenth and late seventeenth centuries, was yet quite sufficient to destroy, in the long term, the viability of cereal cultivation on the more exposed and marginal uplands; in the short term, a succession of spoilt harvests in unusually wet summers could trigger off, again especially on the frontiers of settlement, a crisis of epic proportions.[39]

On *this* side of the scientific threshold, the Intergovernmental Panel on Climate Change (IPCC) Third Assessment summary of the MCO states:

> Recent analyses suggest that the Northern Hemisphere climate of the past 1,000 years was characterised by an irregular but steady cooling, followed by a strong warming during the 20th century. Temperatures were relatively warm during the 11th to 13th centuries and relatively cool during the 16th to 19th centuries. These periods coincide with what are traditionally called the medieval Climate Opti-

39. Colin Platt, *The Abbeys and Priories of Medieval England* (London: Chancellor Press, 1984), 127.

mum and Little Ice Age, although these anomalies appear to have been most distinct only in and around the North Atlantic region. Based on these analyses, the warmth of the late 20th century appears to have been unprecedented during the millennium.[40]

This passage also explains, again, why scientific and political imperatives are now driving climate studies forward: our acceptance that we live in a period of rapid climate change and global warming due to anthropogenic forcing.

The IPCC was established in 1988 by the United Nations and World Meteorological Organisation to assess scientific and socioeconomic information on climate change and impacts and to advise the UN Framework Convention on options for mitigation and adaptation. Almost all of the world's governments are signed up and accept its broad findings. It is instructive—and useful to the present subject and to climate historians—that the IPCC's vital modeling and forecasting of future climate change and landsurface impacts should also review evidence of the extent and character of the MCO. By doing so, climatologists can check and calibrate the existence of our current rapid warming trend against historic events, however imperfectly known, to ascertain whether the trend exceeds that expected by natural climate variability associated with radiative forcing and to forecast our climatic future. During this process, the burgeoning body of high-resolution data of all parts of the climate system, along with our growing knowledge and understanding of climate coupling with terrestrial energy flows and water and carbon cycles, may enable us to throw much more light on climate–land use characteristics during the MCO.

Our existing knowledge of the MCO's impacts on Cistercian land-based activities and economy—and their response—can expect to benefit from these research developments in at least four specific areas. First, an improved understanding of climate variability should clarify the perceived inter-regional variability and asynchronicity of climate change[41] that currently com-

40. C. K. Folland, T. R. Karl, et al., "Observed Climate Variability and Change," in *Climate Change 2001: The Scientific Basis; Contribution of Working Group 1 to the Third Assessment Report of the Intergovernmental Panel on Climate Change,* ed. J. T. Houghton et al. (Cambridge: Cambridge University Press, 2001), 91–92.

41. Folland, Karl, et al. define climate variability and change, as well as the climate system, as follows. The *climate system* is the highly complex system of five major components—atmosphere, hydrosphere, cryosphere, landsurface, and biosphere—and the interactions among them. *Climate variability* refers to variations in the mean state and other statistics (such as standard deviations, the occurrence of extremes, and so on) related to the climate on all temporal and spatial scales beyond that of individual weather events. *Climate change* refers to a statistically significant variation in either the mean state of the weather or its variability, persisting for an extended period (typically decades or longer). Extracted from ibid., 788–89.

plicate our reconstructions from proxy and documentary records. Second, we will acquire a better understanding of the causes and periodicity of medieval climate change. (Where we relied previously on decadal-centennial scale variability, we can now expect annual-decadal understanding, which should allow us to examine the links between El Niño–Southern Oscillation and North Atlantic Oscillation[42] events, for example.) Third, we may better appreciate the occurrence and impact of other extreme climate or weather events that tend to feature more strongly in medieval documentary and proxy records because of their noteworthiness or greater environmental impact. We know that periods of rapid climate change are accompanied by greater climatic disturbance and extreme weather events, which accords well with much evidence from the MWP to LIA transition in the fourteenth and fifteenth centuries. Fourth, more comprehensive modeling of how anthropogenic activities interact with the dynamics of geologic, hydrologic, biological, and atmospheric systems—each with widely differing components in different states of equilibrium and nonlinear interactions—will help us understand more fully medieval and modern human-environment events, activities, feedbacks, and responses.

SENSITIVITIES AND SYNTHESIS

Environmental and socioeconomic systems are partially but not wholly interactive, and their condition during the period 1128–1540—the lifetime of the medieval Cistercian Settlement in Britain—is not known but conjectured on the basis of proxy environmental and documentary evidence. The evidence is incomplete, and what is there is not fully researched or understood. In addition, environmental and socioeconomic systems experience changes that are asynchronous within themselves and also in relation to each other; there are lags in response times. But interdisciplinary research has, despite these obstacles, already achieved substantial, plausible reconstructions of the medieval world, for which we are indebted to the pioneering White Monks who posed the intriguing questions and the pioneering scholars who began to provide the answers. We could now be poised on the threshold of further advances in our collective understanding as a result of intense contemporary interest and research into global climate–human interactions. Exploring the

42. The El Niño–Southern Oscillation and North Atlantic Oscillation are recognized cyclic disturbances in the ocean-atmosphere systems of the broad eastern Pacific and northern Atlantic regions with associated landsurface impacts. They operate on annual-to-decadal time scales.

sensitivity of the Cistercian Settlement to climate change also uncovers the further sensitivities of the landsurface and cultural landscape to the Cistercian footprint, the feedbacks of the footprint on the Cistercians themselves, and an increasing awareness of climate variability and sensitivity to change.

Hundreds of Cistercian monasteries and thousands of their granges were in place across Europe as point sources of environmental impacts and as proxy recording sites for climate and related landsurface impacts at a time of significant climate change. Europe in general, and western Europe in particular, is located on the windward margin of an ocean whose capricious oceanic and atmospheric currents translate and magnify the effects of disturbance in the ocean-ice-atmosphere system to landsurface and human impacts. Our challenge is to be able to refine the collection and interpretation of parameteorological documentary and environmental proxy records to enhance our understanding of medieval environmental and cultural landscapes. How responsible was the MWP, directly or indirectly, for the unprecedented success and spread of the Cistercian Settlement? Was the climate deterioration that led to, and became, the LIA similarly responsible for the socioeconomic and environmental demise of the Order? It may seem unfashionable to ask this in an apparent age of human supremacy—until we appreciate the threat posed by advanced technoindustrial societies for global climate change and human well-being.

The new science coming out of the research on rapid climate change has enhanced, perhaps as never before, the opportunities for interdisciplinary and international collaboration in allied fields. It can be embraced by those whose expertise lies more in landscape, cultural, socioeconomic, and documentary history who seek to match the science with the human record. As Lamb exhorted: "More documentary reports could certainly be unearthed if the effort could only be organised. Many great archives have hardly yet been tapped for this purpose. And where lengthy historical manuscripts have been printed and published, any weather information has commonly been omitted in the interest of economy, so that the original manuscript should be sought out."[43] As a practical step in collaboration, representatives of relevant disciplines might contemplate the utility and application of modern environmental impact analysis, risk assessment, and planning techniques by producing some serious simulated analyses and assessments for abbey and grange development.

I conclude with what amounts to a postscript and a personal plea. In the

43. Lamb, *Climate, History, and the Modern World,* 82.

conservation and interpretation of the Cistercian Settlement in the landscape, Britain's statutory heritage agencies focus almost entirely on the abbeys themselves, and understandably so. There are, it is true, a small number of conserved Cistercian barns and other buildings and references to granges in their increasingly well-presented and informative site publications, but the dynamic, holistic, single entity of the abbey, precinct, and grange and its former hinterland is now almost impossible to detect. Much of this is because the granges survived less well or came under private ownership and modification after the dissolution; much, too, is down to heritage agency budgets. One example will suffice to illustrate what is mostly dispersed and lost.

Abbaty Tyndwrn—Tintern Abbey—is one of Cadw: Welsh Historic Monuments' star sites. The abbey church, cloister, and immediate precinct are in public ownership, with full access. Yet 400 meters to the north lay a small stone harbor, water mill, fish tank, and outbuildings with strong abbey associations. These are still accessible, after a fashion, but the harbor has been filled in, the fish tank is an ornamental pool (with fish!), and the privately owned former mill and outbuildings now sell craft goods, souvenirs, and food to tourists. Upstream of the harbor, in the narrow valley of Angidy Brook (which watered the monastery), lie artificial pools, conduits, and sluices and disused ironworks on the sites of their earlier monastic counterparts. (The ironworks is in heritage care.) On a hillside facing the abbey lies a modern vineyard—indicative of global warming—and five miles away are the modern private residences of Woolaston Grange Farm, on the site of one of Tintern's largest granges. Fragments of the grange chapel and other walls can still be seen. Until recently, one of the last grand Cistercian barns still served a farming function, housing an iron mill of seventeenth-century origin, successor to the grange mill, with traces of the millrace still visible in an adjacent field. Farming realities have since led to its conversion to a superbly appointed and expensive private residence. The opportunities to tell the *full* story of Tintern in its landscape are still there, if mostly only accessible to the distant gaze—but there may still be a rapidly dwindling supply of similar opportunities elsewhere. At a time of increasing environmental awareness and interactive, living history reconstruction and reenactment, to know this and do nothing not only understates the size and impact of the Cistercian Settlement but does the memory of the White Monks themselves a great disservice.

10

VISIBLE AND INVISIBLE LANDSCAPES:
MEDIEVAL MONASTICISM AS A CULTURAL RESOURCE
IN THE PACIFIC NORTHWEST

Ann Marie Rasmussen

Listen—something else hovers out here, not
color, not outlines or depth when air
relieves distance by hazing far mountains,
but some total feeling or other world
almost coming forward, like when a bell sounds
and then leaves a whole countryside waiting.

—WILLIAM STAFFORD, "IS THIS FEELING ABOUT THE WEST REAL?"

This chapter explores notions of the sacred landscape as a dimension of modern environmental writing and practice in the Pacific Northwest, especially in the state of Oregon, by looking at the ways in which contemporary writers and journalists, churchmen, activists, and ecologists use ideas about medieval monasticism as a cultural resource for understanding the relationship between humans and the wild. First, though, the chapter orients the reader in the landscapes of Oregon, a state whose inhabitants have developed an extraordinarily rich and complex sense of it as a place—that is, as "a lived relation constituted by human activity and brought close to one's being in the world."[1] Such a sense of place is expressed with force and beauty in William Stafford's poetry about Oregon. The final stanza of his "Is This Feeling about the West Real?" serves as this chapter's epigraph; it reminds us that a landscape's appeal may derive from its unique combination of physical characteristics, but it is only our changing human understanding of the source and

This essay is dedicated to the memory of my great-uncle, Arnold Bodtker (1904–2000). William Stafford's "Is This Feeling about the West Real?" from *My Name is William Tell* (Lewiston, Idaho: Confluence Press, 1992) is used in Chapter 10 by permission of the publisher.

1. This phrase is from my notes from Fred Orton's presentation to the "Place to Believe In" conference (Whitby, England, July 2003), echoed in his essay for this volume, "At the Bewcastle Monument, in Place."

value of beauty in the physical world that imbues place with deep meaning.[2] In Stafford's imagery, such meaning is sublime, invisible yet powerfully present: "some total feeling or other world / almost coming forward." This total feeling—whether one of beauty, power, or belief, which summons readers like the tolling of a church bell to attend closely and reverently to their place in the landscape and, by extension, the world—might also be called the metaphysical or transcendent dimension of a place or, more simply, the sacred.

A GEOGRAPHY LESSON

Located between the latitudes 42°N and 46°N (in the same latitude range as southern France) and bordered by the Pacific Ocean to the west, the Columbia River and the state of Washington to the north, the Snake River and the state of Idaho to the east, and the states of Nevada and California to the south, the state of Oregon is a political entity (fig. 30).[3] Oregon is also considered part of a transnational region called the Pacific Northwest, which includes Washington and Idaho as well as the Canadian province of British Columbia. Oregon possesses extraordinarily rich, complex, and diverse landscapes that scientists and geographers describe in terms of landforms ("physiographic provinces") and ecoregions (ecological regions), among other classifications.[4] More colloquially (but in a way congruent with such scientific categories), Oregonians divide their state's geography into (1) the coast, (2) the Willamette Valley, (3) the Cascades, and (4) the high desert. The high desert earned its name due to its high elevation and sparse rainfall. Its basins and mountain ranges east of the Cascades make up about 60 percent of the state's land mass.[5]

Oregon is also an idea, a "construction of time and place that is highly contingent and relational" that involves layers of history and human use.[6]

2. For an introduction to the scholarly literature on the connections between the romantic sensibility of the sublime and American and European sensibilities about the landscapes of the American West, see John F. Sears, *Sacred Places: American Tourist Attractions in the Nineteenth Century* (New York: Oxford University Press, 1989).

3. The best source of information about the geography of Oregon is Stuart Allan, Aileen R. Buckley, and James E. Meacham, *Atlas of Oregon,* ed. William G. Loy, 2nd ed. (Eugene: University of Oregon Press, 2001).

4. On landforms, see ibid., 118–47, esp. 119; on ecoregions, see 172–85, esp. 174.

5. The high desert is made up of a number of distinct ecoregions, and while the amount of rainfall is low, many of these ecoregions east of the Cascades feature lakes and rivers.

6. William L. Lang, "Beavers, Firs, Salmon, and Falling Water: Pacific Northwest Regionalism and the Environment," *Oregon Historical Quarterly* 104, no. 2 (Summer 2003): 151–65, at 151.

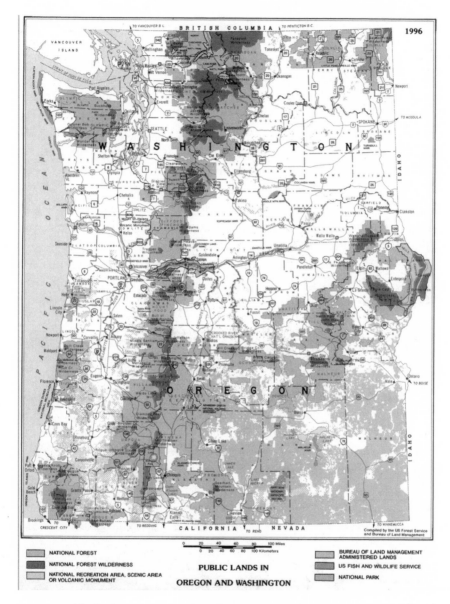

FIG. 30 Public lands in Oregon and Washington, 1996. Map courtesy Bureau of Land Management, United States Department of the Interior.

The state's political geography is complex. Figure 30 displays a contrasting patchwork denoting the amounts of publicly administered and privately held lands in Oregon: white designates privately owned land and grey designates lands administered by federal and state agencies. Over half of the state of Oregon is public land administered by the federal government. This includes United States Forest Service lands under the Department of Agriculture; Bureau of Land Management lands under the Department of the Interior; and lands administered by the National Park Service and the Fish and Wildlife Service (both in the Department of the Interior) as well as state forests.[7] The notion of shared property—of public land managed for the common good—is not abstract to Oregonians. To grow up and live in Oregon is to experience, perhaps on a daily basis, the concept of public property.

Human beings have inhabited Oregon for at least 13,500 years.[8] Insofar as generalizations can be made about a cultural arena of such chronological depth and extraordinary linguistic and cultural diversity, anthropologists have argued that "indigenous people in the Pacific Northwest may have lived in what we should understand as an enchanted environment, one that had meaning embedded in interrelationships between humans and the non-human world that included cohabitation with spiritual forces and beings."[9] Euro-American beliefs and practices about Oregon have been shaped primarily by the area's rich natural resources, especially timber, fish, and water. Indeed, Euro-Americans explored the Pacific Northwest and then began to trap beaver on an industrial scale in the 1820s.[10] Like the settlers who were soon to follow, they saw Oregon as a wilderness—the opposite of civilization and an apparently inexhaustible source of valuable economic resources. First Peoples (Native Americans) had, of course, also interacted with their environment. They may well have modified it, practicing selective burning of underbrush in wide swathes of the Willamette Valley, for example, to maintain savanna-like grasslands that supported large game. Euro-Americans, on the other hand, have profoundly transformed the natural world: in the name of human good or economic profit, they have used, exploited, damaged, and

7. Private, 43.89 percent; public, 56.11 percent. Public land is divided into USFS and BLM lands at 50.64 percent (USFS, 25.26 percent; BLM, 25.38 percent); other federal lands, 2.96 percent; and state lands, 2.51 percent. See Allan, Buckley, and Meacham, *Atlas of Oregon,* 82–85, at 84.

8. For more information about Oregon's native peoples, see *The First Oregonians: An Illustrated Collection of Essays on Traditional Lifeways, Federal-Indian Relations, and the State's Native Peoples Today,* ed. Carolyn M. Buan and Richard Lewis (Portland: Oregon Council for the Humanities, 1991).

9. Lang, "Beavers," 156.

10. Jennifer Ott, "'Ruining' the Rivers in the Snake Country: The Hudson's Bay Company's Fur Desert Policy," *Oregon Historical Quarterly* 104, no. 2 (Summer 2003): 166–95.

at times destroyed Oregon's natural resources. Examples include the fur de-
sert policy of the 1820s, under which the Hudson's Bay Company's teams of
trappers systematically exterminated beaver in entire watersheds in order to
run competing firms out of business, thereby doing inestimable ecological
damage; the transformation of the Willamette Valley into farmland; the re-
moval of virtually all old-growth timber in the huge logging operations of
the 1950s, 1960s, and 1970s; and the tens of thousands of cattle grazing the
high-desert landscapes of eastern Oregon. Dam-building projects in the 1940s
and 1950s created the "engineered and managed Columbia River" (which
fuels Oregon, Washington, and California industry with cheap hydroelectric
power) but destroyed the salmon runs on the upper reaches of the Columbia
and Snake River watersheds. Finally, campgrounds, hiking trails, and other
amenities have been created for recreation—the newest outdoor resource-
based industry in Oregon. There are beautiful preserves called "wilderness
areas" in Oregon, and there are thousands of square miles of wild places, but
there is no place in Oregon—no natural area, no landscape—that does not
bear the imprint of human activity. And throughout Oregon, small commu-
nities still exist whose livelihoods and existence continue to be intimately
tied to resource use and the land.

NOTIONS OF THE SACRED IN OREGON'S LANDSCAPES

Euro-American ideas about and practices in Oregon closely track normative
American beliefs about wilderness and the wild: namely, that humankind has
a God-given right of dominion and control over nature and must conquer
it; that wilderness can provide freedom and liberty from the constraints of
civilization and conventional morality; and that material progress is entirely
good.[11] These beliefs and the practices they foster remain relevant today. (In
current American politics, one catchword is "wise-use industrialism," which
means capitalist exploitation of natural resources unhampered by environ-
mental concerns.) At the same time, there have also always been philoso-
phers, writers, and activists in the United States such as Henry David Thoreau
(1817–1862), John Muir (1838–1914), and Aldo Leopold (1887–1948), who
challenged dominant American beliefs about the relationship between nature

11. See, for example, Neil Evernden, *The Social Creation of Nature* (Baltimore: The Johns Hopkins
University Press, 1992); Max Oelschlaeger, *The Idea of Wilderness: From Prehistory to the Age of Ecology*
(New Haven: Yale University Press, 1991); Roderick Frazier Nash, *Wilderness and the American Mind*,
4th ed. (New Haven: Yale University Press, 2001).

244 A PLACE TO BELIEVE IN

and mankind and whose works are now considered classics of the environ-
mental movement.

All of these ways of thinking about humans and the wild exist in Oregon
today, both as ideas about the state itself and as forms of human activity
and practice. Intense political conflicts surround Oregon's landscapes and its
resources. These conflicts are increasingly being cast in spiritual as well as
in scientific, economic, and political terms. A new sense of sacredness has
crystallized around specific Oregon landscapes, particularly the remaining
old-growth Douglas fir forests and sequoia redwood forests of the Cascades
and Coast Range along with the many coastal and mountainous forest water-
sheds (and the great Columbia River watershed) inhabited by the anadro-
mous fish species known collectively as "salmon." The three texts discussed
below illustrate this emerging sense of sacredness. One emerges from the
perspective of an established religion (the Catholic Church); the other two
have developed from nonreligious perspectives. These latter texts are all the
more worth exploring because they demonstrate an important regional trend.
Of all fifty states, Oregon and Washington have the highest percentages of
people who report no religious preference—21 and 25 percent of the popula-
tion, respectively.[12] Indeed, those who answer "none" when asked about a
religious affiliation are the single largest "religious" group in Oregon and
Washington. But as the texts will show, a strong regional culture of rejecting
established religion can coexist with the development of a sense of the sacred
in the landscape.

In their international pastoral letter from 2001, "The Columbia River
Watershed: Caring for Creation and the Common Good," the Catholic arch-
bishops and bishops of the Columbia River watershed articulate an activist
environmental policy that is based on human stewardship of nature. They
call for social and economic justice in the human community.[13]

> The watershed is the common home and habitat of God's creation,
> a source of human livelihood, and a setting for human community.
> The commons belongs to everyone, and yet belongs to no one. We
> hold this land in trust for our present use, for future generations, and
> ultimately for God, from whom all good things come. . . . The

12. Don Lattin, "Church of 'None' Growing in U.S.," *Durham Herald-Sun*, 6 December 2003,
A6. In 1991, 17.2 percent of Oregonians reported no religious affiliation. (See the statistics in Allan,
Buckley, and Meacham, *Atlas of Oregon*, 46–47.)

13. "The Columbia River Watershed: Caring for Creation and the Common Good," Columbia
River Pastoral Letter Project, 2001, http://www.columbiariver.org/index1.html (accessed 27 January
2004).

recognition of the presence and plan of God challenges us to work to understand better the ecosystems of our region and to seek to utilize its goods justly while respecting the value of all its creatures.[14]

The bishops' decision to constitute themselves as a community based on the massive watershed of the Columbia River testifies to the potential organizing force of thinking in terms of landscape. The pastoral letter employs the watershed's full rhetorical potential in order to think deeply about the interconnectedness and interdependence of life forms. At the same time, the nature and the landscape are sacred in the specific, theological sense that nature reveals signs of God's presence in the world: "The watershed, seen though eyes alive with faith, can be a revelation of God's presence, an occasion of grace and blessing. There are many signs of the presence of God in this book of nature, signs that complement the understandings of God revealed in the pages of the Bible, both the Hebrew and Christian Scriptures."[15]

The second text under discussion dates from July 2003, when an ecofeminist manifesto was posted on the Web to justify an illegal, women-only "tree sit" that took place in an old-growth Douglas fir grove located in a tract that had been sold for timber harvest in the Willamette National Forest near Oakridge, Oregon, in the Cascade Mountains. (The sale was known as the Straw Devil timber sale.) Tree sitting is a form of environmental activism in which hardy (and usually young) individuals live on platforms high in trees slated for logging. By refusing to descend to earth, thus making it impossible to cut down the trees without seriously harming the humans dwelling in them, tree sitters attempt to force logging activities to stop.[16] Activists see the nonviolent but illegal action of tree sitting as a radical form of stewardship in defense of public land, a notion that is well expressed in the anonymous manifesto: "Today we announce the beginning of an all-womyn's action, occupation and tree-sit in defense of public land sold off to private industry."[17]

The phrase "public land" is salient here. Again, as fig. 30 demonstrates, in Oregon (as in much of the West) the notion of public land is not an abstract concept but an ordinary reality. By literally dwelling in groves of trees in

14. Ibid., 3.

15. Ibid.

16. Heather Millar, "Generation Green," *Sierra,* November/December 2000, 36–47, 94; and Cheri Brooks, "Up a Tree: Notes from the Front Lines of Forest Defense," *Forest Magazine,* September/October 2000, 14–19.

17. The Womyns Action, "Womyn's Occupation of the Straw Devil Timber Sale," Cascadia Forest Defenders, http://treesit.org (posted 3 July 2003).

defiance of legally binding timber sales, the tree sitters activate—in a sharp-ened, focused way—this lived experience of the Pacific Northwest landscape. They undertake this action in a principled way, articulating a notion of the common good that, unlike the economically driven models of industry and government, can place the highest value on the health and longevity of an ecosystem.

In expressing its vision of environmental justice, the "Womyn's Occupa-tion" manifesto uses a political discourse of oppression and liberation that establishes a parallel between the macrocosm of a healthy old-growth forest ecosystem and the microcosm of a healthy and whole human being: "In addition to defending the last 2% of native old growth forest that still stands in Oregon, the Womyn's Action is dedicated to building a community that is intolerant of all forms of oppression. We work to build a space of mutual learning and growth—a space where we can conquer not only the demons of capitalism, patriarchy and indifference that surround us but also the demons of oppression, self-loathing and fear that reside within us." The trea-tise elaborates this analogy, paralleling the oppression of women with the abuse of the natural world. Most important for my purposes here, it also evokes the aesthetic of the sublime in the old-growth forest landscape ("wild beauty"). The forest's value to humankind is so great that it deserves protec-tion from the forces that threaten to destroy it: "It is our belief that the oppression of womyn and the destruction of the earth comes [sic] from the same unsustainable need to dominate and control. The same ones who wish to take away our autonomy wish to take away the last of the wild beauty on earth."

The "Womyn's Occupation" manifesto is a political document, yet it is suffused with a deep sense of the sacredness of the old-growth forest land-scape. This place possesses a "wild beauty" whose full dignity resides pre-cisely its natural power and complexity, which can never be entirely captured or expressed by human beings. Because such places are endangered—and because they represent but a fragment ("the last") of the majesty of untram-meled nature—the treatise calls on humankind to show its reverence for such places by protecting them.

The final text addressed here—David James Duncan's essay "god"—takes the form of a dream vision, itself a venerable genre of Christian spiritual writing and of late medieval love poetry, in order to talk about the life and death of the Columbia River watershed as exemplified by the threatened extinction of the salmon. With rhetorical force, Duncan presents a literary exploration and articulation of the spiritual dimension of this landscape,

which is summed up by the first-person narrator when he awakens from his dream.

> Whether I can convey it or not, I woke from this dream flooded by the feeling that a so-called species—such as the coho, sockeye, steelhead, Chinook—is a gift created in an unending Beginning, and a product less of evolution or natural selection than of unconditional love; I woke convinced that all such species constitute a life-creating force that extends divine generosity to the world as sunbeams create life by extending to us the sun; I woke convinced that these primordial populations of fish bear a greater resemblance to what we envision when we hear the words "angel" or "god" than to what we imagine in hearing the embattled term "endangered species"; I woke feeling that to cause the extinction of such beings—as America is now doing under federal mandate—is an act not just of biocide, but of spiritual suicide.[18]

Again, Duncan asserts that the salmon are themselves divine: "all such species constitute a life-creating force that extends divine generosity to the world as sunbeams create life by extending to us the sun." This perspective resonates powerfully with the beliefs of many First Peoples in the Columbia River watershed, whose inspiration Duncan acknowledges in this and other works.[19] It also resonates with the analogical microcosm/macrocosm thinking of the Womyn's Action manifesto. Duncan insists that a spiritual understanding of landscapes can connect human beings to them (and, more important, to themselves) in powerful and life-changing ways. It is not that the salmon are an extension of us; we are a manifestation of the salmon. Thus the real and impending extinction of the salmon is an act of "spiritual suicide," an act of violence directed against ourselves—more specifically, against our higher, spiritual, selves.

The "Womyn's Occupation" treatise and "god" share a deep sense of outrage about human beings' wanton abuse and destruction of wild places. The activism envisioned in the manifesto grows directly out of this anger. Duncan's essay, on the other hand, is also suffused with a sense of grief about the ultimate fate of the wild landscapes—"the wild beauty"—of the Pacific Northwest, even as the narrator's dream reveals to him, in time-honored

18. David James Duncan, "god," in *My Story as Told by Water* (San Francisco: Sierra Club, 2001), 263–71, at 264.

19. See, for example, the essays in *The First Oregonians,* ed. Buan and Lewis.

fashion, the divinity of all creation. The occasionally apocalyptic tone of "god" contrasts strongly with the measured and stately calm of "The Columbia River Watershed: Caring for Creation and the Common Good," the pastoral letter whose deep theological grounding encompasses a hope for a healthy future for the watershed. In the letter, the sacredness of the Columbia River watershed landscape is legible because of the primary sacredness of Christian scripture. The Womyn's Action manifesto and "god" move closer to asserting that what is sacred in these landscapes inheres in the wildness of the place and the natural creatures themselves. In the worldview expressed in these texts, the spiritual value of old growth and salmon is intrinsic. Forests and salmon are "symbol and reality in one."[20]

MEDIEVAL MONASTICISM AS A CULTURAL RESOURCE

> But if you don't get it, this bonus, you can
> go home full of denial, and live out your years.
> Great waves can pass unnoticed outside your door;
> stars can pound silently on the roof; your teakettle
> and cozy life inside can deny everything outside—
> whole mountain ranges, history, the holocaust,
> sainthood, Crazy Horse.
>
> —STAFFORD, "IS THIS FEELING ABOUT THE WEST REAL?"

The works of naturalists, writers, ecocritics, and ecoactivists concerning the Pacific Northwest display eclectic philosophical, spiritual, and religious beliefs, but overall, they tend to reject mainstream Euro-American religious thought and practice. Both the radical and scientific environmental movements express a strong sense that Euro-American religious models are exhausted, played out, too deeply implicated in the kinds of beliefs and practices that got us into this environmental mess in the first place to be persuasive.[21] Instead, First Peoples and their lives on the land—before the arrival of Euro-Americans—loom large in much of this writing. The second stanza of Staff-

20. Lang, "Beavers," 156.
21. The active and influential scientists, rangers, and foresters—who must often balance competing interests as they manage public and private lands—represent yet another perspective. As forester James E. Coufal put it in a letter to the editor published in *Distant Thunder*, the newsletter of the Forest Stewards Guild, "I may not currently have the God-centered religiosity of my youth, but I am not about to substitute nature worship for a theocracy, to worship the creation instead of the creator." "Why I Haven't Joined the Guild," *Distant Thunder*, Spring/Summer 2001, 7, http://www.foreststewardsguild.org/ (accessed 3 July 2003).

ord's "Is This Feeling about the West Real?" ends its list of realities with which each new generation of American Westerners must contend by naming the great Lakota warrior and visionary leader, Crazy Horse (1849–1877). His quest to preserve the traditional ways of his people ended when he was assassinated by American soldiers. In Stafford's poem, Crazy Horse's life story conjures and combines all the terms that precede it: "mountains," "history," "holocaust," "sainthood." Duncan's essay "god" draws on the mythologies and practices of First Peoples to create a deep human context for its sense of the sacredness of Oregon's wild places. Even the Reflection Guide that is published together with "The Columbia River Watershed: Caring for Creation and the Common Good" evokes "native religions" that "taught respect for the ways of nature personified as a nurturing mother for all creatures."[22] Native American spiritual and social understandings of the relationships between humans and the wild have a living presence in Oregon and Washington, along with a deep sense of the injustices perpetrated against First Peoples by Euro-Americans. Native American groups also remain important political players in the struggles, for example, over salmon and water in the Klamath Lake Basin and the Columbia River watershed.

And what about medieval monasticism? There is no mention of it in the Womyn's Action manifesto or in "god." A monk does appear in Duncan's essay "Who Owns the West? Seven Wrong Answers," but the monk is not a Christian; he is a Buddhist, the Japanese hermit monk Ryokan.[23] There is also no direct mention of monasticism in "The Columbia River Watershed: Caring for Creation and the Common Good." But a parallel source suggests that theological perspectives on the right relationship between man and nature, as developed in the traditions of medieval European monasticism, form part of the document's intellectual foundation. In his 1998 lecture "The Columbia, Flowing Waters of Life: A Gift and Treasure," one of the international pastoral letter's authors, Bishop William S. Skylstad (Diocese of Spokane, Washington), reflects in both personal and doctrinal terms on the deliberations that would receive their final, public form in the letter.[24] Skylstad sets the committee's work in a theological context by naming three saints:

22. "Reflection Guide," 3, http://www.columbiariver.org/main_pages/Watershed/PDF/reflection_guide.pdf (accessed 27 January 2004). Also see "The Columbia River Watershed," 8, which repeatedly calls for economic justice for the indigenous peoples of the Pacific Northwest.

23. David James Duncan, "Who Owns the West? Seven Wrong Answers," in *My Story as Told by Water*, 61–80.

24. William S. Skylstad, "The Columbia, Flowing Waters of Life: A Gift and Treasure," Tobin Lecture 1998, 11, http://www.columbiariver.org/main_pages/news/tobin.htm (accessed January 2004).

"We have a glorious tradition of saints like Saint Benedict, Saint Hildegard, and Saint Francis of Assisi who had deep respect and reverence for creation. Our work together as Church can be a community effort to promote justice in our land and reverence for God's creation."[25] Together with Pope John Paul II and Romano Guardini, Saints Benedict, Hildegard, and Francis are the only Church authorities mentioned. These three are not only medieval saints (who died in the sixth, twelfth, and thirteenth centuries, respectively) but also monastic saints, founders and leaders of communities and orders. (Indeed, Saint Benedict was the great originator and institutionalizer of the idea of monastic community.)

In "The Columbia, Flowing Waters of Life," Saints Benedict, Hildegard, and Francis are remembered because of their respect and reverence for nature. Skylstad's lecture does not intend to reflect on whether cloistered community life might be understood as a unique, radical way of being in the world that made possible deep theological thought and religious reflection on the relationship between God, humankind, and nature. Historians of medieval monasticism who have focused less on the ideological and spiritual beliefs of monastics than on the way cloistered communities created new ways of living in the world—and, in the process, changed the world around them—hold divergent positions on the relationship between monastic communities and nature. In his 1966 *The Myth of the Machine: Technics and Human Development,* Lewis Mumford developed a sociological analysis of the Benedictine community.[26] In his view, the innovation of the self-governing economic and religious monastic communities lay not in the strictness of their discipline and order, which earlier organization of human manual labor into huge work units (or "megamachines") had also required, but in the development of an ideology or belief system that taught the members of such communities to internalize this order and discipline.

> The difference lay in its modest size, its voluntary constitution, and in the fact that its sternest discipline was self-imposed. Of the seventy-two chapters comprising the Benedictine rule, twenty-nine are concerned with discipline and the penal code, while ten refer to internal administration: more than half in all. By consent, the monk's renunciation of his own will matched that imposed upon its human parts by the earlier megamachine. Authority, submission, subordina-

25. Skylstad, "The Columbia," 7.
26. Lewis Mumford, *The Myth of the Machine: Technics and Human Development* (New York: Harcourt, Brace and World, 1966).

tion to superior orders were an integral part of this etherealized and moralized megamachine.[27]

Mumford believed that this new form of human labor organization provided fertile ground for technological development, specifically for the invention and use of labor-saving devices such as watermills. The Benedictine community, he wrote, provides "a model for cooperative effort on the highest cultural plane."[28]

Twenty-five years later, Max Oelschlaeger told a different story about monastic communities in *The Idea of Wilderness: From Prehistory to the Age of Ecology*. The Middle Ages are summed up in 3 pages of this 480-page study: "though theological disputes and heresies were prevalent throughout the Middle Ages, this was an age of intellectual tranquility and surety. The medieval mind had a unity quite foreign to our own."[29] Regarding monasticism, we learn that "cloistered societies were possibly the *single* largest agent of environmental change during the Middle Ages." That this environmental change was for the worse is made clear: "Woodlands were ravaged by ax-wielding monks." These monks vigorously enacted human dominion over wild nature, which "had to be tamed, and thereby civilized or brought into harmony with the Divine Order."[30] Whether this is true of medieval monasticism or not, Oelschlaeger uses monasticism to create a story, a "long durée" for a Western hostility to and exploitation of wild nature that is grounded in Christian religious belief and practice.

In general, though, it is not the cloistered monks who excite the modern imagination but rather the cenobitic monks, or hermits, who live outside established communities. The cenobite or hermit is typically portrayed positively as a wise man, a sage. Duncan's description of the Buddhist monk Ryokan fits this template. *The Idea of Wilderness* refers to early Christian cenobitic monasticism in a footnote summarizing an article by Susan Power Bratton that favorably depicts the relationship of hermit monks to the wild. The fact that this discussion is relegated to a footnote suggests that Oelschlaeger's study cannot assimilate this divergent view of medieval monasticism to its

27. Ibid., 264.

28. Ibid., 266. "Yet the Benedictine system demonstrated how efficiently the daily work could be done, when it was collectively planned and ordered, when cooperation replaced coercion, and when the whole man—sexuality aside—was employed: above all, when the kind and quantity of work done was regulated by the higher needs of human development" (267).

29. Max Oelschlaeger, *The Idea of Wilderness: From Prehistory to the Age of Ecology* (New Haven: Yale University Press, 1991), 71.

30. Ibid., 72, 70.

overarching thesis; it must thus subordinate the hermit monk's putative toler-
ance and even celebration of the wild to the cloistered community's putative
hostility to the wild. The latter's attitude (whether hostile or well-meaning)
had greater long-term ecological and environmental effects.[31]

Whether deriving from Asian or early Christian cultures, or the Celtic
myths and legends with which American popular culture is replete, images
of hermits and their relationship to nature have become stock figures of the
modern American cultural imaginary. A recent essay in *Harper's*, "A Gospel
According to the Earth: Sown by Science, a New Eco-Faith Takes Root,"
by Jack Hitt, uses medieval cenobitic monasticism as an explanatory frame-
work for modern environmental activism and practice.[32] The analogy be-
tween ecoactivism and monasticism is based on what Hitt presents as their
shared denial of pleasure. He writes, "'Off the grid,' 'monastery': Both are
forms of asceticism, and the practices of friends of mine who live off the grid
do resemble a monastic life. Both involve a kind of sensual denial."[33] Seeking
to establish a religious precedent for tree sitting, Hitt's essay concocts a ver-
sion of early Christian history featuring hermit monks who are simultane-
ously performance artists and marketing executives.

> After the conversion of Constantine in A.D. 312, the techniques for
> attracting followers had to become more creative. Martyrdom was
> no longer an option, so the more innovative followers relied upon
> unusual types of performances. In some locales Christians tried to
> get closer to God, paradoxically, by isolating themselves in some
> way. These were sort of beta tests for behavior that would eventually
> be codified as monastic life. With these early proto-monks, though,
> the point seemed to be to draw attention to their beliefs. They were
> performance artists of sorts. . . . Nearly all these early saints drew
> crowds. Their very oddness was the point. It disconcerted the Estab-
> lishment and made people try to understand what powerful idea
> nested in the hearts of these lunatics. Tell me again, Lucia, the name
> of this new religion? One subset of stylites chose not to live atop

31. Ibid., 72n17. The article is question is Susan Power Bratton, "The Original Desert Solitaire:
Early Christian Monasticism and Wilderness," *Environmental Ethics* 10 (1988): 31–53.

32. Jack Hitt, "A Gospel According to the Earth: Sown by Science, a New Eco-Faith Takes
Root," *Harper's*, July 2003, 41–55.

33. Ibid., 43: "Both groups try to integrate into the world around them ideas they have about
living a just life. Both find virtue in absence [*sic*], and cultivate abstention because they believe that by
opening an intimate space within their daily lives, it will be filled with something that is closer to God
or Nature."

man-made pillars. Even that was too easy, too comfortable. They were called Dendrites. They built their platforms in trees.[34]

The essay jumps from depicting fourth-century Christianity to portraying the horrific injuries suffered by tree sitter Tre Arrow in Oregon's Tillamook State Forest in 2001 during a confrontation with loggers and law-enforcement officials, a transition suggesting that Tre Arrow's sense of purpose and physical trials can best be understood in the context of Christian martyrdom. It can be hard to get past the essay's facile, tendentious treatment of history and the narrator's somewhat ironic tone, both of which undercut the essay's important thesis and its interesting attempt to put a modern form of ecoactivism into historical perspective. Both hermit monks and tree sitters are odd, and it is their "will to oddity" that excites the curiosity of the urbane narrator, who is, presumably, writing from an implicit perspective of mainstream normalcy and conformity.

My final example of the modern use of medieval monasticism as a resource for thinking about our interactions with the wild appears in *Into the Wild,* Jon Krakauer's study of Chris McCandless, a young American from the suburbs of Washington, D.C. At the age of twenty-two, McCandless fled the malaise of modern civilization to seek self-discovery in the American West's wild places. His journey ended after two and one-half years with his death in the Alaskan wilderness.[35] Krakauer's study offers many contexts and perspectives from which to interpret McCandless's journey, including a series of biographical comparisons between McCandless and other twentieth-century American seekers and risk-takers. About halfway through the book, chapter 9 discusses Everett Ruess, who disappeared in 1935 while on a solitary trek in Arizona. The chapter's concluding paragraph places McCandless and Ruess in the larger context of medieval monasticism, specifically recalling the journeys of early medieval Irish monks across the North Atlantic to Iceland: "They were drawn across the storm-racked ocean, drawn west past the edge of the known world, by nothing more than a hunger of the spirit, a yearning of such queer intensity that it beggars the modern imagination. Reading of these monks, one is moved by their courage, their reckless innocence, and the urgency of their desire. Reading of these monks, one can't help thinking of Everett Ruess and Chris McCandless."[36]

What can be said about these modern uses of medieval monasticism? Both

34. Ibid., 49.
35. Jon Krakauer, *Into the Wild* (New York: Anchor Books, 1996).
36. Ibid., 97.

Hitt and Krakauer construct monasticism as a human oddity, a way of life that contrasts starkly, then and now, with the way of life in the world around it. This assumption might not bear up well under historical scrutiny. Krakauer does not mention the idea of sacred vocation, of faith, that infused and motivated the cenobitic life. In its place stands the explanatory paradigm of universalized personal psychology: people have drives or desires that make them do strange things. It is apparently the supposed oddity of these people, past and present, and the "will to oddity" they represent that arouses the imagination of writers such as Hitt or Krakauer. (Unlike Hitt's narrator, Krakauer's clearly counts himself among those human beings driven to take up similarly unusual pursuits.) Krakauer, Hitt, and even Duncan construct their image of medieval monks in the landscape as rogue individualists in the wild—the wise man of nature who is not a Christian but a Buddhist, the early Christian zealots who sat in trees because martyrdom was no longer an option, the Irish monks whose obscure quest propelled them into the unknown. Monks as loners, as performance artists, as risk-takers, as sages in intimate communion with nature: these figures have become characters in a great American myth, the myth of the wild, the west, Alaska, Oregon, as a place of freedom from social conventions and liberation from community, legitimized and sanctioned by the notion that theirs is a mystical pursuit of spiritual self-discovery.

What does the medievalist find absent in these accounts of the medieval past? For one thing, these popular images of medieval monks as rogue individualists ignore the fact that the overwhelming majority of monks lived, and continue to live, in community. Hitt's essay is given a visual framing (fig. 31) that mimics medieval manuscript illumination, presumably to illustrate the essay's use of cenobitic monasticism as an explanatory framework. Yet the production and illumination of medieval manuscripts is an achievement rooted and fixed in communal monasticism. Moreover, the style of illustration chosen is neither individualistic nor even monastic. It imitates a Gothic style of illumination from a period when the craft was practiced by lay professionals in urban centers. Another problem is that in these accounts, medieval monks are all men. This narrowed, modern vision of medieval monasticism ignores religious women and the many forms of communal living they organized and inhabited. Third, these medieval monks do not appear to read or write. If monks are in the woods—in the wild—they are not intellectuals. The knowledge that medieval monks cultivated reading and writing is still commonplace (indeed, fig. 31 confirms this), but it would seem that for the modern American imagination, when monks and the outdoors come to-

tossed into a coliseum to be mauled by a savage beast. (It actually was a wild "cow.") Even the Romans, though, suddenly became horrified by the butchery of a lovely, well-to-do madonna (Perpetua was nursing her newborn up until the moment of her slaughter). So the governor paused the Grand Guignol and ordered that a tunic be provided and that a gladiator be sent in to finish her off. According to written accounts, the gladiator was totally unnerved by her calm. The rabble sitting on the stone benches could see that the hand in which he held the sword was trembling. He froze. So Perpetua did him a favor. She reached up, steadied his weapon, and plunged it into her throat.

Picture that pagan guy again, sitting there, watching this. Um, Lucia, tell me again the name of this new religion?

After the conversion of Constantine in A.D. 312, the techniques for attracting followers had to become more creative. Martyrdom was no longer an option, so the more innovative followers relied upon unusual types of performances. In some locales, Christians tried to get closer to God, paradoxically, by isolating themselves in some way. These were sort of beta tests for behavior that would eventually be codified as monastic life. With these early proto-monks, though, the point seemed to be to draw attention to their beliefs. They were performance artists of sorts, and in fact they make our own—the folks who stick yams up their rears or publicly pierce their bodies with pins—look like hopeless pikers.

Take the boskoi—the word means "shepherds" in Greek. Intentionally homeless, these early monks wandered hillsides alone and were said to eat grass on all fours like beasts of burden. They were hard to miss, according to Ephrem the Syrian, because "in appearance their hair bears a closer resemblance to the wings of an eagle than the hair of a human." Observers of the boskoi also seemed obsessed with the improbable length of their fingernails. Ephrem wrote that they were often "mixing with stags and leaping with fawns." They didn't do this just for a one-time appearance at the Performing Garage in SoHo. They did it for the rest of their lives.

The Catenati wrapped themselves in chains and dragged their literal burdens everywhere. Other devotees, such as the stylites, climbed up a pole and never left. St. Alypius spent fifty-three years standing upon his pillar. When age and fatigue reduced him to lying on his side, he spent the next fourteen years on his pillar, couchant.

Nearly all these early saints drew crowds. Their very oddness was the point. It disconcerted the Establishment and made people try to understand what powerful idea nested in the hearts of these lunatics. Tell me again, Lucia, the name of this new religion? One subset of stylites chose not to live atop man-made pillars. Even that was too easy, too comfortable. They were called the Dendrites. They built their platforms in trees.

VII. The Book of the Tree-sitters

N OCTOBER 4, 2001, a radical environmentalist who had taken the forest name Tre Arrow shimmied up a tree as a crew of loggers arrived to cut timber on a parcel of Oregon public land called God's Valley. Then Tre Arrow fell, breaking his sixty-foot plunge by slamming into some limbs before crashing to the ground, his head split open, a lung punctured, bones broken.

The news coverage was interesting. The Associated Press simply reported that he "tumbled 60 feet from a treetop perch in the Tillamook State Forest and suffered multiple broken bones." What none of the stories reported was that the loggers chased this radical higher and higher up the tree, lopping off all the lower branches. When the chain saw got close, Tre Arrow leapt into another tree, so they sheared the bottom limbs off that one too. With no way out, Tre Arrow sat in the tree with no water or food. The loggers and law-enforcement officials below shouted insults, shone lights, and blared music at him throughout the night. The jeering and mockery at this guy lasted for forty-eight hours. It only ended when the object of their hatred passed out right in front of their eyes and plummeted to the ground. The state forestry spokesman, Jeff Foreman, told a newspaper: "That was unfortunate and obviously something we hoped would not happen."

Or precisely what we hoped might happen. You know, depending.

Tree-sitting dates only to the late nineties as a form of protest. The practice became popular in 1998 after a young woman named Julia Hill climbed up a giant redwood tree in California and stayed there for two years. She took a forest name, Butterfly, and gave her tree a name, Luna. She later wrote a book about her experience at defeating a timber company's intention to cut down thousand-year-old redwoods. On some websites, the denunciations of "dreadlocked bongo-playing hippies" and rage at their "stupidity" are commonplace. Tree-sitters tend toward odd language, like calling their trees "ancient ones," one of those crypto-aboriginal terms that drive opponents berserk. In terms of private property, tree-sitters are obvious trespassers. The timber companies have legal permits. Often they are cutting trees on land

FOLIO 49

FIG. 31 Illuminated page from Jack Hitt, "A Gospel According to the Earth." Illustration by Rodica Prato. Copyright © 2003 by *Harper's Magazine*. All rights reserved. Reproduced from the July issue by special permission.

gether, the baggage of book learning goes out the window. Finally, medieval monks are spiritual seekers who never do anything productive or practical. Only Oelschlaeger, whose example of ax-wielding monks seems ill chosen, hints at the fact that cloistered societies, as landowners and land workers, may well have been pragmatic scientists; agriculturalists who developed three-field rotation and social enrichment systems; animal husbandry experts; herbalists; and gardeners. In short, they were not just social ecologists (which they surely were) but also, in some sense, the proto-scientific ecologists of their time.

Popular views of medieval monasticism may be incomplete, or mistaken, but their persistence in the modern American imaginary manifests their enduring hold on our imaginations and our ongoing need to understand the present in light of the past. Such persistence creates a space for rethinking and reexamining our understandings of medieval monasticism, a space where we might develop yet another view—one that emphasizes humans living in community, developing a concept of the common good, and seeking to understand the complex interactions of human and biological systems. We might find in medieval monasticism examples of communities that, being largely fixed in place, sought to develop norms and practices for sustaining and renewing, not exhausting, natural resources.

VISIBLE AND INVISIBLE LANDSCAPES

> All their lives out here some people know
> they live in a hemisphere beyond what Columbus discovered.
> These people look out and wonder: Is it magic? Is it
> the oceans of air off the Pacific? You can't
> walk through it without wrapping a new
> piece of time around you, a readiness for a meadowlark,
> that brinkmanship a dawn can carry for lucky people
> all through the day.
>
> —STAFFORD, "IS THIS FEELING ABOUT THE WEST REAL?"

This essay's focus on the Pacific Northwest and on Oregon partakes to a certain extent in what has been called "Oregon exceptionalism." It looks to Oregon out of a belief that the best aspects of this regional pride, this sense that things are done differently in Oregon (itself a historical development that is now hotly contested politically), exemplifies a connection to the past that can be sustained through education and belief. For if some of us, in Stafford's

words, intuit that we live in a unique place, if we know that we "live in a hemisphere beyond what Columbus discovered" (whether that be Oregon or not), then how might we pass that sense of place on to others—our children, neighbors, and fellow travelers? Wendell Berry's reflections on the problem of renewing and transmitting cultural understandings of landscape are particularly cogent here.

> Memory, for instance, must be a pattern upon the actual country, not a cluster of relics in a museum or a written history. What Barry Lopez speaks of as a sort of invisible landscape of communal association and usage must serve the visible as a guide and as a protector; the visible landscape must verify and correct the invisible. Alone, the invisible landscape becomes false, sentimental, and useless, just as the visible landscape, alone, becomes a strange land, threatening to humans and vulnerable to human abuse.[37]

Can ecomedievalism, if we might call it that, be a resource in this quest to connect and reconnect the visible and invisible landscapes of, say, Oregon? This essay closes by describing a project directed by the ecologist and community activist Richard Hart, a former member of the Order of Christian Brothers who draws on his knowledge of modern and medieval monasticism in order to translate ideals of land stewardship, the common good, and sustainable land use into practice.[38] In Lake County, a remote and sparsely populated corner of south-central Oregon,[39] Hart developed and directs the Chewaucan Biophysical Monitoring (CBM) Project, which establishes a pragmatic link between the scientific assessment of the health of a rivershed and the social health of the tiny communities of this remote place.[40] Scientifically, the CBM project is a field study documenting the soil conditions, stand composition, and general environmental health of the Chewaucan River water-

37. Wendell Berry, "Writer and Region," reprinted in *What Are People For?* (New York: North Point Press, 1987), 71–87, at 84.

38. Information based on personal interviews conducted with Richard Hart, Summer Lake Hot Springs, Oregon, and Paisley, Oregon, on 27 and 28 June 2003.

39. Lake County, Oregon, is 8,359 square miles in size (roughly the size of Wales) and in the year 2000 had a population of 7,422. (In that same year, there were roughly 87,600 head of cattle in Lake County.) Lake County and its neighboring county to the east, Harney (pop. 7,609), are together bigger than Switzerland; Lake, Harney, and Malheur counties (Malheur, pop. 31,615, to the east again of Harney County and bordering the state of Idaho) are together just a little smaller than Scotland or Austria. All Oregon statistics are from Allan, Buckley, and Meacham, *Atlas of Oregon,* 96.

40. Lake County Resources Initiative, "Chewaucan Biophysical Monitoring Project," http://www.lcri.org/monitoring/index.html (accessed 23 August 2005).

shed, about 268 square miles (or 171,562 acres) of chiefly Ponderosa pine forest that has been heavily damaged by human use (including road building, logging, and grazing). The project also documents the effects of restoration activities currently under way. It runs during the summer months on federal monies that are dispensed in Lake County via the Lake County Resources Initiative, whose goal is to restore Lake County to health: that is, environmental, economic, and social viability. During the summer months, high school and college students who are enrolled in or have graduated from Lake County High School collect data in the field. Eight young people make up the team, and they come back from far-flung schools to work on the project.

Forty years ago, Hart studied medieval monastic communities—specifically, the sustainable agricultural practices and the notions of stewardship they developed partly in response to the need to maintain the economic and ecological health of a place-bound community. From this work on monasticism, Hart developed the fundamental principles of ecology as a holistic enterprise that have guided the CBM project. The students perform the hard, meticulous work of observing, counting, monitoring, analyzing, and identifying the entire spectrum of life in the landscape. These efforts translate into practice and make concrete the thinking of geographer Yi-Fu Tuan, as summarized by Lees and Overing in the first essay in this volume: "If we train our eye, if we look ever more closely, a landscape can reveal its singular ordering of reality." As the students name and attend to this specific landscape in all its diversity and complexity, they create a pattern of scientific memory for the visible landscape. They are constructing the knowledge and understanding of the visible landscape that, in Berry's words, "must verify and correct the invisible."

For the young people—themselves local residents—involved in this project, the Chewaucan River basin also has a specific human history. They are working in places about which their families, often over multiple generations, tell stories. Memory, then, is the creation of human community over time through stories. Not only do family stories attain "color," "outlines," and "depth" (to quote William Stafford) when they are recollected in the settings in which they took place, but the young people, through their experiences with the CBM project, are also creating their own stories, which form a new layer of community memory. These memories and stories about place anchor the science—or perhaps better, build the social, cultural, and spiritual patterns that give the landscape deep meaning. They become, as Berry put it, "the invisible landscape of communal association and usage [that] must serve the visible as a guide and as a protector." The words of the project participants,

as posted on their Web site, express this sentiment best. Luke Dary, for instance, said, "When you start getting involved in the area around where you live . . . living in place becomes more of a desire." Alex Plato added,

> I learned that we have a responsibility, but I've developed this huge respect for nature and the outdoors . . . here we have this "outdoors," this great beautiful place. That we can go out in God's creation and work in it. We can be stewards of it It means a lot to me that we . . . can contribute to it and its beauty and we can be part of it.

And Grant Morrison thought, "If we do have an impact on this forest, I'll probably be around in my older years to see it. . . . And I'll remember the places we went and the things we did, and it's just neat to think that I can have an impact and I'll be able to see that change."[41]

Hart has sought to turn his formative experiences as a member of the Order of Christian Brothers and his study of medieval monasticism into a resource for the present and future. The medieval period is, in some ways, the period *par excellence* of the local and the particular. The lesson of Hart's work—and, by extension, his practice of ecomedievalism—is that the past can and must be conserved and experienced through connections to specific locations, locales, landscapes.

The title of the three-stanza poem by William Stafford that has accompanied this essay asks an impossibly simple question: Is this feeling about the West real? Perhaps for these young people, participating in a process of scientific assessment that seeks to transform them into stewards of this place, the answer is "yes." And perhaps the answer is "yes" for Richard Hart as well, as he expresses his understanding of medieval monasticism through a holistic approach to environmental study, sustainable land use, and community development. The dynamic, living experience of dialogue between physical environment and human perception *teaches* a feeling about the West—and makes that feeling real in its scientific, social, and sacred dimensions, connecting the visible and invisible landscapes of one rivershed in Lake County, Oregon.

41. Ibid. (accessed 3 November 2003).

ABOUT THE CONTRIBUTORS

Kenneth Addison is Senior Lecturer in Environmental and Analytical Sciences, School of Applied Sciences, at Wolverhampton University and Fellow and Tutor in Physical Geography at St. Peter's College, Oxford University. His principal areas of teaching and research are in the fields of Quaternary geology, geomorphology, environmental processes, landsystems, and climate change; he has worked extensively in the icefields and mountains of Europe, Scandinavia, and North America. He has published related papers in journals such as the *Annals of Glaciology, Earth Surface Processes and Landforms, Geological Journal,* and *Journal of Quaternary Science* and is co-author of Routledge's leading environmental textbook, *Fundamentals of the Physical Environment,* which is now approaching its fourth edition. His consultancy focuses on the new field of Earth Heritage, leading to the publication of a number of interpretive field guides and chairmanship of UKRIGS, the public partner of the UK's statutory conservation agencies. These twin interests, environmental and climate change along with heritage conservation, have inspired his growing attention to medieval landscape changes and—almost inevitably—to monastic settlement.

Sarah Beckwith is Professor of English at Duke University. She works on late medieval religious writing. She is particularly interested in Middle English religious writing in its fully cultural dimensions and in the intersections of writing and religious practice. She has published on Margery Kempe, the literature of anchoritism, medieval theater, and sacramental culture in numerous essay collections and journals such as the *South Atlantic Quarterly* and *Exemplaria.* Her book *Christ's Body: Identity, Religion, and Society in Medieval English Writing* was published by Routledge in 1993; her *Signifying God: Social Relation and Symbolic Act in York's Play of Corpus Christi* was published by the University of Chicago Press in 2001. Her next book, *How to Do Words with Things,* will explore the implications of Wittgensteinianism and ordinary language philosophy in medieval drama and culture. She is also beginning research on a book spanning the Middle Ages and Renaissance on childhood and revenge. She is co-editor of the *Journal of Medieval and Early Modern Studies.*

Stephanie Hollis is Professor of English at the University of Auckland in New Zealand. She has published books on Anglo-Saxon women and Old English prose of secular learning as well as articles on Old English, Chaucer, and medieval drama and romance. Her publications are various, but her 1992 book *Anglo-Saxon Women and the Church: Sharing a Common Fate* continues to be one of her most important works. She is the editor of *Writing the Wilton Women,* a collection of essays on Goscelin's Legend of Edith and *Liber confortatorius,* with accompanying translations, published in 2004.

Stacy Klein is Assistant Professor of English at Rutgers University, where she teaches Old and Middle English literature. She received her B.A. at Dartmouth, her M.A. at the University of Sussex, and her Ph.D. at Ohio State University. Author of a number of articles on Anglo-Saxon literature, her book *Ruling Women: Popular Representations of Queenship in Late Anglo-Saxon England,* is scheduled for publication in 2006 with the University of Notre Dame Press.

Clare A. Lees is Professor of Medieval Literature and the History of the Language at King's College London. She has published widely on Anglo-Saxon literature, gender, and culture and is the author of *Tradition and Belief: Religious Writing in Late Anglo-Saxon England* (1999). She co-authored, with Gillian R. Overing, *Double Agents: Women and Clerical Culture in Anglo-Saxon England* (2001); she is also the editor of *Medieval Masculinities: Regarding Men in the Middle Ages* (1994) and the co-editor, with Thelma S. Fenster, of *Gender in Debate from the Middle Ages to the Renaissance* (2002). With Gillian Overing, she co-edited the special issue *Gender and Empire in the Early Medieval World* for the *Journal of Medieval and Early Modern Studies* (2004).

Fred Orton, Professor of History of Art and Theory at the University of Leeds, has wide-ranging interests. He studied fine art at Coventry College of Art and art history at the Courtauld Institute, University of London. He was Reviews Editor of Art History from 1983 to 1987 and an editor of the *Oxford Art Journal* from 1987 to 1992. He has held visiting appointments at the State University of New York, Cortland; the University of Texas at Austin; the University of California at Los Angeles; and, most recently, at Northwestern University. He is co-author, with Charles Harrison, of *A Provisional History of Art & Language* (1982). His most recent books include *Figuring Jasper Johns* (1994) and *Jasper Johns: The Sculptures* (1996). His research interests include aspects of Anglo-Saxon stone sculpture, nineteenth- and twentieth-century European art, modern American art, and the appropriation of contemporary

critical theory to art history. He is presently engaged on projects focused on the Ruthwell and Bewcastle monuments, the art of Jasper Johns, and the photographs of the Canadian artist Jeff Wall.

Gillian R. Overing is Professor of English at Wake Forest University, where she teaches Old English, Scandinavian literature, gender studies, and linguistics. Author of *Language, Sign, and Gender in 'Beowulf'* (1990), she is also the co-author, with Marijane Osborne, of *Landscape of Desire: Partial Stories of the Medieval Scandinavian World* (1994) and co-editor, with Britton J. Harwood, of *Class and Gender in Early English Literature* (1994). With Clare A. Lees, she has published *Double Agents: Women and Clerical Culture in Anglo-Saxon England* (2001) and is co-editor of *Gender and Empire in the Early Medieval World* (2004). She has also published widely on Old English literature and culture.

Ann Marie Rasmussen, Associate Professor of German at Duke University, has published extensively on medieval German literature. Her monograph, *Mothers and Daughters in Medieval German Literature, 1187–1557,* reads male-authored stories of the transfer of knowledge between women as narratives of conflicting power relations. Most recently, she co-edited *Medieval Woman's Song: Cross-Cultural Approaches* (2002). Born in Redmond, Oregon, she graduated from Junction City (Oregon) High School and received her B.A. from the University of Oregon. Her paternal great-grandparents, Meta and Ole Rasmussen and Marie and Peter Bodtker, immigrated to Oregon from Denmark and the Faroe Islands.

Diane Watt, Professor of English at the University of Wales, Aberystwyth, is interested in medieval English literature, especially Ricardian poetry, religious texts, and women's writing, and theories of gender and sexuality. She also has interests in early modern English and Middle-Scots literature. Recent publications include *The Paston Women: Selected Letters* (Cambridge: D. S. Brewer, 2004) and *Amoral Gower: Language, Sex, and Politics in Confessio Amantis* (Minneapolis: University of Minnesota Press, 2003). Along with Jacqueline Murray, Diane is the general editor of the series Gender in the Middle Ages, published by Boydell and Brewer. With Denis Renevey, Diane is general editor of the series Religion and Culture in the Middle Ages, published by University of Wales Press. The series is interdisciplinary in nature and is largely concerned with the religious culture of medieval Western Europe. Her first book, *Secretaries of God: Women Prophets in Late Medieval and Early Modern England,* was published by D. S. Brewer in 1997.

Kelley Wickham-Crowley is Associate Professor of English at Georgetown University and also teaches for its programs in women's studies and medieval

studies. She holds degrees in medieval studies, earned at Cornell, and in Anglo-Saxon and Viking archaeology from the University of Durham. She has published widely on Laȝamon's *Brut* as well as on Anglo-Saxon and early medieval archaeological issues, and she is a co-editor, with Catherine Karkov and Bailey Young, of *Spaces of the Living and the Dead: An Archaeological Dialogue* (1999). Her latest book, *Writing the Future: Laȝamon's Prophetic History*, came out in 2002 from the University of Wales Press.

Ulrike Wiethaus, Professor of Humanities at Wake Forest University, is currently completing a book-length study of the construction of alterity in medieval Christian mysticism in Western Europe, entitled *Trace of the Other: Medieval Christian Mysticism in Contemporary Context*. Author of *Ecstatic Transformation: Transpersonal Psychology in the Work of Mechthild of Magdeburg* (1996), she is also editor of *Maps of Flesh and Light: The Religious Experience of Medieval Women Mystics* (1993) and co-editor, with Karen Cherewatuk, of *Dear Sister: Medieval Women and the Epistolary Genre* (1993). Her most recent publication is a translation of *The Life and Revelations of Agnes Blannbekin, Viennese Beguine* (Boydell and Brewer, 2002). She wrote an article for the 1999 collection *New Trends in Feminine Spirituality: The Holy Women of Liège and Their Impact* called "Female Spirituality, Medieval Women, and Commercialism in the United States."

Ian Wood is Professor of Early Medieval Studies at the University of Leeds. Author of a wide range of articles on early medieval history, his most recent book contributions include "An Absence of Saints? The Evidence for the Christianisation of Saxony" in *Am Vorabend der Kaiserkronung* (Paderborn, 2002), and "Deconstructing the Merovingian Family," in *The Construction of Communities in the Early Middle Ages* (Leiden, 2002). He is author of *The Merovingian Kingdoms, 450–751* (1994) and *The Missionary Life: Saints and the Evangelisation of Europe, 400–1050* (2001). Most recently, he and Danuta Shanzer translated and edited the correspondence of Avitus of Vienne: *Avitus of Vienne, Letters and Selected Prose* (Liverpool, 2002).

INDEX